FIFTY KEY TEXTS IN ART HISTORY

'Considered together these layered texts that interlace generations of thinkers take a pluralistic approach to the knotted problem of teaching and transforming our archives.'

Professor Claire Farago, *University of Colorado, Boulder*

'A judicious selection of voices, complemented by careful and authoritative exegesis from a diversity of contemporary thinkers. A touchstone for scholars in art history's "post-canonical" age.'

Leon Wainright, *Lecturer in Art History, The Open University*

Fifty Key Texts in Art History is an anthology of critical commentaries which explores some of the central and emerging themes, issues and debates within an increasingly expansive and globalised discipline. The texts are arranged chronologically with each entry including suggestions for further reading in a selected bibliography. International contributors include art historians, artists, aestheticians, curators and gallerists. The texts discussed include:

- Ananda K. Coomaraswamy's *Art and Swadeshi* (1909–11)
- Rozsika Parker and Griselda Pollock's *Old Mistresses*: *Women, Art and Ideology* (1981)
- Georges Didi-Huberman's *Confronting Images: Questioning the End of a Certain Art History* (1990)
- Homi Bhabha's *The Location of Culture* (1994)
- Judith Butler's *Gender Trouble* (1999).

Diana Newall is a Research Associate at the Open University, an Associate Lecturer at the University of Kent and co-author of *Art History: The Basics* (2008) and *The Chronology of Pattern* (2011).

Grant Pooke is a Senior Lecturer at the University of Kent. He is the author of *Francis Klingender 1907–1955: A Marxist Art Historian Out of Time* (2008) and *Contemporary British Art: An Introduction* (2010).

ALSO AVAILABLE FROM ROUTLEDGE

Art History: The Basics
Grant Pooke and Diana Newall
978-0-415-37308-1

Art History: The Key Concepts
Jonathan Harris
978-0-415-31977-5

FIFTY KEY TEXTS IN ART HISTORY

Edited by
Diana Newall and Grant Pooke

LONDON AND NEW YORK

First published 2012
by Routledge
2 Park Square, Milton Park, Abingdon, Oxon OX14 4RN

Simultaneously published in the USA and Canada
by Routledge
711 Third Avenue, New York, NY 10017

Routledge is an imprint of the Taylor & Francis Group, an informa business

British Library Cataloguing in Publication Data
A catalogue record for this book is available from the British Library

Library of Congress Cataloging in Publication Data
Fifty key texts in art history / edited by Diana Newall and
Grant Pooke. – 1st.
p. cm. – (Routledge key guides)
Includes bibliographical references.
Summary: "Arranged chronologically, each entry includes a bibliography for further reading
and a key word index for easy reference. Text selections range across issues including artistic
value, cultural identity, modernism, gender, psychoanalysis, photographic theory,
poststructuralism and postcolonialism. - Rozsika Parker and Griselda Pollock Old Mistresses:
Women, Art & Ideology (1981) - Victor Burgin's The End of Art Theory: Criticism and
Postmodernity (1986) - Homi Bhabha The Location of Culture - Geeta Kapur When was
Modernism in Indian Art? (1995) - Judith Butler's Gender Trouble (1999) - Georges
Didi-Huberman Confronting Images. Questioning the Ends of a Certain History of Art
(2004)"– Provided by publisher.
1. Art–History. 2. Art–History–Bibliography. I. Pooke, Grant. II. Newall, Diana. III. Title:
Fifty key texts in art history.
N5303.F54 2012
709–dc23
2011028404

ISBN: 978-0-415-48705-4 (hbk)
ISBN: 978-0-415-49770-1 (pbk)
ISBN: 978-0-203-13878-6 (ebk)

Typeset in Bembo
by Taylor & Francis Books

Printed and bound in Great Britain by the MPG Books Group

This book is dedicated to the memory of
Catherine Zaks

CONTENTS

CHRONOLOGICAL LIST OF TEXTS

CONTRIBUTORS

Kath Abiker is a Lecturer in Art History at K College, Kent, teaching primarily on the significance of philosophy and Postmodern theory in relation to contemporary art and design. She completed an MA in the History and Theory of Modern Art at Chelsea School of Art and Design, London. As a practitioner she sits between disciplines – painting, exhibiting and writing about art. Recent publications include 'In no particular order' *Text + Work*, the Arts Institute at Bournemouth (2008) and, as a co-editor, a book of transcripts which explores the interaction of language and art (2009).

David Ayers is Professor of Modernism and Critical Theory at the University of Kent. His books include *Wyndham Lewis and Western Man* (1992), *English Literature of the 1920s* (1999), *Modernism: A Short Introduction* (2004), and *Literary Theory: A Reintroduction* (2008). His recent Leverhulme Trust funded project studied the cultural impact in Britain of the Russian Revolution. He is also Chair of the European Network for Avant-Garde and Modernist Studies (EAM) and the International Relations Chair of the Modernist Studies Association (MSA).

Debashish Banerji is the author of *The Alternate Nation of Abanindranath Tagore* (2010) and teaches Asian Art History at Pasadena City College and Indian Studies at the University of Philosophical Research, Los Angeles. He works in the Department of Asian and Comparative Studies, California Institute of Integral Studies, San Francisco. He has curated a number of exhibitions, including *Divine Carriers: Recent Art From India and Nepal* (Laband Art Gallery), Loyola Marymount University, Los Angeles (1998), *Contours of Modernity: Contemporary Art of India* (Founder's Hall) Soka University, California (2005) and *The World of Ajanta* (Sri Aurobindo Ashram Art Gallery), Puducherry, India (2008).

David Bindman is Emeritus Professor of the History of Art at University College London and has written mainly on British art but also on the

representation of race. He has lectured extensively, holding fellowships at Yale, the National Gallery of Art, Washington, the Getty Institute and the Du Bois Institute, Harvard. He is the author of *Ape to Apollo: Aesthetics and the Idea of Race in the 18th Century* (2002) and is the general editor (with Henry Louis Gates, Jr) of *The History of British Art*, 3 vols (2008) and *The Image of the Black in Western Art* (forthcoming 2014).

Patricia Chan is a PhD candidate at the University of Kent. She is currently researching the representation of borders in contemporary visual art. Engaging with the rhetoric of illegality and immigration in political discourse, and changing concepts of citizenship and migration, her thesis examines how a range of artists disturb the notion of borders as neutral markers of territory. She holds a BA and MA in Photography from IADT, Dun Laoghaire Institute of Art (2004) and the Royal College of Art (2007). In 2009, she completed an MRes in Humanities and Cultural Studies from the London Consortium.

Jonathan Clarkson lectures on the History and Theory of Art at Cardiff School of Art and Design, University of Wales Institute, Cardiff and is a member of CFAR (Centre for Fine Art Research). He co-edited (with Neil Cox) *Constable and Wivenhoe Park: Reality and Vision* (2000) and his latest book on the artist, *Constable*, was published by Phaidon in 2010. He has also published essays on contemporary painting, photography and sculpture and was co-editor (with Sean O'Reilly) of *Sense in Place* (2006), documenting a Europe-wide programme of exhibitions of site-specific art. He edits the online journal *The Cardiff Review of Art*.

Verity Clarkson lectures part-time at the University of Brighton. She recently completed her PhD on Cultural Exchanges during the Cold War entitled 'The Organisation and Reception of Eastern Bloc exhibitions on the British Cold War "Home Front" c. 1956–75' (AHRC Collaborative Doctoral Award, University of Brighton and the Victoria and Albert Museum). Prior to doctoral research, she studied Modern History at St Hilda's College, University of Oxford and investigated the material culture meanings of vintage analogue synthesizers during her MA in Design History. She contributed to the 'Art Histories, Cultural Studies and the Cold War' conference at the IRGS in 2010.

Mavernie Cunningham is currently Course Leader of BA (Hons) Fine Art at K College, Kent and is a practising printmaker. Her research interests include the study of postcolonialism and the investigation of its impact in relation to the thematics of identity, culture and art. She

has a particular interest in the history and development of the Expressionist print, notably the psychology of emotion explored through the genre of the woodcut. She draws inspiration from works including 'Peter Schemihl's Wondrous Adventure' by Ludwig Kirchner, 'The Sun' by Franz Masereel as well as Lynd Ward and the era of the wordless novel.

Mark Durden is Professor of Photography at the University of Wales, Newport and has published extensively on photographic practice and contemporary art. He is currently editing *Fifty Key Writers on Photography* (forthcoming 2012), the companion volume to *Fifty Key Texts in Art History*, and is completing a major study of photography from the 1960s to the present, *Photography Today*. Since 1997, and as part of the artists' group 'Common Culture' (with David Campbell and Ian Brown), he has exhibited nationally and internationally. 'Common Culture' took part in the major group show *Shopping* at Tate Liverpool (2002–3) and the Shanghai Biennale (2006).

Claire Farago is Professor of Renaissance Art, Theory and Criticism at the University of Colorado at Boulder and is currently Fulbright-York Scholar and Visiting Distinguished Professor at the University of York. She has published widely on art theory and historiography, with an emphasis on historical processes of cultural interaction. Her publications include *Reframing the Renaissance: Visual Culture in Europe and Latin America 1450 to 1650* (1995), *Transforming Images: New Mexican Santos In-between Worlds*, co-authored with Donna Pierce (2006), and *Art is Not What You Think It Is*, co-authored with Donald Preziosi (forthcoming 2012). She is currently editing Leonardo da Vinci's *Treatise on Painting* originally published in 1651, with a team of other Leonardo scholars.

Chris Hunt is a Course Leader and Senior Lecturer in Visual Theory in the School of Communication Media at the University for the Creative Arts (UCA) in Kent. His research interests are wide-ranging, encompassing Japanese film, the paintings of Philip Guston and reflections on art and cinema in the philosophies of Emmanuel Levinas, Slavoj Žižek and Gilles Deleuze. He works as an external examiner for art and design courses in the UK and Pakistan, and is a practising artist with a studio in Kent.

Jon Kear lectures at the University of Kent, is a graduate of the Courtauld Institute and has taught at Birkbeck College and Marburg University. He is the author of *Sunless* (1999), a study of Chris Marker's film *Sans Soleil*, *The Impressionists* (2008) and *Degas* (forthcoming 2012). He has published on various aspects of nineteenth and twentieth century European art, film and photography and is currently working

on studies of Fantin-Latour and Cézanne and is curating an exhibition of the artist collective *Art and Language* (2011). He co-curated *Spectres of Painting* (2007), *The Art of Lithography* (2010) and *In Elysium: James Barry and his Contemporaries* (2010).

Catherine King is Professor Emerita and founder member of the Arts Faculty at the Open University (1969–2011) who chaired courses on 'Art in Italy 1480–1580' and 'Issues in Women's Studies' as well as contributing to many interdisciplinary and specialist art history courses. Her research interests include gender, consumption and spectatorship (for example in *Renaissance Women Patrons: Wives and Widows in Italy c. 1300–1550* (1998)) and also historiography (for example in *Views of Difference: Different Views of Art* (1999) and *Representing Renaissance Art c. 1500–1600* (2007)).

Vicki Kirby is Associate Professor in the School of Social Sciences and International Studies at The University of New South Wales, Sydney. She is the author of *Telling Flesh: The Substance of the Corporeal* (1997) and *Judith Butler: Live Theory* (2006). Her most recent book, *Quantum Anthropologies: Life at Large* (2011), considers the relevance of Derrida's work for posthumanism by reading 'textuality' as Nature. She recently completed an Australian Research Council Discovery Project on the implications of the linguistic turn for the life sciences.

Alexandra M. Kokoli lecturers in Critical and Contextual Studies at Gray's School of Art, The Robert Gordon University, Aberdeen. She writes on feminism, gender and race in visual art and culture and has published in *n.paradoxa* and *Wasafiri*, among other journals. She is the editor of *Feminism Reframed: Reflections on Art and Difference* (2008) and *Susan Hiller, The Provisional Texture of Reality: Selected Talks and Texts, 1977–2007* (2008), and a contributor to the Tate Britain exhibition catalogue *Susan Hiller* (2011) and to the forthcoming volume *Politics in a Glass Case*, edited by Angela Dimitrakaki and Lara Perry.

Pil and Galia Kollectiv are London-based artists, writers and curators working in collaboration. Both PhD candidates (Goldsmiths), they also lecture in Fine Art at the University of Reading and are contributing editors at *Art Papers* and directors of the artist run project space xero, kline & coma. They have had solo shows at Te Tuhi, New Zealand, S1 Artspace, Sheffield and The Showroom Gallery, London. They have also presented live work at the Berlin Biennial and the Montreal Biennial, as well as at Kunsthall Oslo, Arnolfini, Bristol, Tate Britain and the ICA, London.

Hans Maes lectures at the University of Kent where he is a member of the Aesthetics Research Group. He is President of the Dutch Association of Aesthetics and received his PhD from the University of Leuven, Belgium, after which he conducted postdoctoral research at the University of Helsinki, Finland, and the University of Maryland, USA. His work has been published in several journals including the *British Journal of Aesthetics, Philosophy and Literature, Philosophical Quarterly* and the *Journal of Aesthetic Education.* He is the co-editor (with Jerrold Levinson) of a volume on *Art and Pornography,* forthcoming with Oxford University Press.

Peter McMaster is a PhD candidate at the University of Kent where he achieved a First Class Honours degree in the History and Philosophy of Art (2007) and the Bann Prize for Excellence in Art History. The subject of his thesis is the life and work of the late British art critic, writer and theorist, Peter Fuller. In 2004, after a career spent in the international heavy construction industry, he decided to make a career change and pursue a life-long interest in art. He was a contributor to the 'Art Histories, Cultural Studies and the Cold War' conference at the IRGS in 2010.

Junko Theresa Mikuriya lectures in photography at the University of Kent where she was awarded a faculty teaching prize in 2009. She completed her BA at University College London and MA at the University of Paris-Sorbonne. She studied photography at Spéos, the Paris Photographic Institute and completed her PhD on photography and magic at the Centre for Cultural Studies, Goldsmiths, University of London. She has extensive experience as a freelance photographer in the fashion and music industries and has taught as a visiting artist and lecturer at the School of Creative Media, City University of Hong Kong.

Diana Newall is a Research Associate at the Open University and lectures part-time at the University of Kent. She is a Fellow of the Higher Education Academy and was the Konstantinos Leventis Research Fellow at the Open University (2008–10). She is author of *Appreciating Art* (2008), co-author of *Art History: The Basics* (2008) and co-author of *The Chronology of Pattern* (2011). Her books have been translated into Chinese, French, German, Korean, Polish, Romanian, Russian and Spanish. Her research includes late Medieval and Early Modern Venetian-dominated Crete (1211–1699) especially the cross-cultural and artistic interactions in the capital Candia.

Grant Pooke is a Senior Lecturer at the University of Kent and a Fellow of the Royal Society of Arts. He studied at the Universities of

St Andrews and Kent, and undertook a PhD at the Winchester School of Art. His interests include post-conceptual art practice, Cold War art historiography, and extending the audiences for Art History. He is the co-author of *Teach Yourself Art History* (2003 and 2008), *Art History: The Basics* (2008) and the author of *Francis Klingender 1907–1955: A Marxist Art Historian Out of Time* (2008) and *Contemporary British Art: An Introduction* (2010).

Kalle Puolakka is a Postdoctoral Researcher of Aesthetics at the Department of Philosophy, History, Culture and Art Studies, University of Helsinki. He received his PhD from the University of Helsinki in 2009 with a thesis entitled 'Reconsidering Relativism and Intentionalism in Interpretation. Donald Davidson, Hermeneutics, and Pragmatism'. Publication of an expanded version of this work is forthcoming with Lexington Books (2011). He has published articles on philosophy of art and aesthetics in journals such as *Philosophia, SATS – Nordic Journal of Philosophy*, and *Contemporary Aesthetics*.

Niru Ratnam is a writer and gallerist. He worked at the Open University's Art History department between 2000 and 2003 and contributed to each of the four books in the series 'Art in the Twentieth Century'. After that he opened the gallery STORE which exhibited emerging artists. He has also worked for Arts Council England developing 'Inspire', the positive action programme for curators of colour. He currently works for the Aicon Gallery, which focuses on artists from South Asia. He has written about contemporary art for a variety of publications including *Art Review, The Spectator, Third Text* and *Frieze*.

Eileen Rubery is a Senior Research Fellow at Girton College Cambridge and lectures for Cambridge University, Birkbeck College and the Victoria and Albert Museum. She received an MA (with distinction) in Byzantine and Medieval Art at the Courtauld Institute of Art and is at present completing her PhD, which focuses on the decorations of the church of St Maria Antiqua in the Roman Forum and its relationship with the Byzantine east and the papacy. She has published on events surrounding the martyrdom of Pope Martin I (649–54/5 CE), on the Monothelite controversy and on the meaning of the 'Empress Ariadne' ivories.

Daniel Rycroft is a Lecturer in South Asian Arts and Cultures at the University of East Anglia. He is author of *Representing Rebellion: Visual Aspects of Counter-insurgency in Colonial India* (2006). In 2004–5, whilst researching a project on 'Subalternity and Visual Representation in India', he co-directed and co-produced a documentary film

entitled *Hul Sengel: The Spirit of the Santal Revolution* (46 minutes, Santali with English subtitles). In 2005 he organised an international conference on 'Reinterpreting Adivasi (Indigenous Peoples) Movements in India', and is currently co-editing a book on *Becoming Adivasi: Indigenous Pasts and the Politics of Belonging.*

Janet Sayers is Professor of Psychoanalytic Psychology at the University of Kent in Canterbury where she also works as a Principal Clinical Psychologist for the NHS. Her books include *Mothering Psychoanalysis* (1992), *Freudian Tales* (1997), *Kleinians* (2000), *Divine Therapy* (2003), and *Freud's Art* (2007). She is currently completing a book provisionally called *Art and Psychoanalysis: The Story of Adrian Stokes.* Her work on Julia Kristeva includes several book chapters and articles, including 'Healing aesthetics: Kristeva through Stokes' (2005) and 'Beyond abjection: art, religion, psychoanalysis' (2006–7).

Christopher Short is a Senior Lecturer in Art History and Theory, and Photography, at Cardiff School of Art and Design. He was a postgraduate student at the University of Essex where he completed his PhD on the relationship of the philosophy of Friedrich Nietzsche to German Expressionist art. He has since published books on the work of Egon Schiele (Phaidon) and Wassily Kandinsky (Peter Lang), and is currently working on a new book entitled *Surf, Art and Philosophy* (forthcoming, 2013). He has also produced a body of artworks relating to the shoreline and surf culture in South Wales.

Michael Squire is Lecturer in Classical Greek Art at King's College, London, having also held various positions at Harvard, Christ's College in Cambridge, Humboldt-Universität in Berlin, and Ludwig-Maximilians-Universität in Munich. His books include *Panorama of the Classical World* (2nd edition, 2008), *Image and Text in Graeco-Roman Antiquity* (2009), *The Art of the Body: Antiquity and its Legacy* (2011), and *The Iliad in a Nutshell: Visualizing Epic on the Tabulae Iliacae* (2011). He has also co-edited volumes on the *Art of Art History in Graeco-Roman Antiquity* (2010), and *Framing the Visual in the Greek and Roman World* (forthcoming).

Brandon Taylor is Professor Emeritus of History of Art at Southampton University, Senior Research Fellow at Southampton Solent University and currently a visiting tutor at the Ruskin School of Fine Art, Oxford University. His books include *Art and Literature under the Bolsheviks* (1991 and 1992), *Art for the Nation: Exhibitions and the London Public* (1999), *Collage: the Making of Modern Art* (2004), *Sculpture and Psychoanalysis* (edited 2006) and *Art Today* (2005). He has

written extensively in the field of contemporary art, and his books have been translated into Spanish, French, Korean, Russian and Chinese.

Ben Thomas lectures at the University of Kent where he is also the Curator of the Studio 3 Gallery. He was awarded a university faculty prize for his teaching on the Print module. He has published on Italian Renaissance art, the history of collecting, the history of prints, and has also curated exhibitions on Van Dyck, mezzotint and James Barry. He is also co-organiser with Grant Pooke of the research network Art Histories, Cultural Studies and the Cold War, where his special interest is the art historian Edgar Wind. He is presently researching a history of print making.

Anna Webber is Head of Faculty for Higher Education at Canterbury College, Kent. Her art practice developed out of ideas which combine art with science. This led to an interdisciplinary Master's in Fine Art, where the question 'why' was deconstructed through talking to physicists, and painting with mixed-media. When teaching History of Art to Access students, as their undergraduate tutor, she recognised this knowledge empowered them to deconstruct theoretical concepts. She believes that it is essential to demystify theory for students in order to support a rigorous and audience-responsive practice in art and design.

Graham Whitham is a teacher and lecturer. Formerly a tutor with the Open University, the University of Sussex, and Hastings College of Arts and Technology, he now teaches on the University of Kent's full- and part-time degree programmes. He is the co-author of *Understand Art History* and *Understand Contemporary Art* (both 2010), and has contributed to publications on art in the 1950s and 1960s, including *This is Tomorrow Today* (1987), *Modern Dreams: The Rise and Fall and Rise of Pop* (1988), *The Independent Group: Post War Britain and the Aesthetics of Plenty* (1990) and the *Allgemeines Künstlerlexicon* (2000).

Kim W. Woods is a Senior Lecturer in Art History at the Open University. She completed her PhD at the Courtauld Institute of Art, University of London and has contributed to various Open University course books including *The Changing Status of the Artist* (1997), *Making Renaissance Art* (2007) and *Viewing Renaissance Art* (2007). Her main research interest is in Netherlandish sculpture c. 1400–c. 1600 and she has authored the first study of Netherlandish sculpture in England, entitled *Imported Images* (2007). She is now working on a monograph of European alabaster sculpture 1330–1530 to be published by Brepols.

ACKNOWLEDGEMENTS

We would very much like to thank all the contributors who have authored entries for this critical anthology, for their hard work, enthusiasm and engagement with the project and for their patience during its preparation. Special thanks also go to John Callow, Marx Memorial Library, Catherine King, the Open University, Leon Wainwright, the Open University, Claire Farago, University of Colorado at Boulder, Angus Pryor and Christina Unwin – their support and guidance has greatly assisted with the development of the anthology.

Our thanks also to Jessica, Jonathan and Tim Klingender for the generous loan and use of the Klingender archive and art library and to the editorial team at Routledge for their help and support, including Natalie Foster, Andy Humphries, Cathy Hurren, Kate Reeves, Rebecca Shillabeer, Katherine Ong and Sophie Thomson.

An earlier version of the essay 'Judith Butler, *Gender Trouble: Feminism and the Subversion of Identity*' (1999) appeared in *Judith Butler: Live Theory* (Continuum, 2006).

The extract from the poem by Aimé Césaire *Cahier d'un retour au pays natal* is reprinted by kind permission of Présence Africaine (© Présence Africaine, 1955).

Material from Lawrence Alloway 'The Long Front of Culture' is reprinted by kind permission of The Getty Research Institute, Los Angels (2003.M.46).

PREFACE

One of the primary obstacles to rethinking the discipline of art history has been the segmentation of our archives. The sheer volume of studies that pre-date the current turn of attention toward identity formation and away from essentialising myths of identity is daunting. In practice, the prospect of training future generations to think differently is hindered because amassing expertise in even one of the longstanding specialisations requires many years of study. Further, yet even more fundamental, obstacles are the epistemological structures that underpin our vast storehouses of knowledge. How to introduce students and general readers to the primary sources without also passing on values that may no longer be tenable? This is an intractable problem unless we frame our inherited texts differently, unless we listen to every voice – contemporary and historical – with an ear open to the position from which they speak. As studies of gender, and of gendering processes, first insisted, all positions are partial and all perspectives are strategic and vested, including the preface you are reading now. There is no escape from the individual responsibility to think critically about all forms of received knowledge. Celebration of past scholarship and veneration of primary sources has never been enough in any open society.

If, on the other hand, the highest form of respect is critical engagement with our inheritance, then the present volume of key primary and secondary sources offers an important contribution in encouraging well-informed, intelligent questioning. And one of its key strategies is mixing periods, texts and cultural histories to emphasise interconnections across the internal boundaries that informed the field of art history in the nineteenth century. It would be shortsighted, in any case, to throw the baby out with the bathwater. For not only would we lose sight of a rich European cultural heritage for writing about and making art, deeply problematic as its configurations might have become in certain respects today, but without an understanding of what makes this inherited discourse troubling, future generations will only reproduce the same problems in displaced form.

If a central aim of the humanities in general has been to shape individual moral character derived from values within the western tradition then, in today's world, the educational responsibility is to raise awareness of what it means to behave ethically regarding everyone's cultural legacy. In the present volume, critical introductions frame each of the fifty selections ranging from ancient accounts with long European histories to contemporary voices interrogating that same legacy. Considered together, these layered texts that interlace generations of thinkers take a pluralistic approach to the knotted problem of teaching and transforming our archives.

An interesting inversion of institutional authority results from practising an anti-canonical approach to canonical texts. The emphasis in this volume is on contemporary writers, although a few examples representing the construction of the pre-modern western tradition of writing about art are included. Other than organising the selections chronologically, the editors make no attempt to synthesise the voices within into one coherent narrative – the disjunctions of style, content and stance result from the way in which participating authors were given freedom to choose their own texts and critical strategies. Some, such as the essay introducing Rozsika Parker and Griselda Pollock's classic intervention into the 'patriarchive' of art history, offer a short historical overview. Others, such as the essays introducing Deleuze and Guattari's *Thousand Plateaus* (1980), and Wölfflin's *Principles of Art History* (1915), offer summaries of the authors' strategies and conceptual framework. Juxtaposing texts written for such different times invites productive comparisons.

Many of the sampled texts originate outside the field of art history but are essential reading for anyone wishing to understand its historical premises for the sake of writing and thinking differently today. And for the future of a practice that seeks to undermine the historically European division of labour into writing about art and making art, it is significant how many of the contributing authors are both artists and critics/ historians of art: Brian O'Doherty/Patrick Ireland might have been in the vanguard, but today's artists are expected also to verbally articulate a critical position. And the same might be anticipated of art historians in the future. This volume is especially relevant for contemplating such a doubled engagement with art and art history.

Professor Claire Farago

INTRODUCTION

Art histories, art theories and the 'post-canonical'

The initial aim for *Fifty Key Texts in Art History* is to provide a companion volume for *Art History: The Basics* (Pooke and Newall 2008). The earlier book had various aspirations, the principal of which was to provide an accessible and academically grounded art history primer for new discipline communities. The text introduced and explored both past and more recent theoretical approaches to the subject, for the student – of art history or art practice – or interested general reader. *Fifty Key Texts in Art History* is an anthology of critical commentaries on a spectrum of art historical theories and texts, introducing the reader to an extensive range of primary and secondary sources across the discipline – from the classical period to the cusp of the twenty-first century. A corresponding volume of critical commentaries on photography edited by Mark Durden, *Fifty Key Texts on Photography*, will be appearing shortly.

In the last few decades, anthologies of art historical texts and commentaries have been influential in providing wider access to some of the theories and issues which inform and situate contemporary art historical discourse.[1] Although any selection of texts will inevitably have a certain contingency, we believe that their strength and resonance is in bringing together accessible introductions to a range of themes, issues and debates within art history. This anthology contains evaluative and critical commentaries on texts which have been chosen and written by thirty-two contributors. The selection includes some recent interventions as well as others which have been overlooked in terms of earlier coverage, have been influential on the development of the discipline or have been subject to more recent scholarly attention and re-interpretation. In particular, there was a perception of a need for an anthology which attempted to reflect some of the emerging priorities and themes within art history, especially in the context of globalisation, postcolonialism and contemporary ideas on the instabilities of gender and identity.

This is not to imply, however, that *Fifty Key Texts in Art History* can mitigate this or that inattention, or that it can otherwise make good past exclusions and absences. But it is to suggest the extent to which art historical 'canons', which privilege or value one perspective over another, are profoundly arbitrary and interest-bound constructions, mediating particular hegemonies of taste, fashion and critical attention. It should be implicit therefore that there is no intention to replicate or to fetishise a new 'canon' of 'great texts' but rather to suggest the instability of normative judgements and claims to value, bound as they habitually are to contemporaneous institutional or hegemonic interests and affiliation. Since the rolling back of high Modernism in the 1960s, and the de-centring of western norms in cultural production, as with much else, there has been increasing scepticism around received and imposed standards of art historical and historiographic judgement. The title of this introduction speculatively suggests the resonance of a new term – the 'post-canonical' – might be employed to register the aim and aspiration of moving beyond the 'canon', embedded within many conventional or traditional art historical methodologies.

The anthology's adjectival qualifier of 'key' is designed to suggest and engage perceptions of a broader continuum of cultural production and the extent to which recent and contemporary readings provide new perspectives on art history and historiography. Or, to frame this another way, any student or interested reader should be able to explore and navigate a range of perspectives within contemporary readings of influential and/or previously overlooked texts and be encouraged to make their own interconnections and judgements between periods, issues and subject-matter.

The selection within *Fifty Key Texts in Art History* has sought to strike a balance between texts from a range of periods, but ultimately all contributors were encouraged to identify what they considered to be formative or 'key' texts from their own professional perspective. To this end, as co-editors, and as made explicit in the preface, there has been no intention to orchestrate the text selections beyond providing a broad framework of ideas for consideration. But naturally, any soliciting of interest among peers and contemporaries inevitably mediates subjectivities of a different kind. The final selection presented here cannot be exhaustive and there will inevitably be compromises and omissions, but we hope the range of coverage provides an indicative and relevant sampling of the issues and themes affecting contemporary art history.

An underlying principle within the anthology is to support critical engagement with a diverse selection of texts and also to encourage readers to make their own connections and comparisons. Whilst there are some

widely known texts, at least within a 'western' tradition, we anticipate that there are many which may be less well studied, referenced or otherwise less typically anthologised. The selected texts are arranged chronologically for ease and consistency of reference. This ordering aims to emphasise the temporality of the texts and assists the reader in judging to what extent the ideas which they contain have a broader cultural relevance and durability. The texts, however, can be linked or grouped in various ways and in order to introduce them and to suggest possible synergies, some of these are considered here.

The first texts discussed in the anthology offer perspectives on classical, Early Christian and western medieval concepts and principles of art and image-making. The commentaries on Pliny the Elder's *Natural History* and Philostratus the Elder's *Images*, by Michael Squire, introduce Graeco-Roman ideas and their abiding influence. Both texts are influential not only for our understanding of 'art' in the classical world, but also for their subsequent western legacy. The early Christian, Byzantine and western medieval texts, including the letters of Pope Gregory the Great, the Acts of the Church Councils relating to iconoclasm and the *Liber Pontificalis* discussed by Kim Woods and Eileen Rubery, provide illuminating insights into debates taking place around the role and function of imagery in Christian worship and doctrine. The influential decisions taken in these early periods are often ignored in western art historical discourse, yet these texts and others related to them, significantly contributed to the early foundations of Christian imagery and underpin much of the iconography that developed in later centuries.

The emerging professionalisation of art practice, its corresponding differentiation from manual 'craft' and subsequent theorisation as an intellectual pursuit is profiled by three texts exploring varying perspectives from the sixteenth century. This comprises commentaries by Catherine King and Ben Thomas including Giorgio Vasari's well-known *Vite*, Lodovico Dolce's *Aretino* and Camerarius' biography of the northern European artist Albrecht Dürer. The beginning of the modern period is referenced by a selection of texts which mark the early idealist paradigms on art, aesthetics and critical values from the European Enlightenment. Commentaries by David Bindman and Michael Squire discuss texts by Johannes Joachim Winckelmann, Immanuel Kant and Georg Wilhelm Friedrich Hegel. The mid-nineteenth century, the putative start of the modern period in art and cultural history, and the early twentieth century are indexed through commentaries on texts by Charles Baudelaire, Wilhelm Worringer, Wassily Kandinsky and Heinrich Wölfflin, by Jon Kear, Chris Hunt and Chris Short.[2] These might be understood as distinct responses and engagements with an

increasingly technologically mediated modernity and its social and aesthetic consequences.

From the beginning of the twentieth century, writers began to explore a wide range of perspectives on art, drawing on psychoanalytic concepts and methods, and the impact of technological innovation on human subjectivity (Jonathan Clarkson on Adrian Stokes and Theresa Mikuriya on Paul Valéry). Other writers explored the phenomenology of art (Chris Hunt on Martin Heidegger) and texts which addressed the ostensible specificity and uniqueness of the art object (Pil and Galia Kollectiv on Walter Benjamin). The mid-twentieth century registered an on-going bifurcation within art history between conservative assertions of the 'canon' (Diana Newall on Sir Ernst Gombrich) and more oppositional and socially situated art histories (Grant Pooke on Francis Klingender).

Modernism, as both an evaluative aesthetic theory and as a broader chronological and socio-political ordering, was variously mediated by a range of artists, critics and curators, sampled here from the late 1950s to the mid-1960s. Graham Whitham explores the theories and approaches of Lawrence Alloway and Clement Greenberg. Mark Durden considers the Modernist inflexion to John Szarkowski's writing on photography and art's curatorial mediation in Brian O'Doherty's *Inside the White Cube*. Brandon Taylor contextualises Michael Fried's influential and polemical essay, 'Art and Objecthood'. A foundational book on modernist Russian art, authored during the Cold War, was Camilla Gray's *The Russian Experiment in Art 1863–1922*, a contribution which is discussed by Verity Clarkson. These interventions identify various points and conjunctions within a Cold War narrative which has, since 1989 and the fall of the Berlin Wall, become increasingly historicised.[3]

At the outset of a new millennium, the term 'late-modern' appears to be developing increasing visibility as a signifier of a plurality of artistic and conceptual practice from the neo-avant-gardes of the late 1950s and 1960s onwards (Krauss 1986: 8–171). It is also beginning to subsume the alternative and commonly used term 'postmodernism', which is now regarded by some academics as inherently problematic (see Jencks 1989; Jameson 1991; Wood 2004). Particularly appreciable within this period has been the increasing synergies between artistic and cultural practice and broader theoretical and conceptual paradigms, some of which were drawn from the foundational work of critical theorists. A major contribution to re-thinking art history and cultural representation has been made by feminist scholarship, sampled here by Alexander Kokoli's commentaries on key texts by Laura Mulvey, Hélène Cixous, and Rozsika Parker and Griselda Pollock.[4] One of the critical responses to capitalism

and the commodification of late-modernity was articulated by members of the Situationist International (SI), centred on Paris – Kath Abiker considers Guy Debord's influential manifesto *Society of the Spectacle*. The work of another key figure of this period is explored by Janet Sayers, who discusses a lesser-known early text by Julia Kristeva, *Giotto's Joy*.

The 1980s have been characterised as a period of both retrenchment and conservatism in some genres (including the emphasis on a return to medium specificity) as well as featuring more pluralist, oppositional and socially critical strands within cultural theory (Connor 1989: 88). Chris Hunt evaluates the jointly authored *A Thousand Plateaus* by Gilles Deleuze and Félix Guattari. Hans Maes and Kalle Puolakka situate Arthur Danto's *The Transfiguration of the Commonplace* as a major intervention in the field of contemporary philosophical aesthetics. Mark Durden evaluates Victor Burgin's 'The End of Art Theory' which sought both a critical defence and reformulation of the latter, and the re-configuration of art schools as bastions of the anti-theoretical and the conservative. In contradistinction to some of these trends, Peter Fuller's *Theoria: Art and the Absence of Grace*, presented by Peter McMaster, articulates the re-introduction of concepts of morality and spirituality in relation to the art within an increasingly secular society. Ben Thomas discusses the inter-mediation of art, language and society as critiqued by Michael Baxandall's *Patterns of Intention*.

In his 1995 anthology, Eric Fernie included consideration of Olu Oguibe's 'In the "Heart of Darkness"' (1993) which raised significant issues about the western-centricity of 'history'. This was partly in response to Francis Fukuyama's 1989 essay 'The End of History', the difficult legacy of western colonial activities and the problematic characterisations of cultures outside the west by western history (Fernie 1995: 314–22). The extract from Oguibe's text opens with the following characterisation:

> Prehistory. History. Post-history. It is evidence of the arrogance of occidental culture and discourse that even the concept of history should be turned into a colony whose borders, validities, structures and configurations, even life tenure are solely and entirely decided by the West.[5]
>
> (Oguibe 1993: 3–8; quoted in Fernie 1995: 317)

Since Fernie's publication, the development of Postcolonial Studies and the consequent broadening of cultural, social and political discourses mediate an increasingly globalised but fractured world. For art practice, art theory and art history, as for other academic disciplines, arguably the challenge is to find ways to respond to the resulting disjunctures and

interactions; inequalities and parities; and proximities and distances. In 2009, Donald Preziosi's new edition of *The Art of Art History: A Critical Anthology* included a revised final chapter 'Globalization and its Discontents' which critiqued texts discussing some of the theoretical, curatorial and epistemological issues raised by this new conceptual landscape. To reflect this, a range of texts have been explored in this anthology, which interrogate postcolonial debates, artistic and cultural boundaries, intersections and cross-cultural perceptions.

Dan Rycroft discusses Ananda K. Coomaraswamy's *Art and Swadeshi* which explores the ethnography, social implications and construction of identities involved in art of British colonial India. Mavernie Cunningham's commentary on Frantz Fanon's *Black Skin White Masks* presents his furious critique of colonialism and racism in pursuit of a liberated black identity – both ethnically and physically. Catherine King considers and contextualises Rasheed Araeen's catalogue introduction to *The Other Story: Afro-Asian Artists in Post-war Britain*, at the Hayward Gallery, profiling issues of diaspora, identity and difference, and John Picton's essay 'Yesterday's Cold Mashed Potatoes' on the history and importance of art criticism in Africa. Pivotal contributions have been made to postcolonial discourse by the scholarship of Homi Bhabha (*The Location of Culture* discussed by Niru Ratnam), Kobena Mercer (*Welcome to the Jungle: New Positions in Black Cultural Studies* explored by Patricia Chan), Partha Mitter (*Art and Nationalism in Colonial India 1850–1922* considered by Debashish Banerji) and Geeta Kapur ('When Was Modernism in Indian Art?' presented by Dan Rycroft).

The concluding commentaries sample, as it were, a tranche of influential texts which range across several ideational and cultural perspectives. Mavernie Cunningham considers Georges Didi-Huberman's *Confronting Images: Questioning the End of a Certain Art History*, which problematises and critiques ideas of certainty within and across the discipline from a turn of the millennium perspective. Anna Webber situates Hal Foster's synoptic analysis of avant-garde theory and practice, *The Return of the Real: The Avant-Garde at the End of the Century*. David Ayers discusses Alan Badiou's *Handbook of the Inaesthetic* and Kath Abiker presents Nicolas Bourriaud's *Relational Aesthetics*, a text which has contributed to a re-thinking of recent strands of art practice, phenomenology and period definition. Finally, Vicki Kirby explores performative identities and instabilities in relation to gender in Judith Butler's *Gender Trouble: Feminism and the Subversion of Identity*.

The continuum of cultural production and its theorisation, reflected in the commentaries in *Fifty Key Texts in Art History*, re-emphasises the contemporary expansiveness and social relevance of art history and art

historiography. These mediate particular imperatives – debates around gender, difference and performativity; centre and periphery; the local and the global; the relational and the political; changing perceptions of the visual from the classical to the late modern – constellations which have gained a renewed cultural impetus and social urgency. These narratives have been evident not just in relation to strands within art theory and writing, but in the process and fashioning of art by what might be termed a 'post-conceptual' generation. For present purposes, the term is used to reference those born in the 1960s and 1970s for whom the above concerns and the neo-avant-garde 'de-materialisation' of the art object have provided a formative cultural landscape which has underpinned their professional development and the initial stages of art world careers (see Lippard 1997).

In this regard one of the striking aspects of post-conceptual practice over the last two decades, and one not primarily limited to the west, has been the extent to which it has been referential of, and inflected by, contemporary art historical, cultural and critical theories – some instances of which are presented in this book. This mutual implication is pervasive and in evidence across a wide range of genres, including painting, installation, sculpture, performance and film-making in which artists and curators are acutely reflexive of the institutional parameters of their practice, the contexts of its reception and the ways in which critical response can become a constitutive register of the work itself. In this regard, *Fifty Key Texts in Art History* provides some insights to aspects of contemporary art practice, its mediation and theorisation.

To cite one example, the London- and New York-based artist and writer, Liam Gillick (b. 1964), has developed a diverse and nuanced aesthetic in various genres and formats including installation, photography, music composition, performance, design and various self-authored texts spanning semi-fiction and criticism. Gillick's work evades straightforward categorisation, although the adjective 'discursive' might be used as a means of registering the opacity of his practice (both literally and metaphorically) and its iteration through authored statements, photographs, manifestoes and books.

A central concern within Gillick's practice explores how the corporate and bureaucratic, and the spaces which their structures colonise, determine decision making and aspects of human subjectivity. He has frequently adopted the language and design rubric of government and the corporate as a way of questioning and subverting its original purpose, described by one critic as resisting an administered society by quoting 'post-industrial society back at itself' (Gair Boase, in Szewczyk 2009: 70). In the exhibition held at the Whitechapel Gallery in 2002, titled *The Wood Way*, Gillick

installed a series of brightly coloured Perspex and aluminium screens which were then overlaid with text. The panels recalled the practical division of office and work space in corporate organisations although the inscribed texts could be read as a subversive stream of consciousness which the visitor negotiated as they walked through the various panel configurations within the gallery space. The exhibition's pastoral-sounding title and the actual subject matter created a deliberate disjuncture between text and image; on the one hand the artist evoked the bland placelessness of a corporatised late modernity and on the other, a radically different vista and a suggestion of a markedly distinct form of social being.

The responses to and readings of his work by a range of art historians, critics and curators, have created some highly productive, imaginative and nuanced exchanges which can be understood as increasingly constitutive of the complex registers of Gillick's actual aesthetic. In *Relational Aesthetics* (1998) authored by the curator and art critic Nicolas Bourriaud (commentary in this volume by Kath Abiker), Gillick was among a tranche of artists whose practice was mooted as symptomatic of a 'relational' sensibility, although he has qualified some of attributions made both by Bourriaud and, in a series of exchanges, by the art historian Claire Bishop (see, for example, Gillick 2006: 95–106). More recently, the collected anthology of critical responses, *Meaning Liam Gillick*, edited by Monika Szewczyk, has provided a highly detailed and expansive range of close readings of his practice, a project supported and assisted by the artist himself.

This example is not intended to valorise any particular artist-practitioner, but it does example a cogent instance where art history, historiography and cultural theory, on the one hand, and the actual cultural production of contemporary artistic practice, on the other, are not discrete or adjacent discourses which occasionally overlap, but reflexively implicate and situate each other. These creative inter-dependencies underline the extent to which art historical and critical theories are already 'immanent' – that is, within and part of, so much contemporary and post-conceptual art practice and its formulation. In recognition of these ongoing and mutual inter-dependencies, contributors to *Fifty Key Texts in Art History* comprise not just art historians, but an 'expanded field' of curators, painters, photographers, film-makers, installation and performance artists, doctoral and postdoctoral researchers, photographic historians, aestheticians, gallerists and those from allied areas including cultural studies, cultural anthropology, post-colonial and gender discourses.

As noted in *Art History: The Basics*, the subject boundaries which broadly characterised the discipline in the 1950s and early 1960s have been profoundly transformed by the concerns of feminist critique, critical theory, globalisation and post-colonialism. Within an increasingly

integrated cultural economy, past and present asymmetries of power and post-colonial histories are mediated through art history and theory as they are by other discourses (Pooke and Newall 2008: xvii–xxi). A central concept which has been cumulatively questioned and re-fashioned is the idea of a central and institutionalised, and typically western-centric 'canon' – a corpus of art works and texts, which are regarded as benchmarks of quality (Pooke and Newall 2008: 10). In this regard, for example, Sir Ernst Gombrich's *The Story of Art* (1950) is among the texts explored in this anthology (by Diana Newall), demarcating as it does, not just a particular kind of empiricism, but, as its definitive titling suggests, a perception of art history and the supremacy of the western canon as self-evident and epistemologically unproblematic. Jonathan Harris has noted Gombrich's concern with 'the canon of great art, and its confirmation in, and by, art history' as 'integral parts of the humanism of western liberal-democratic society'. Characterising the consequences of Gombrich's cultural position for art history, Harris continues:

> The perspective and values of the art historian are authentic and irreducible *because* they accord so accurately with the objective reality of the canon. ... [Gombrich's position] is therefore a classic defence of scholarly neutrality, based on the certainty that art history's canon of artworks represents unquestionable value and greatness.
>
> (Harris 2001: 37)

Although *The Story of Art* indexes a self-referential western confidence, European economic and political supremacy had already been surrendered to the nascent superpowers of the United States and the Soviet Union in the decade before its publication.

The events and shifts of the past half century have continued to emphasise the west's diminishing geo-political reach and, with it, a privileged art history rooted in a western-centric canon has faced accumulating pressures to its relevance. Among the themes presented by Fred Orton at the 2006 Association of Art Historians (AAH) conference 'Art and Art History: Contents, Malcontents, Discontents', the question of art history's academic position and future was raised.[6] It is perhaps reasonable to ask what the discipline has to offer and how it can articulate a contribution to a globalised and postcolonial polity. The register and inflexions of the texts and critical commentaries in this volume suggest that such questions remain both open and pressing and that art historical discourse is cogently exploring nuanced responses and new trajectories.

Diana Newall
Grant Pooke

Notes

1 Notable anthologies of commentaries include Fernie (1995) and Preziosi (2009). Prominent in the anthologies of texts are Harrison and Wood (1992, 2003) and Harrison, Wood and Gaiger (1998 and 2000). Harris (2006) is a parallel volume containing a definition of critical terms.
2 The chronological beginning of modernism in art history is a problematic issue. The idealist doctrine, developed by G.W.F. Hegel in his lectures of 1830–31, provided an influential paradigm for understanding modernity and the realm of the aesthetic as a manifestation of a particular *zeitgeist*, colloquially understood as the 'spirit of the age' (for a broader discussion of these ideas see Pippin 1997). T. J. Clark (1999: 15) suggests that it could be located as far back as Jacques-Louis David's painting *Death of Marat* (1793). A more generally referenced start is Courbet setting up his booth outside the Exposition Universelle (1855) and Édouard Manet's exhibiting of *Le Déjeuner sur l'Herbe* at the Salon des Refusés (1863) (Brettell 1999: 1–7).
3 The exploration of some of these mid-century texts arose from research papers delivered as part of the 'Art Histories, Cultural Studies and the Cold War' conference at the IRGS, London, 24 September 2010, co-convened by Grant Pooke and Ben Thomas, History and Philosophy of Art Department, University of Kent.
4 We are very grateful for Griselda Pollock's suggestions for contributions in this area.
5 We are grateful to Catherine King for her insights on the connotations of the word 'west'. She noted that it has different meanings and inflections depending on the context, usage and perspective. For present purposes we follow her guidance on this and take 'west' to reference the cultural power of European colonisers and their post-colonial heirs, including in North America, Canada, South Africa and Australia etc. This definition allows one to understand how some descendants of colonised peoples in, for example, the UK or US, could still be disparaged as artistically inferior by the heirs of former colonisers. For a more detailed exploration of this, and related terms and issues, see: King, C. (1999) (ed.) *Views of Difference: Different Views of Art*, New Haven, CT: Yale University Press in association with the Open University.
6 Conference brochure 2006, AAH conference archive, www.aah.org.uk/ programmes-archive (Accessed July 2011).

Selected bibliography

Brettell, R. (1999) *Modern Art 1851–1929*, Oxford: Oxford University Press.
Clark, T. J. (1999) *Farewell to an Idea: Episodes from a History of Modernism*, New Haven, CT: Yale University Press.
Connor, S. (1989) *Postmodern Culture: An Introduction to Theories of the Contemporary*, Oxford: Blackwell.
Fernie, E. (selection and commentary) (1995) *Art History and Its methods: A Critical Anthology*, London: Phaidon Press.
Gillick, L. (2006) 'Contingent factors: a response to Claire Bishop's "Antagonism and relational aesthetics"', *October*, 115 (Winter), 95–106.

Harris, J. (2001) 'Radical art history: Back to its future?', in *The New Art History: A Critical Introduction*, Oxford: Routledge.

———(2006) *Art History: The Key Concepts*, London: Routledge.

Harrison, C. and Wood, P. (eds) (1992, 2003) *Art in Theory 1900–2000: An Anthology of Changing Ideas*, Oxford: Blackwell.

Harrison, C., Wood, P. and Gaiger, J. (eds) (1998) *Art in Theory 1815–1900: An Anthology of Changing Ideas*, Oxford: Blackwell.

———(2000) *Art in Theory 1648–1815: An Anthology of Changing Ideas*, Oxford: Blackwell.

Jameson, F. (1991) *Postmodernity, or The Cultural Logic of Late Capitalism*, London: Verso.

Jencks, C. (1989) *What is Post-Modernism?*, London: Academy Editions and New York: St Martin's Press.

King, C. (1999) (ed.) *Views of Difference: Different Views of Art*, New Haven, CT: Yale University Press in association with the Open University.

Krauss, R. E. (1986) *The Originality of the Avant-Garde and Other Modernist Myths. Part I, Modernist Myths*, London: The MIT Press.

Lippard, L. (1997) *Six Years: The Dematerialisation of the Art Object from 1966 to 1972*, University of California Press.

Oguibe, O. (1993) 'In the "Heart of Darkness"', *Third Text*, 23, 3–8.

Pippin, R. B. (1997) *Idealism and Modernism: Hegelian variations*, Cambridge: Cambridge University Press.

Pooke, G. and Newall, D. (2008) *Art History: The Basics*, London: Routledge.

Preziosi, D. (ed.) (1998) *The Art of Art History: A Critical Anthology* (new edition 2009), Oxford: Oxford University Press.

Szewczyk, M. (ed.) (2009) *Meaning Liam Gillick*, Cambridge, MA: The MIT Press, 2009.

Wood, P. (2004) 'Inside the Whale: An Introduction to Postmodernist Art', in G. Perry and P. Wood (eds), *Themes in Contemporary Art*, Hew Haven, CT: Yale University Press in association with the Open University, 5–43.

FIFTY KEY TEXTS IN
ART HISTORY

PLINY THE ELDER (GAIUS PLINIUS SECUNDUS), *NATURAL HISTORY [HISTORIA NATURALIS]* (70s CE)

The most accessible English text is in the Loeb Classical Library, where the Latin is presented with facing English translation: books 33–37 occupy volumes 9 and 10.[1] Jex-Blake and Sellers' 1896 edition of selected passages also contains both Latin text and English translation (the edition was revised by R. V. Schoder in 1968): the book's notes are sometimes useful, although the editors foolhardily isolate the 'chapters on the history of art' from the rest of the *Natural History,* and anachronistically relate Pliny's account to 'the Arts and Crafts of Civilized Life' (p. xiii). Although there is not yet a full English translation online, a Latin text is available at http://penelope.uchicago.edu/Thayer/ E/Roman/Texts/Pliny_the_Elder/home.html. Carey 2003 provides the best general introduction to the text – at least for anyone with interests primarily art-historical.

Some readers may be surprised to find the Elder Pliny's *Natural History* in this book. Even if Graeco-Roman antiquity were to have had a concept of 'art' or 'art history', Pliny conceived of this work rather differently: his comments on sculpture and painting form part of a 'natural historical' project. And yet, more than any other extant ancient writer, Pliny provided a template for post-Renaissance discourses of art and the artist. Not only is Pliny the most important source for our knowledge about Classical painters and sculptors, he also established a model for telling stories about art and its development. The *longue durée* of this influence – over almost 2000 years – secures his place within art history's fifty key texts. Indeed, the *Natural History* arguably deserves the number one top spot – as *the* key text of all western art history.

We know about Pliny not only from his surviving work, but also from the accounts of his nephew (known as 'Pliny the Younger').[2] Despite hailing from Novum Comum in Cisalpine Gaul, the Elder Pliny quickly established himself at the centre of Roman power. After serving alongside the future Emperor Titus during Roman military campaigns in Germany, and generally benefitting from the support of the Flavian Emperors, he became commander of the Roman fleet at Misenum – one of the most prestigious and powerful positions in the Roman Empire. Pliny was a remarkably prodigious writer, authoring numerous other works on a variety of topics – among them, a twenty-volume history of the Roman wars against Germany, a series of oratorical exercises and a treatise on literary composition (all now lost). His nephew characterises Pliny as an obsessive workaholic, driven by a genuine (if

not slightly neurotic) thirst for knowledge. Pliny's death in 79 CE constitutes the classic example: after deliberately sailing to the area around Mount Vesuvius, he died during the same volcanic eruption that buried Pompeii, Stabiae and Herculaneum. Inquisitive to the last, and always faithful to his civic duty (he was reputedly masterminding a relief effort), Pliny was killed by the natural wonders that he had spent his life researching.

The *Natural History* reflects these various character traits: it is not only a work of fastidious scholarship, but also a bastion of Roman Imperial values. Casting a broad intellectual net, Pliny sets 'Nature' as his subject, together with the various ways in which humans have exploited and manipulated her: *natura, hoc est vita, narratur* ('Nature, that is to say Life, is the subject of my narrative', Pref. 13). The work is conceived in proto-encyclopaedic terms – as a global synthesis of all human knowledge. Everything is contained within: agriculture, anthropology, botany, geography, manufacture, medicine, mineralogy, zoology. What is more, Pliny is at pains to emphasise his comprehensiveness: the preface boasts that the work contains 20,000 noteworthy facts, summarising 2000 earlier volumes (Pref. 17). Although the *Natural History* is structured in thirty-seven separate books, the first book comprises a meticulous 'table of contents', indexing all the disparate ideas contained. The result amounts to a miniature empire of words, with each subject duly classified, catalogued and subsumed (Rouveret 1987; Carey 2003: 17–40; Murphy 2004: 1–25; Squire 2011: 7).

This helps to explain Pliny's treatment of 'artistic' subjects in the *Natural History*'s last five books (33–37). Traditionally, scholars have applied a 'pick and mix' approach here, tending to raid rather than read the text, and effacing the author's own role in organising his subject (Carey 2003: 7–10). It is therefore especially important to emphasise that Pliny's comments on sculpture and painting form 'part of what is for us an entirely different topic, the taxonomy and technology of metal and stone' (Gordon 1979: 7).

A brief summary might help here. Book 33 announces its topic to be 'metals', and proceeds from the precious to the base, taking in the full history of their extraction and use along the way. Book 34 treats metal alloys, especially copper and bronze, exploring first the geographical history of bronze casting, and then its uses, above all in statuary; this in turn gives way to a description of the alloy process, its by-products, and other alloyed metals (iron, lead, tin, etc.). The move from Book 34 to Book 35 is somewhat less comfortable: the ostensible subject is painting (35.2–28), but this is interrupted by a description of different pigments and their extraction (chapters 29–50), a prosopographic history of different painters (chapters 53–148), and finally of other representational forms and their sources (encaustic painting, plaster modelling, pottery, etc.). In Book 36, Pliny

turns to 'the nature of stones', discussing raw materials, their different uses, and the (primarily Greek) stonemasons famous for their sculptural work. Book 37, the last book, is concerned with gemstones of all sorts (touching upon gemstone engravings). Appropriately, Pliny ends with a hymn to 'Nature, the mother of all things' (*parens rerum omnium Natura*, 37.205).

As is immediately obvious, Pliny's essential interest is with the classification of different natural resources. The author organises his material around a variety of structural frames. Some have associated this with the different earlier sources employed: we can be sure that Pliny derived much of his information from Hellenistic Greek manuals of the third and second centuries BCE, above all from the work of Xenocrates, Duris and Antigonos (Tanner 2006: 213–14, 239–42). This helps to explain some of the more puzzling aspects of Pliny's account: its chronological range (focusing especially on the fifth and fourth centuries BCE), its geographical spread (concentrating on Greek rather than Roman developments), and its down-playing of more recent Hellenistic contributions (not least the curious declaration that art 'stopped' between 156 and 153 BCE: *Natural History* 34.52).

What is most striking about Pliny's 'art history' is its conceptual remove from any more modern understanding of an autonomous academic discipline. For Pliny, what we call 'art history' is a history of separate but related technological innovations, each of them medium-bound. At the same time, a largely unspoken ideology stretches across the different books and materials described. Art's development over time is charted in terms of its progressive verisimilitude – how different media all separately came to imitate the appearances of nature. It is a rhetoric that has very much endured: for example, it dominates Vasari's *Lives*, as well as later attempts at charting the 'history of art' – from Winckelmann's 1764 *Geschichte der Kunst des Alterthums*, to Gombrich's blockbusting 1950 book, *The Story of Art* (and indeed beyond). At the same time, the philosophical rationale behind Pliny's framework is markedly removed from later Judaeo-Christian appropriations: according to Pliny's Stoic rationalist cosmology, the 'pinnacle of artistic achievement is correspondingly marked by the perfect adaptation of the work of art to the world-immanent reason of Nature' (Tanner 2006: 245; cf. André 1978; Wallace-Hadrill 1990; Beagon 1992).

Pliny might be said to have shaped art history in at least two other ways. First, he preserved for posterity information about lost Graeco-Roman artworks: this was something particularly important during the Italian Renaissance, when, along with Vitruvius, Pliny provided details about antiquities which contemporary artists were seeking to revive, recreate and even surpass. Botticelli's *Birth of Venus* is just one example,

derived in part from Pliny's description of Zeuxis' *Aphrodite Anadyomene* painting (35.91–92: also Squire 2010: 148–52).

Second, and arguably still more important, is Pliny's concern with the individual artist. Pliny structures sections of his narrative around a series of individual artistic innovations. This mode of defining art in terms of artists became increasingly important during the Renaissance (Settis 1995; Barkan 1999: 65–117). In his *Lives of the Artists* (first published in 1550), for example, Vasari structured his own account after portions of Pliny's text. Indeed, Vasari took many of Pliny's anecdotes about ancient artists and applied them to those working in sixteenth-century Italy. If the Renaissance meant a rebirth of ancient art, did not Renaissance writing about art have to (or have to be seen to) resurrect ancient literary precedent?

Michael Squire

Notes

1 Translated by D. E. Eichholz and H. Rackham respectively, 1952/1962, Cambridge, MA: note, though, that the English translations are frequently unreliable.
2 Most famous are two of Pliny the Younger's Latin letters, translated in Melmoth (ed.) 1915: 1.196–205 [= *Letters* 3.5], 474–83 [= *Letters* 6.16].

Selected bibliography

André, J.-M. (1978) 'Nature et culture chez Pline l'ancien', in J. M. André (ed.), *Recherches sur les artes à Rome*, Paris: Les Belles Lettres, 7–17.

Barkan, L. (1999) *Unearthing the Past: Archaeology and Aesthetics in the Making of Renaissance Culture*, New Haven, CT: Yale University Press.

Beagon, M. (1992) *Roman Nature: The Thought of Pliny the Elder*, Oxford: Clarendon Press.

Carey, S. (2003) *Pliny's Catalogue of Culture: Art and Empire in the Natural History*, Oxford: Oxford University Press, esp. 1–16.

Gordon, R. (1979) 'The real and the imaginary: Production and religion in the Graeco-Roman world', *Art History*, 2.1, 5–34.

Isager, J. (1991) *Pliny on Art and Society*, London: Routledge.

Jex-Blake, K. and E. Sellars (eds) (1896) *The Elder Pliny's Chapters on the History of Art*, London: Macmillan.

Melmoth, W. (ed.) (1915) *Pliny: Letters*, revised by W. M. L. Hutchinson, 2 vols, Cambridge, MA: Harvard University Press.

Murphy, T. (2004) *Pliny the Elder's Natural History: The Empire in the Encyclopaedia*, Oxford: Oxford University Press.

Rouveret, A. (1987) 'Toute la mémoire du monde: La notion de collection dans la NH de Pline', in J. Pigeaud and J. Oroz (eds), *Pline l'Ancien. Témoins de son temps*, Salamanca: Kadmos, 431–49.

Settis, S. (1995) 'Did the ancients have an antiquity? The idea of Renaissance in the history of Classical Art', in A. Brown (ed.), *Language and Images of Renaissance Italy*, Oxford: Oxford University Press, 27–50.

Squire, M. (2010) 'Introduction: The art of art history in Graeco-Roman Antiquity', in V. J. Platt and M. Squire (eds), *The Art of Art History in Graeco-Roman Antiquity* (= *Arethusa* 43.2), 133–63.

——(2011) *The Iliad in a Nutshell: Visualizing Epic on the Tabulae Iliacae*, Oxford: Oxford University Press.

Tanner, J. (2006) *The Invention of Art History in Ancient Greece: Religion, Society and Artistic Rationalisation*, Cambridge: Cambridge University Press.

Wallace-Hadrill, A. (1990) 'Pliny the Elder and man's unnatural history', *Greece and Rome* 37, 80–96.

PHILOSTRATUS THE ELDER, *IMAGES* [*IMAGINES/ EIKONES*] (THIRD CENTURY CE)

This Greek text is most often referred to by its Latin title, *Imagines*, although its Greek title seems to have been *Eikones*. There is only one (regrettably weak) English translation of *Imagines* – the Loeb Classical Library version by Arthur Fairbanks (Cambridge, MA, 1931, with facing Greek text). The best edition of the Greek is *Philostratos: Die Bilder* by O. Schönberger and E. Kalinka (Munich, 1968), with German translation and helpful notes.

How are images turned into words? Can we ever verbally represent what we see? And in what ways do images themselves work through *extra*-visual means – appealing to a differently structured medium of knowledge, memory or imagination?

These questions are key to every art-historical project. At the most fundamental level, art historians strive to speak for, through and in response to pictures, regardless of what they end up saying. Yet the paradox of all art criticism is that, while designed to aid visual under-standing, interpretative discourse simultaneously imposes onto visual imagery an alien system of verbal hermeneutics: responding to images means reducing pictures to the spoken and written language in which we represent and make sense of them.

By describing a collection of paintings (*pinakes*), Philostratus' *Imagines* got to the heart of these issues in the early third century CE. The *Imagines* eschews the sorts of secondary analysis familiar to modern art theoreticians. Instead, Philostratus acts these questions out, interrogating the boundaries between what can be seen and what can be said. The result is a deliberately unstable, teasing and inter-medial text. Where modern critics tend to assume

a bipartite separation between words and pictures – the classic example being Lessing's 1766 *Laocoon* essay 'on the limits of painting and poetry' (Squire 2009: 90–193, especially 97–111) – Philostratus toys with their ludic relationship in much more creative and sophisticated ways.

Right from the beginnings of ancient Greek poetry, the verbal representation of a visual stimulus was a major, self-reflexive literary concern. The description of the shield of Achilles in the eighteenth book of Homer's *Iliad* stands at the head of this tradition (vv. 478–608) – a passage that came in for immediate imitation, and in all manner of different genres (Elsner 2002).[1] By later antiquity, the phenomenon was explicitly theorised. According to the *Progymnasmata* (a series of Greek Imperial rhetorical 'textbooks'), such passages came under the heading of 'ecphrasis' – a 'descriptive passage which brings the portrayed subject before one's sight with visual vividness' (Webb 2009, with the appendix of texts on 197–211; Squire 2009: 139–46). Vividness (*enargeia*) and clarity (*sapheneia*) were the *sine qua non* of ecphrasis: these qualities enabled words to evoke the same inner vision – the same *phantasia* – that had originally been brought to the mind's eye of an artist, viewer and author.

Philostratus' *Imagines* consciously refers to this critical backdrop. We know very little about the author: at least three ancient 'Philostrati' are documented, all of them related. The present text was probably penned by the second of them, most likely the author of the *Life of Apollonius*, *Lives of the Sophist* and *Heroicus*, among other works (Anderson 1986: 259–69, 291–96). The cultural context in which Philostratus was writing has come to be called the 'Second Sophistic' – a term coined by Philostratus himself – when Greek intellectual culture enjoyed a self-styled 'renaissance' within the Roman Empire. This explains the overarching rationale of the *Imagines*. For Philostratus, paintings become an occasion for demonstrating literary learning (*paideia*). The aim is to present a series of lectures on paintings, so that the young 'will put them into words (*hermēneusousi*) and cultivate a sense of appreciation (*tou dokimou*)' (Proem 3). There are numerous contemporary *comparanda* – among them Lucian's dialogue *On the Hall*, the opening of Longus' *Daphnis and Chloe*, and the first ecphrasis of Achilles Tatius' *Leucippe and Cleitophon*.

After Philostratus' proem, there follow some 65 prose descriptions, structured around two books. For many Classicists, the scholarly objective has been to prove or disprove the 'reality' of the gallery: is Philostratus describing an *authentic* collection of paintings? This is Classical Archaeology at its most unthinking and positivistic (for two more sophisticated critiques, see Bryson 1994 and Giuliani 2006). Certainly, ancient readers may have wondered about the issue, but the question goes hand in hand with the text's larger oscillation between reality and fiction, truth and

representation, and image and text. The visibility-cum-invisibility of the pictures(or rather the text representing them) is precisely the point that we are supposed to ponder. Indeed, the author hints as much when he vaguely locates the paintings in a *stoa* 'on four, I think, or even five terraces' (Proem 4).

While attempts to reconstruct these different 'terraces' go back to Johann Wolfgang von Goethe in the nineteenth century, reconstructions of the 'original' edifice (most famously Lehmann 1941) are irredeemably misconceived. This is not to say that Philostratus does not play with order and sequence. He arranges and interconnects his descriptions with gleeful artifice, so that the *Imagines* resemble Graeco-Roman assemblages of paintings on the one hand, and ancient literary and poetic anthologies on the other. The ring-compositional evocation of the Seasons, or Horai, testifies to this self-conscious framing (Proem 1; 2.34) – not least because *hora,* 'beauty', was a widespread term of both literary and artistic critical appreciation (Elsner 2004; Squire 2009: 416–27).

The descriptions bring together a vast array of mythological, historical and topographical subjects, moving between narrative and descriptive modes. Philostratus embarks upon a tour not only of different painting types, but also of literary genres – among them epic (e.g. 1.1, 1.7, 2.7), tragedy (1.18, 2.4, 2.10), lyric (2.12), pastoral (1.31, 2.20, 2.33) and epigram (translating the pithy formulae of two-line poems on artworks into much lengthier prose images). Throughout, the game lies in the speaker's duplicitous slippage between words and pictures. One of Philostratus' favourite puns revolves around the Greek verb *graphein,* meaning both 'to write' and 'to paint' (e.g. 1.24.1, 1.19, 2.9.1; Squire 2009: 146–49). In the very first description of a Scamander painting, for example, the speaker begins by exhorting us to 'turn away' and 'look at the things from which the painting (*hē graphē*) descends' – that is, the twenty-first book of Homer's *Iliad* (1.1). But exactly where are the boundaries between the Homeric text, the painting and this description? Philostratus' *graphē* encompasses *all* of these different ontological registers.

This *mise-en-abîme* of replications is arguably the most sophisticated aspect of Philostratus' work. On one level, it is to be seen, or rather read, within the text's own representational fiction, which represents through written words a series of performed oral speeches (Webb 2009: 187–90). Typical too is the author's evocation of a painted Narcissus – the mythological hero who fell in love with his own reflection. 'The pool paints/describes (*graphei*) Narcissus', writes Philostratus, 'but the painting/ description (*hē graphē*) paints/describes everything that has to do with Narcissus' (1.19.1; Bann 1989: 108–11; Boeder 1996: 153–61; Elsner 2007: 132–76; Squire 2009: 270–73).

These themes have a universal significance for every art historian. Philostratus exposes the positivist reductionism involved in verbally responding to pictures. Indeed, he explicitly contrasts his own critical mode with those of other writers (Proem 3). At the same time, the *Imagines* has to be understood in its particular cultural context. Philostratus was writing at a time when the 'realistic' mimetic modes of Classical Greece were being increasingly combined with more abstract forms – the sorts of visual styles that would come to dominate Byzantine and Medieval art (only overturned during the Italian Reformation). The *Imagines*, in other words, occupies something of a cultural, intellectual and artistic cross-roads. This must partly explain the text's particular concern with 'seeing as' vs. 'seeing in': do our visual responses stem from a formal *ad hoc* reaction to material objects, or do they derive from subjective imagination – the *mental* impression (*phantasia*) of the seeing respondent (Onians 1980)?

As for the *Imagines*' afterlife, my own view is that it became famous almost immediately after publication. It certainly spurred a variety of imitations – if not in the ecphrastic descriptions of Libanius and Callistratus, at least in the *Imagines* of the Younger Philostratus, who claims the Elder Philostratus as his grandfather, explicitly acknowledges his debt, and develops such replicative games in still more mind-boggling ways (Squire 2011: 331–33, 340–41). The text remained known throughout Byzantine antiquity: for example, John of Sardis' commentary on Aphthonius' *Progymnasmata* cites the *Imagines* as an explicit example of ecphrasis. But it became particularly important during the Italian Renaissance. Like other ancient texts about 'lost' paintings, the *Imagines* was used to 'recreate' ancient 'masterworks', such as Raphael's *Triumph of Galatea*, derived in part from *Imagines* 2.17 (Squire 2009: 349–51). Philostratus also informs Pierio Valeriano's *Hieroglyphica* of 1556, although it was in the sixteenth-century French translation by cryptographer Blaise de Vigenère that the text won its greatest posthumous influence (Crescenzo 1999).

Despite a flurry of recent interest, the *Imagines* has still not received the attention it deserves. Classical philologists have largely left the text to Classical archaeologists, while Classical archaeologists have lacked the linguistic or literary expertise, cultural knowledge and creativity that it so conspicuously requires. More modern art historians, by contrast, have mostly read the text in ill-serving translations. As Philostratus knew only too well, the *Imagines* requires a simultaneous sort of artistic-cum-literary imagination: only then can its visual-verbal arts of fiction, subjectivity and rhetorical performance come to life off the page.

Michael Squire

Note

1 The passage can be found in the Loeb Classical Library edition of Homer (Greek with facing English translation): Murray (ed.) 1999: 2.322–35.

Selected bibliography

Anderson, G. (1986) *Philostratus: Biography and Belles Letters in the Third Century*, London: Croom Helm.

Bann, S. (1989) *The True Vine: On Visual Representation and the Western Tradition*, Cambridge: Cambridge University Press.

Boeder, M. (1996) *Visa est Vox: Sprache und Bild in der spätantiken Literatur*, Frankfurt: Lang.

Bryson, N. (1994) 'Philostratus and the imaginary museum', in S. D. Goldhill and R. G. Osborne (eds), *Art and Text in Ancient Greek Culture*, Cambridge: Cambridge University Press, 255–83.

Conan, M. (1987) 'The *Imagines* of Philostratus', *Word and Image*, 3.2, 162–71.

Constantini, M., Graziani, F. and Rolet, S. (eds) (2006) *Le défi de l'art. Philostrate, Callistrate et l'image sophistique*, Paris: Presses Universitaires de Rennes.

Crescenzo, R. (1999) *Peintures d'instruction: La postérité littéraire des 'Images' de Philostrate en France de Blaise de Vigenère à l'époque classique*, Geneva: Droz.

Elsner, J. (1995) *Art and the Roman Viewer: The Transformation of Art from the Pagan World to Christianity*, Cambridge: Cambridge University Press, 28–39.

——(2000) 'Making myth visual: The Horae of Philostratus and the dance of the text', *Mitteilungen des Deutschen Archäologischen Instituts (Rom)*, 107, 253–76.

——(2002) 'Introduction: The genres of ekphrasis', *Ramus*, 31, 1–18.

——(2004) 'Seeing and saying: A psychoanalytical account of ecphrasis', *Helios*, 31.1, 157–86.

——(2007) *Roman Eyes: Visuality and Subjectivity in Art and Text*, Princeton, NJ: Princeton University Press.

Elsner, J. and Squire, M. J. (forthcoming) *Vision and Invisibility in Philostratus the Elder's Imagines*.

Giuliani, L. (2006) 'Die unmöglichen Bilder des Philostrat. Ein antiker Beitrag zur Paragone-Debatte?', *Pegasus*, 8, 91–116.

Heffernan, J. (1999) 'Speaking for pictures: The rhetoric of art criticism', *Word and Image*, 15.1, 19–33.

Lehmann, K. (1941) 'The *Imagines* of the Elder Philostratus', *Art Bulletin*, 23, 95–105.

Murray, A. T. (ed.) (1999) *Homer, The Iliad*, 2 vols, second edition, Cambridge, MA: Harvard University Press.

Newby, Z. (2009) 'Absorption and erudition in Philostratus' *Imagines*', in E. Bowie and J. Elsner (eds), *Philostratus*, Cambridge: Cambridge University Press, 322–42.

Onians, J. (1980) 'Abstraction and imagination in late antiquity', *Art History*, 3, 1–24.

Schönberger, O. (1995) 'Die "Bilder" des Philostratos', in G. Boehm and H. Pfotenhauer (eds), *Beschreibungskunst – Kunstbeschreibung. Ekphrasis von der Antike bis zur Gegenwart*, Munich: W. Fink, 157–73.

Schönberger, O. and Kalinka, E. (eds) (1968) *Philostratos: Die Bilder*, Munich: Heimeran.

Squire, M. J. (2009) *Image and Text in Graeco-Roman Antiquity*, Cambridge: Cambridge University Press.

——(2011) *The Iliad in a Nutshell: Visualizing Epic on the Tabulae Iliacae*, Oxford: Oxford University Press.

Webb, R. (2009) *Ekphrasis, Imagination and Persuasion in Ancient Rhetorical Theory and Practice*, Farnham: Ashgate.

GREGORY THE GREAT'S LETTERS TO SERENUS (599 CE) AND SECUNDINUS (769 CE)

In 599, Pope Gregory the Great (c. 540–604) made same influential claims concerning the role of sacred art. One of his bishops, Serenus of Marseilles, was destroying Christian images, which were presumably mostly narrative mosaics or wall paintings, claiming they were being idolised. Since it is difficult to idolise a narrative, however, these works of art must also have contained images capable of serving as surrogates of the sacred. Gregory agreed that idolatry must be opposed, but, unlike Serenus, did not consider this a risk inherent to Christian art. His response was to defend images on the grounds of their utility for the illiterate, claiming that art served as a substitute for books. Gregory wrote to Serenus again the following year, repeating and expanding his defence of images. Their exchange is an interesting indication of the importance attached to sacred art at this early date and of how divergent opinion could be on this issue. Gregory's statements formed the crucial justification for religious art in subsequent centuries but understanding his stance is not straightforward.

There is some evidence to suppose that Gregory had a modest interest in and understanding of religious art. Gregory could have been introduced to Greek perspectives on religious images during his six years as Papal envoy to Constantinople. In Greek writers, including Gregory of Nyssa (c. 313–c. 395), Gregory could have encountered precedents for the concept of art's utility for the illiterate (Chazelle 1990: 144–45). According to legend, a plague outbreak during Gregory's Papacy ended when the icon of the Virgin Mary was processed through the streets of Rome and subsequently venerated in Sta Maria Maggiore at his instigation (Voragine 1993: I 174). Similarly, the prototype icon of Christ as a Man of Sorrows was reputed to have been made, with indulgences attached to it, on Gregory's instructions following a vision of Christ experienced while celebrating Mass.

His letters to Serenus raise questions about who exactly was to benefit from religious art and how. The second letter's wording shows that Gregory

saw sacred art as particularly, though not exclusively, intended for the illiterate. Although this function was later given the epithet 'Bible of the poor' (*Biblia Pauperum*), there is no designation here of a particular social stratum. Defining art as a substitute 'book' begs the question of what the *literate* might be expected to derive from written sources. Since depictions of the complex themes of sacred art self-evidently do not tell a coherent story without any kind of verbal or written explanation, he is unlikely to have meant learning new narratives or doctrines from scratch.[1] One of Gregory's fundamental concerns was the task of preaching, and his *Rules for Pastors* focuses on this theme. He is likely to have valued art for its pedagogic usefulness in illustrating, recalling and reinforcing oral teaching through sermons (Chazelle 1990: 147–48). Since Gregory refers specifically to paintings of the histories of saints, he may also have perceived art's potential to present exemplars for believers and converts, although these relatively uncontroversial concepts seem unlikely to be at the heart of Serenus's objections.

Images were again a controversial subject at the Second Church Council of Nicaea (787 CE). Here, both sides opposed idolatry, and were prepared to agree that narrative paintings 'have a certain ability to remind one of the things that have happened' (Kessler 1994: 535). The two parties divided over Pope Hadrian's contention that images also offer the viewer a distinctively spiritual experience, possibly the same issue that lay at the heart of Gregory's dispute with Serenus.[2] Gregory's concept of paintings as a surrogate 'book' could be understood in terms of an equivalent focus of spiritual contemplation on what should be worshipped and followed. Alternatively it could have been pedagogic – a compromise departure from the concept of art offering distinctively spiritual insights.[3] Whichever is correct, for the eighth-century church, Gregory became the authority not just for art's didactic potential but also for its affective power.

Another of Gregory's letters, this time to the hermit Secundinus, was read before the Lateran Council of 769 to define the orthodox position on religious images (Chazelle 1995: 186). A passage had been inserted into Gregory's original text, which shows the extent to which the Western Christian Church had begun to reflect and expand on Gregory's teaching.[4] It also articulated the very aspect of religious art left so ambiguous by Gregory himself. This interpolated section stressed the affective, rather than the instructive potential of art:

> With every effort you seek in your heart him whose image you desire to have before your eyes, so that, every day, what your eyes see brings back to you the person depicted, … so that while you

gaze at the picture your soul burns for him whose image you so carefully contemplate ... We know that you do not want an image of our Saviour in order to worship it as though it were a god, but in order to recall the Son of God and thus warm in love of him whose image you take care to behold. And certainly we do not prostrate ourselves before that image as if before a deity, but we adore him whom we remember through the image, at his birth or passion or seated on his throne.

(Appleby 2002: 89–90)

This passage introduces an image's potential to evoke an emotional and intellectual response from the viewer. In referencing prostration, it appears to validate ritualistic action before images. Gregory refers to sending the hermit images of Christ and the Virgin, of Sts Peter and Paul, and also a cross. Emphatically, this passage concerns not narrative mosaics or wall paintings, but what might be described as icons for private scrutiny. Implicitly, an image is regarded as a valid focus of meditation as much as the written word.

Gregory's letters, including the interpolated passage in the letter to Secundinus, were reiterated and reinterpreted through the centuries leading up to the Protestant Reformation. St Thomas Aquinas, for example, condensed Gregory's teaching on religious art into the much-cited threefold function of instruction, affect and recall (Kessler 2006). Aquinas retains the idea of religious art as a substitute book for the illiterate, as did many other medieval thinkers. There are subtle shifts in Aquinas's position, however. He does not restrict the second and third functions of art to the illiterate, by implication extending the potential benefits of religious art to the whole of the Christian community whether literate or illiterate, clerical or lay. Crucially, he claims that in fostering memory and inspiring an emotional response, art was actually superior to other media, including the written word. These claims to superiority are made explicit in the *Rationale divinorum officiorum*, the text on Church ritual by William Durandus (c. 1230–96), 'for paintings appear to move the mind more than descriptions'.[5]

The initial dispute between Gregory and Serenus was probably about whether art offered a route to the spiritual or simply to idolatry. Subsequently, it has often been commuted to the problematic idea that images can teach the illiterate. During the medieval period, images might have been understood in terms of their capacity to reinforce oral teaching (Camille 1985). Since the processes of memory were believed to operate by means of mental images, art may also have been valued for its mnemonic power to facilitate learning (Carruthers

1990 and 1998; Camille 2000; Yates 1992). Neither of these instructional forms is restricted to the illiterate, however, and it is surely incorrect to suppose that much medieval religious art was designed with only the common person in mind. Art was commissioned to adorn religious houses, private chapels or private wealthy households, and even in public churches, was often paid for by lay patrons with their own agendas, or positioned in such a way that visibility was restricted.[6]

The concept of art teaching unmediated is just as problematic. However, it is perhaps easier to see why it gained credence in art history. From the Renaissance onwards, academic art theory stressed art's intellectual and moral content, which served to edify the viewer. Formal devices such as composition and gesture were supposed to convey the narrative in such a way that it might be 'read' by the viewer. The idea of religious art with a serious content and the power to instruct dovetails neatly with the familiar ideals of history painting, and may therefore have prompted fewer challenges from art historians than it perhaps deserved.

Kim W. Woods

Notes

1 See Duggan (1989) on the problems associated with Gregory's idea of art teaching the illiterate.
2 This is the line taken in Mariaux (1994).
3 Brown (1999) takes this view.
4 This was revealed as an interpolation only relatively recently, for example, Ringbom, in his groundbreaking book of 1965 *From Icon to Narrative*, seems to have been unaware that this passage was not written by Gregory himself.
5 Neale and Webb (1843: 56). Cited in a different translation in Aston (1984: 116).
6 For an incisive examination of this issue in relation to stained glass see Caviness (1992).

Selected bibliography

Appleby, D. (2002) 'Instruction and inspiration through images in the Carolingian period', in J. J. Contreni and S. Casciani (eds), *Word, Image, Number, Communication in the Middle Ages*, Turnhout: Brepols, 85–111.
Aston, M. (1984) *Lollards and Reformers: images and literacy in late medieval religion*, London: Hambledon press.
Brown, P. (1999) 'Images as a substitute for writing', in F. Chrysos and I. Woods (eds), *East and West: modes of communication*, Leiden: Brill, 15–34.
Camille, M. (1985) 'Seeing and reading: some visual implications of medieval literacy and illiteracy', *Art History*, 8.1, 26–49.
——(2000) 'The internal senses and late medieval practices of seeing', in R. S. Nelson (ed.), *Visuality Before and Beyond the Renaissance: seeing as others saw*, Cambridge: Cambridge University Press, 197–223.

Carruthers, M.(1990) *The Book of Memory*, Cambridge: Cambridge University Press.

——(1998) *The Craft of Thought*, Cambridge: Cambridge University Press.

Caviness, M. H. (1992) 'Biblical stories in windows: were they Bibles for the poor?', in B. S. Levy (ed.), *The Bible in the Middle Ages: its influence on literature and art*, medieval and Renaissance texts and studies, Binghamton, NY: Binghamton University, 103–47.

Chazelle, C. M. (1990) 'Pictures, books and the illiterate: Pope Gregory I's letters to Serenus of Marseilles', *Word and Image, 6*, 138–53.

——(1995) 'Memory, instruction, worship: Gregory's influence on early medieval doctrines on the artistic image', in J. C. Cavadini (ed.), *Gregory the Great, a symposium*, Notre Dame, IN: University of Notre Dame Press, 181–215.

Duggan, L. G. (1989) 'Was art really the "book of the illiterate"?', *Word and Image*, 5, 227–51.

Kessler, H. (1994) 'Carolingian art as spiritual seeing', *Testo e imagine nell'alto medioevo*, vol 2, Spoleto, 533–94.

——(2006) 'Gregory the great and image theory in northern Europe during the 12th and 13th centuries', in C. Rudolph (ed.), *A companion to medieval art*, Malden: Blackwell Publishing.

Mariaux, P.-A. (1994) 'Voir, lire et connaître', *Études des Lettres*, July/December, 47–59.

Neale, J. M. and Webb, B. (1843) *The Symbolism of Churches and Church Ornaments, the translation of Book 1 of the Rationale Divinorum Officorum by W. Durandus, Bishop of Mende*, Leeds: T. W. Green.

Ringbom, S. (1983), *From Icon to Narrative: the rise of the dramatic close-up in 15th century devotional painting* (originally published 1965), Doornspijk: Davaco publishers.

Voragine, J. de (1993) *The Golden Legend: readings on the saints*, translated W. Granger Ryan, 2 vols, Princeton: Princeton University Press.

Yates, F. (1992) *The Art of Memory* (first published 1966), London: Pimlico.

ACTS OF THE SEVENTH ECUMENICAL CHURCH COUNCIL OF 787 CE AND THE ICONOCLAST COUNCIL OF 815 CE

The arguments for and against iconoclasm, 787 and 815 CE

Mansi (1759–98) remains the main source for the Greek and Latin texts for the Acts of the Councils, with Alexander (1953), providing additional material and the Greek text of the 815 council in an appendix. A complete English translation of the Acts of the Councils is lacking; only the sixth day's proceedings (which includes the 754 *Horos* and the 787 *Horos*) are translated by Sahas (1986). Significant sections of the key texts can also be found translated in the various works of Anastos and Alexander, in Hefele (2007), Bryer and Herrin (1977: 180–86) and Mango (1972: 149–77). Grabar (1984) is also invaluable, especially in linking the texts to documents, but is in French.

Iconoclasm has been a recurrent feature of Christian doctrine. It can be defined as opposition to the use of images of God and the saints in worship, often leading to the destruction of pre-existing religious images. The issue stems from the second commandment:

> Thou shalt not make unto thyself any graven image, or any likeness that is in heaven above, or that is in the earth beneath, or that is in the water under the earth.
>
> (Exodus 20: 4)

The earliest Christians presumably initially followed this commandment as rigorously as their Jewish counterparts, strongly influenced by a concern to be visibly differentiated from the pagans who worshiped 'graven images'.[1] Certainly there is a dearth of unmistakably Christian imagery surviving from the first few centuries after the crucifixion (Finney 1994). The earliest official statement on the topic, which unfortunately provides little information on the intentions behind the edict, is from the local Council of Elvira of around 306 CE, where Canon 36 states:

> Resolved that paintings should not be in church, not to be painted on walls to be revered and worshipped.
>
> (Mansi 1759–98: 2, column 11)[2]

Constantine the Great (306–37) began the Christianisation of the Roman Empire, which was accompanied by a more permissive attitude to imagery. By the eighth century CE, images of Christ were an increasingly important part of devotional practice, and Canon 82 of the Quinisext Council, convened by Emperor Justinian II (685–95: 705–11) at Trullo in the 690s, even banned replacing Christ by the symbol of the Lamb:

> in order that perfection be represented before the eyes of all people, even in paintings, we order that from now on Christ our God, the Lamb who took upon himself the sins of the world, be set up, even in images, according to his human character, instead of the ancient Lamb. Through this figure we realise the height of the humiliation of God the Word and are led to remember his life in the flesh, his suffering and his saving death, and the redemption ensuing from it for the world.[3]
>
> (Mansi 1759–98: 11, 978E–9AB)

The image of Christ is here described as 'perfection', Christ's humiliation is emphasised by realistically depicting him as man; any concern at the

incomplete depiction of his divinity is lacking. By the end of the seventh century, *Acheiropyta* images – from the Greek meaning 'not made by human hands' but supposedly by divine intervention – of Christ and the Virgin became increasingly popular both in western Europe and the Byzantine Empire. Although the precise motivations for the rise of iconoclasm in the Byzantine Empire are disputed, in the early eighth century, the veneration of these 'miraculous' images risked an unacceptable transgression into 'worship' and 'idolatry'. The increasing military success of Islam and the move towards 'aniconic' images by Muslims in the early eighth century are also thought to have contributed to the development of 'Byzantine' iconoclasm.[4]

The two periods of imperially backed iconoclasm span approximately 100 years, beginning with the local council at Hiereia in 754 which banned images and ending with the small local council in Constantinople of March 843 which re-instated them for the second and final time.[5] The Seventh Ecumenical Church Council, held at Nicaea in 787, ended the first period of iconoclasm, but was followed, in 815, by a further local Council ushering in the second period of iconoclasm. The small council convened by Empress Theodora (842–55) in 843, declared the 815 Council invalid and the 787 council ecumenical, so finally making images orthodox – that is, sanctioned by edict – without the need for a further ecumenical council (Ostrogorsky 1969: 219–20; Dvornik 1953: 69–97, who also outlines possible later developments).

The Acts of the Seventh Ecumenical Church Council of 787 survive in full (Mansi 1759–98: 12, 951–1154 and 13, 1–485). Brubaker and Haldon (2001: 233–42) provide a critical analysis of the surviving texts, and Alexakis (1996) discusses the important issue of the use of florilegia – collections of short extracts from earlier Christian writings that support a particular point of view – and books during the council. It was common practice to destroy papers bearing the arguments used by heretics (Mansi 1759–98: 13, 208C–356D; Alexander 1958a; Anastos 1955: 178) so surviving sources for the iconoclasts' arguments are sparse.[6] Fortunately the 'Definition' (ὅρος/*Horos*) or conclusions of the iconoclast council of 754 were read out at the sixth session of the 787 council, where each conclusion was followed by justification for the use of images by the iconophile, Epiphanius, *cubicularius* of Constantinople. So these Acts contain both sides of the argument (Mansi 1759–98: 13, 208C–356D).

The Acts of the 'iconoclast' council of Constantinople of 815 do not survive, but the 'Definition' has been reconstructed (Alexander 1953) and provides the arguments put forward for the second iconoclast period. Comparison of 'Definitions' from 754 and 815 permits an assessment of how the official iconoclast argument developed over time,

(Alexander 1958a, 1958b: 136–213 esp. 139; 214–62). The Acts of the small council of 843 have not survived.

What are the key iconoclast arguments, and just whose images are banned? Christ should not be depicted because he is both human and divine, and so is 'uncircumscribable'. This meant that he could not be entirely encompassed in any image. Portraying only a part of him meant dividing him, and so these arguments were linked into debates at earlier councils about the relationship between Christ's human and divine natures. The councils that had rejected the various forms of monophysitism – a doctrine which believed that Christ had only one nature – had agreed that Christ's flesh – his humanity – was inseparable from his divinity. Since any *image* of Christ could not represent his divinity, it split the indivisible and so was heretical (Anastos 1955: esp. 188). A parallel argument included spirituality in the concept of representation and asserted that the only acceptable earthly representation of Christ was the Eucharist (Mansi 1759–98: 13, 240C; 241E; 244D). For the iconoclasts 'likeness' was best viewed as a spiritual closeness to God which was not amenable to portraiture.

The ban on images of the Mother of God, the prophets, apostles and martyrs focused more on the spirituality argument, emphasising the inability of wood and paint to completely represent such spiritual beings (Mansi 1759–98: 13, 272ABD). Since Mary was 'more exalted than the heavens and holier than the cherubim' (Mansi 1759–98: 13, 277D) she was degraded by being depicted in such rude materials. The same argument applied to the depiction of the saints who would reign with Christ at the Last Judgement (Mansi 1759–98: 13, 277CDE). The debate continued by linking the ban to selected texts from the scriptures and the writings of the church fathers.

The acts of the councils cannot provide information on the *effects* of iconoclasm; on how rigorously it was enforced or on who acted according to or against the heresy. But they do indicate the claims being made and their bases. Since this policy was driven from the top by the Emperors (much of the *Horos* of 754 is thought to have come from the writings of Constantine V (741–75)), these claims are a key part of the puzzle. There is, of course, difficulty in fully understanding what was meant by the texts and extracts used in the formalised arena of a council. Medieval logic is not the same as contemporary logic and some of the arguments that can appear forced to modern minds were nevertheless powerful at the time. A study of the acts of the councils is key to understanding the period, and provides the nearest thing we have to a balanced record of the arguments as perceived at the time.

The literature on actions and events during the period of 'Byzantine' iconoclasm is extensive and debate over issues like the nature and extent

of destruction of images during this period continues. The papacy and the western church never espoused the doctrine, and a number of their letters and other writings expounding the papal position, including the results of western councils that considered the issue, also survive. The best accounts of events *around* the councils linked to the surviving documents are Hefele (2007; originally published 1894: 260–400) and Schaff and Wace (1997, 14: 521–87). Useful sources of reviews of the texts and the heresy are Bryer and Herrin (1977), and Brubaker and Haldon (2001: 232–42). The latter includes a critical appraisal of the texts and assessment of issues such as insertions and deletions. There is also the concise opening section in Thomas Noble's recent book on iconoclasm and the Carolingians (2009: 1–110). Stephen Gero's books on Leo III (1973) and Constantine V (1977) provide critical analyses of the policy and its implementation in the two periods. A further analysis of the iconoclast period from Brubaker and Haldon (2011) was published shortly after completion of this paper.

Eileen Rubery

Notes

1 Exactly how rigorously Jews did follow this commandment remains uncertain, especially following the discovery of the frescoes in the synagogue in the border town of Dura Europos on the banks of the Euphrates river; see Weitzmann and Kessler (1990).
2 For the Latin see also Hefele (2007), vol. 1, Section 13, 131–72, esp. 152: 'Placuit, picturas in ecclesia esse non debere, ne quod colitur, et adoratur, in parietibus depingatur'. Trans. from Bryer and Herrin (1977) 180, of Mansi 2, column 11: *Concilium Liberitanum*.
3 Trans. from Bryer and Herrin (1977) 182 of Mansi, 11, column 977–80.
4 Strictly the doctrine was the product of the Emperor in Constantinople, and only imposed on those lands still under his control, but, for brevity, this period is often called Byzantine iconoclasm to differentiate it from other periods of iconoclasm.
5 There may have been some official statement about images as early as 726. See Anastos (1979).
6 The ninth canon of the 787 council (Mansi 13, 430AB) forbids the hiding of iconoclast books and orders that copies be handed in to the Bishop of Constantinople.

Selected bibliography

Alexakis, A. (1996) *Codex Parisinus Graecus 1115 and its Archetype*, Washington, DC: Dumbarton Oaks Research Laboratory and Collection.
Alexander, P. J. (1953) 'The Iconoclastic Council of St. Sophia (815) and its definition (Horos)', *Dumbarton Oaks Papers*, 7, 35–66.

——(1958a) 'Church Councils and Patristic Authority: the iconoclast councils of Hiereia (754) and St. Sophia (815)', *Harvard Studies in Classical Philology*, 63, 493–505.

——(1958b) *Patriarch Nicephorus of Constantinople: Ecclesiastical policy and image worship in the Byzantine Empire*, Oxford: Clarendon Press.

Anastos, M. V. (1954) 'The Ethical Theory of images formulated by the iconoclasts in 754 and 815', *Dumbarton Oaks Papers*, 8, 151–60.

——(1955) 'The Argument for iconoclasm as presented by the iconoclastic Council of 754', in K. Weitzmann (ed.), *Late Classical and Medieval Studies in Honor of Albert Mathias Friend, Jr.*, Princeton: Princeton University Press, 177–88.

——(1979) Leo III's edict against the images in the year 726–27 and Italo-Byzantine relations between 726 and 730', in M. V. Anastos, *Studies in Byzantine Intellectual History*, London: Variorum Reprints.

Brubaker, L. and Haldon, J. (2001) *Byzantium in the Iconoclast Era (ca 680–850): the sources: an annotated survey*, Aldershot: Ashgate.

——(2011) *Byzantium in the Iconoclast Era (ca 680–850): A History*, Cambridge: Cambridge University Press.

Bryer, A. and Herrin, J. (eds) (1977) *Iconoclasm*, Birmingham: Centre for Byzantine Studies.

Dvornik, l. F. (1953) 'The Patriarch Photius and Iconoclasm', *Dumbarton Oaks Papers*, 7, 69–97.

Epiphanius of Salamis, *Treatise against those who are engaged in making after the fashion of idols, images in the likeness of Christ, the Mother of God, Martyrs, Angels and Prophets*, (Fragment 30 B from the reconstituted acts of 815, in Alexander (1953) Appendix.)

Finney, P. C. (1994) *The Invisible God: The Earliest Christians on Art*, New York: Oxford University Press.

Gero, S. (1973) *Byzantine Iconoclasm During the Reign of Leo III with Particular Attention to the Oriental Sources*, Louvain: Corpus Scriptorum Christianorum Orientalium, vol. 346.

——(1977) *Byzantine Iconoclasm During the Reign of Constantine V with Particular Attention to the Oriental Sources*, Louvain: Corpus Scriptorum Christianorum Orientalium, vol. 384.

Grabar, A. (1984) *L'Iconoclasme Byzantin: le dossier Archéoligique*, Paris: Flammarion.

Hefele, K. J. (2007) *A History of the Councils of the Church from the Original Documents* translated from the German by W. R. Clark, Volumes 1–5. Originally published by T. and T. Clark (1894), reprinted Eugene, OR: WIPF and Stock.

Mango, Cyril (1972) *The Art of the Byzantine Empire 312–1453*, Toronto: University of Toronto Press.

Mansi, J. D. (1759–98) *Concilium Sacrorum Conciliorum nova et amplissima collectio.* Originally published in Florence and Venice, reprinted (1901) Paris: J. B. Martin and L. Petit.

Noble, T. F. X. (2009) *Images, Iconoclasm and the Carolingians*, Philadelphia: University of Pennsylvania Press.

Ostrogorsky, G. (1969) *History of the Byzantine State*, Piscataway, NJ: Rutgers University Press.

Sahas, D. (1986) *Icon and Logos: sources in eighth-century iconoclasm: an annotated translation of the Sixth Session of the Seventh Ecumenical Council (Nicea, 787) containing the Definition of the Council of Constantinople (754) and its refutation, and the Definition of the Seventh Ecumenical Council,* Toronto: University of Toronto Press.

Schaff, P. and Wace, H. (eds) (1997) *Nicene and Post-Nicene Fathers,* 2nd Series, 14, *The Seven Ecumenical Councils,* Edinburgh: T. and T. Clark.

Weitzmann, K. and Kessler, H. L. (1990) *The Frescoes of the Dura Synagogue and Christian Art,* Washington, DC: Dumbarton Oaks Research Library and Collection.

THE *LIBER PONTIFICALIS*
Papal attitudes to imagery up to the end of the ninth century (to c. 900 CE)

Although there were earlier editions, Louis Duchesne's two-volume edition of the Latin text (1955–57) with his extensive commentaries and notes, is now the standard edition, with a third volume edited by Vögel a useful addition that includes further reference material. Davis (1989 revised in 2000; 1992 revised in 2007; 1995) is an accessible English translation in three volumes, which translates the *vitae* from St Peter to Stephen V (died 891) and also includes notes and commentary. After the ninth century the quality of the biographies became more variable as interest in maintaining the series appears to diminish.

Because the upkeep of the churches was regarded by the papacy as one of its key responsibilities, the *Liber Pontificalis* or 'Book of the Popes' (LP) is a unique and essential resource relating to art of the city of Rome. As Duchesne (1955–57) wrote in the preface to his edition of the Latin text it is:

> one of the principal documents of the story of the Popes and especially of the history of Rome in the Middle Ages, of its monuments and its internal crises, of its religious institutions and its politics.

The text also forms an essential complement to surviving examples of early Christian iconography by filling in gaps due to later material losses so permitting a more balanced understanding of the development and distribution of iconography in the early Christian world. Notwithstanding this, its value has often been overlooked. For example, the entry on the LP in *Dictionnaire d'archéologie chrétienne et de liturgie* (Cabrol and Leclerq 1855–1937) devotes just 20 lines (col. 425) of over 100 columns (Vol IX, I, 354–460) to artistic aspects.

Although including sources as early as the second century, the earliest version of the LP was compiled around 530–40 (Davis 2000: xi–xvi), by someone who also inserted an introductory apocryphal exchange of letters between St Jerome and Pope Damasus (366–84) (translated in Davis 2000: 1). Nothing further was added until the time of Pope Honorius I (625–38). From then until the end of the ninth century the LP was regularly updated following a Pope's death; sometimes also at intervals during his life. From the sixth century the compilers are considered to be papal administrators:

> Our authors are best imagined as humble clerks (conceivably keepers of the archives at the Lateran *vestiarium*) working for the Roman church and devoted to it, interested in its history though lacking the knowledge to see that history in its full context … and taking sides in disputes over papal elections.
>
> (Davis 2000: xiv–xvi)

Occasionally more direct insights into papal activity provide local colour. Thus St Cecilia visits Paschal I (817–24) in a dream, telling him where her remains are in the catacombs (Davis 1995: 15); and later on he rushes to help extinguish the fire in the Borgo (Davis 1995: 8). These events read like reports of personal experience, but most of the information probably came from records commissioning and paying for items decorating the churches and from papal inventories. Such sources would have provided verifiable parameters like weight, composition and the intended position of an object in the church, which is the sort of detail most usually present. These references are usually accurate. In contrast, when reporting on political events, mistakes are more frequently found. From the ninth century, the authorship of the LP was frequently spuriously attributed to Anastasius Bibliothecarius (papal librarian from 867/8 to the late 870s). The numerous surviving copies of the text attest to its contemporary importance and influence.

Croquison (1964) provides an excellent and undervalued analysis of the iconography in the LP. Duffy's *Saints and Sinner* (1997) is a useful, but superficial source on papal imagery. The best source of brief, reliable papal biographies is Kelly's *Oxford Dictionary of Popes* (1986) which provides key references but unfortunately tends to omit art historical information. Fuller lives of popes from Gregory I (590–604) onwards, linked to earlier textual resources can be found in Mann (1902–). Ullmann's books (1955, 1972) on the papacy are useful, though frequently unhelpfully influenced by a focus on papal domination in the medieval world. Richards (1979) remains a valuable comprehensive resource yet to be bettered.

There are four major areas of art historical importance:

a: The names and dates of establishment of Roman churches

There are several lists of churches in Rome and donations made to them. These assist with dating the establishment and decoration of churches, with recognising changes in their names and in understanding their importance. The earliest list is in the *vita* of Pope Sylvester I (314–35) (Davis 2000: 14–28) which purports to list donations made by Constantine the Great.[1] A second list dates to 807 (Davis 2007: 205–27) providing the fullest list of Roman churches from the first millennium. Shorter lists occur in other *vitae*. These references are usually to the establishment of buildings or the donation of church furniture rather than to images: thus the 807 list identifies over 100 churches receiving either a 'silver crown' or 'silver canister' (Davis 2007: 205–15).[2]

b: A record of major items of metalwork

Constantine's first Christian decorations, following his arrival in Rome, were installed at the 'Constantinian' basilica (Lateran) and consisted of:

> a hammered silver fastigium[3] – on the front it has the Saviour seated on a chair, 5 ft in size, weighing 120 lb, and 12 apostles each 5 ft and weighing 90 lb with crowns of finest silver.
>
> (Davis 2000: 16.9)

Were these statues or bas-reliefs? If the latter then they resembled the replacements donated by Pope Gregory III (731–41) (Davis 2007: 21–23). If they were statues this suggests that, immediately after his conversion, Constantine persuaded the Christians to accept sculpture perilously close to the 'graven images' of the pagans to decorate their church.

c: As a record of donations of textiles

The descriptions of textiles emphasise their richness, stress the presence of gold and gems and sometimes identify their iconography. Leo III (795–816) is credited with donating to St Peter's:

> a gold-studded cloth decorated with precious jewels, representing the Lord's resurrection; white silk veils for the silver arches;[4] and for

the same arches very beautiful cross-adorned silk veils for use on the feast day of God's apostle.

(Davis 2007: 190)

In the same entry St Paul's receives:

a white gold-studded altar-cloth representing the holy resurrection, another gold-studded cloth representing the Lord's birth and the holy innocents, and another tyrian[5] cloth representing the blind man being given his sight and the resurrection.

(Davis 2007: 190)

Then the church of St Maria Maggiore receives:

a white gold-studded cloth representing the holy resurrection and another cloth with gold-studded disks representing the annunciation and SS Joachim and Anne.

(Davis 2007: 190)

It is notable that all three churches receive an altar-cloth decorated with an image of the resurrection, with narrative images of the life of Christ as secondary decoration. A focus on this iconography is not obvious from a consideration of only the art that survives from the period. In total, remarkably, over 2000 textiles were donated over a seventy-five year period, of which St Peter's received 367 pieces and St Maria Maggiore 184. Such extravagance in the use of textiles cannot be deduced from any other source.

d: As a record of the iconography of mosaics and other images

Sometimes the earliest iconographic evidence for a composition is in the LP, as possibly occurs for the Assumption, first mentioned in the *vita* of Hadrian I (772–95), (Duchesne 1955–57: I, 500, line 2). The description of the mosaics that Pope Paschal I (817–24) placed in the apse and sanctuary at St Prassede shows the type of detail sometimes provided:

He fittingly decorated this church's apse adorned with mosaic work in different colours. Likewise he embellished the triumphal arch with the same minerals carrying it out in a marvellous fashion.

(Davis 1995: 9–10)

These mosaics survive today (Oakeshott 1967: 207 and Plate 107) and while the hyperbole of the term 'marvellous fashion' is itself exceptional

for the LP, it still fails to convey the brilliance of the colours of these works.

The *Liber Pontificalis* provides some of the earliest and most reliable information on early Christian church decoration and iconography as produced by the papacy. Given the impact of Roman church decoration on the art of both the East and the West, and the heavy losses in art of this period outside Rome, it is an invaluable supplement to surviving images and artefacts. While it largely omits decorative and stylistic details of compositions, it provides much data on the iconography most widely in use, types of decorative art commissioned and quantities of objects used in churches. It provides details like weight, and position of decoration unavailable from other sources. There is a particular focus on the iconography of metal work and of mosaics. Portable images are mentioned more rarely; whether because they were of lesser importance or because of a focus on architectural and structural features is unclear. The direct link with specific popes permits secure dating producing invaluable starting points for dating other artefacts. The document is not comprehensive: only churches that fell under the responsibility of the papacy are included, and by no means all of them are mentioned. Even in those mentioned the items referred to are highly selective. Nevertheless, the text permits some assessment of the relative importance and likely functions of much of the decorative art found in churches and of the dates at which dedications changed. Intelligent reading between the lines also permits deduction of much else.

Eileen Rubery

Notes

1 Davis suggests an actual date at the end of Constantius II's (317–40) reign.
2 These are lights or candle-holders.
3 Probably a screen across the apse in front of the tomb of St Peter.
4 The arches of the balustrade surrounding the *Presbyterium.*
5 The imperial purple dye.

Selected bibliography

Cabrol, F. and Leclerq, H. (1855–1937) 'Liber Pontificalis', in F. Cabrol, *Dictionnaire d'archéologie chrétienne et de liturgie*, Paris: Letouzey et Ané.
Croquison, J. (1964) 'L'iconographie chrétienne à Rome d'après le *Liber Pontificalis*', *Byzantion,* 34, 535–606.
Davis, R. (1995) *The Lives of the Ninth-century Popes* (Liber Pontificalis), Liverpool: Liverpool University Press.

——(trans. and introduction) (2000) *The Lives of the Pontiffs* (Liber Pontificalis): *The ancient biographies of the first ninety Roman Bishops to AD 715*, Liverpool: Liverpool University Press.

——(trans., introduction and commentary) (2007) *The Lives of the Eighth-century Popes* (Liber Pontificalis), Liverpool: Liverpool University Press.

Duchesne, L. (ed.) (1886–92 re-issued in 1955–57 with third volume including further material by C. Vögel) *Le Liber Pontificalis: Texte, introduction et commentaire*, Paris: Bibliothèque des Écoles françaises d'Athènes et de Rome.

Duffy, E. (1997) *Saints and Sinners: A history of the Popes*, Italy: Yale University Press.

Kelly, J. N. D. (1986, updated 2005) *Oxford Dictionary of Popes*, Oxford: Oxford University Press.

Mann, H. K. (1902–) *The Lives of the Popes in the Middle Ages*, London: Kegan Paul.

Oakeshott, W. (1967) *The Mosaics of Rome*, London: Thames and Hudson.

Richards, J. (1979) *The Popes and the Papacy in the Early Middle Ages*, London: Kegan Paul.

Ullmann, W. (1955) *The Growth of Papal Government in the Middle Ages*, London: Methuen.

——(1972) *A Short History of the Papacy in the Middle Ages*, London: Methuen.

JOACHIM CAMERARIUS, ON *ALBRECHT DÜRER*, PREFACE TO THE LATIN EDITION OF *DE SYMMETRIA PARTIUM HUMANORUM CORPORUM* [CONCERNING THE SYMMETRY OF THE PARTS OF THE HUMAN BODY], NÜRNBERG, 1532

The Latin text may be found in Rupprich (1956–69: I, 307–12). The only English translation by William Conway is used here but some passages have been re-translated where recent interpretations have shifted emphases (e.g. translations for 'ingenium'): Conway (1958: 136–41).

Joachim Camerarius (1500–74) was Professor of History and Greek at Nürnberg University and friend of the painter and engraver of that city, Albrecht Dürer (1474–1528). On the artist's deathbed, Camerarius promised to publish a Latin translation of Dürer's treatise on human proportion which initially appeared, in 1528, in German. When Camerarius kept his promise in 1532, entitling the work *De symmetria partium humanorum corporum*, that is *Concerning the Symmetry of the Parts of the Human Body*, he included a lengthy Preface on the artistic prowess and personal qualities of the author. The fact that the Preface was in Latin meant that it accorded Dürer considerable respect, reaching a large audience via six editions issued between 1532 and 1557 (Von Schlosser-Magnino 1956: 274).

This Preface is a landmark text because it is the first extensive printed tribute to any artist and precedes the better known biographies of Giorgio Vasari by two decades. Dürer could be seen as deserving this distinction since he was an acclaimed painter and print maker and had prepared treatises on geometry, proportion and fortifications for publication. In a period when painters were beginning to be deemed worthy of professional status similar to that of writers if they could be judged to employ scholarly intellect and poetic imagination, Dürer met the criteria. The Preface could be seen as an expansion of some brief printed commendations. One was by Jakob Wimpfeling (1450–1528) who recorded that Dürer was compared by Italians to ancient Greek painters (1505). In addition Christoph Scheurl (1481–1552) claimed that his works displayed 'divine talent – divini ingenii' (1508) (Rupprich 1956–69: I, 290–91), which was the first time that any visual artist had been so honoured, and celebrated Dürer's personality as affable, trustworthy and eloquent (1515) (Rupprich 1956–69: I, 294).

Camerarius argued that even though Dürer was termed an 'artifex' (meaning someone using manual skill as 'a maker of art') he was worthy of the kinds of commemoration traditionally reserved for the intellectual and social superiors of manual workers. Camerarius drew first on the trope conventionally used to praise soldiers, writers and statesmen, that Virtue is rewarded by Fame (King 2007a: 56–87), by stating that Dürer had achieved fame for the virtue and worth of 'works of undying glory – opera sempiterna gloria' (Rupprich 1956–69: I, 307). This rhetorical figure defined masculine virtue as a matter of being good at what you do professionally and also morally good, and was therefore supported later in the Preface by assurances as to Dürer's personal 'honour and rectitude' and pious selection of subjects (Rupprich 1956–69: I, 308). Moreover, Camerarius drew on the theme rehearsed by some Italian writers since the late fourteenth century that because painters needed imagination and reason to execute their works and not merely manual skill, they should be treated as close in status to scholars such as mathematicians and poets. In support of this argument Camerarius represented Dürer: as one who was a friend of scholars like himself and Wilibald Pirckheimer (1470–1530); was so learned in mathematics and geometry that he had composed the treatise that Camerarius was now publishing; and had employed manual dexterity in the service of the plans thought out for his compositions. Camerarius was opposing the old-fashioned view that Painting was one of the lowly Practical Arts, quite different from the intellectually demanding Liberal Arts (supposedly taught to 'free men' in Imperial Roman society and by implication later to gentlemen). The Liberal Arts comprised the numerate arts of

Geometry, Arithmetic, Astronomy and Music, with the verbal arts of Logic, Rhetoric and Grammar. Scholars had further claimed that the Liberal Arts could only be professed by men able to bring 'innate personal talent' (that is 'ingenium') to their education in practical skills, such as writing or drawing diagrams. By contrast it had been argued that painters and other humble craftsmen such as cobblers could learn their arts simply by repetition or practice: hence the phrase 'Practical Arts' (King 2007a: 255–56).

The deeds, character and appearance of men of outstanding personal talent in government, war and the Liberal Arts had been traditionally memorialised in histories as well as portraiture. Therefore when Camerarius described Dürer's appearance early on in the Preface he was challenging the exclusion of visual artists from such treatments.[1] Camerarius quoted as support for this strategy, the ancient Greek writer Hippocrates's opinion that conspicuous bodies often clothe 'distinguished minds' ('praeclaris mentis').[2]

> His head was intelligent, his eyes flashing, his nose honourably formed and, as the Greeks say 'tetragonon.' ['square' or perhaps here 'angular'] His neck was rather long, his chest broad, his body not too stout, his thighs muscular, his legs firm and steady. But his fingers – you would vow that you had never seen anything more elegant.
>
> (Conway 1958: 137)

The fact that this is the earliest detailed description of any artist's physique underlines the significance of the Preface in asserting the high status of painting. The Preface evinces interests in the personal appearance of artists parallel to that being displayed by art collectors who were purchasing portraits of artists from the first decades of the sixteenth century onwards (King 2007b: 108–14).

Camerarius then related that Dürer displayed 'sweetness and wit of conversation' perhaps recalling the way in which the Elder Pliny had described the 'benign' character and eloquence of the ancient Greek painter Apelles (Jex-Blake and Sellars 1967: 124). He assured the reader that Dürer was learned in 'the natural and mathematical sciences' as well as in Roman and Greek literature in German translations, and was able to state his knowledge in words and practice. Here Camerarius was emphasising that Dürer was acquainted with some branches of the Liberal Arts and able to use his intellect, as those learned in the Liberal Arts were said to do, in order to theorise about their arts. Camerarius ended his account of Dürer the person by praising him as 'pleasant', 'cheerful' and possessing 'honour and rectitude'.

Camerarius moved to describing Dürer's education and patrons. Like all painters Dürer had learned by imitating others, but, it was stressed, had copied with discrimination, and had analysed the principles informing his exemplars. Camerarius then explained that Dürer was supported by the most powerful men, thus demonstrating that the greatest rulers considered him the greatest painter. It was perhaps because his work had been admired by the Emperor that Camerarius was emboldened to state that, 'once his hand had matured, it was possible to understand the sublime and virtue loving personal talent of his works, for all was done with grandeur and in terms of praiseworthy subject matter'.[3] The adjective 'sublime', meaning 'lofty', to describe the talent of a visual artist was unprecedented, being employed to describe an elevated mind or poetic style. Camerarius ended by characterising the painter's 'pious and modest' choice of subject matter, and a wise style of depiction which never fell into the errors of either too minute or too careless a finish.

Camerarius now turned to Dürer's manual skill, but was careful to emphasise that his hand was obedient to his intellect and to frame this discussion in a refined way, by referring to the value placed by ancient Greeks on painting as the equivalent of poetry (King 2007a: 274). First Camerarius equalled Dürer's manual accuracy to that of the instruments of the Liberal Art of geometry: the rule and compass. Second he recalled watching how Dürer's hand followed his head: 'in a trice he would throw down (or as they say compose) on paper with brush or pencil, images of anything whatever, for his hand was in tune with the concepts in his mind.'[4] Camerarius underscored the role of mental planning by explaining that Dürer would draw different parts of a composition and parts of bodies that would later be found to join together perfectly in a work. Finally he made wide claims concerning Dürer's breadth of knowledge: 'this singular art-maker's mind, instructed with all cognition and understanding of the truth and of the agreement of the parts with one another, governed and guided his hand.'[5]

Two anecdotes ensued allowing Camerarius to define Dürer's style by comparison with those of Giovanni Bellini and Andrea Mantegna to show his superiority over Italian artists. The first story proved that Dürer's 'fineness and delicacy' in handling the brush was acknowledged by Bellini himself. The second established that Mantegna's 'hard and stiff – dura et rigida' form of representation was inferior to the softer effects of Dürer. Camerarius concluded by reiterating his initial tropes: that of the artist attaining glory by seeking moral and professional worth, and that of painting being accounted an intellectual art. Dürer was therefore represented, in the tradition of the hero searching for virtue, as

one who was, 'with his great and celestial mind always yearning for something above'.[6] Finally he pronounced Dürer leader of German-speaking painters in establishing the importance of theorising one's practice and publishing one's conclusions in treatises. By doing so Dürer benefited other painters and other professions, 'so that he was able to lead painting to walk the road of precepts and call it back to follow a system of teaching'.[7]

Catherine King

Notes

1 See for example *Plutarch's Lives*, trans. Bernadotte Perrin, 11 vols, London, 1920, IX, 145 for the detailed description of the appearance of the Roman leader Antony (soldier and lover of Cleopatra).
2 For the Latin text see Rupprich (1956–69: I, 307).
3 Rupprich (1956–69: I, 308), 'sed ubi iam habuit illius manus, ut ita loquor, maturitatem, tum maxime de operibus intelligeres ingenium sublime et virtutis amans, talia enim omnia faciebat grandia et laudabilis argumenti.'
4 Rupprich (1956–69: I, 308), 'Quid memorem, qua[m] dextrae cum animi conceptibus congruentia, saepe in chartas statim calamo aut penna figuras quarumcunque rerum conciecerit, sive ut ipsi loquuntur, collocarit.'
5 Rupprich (1956–69: I,308), 'Mens artificis singularis instructa omni cognitione et intelligentia veritatis consensusque inter se partium, ipsa moderabatur ac regebat manum.'
6 Rupprich (1956–69: I, 309), 'Quamvis enim Albertus summus esset tamen aliquid animo suo magno et excelso supra semper concupiscebat.'
7 Rupprich (1956–69: I, 310), 'picturam in viam praeceptionum induxerat et revocarat ad rationem doctrinae.'

Selected bibliography

Conway, W. (1958) *The Writings of Albrecht Dürer*, London: Peter Owen.
Jex-Blake, K. and Sellars, E. (1967) *The Elder Pliny's Chapters on the History of Art*, Chicago: Ares Publishers.
King, C. (1999) 'Italian artists in search of virtue, fame and honour', in Emma Barker, Nick Webb and Kim Woods (eds), *The Changing Status of the Artist*, New Haven, CT: Yale University Press, 56–87.
——(2007a) 'Making histories: publishing theories', in Kim Woods (ed.), *Making Renaissance Art*, New Haven, CT: Yale University Press), 251–80.
——(2007b) *Representing Renaissance Art 1500–1600*, Manchester: Manchester University Press.
Rupprich, H. (1956–69) *Dürer Schriftlicher Nachlass*, 3 vols, Berlin: Deutscher Verein für Kunstwissenschaft.
Von Schlosser-Magnino, J. (1956) ed. O. Kurz, *La letteratura artistica*, Florence: Leo Olschki.

GIORGIO VASARI, *LE VITE DE' PIÙ ECCELLENTI PITTORI, SCULTORI E ARCHITETTORI* [*THE LIVES OF THE MOST EXCELLENT PAINTERS, SCULPTORS AND ARCHITECTS*] (1550 AND 1568)

The full Italian text of both editions of Vasari's *Lives* can be found in Paola Barocchi and Rosanna Bettarini (eds), *Le Vite de' più eccellenti pittori, scultori e architetti nelle redazioni del 1550 e del 1568*, 6 vols, Florence: Sansoni, 1966–87. There are numerous selections from the *Lives* in English translation. The one cited here is the 4 volume Everyman edition (London and Toronto: Dent, 1927) translated by A. B. Hinds – one of the more complete translations, although omitting the dedicatory letters, 'Proemio' and technical introduction.

The PURPOSE of your endeavors is not to write about the lives of painters … but only about their WORKS … Only princes, or men who are involved in the affairs of princes, should have biographies written of them and not ordinary people, and you are only concerned here with their art and the works made by their hands.

(Frey and Frey 1930, II: 100–2)

These words were written to the painter and architect Giorgio Vasari (1511–74) in 1564 by the historian Vincenzo Borghini (1515–80), his friend and editor, while he was preparing the second edition of his *Lives of the Artists*. Borghini had been part of the editorial team that had seen the first edition of Vasari's book through the Torrentino press in Florence in 1550, providing it with an unusually good index that enhanced its use as a reference or guide book. When Vasari entered the service of Duke Cosimo of Florence he worked frequently with Borghini who acted as his iconographical advisor, providing him with erudite subject matter for his frescoes in the Palazzo Vecchio. For the second, greatly expanded edition of the *Lives*, printed by the Giunti press in 1568, Borghini was the shaping influence on Vasari, urging him to higher standards of factual accuracy, proof-reading the emerging text and making voluminous notes himself. It is striking, therefore, to find Vasari's closest collaborator criticizing what is possibly the most obvious feature of his work – its biographical nature.

If Vasari had followed his friend's advice we would not have the wealth of wonderful anecdotes about artists admitted to the second edition – like the Florentine painter Jacopo Pontormo, an eccentric recluse unable to hear death mentioned, who slept and sometimes worked in a room reached by 'a wooden ladder which he drew up after him, so that no one could come up without his knowledge or permission'

(Vasari 1927, III: 250). Vasari's characterization of Pontormo is confirmed by his surviving diary, and by a letter he wrote to the philosopher Benedetto Varchi in 1547. Here Pontormo reflected on how the painter's absorption in improving on nature by endowing figures on a flat surface with the appearance of life was likely to provoke melancholy, making him 'troubled in mind rather than improved in health, overbold, desiring to imitate with colours everything that nature has made' (Barocchi 1960–62, I: 68). Pontormo's obsessive nature was responsible, Vasari thought, for the decline of his art represented by his last works in the church of San Lorenzo in Florence. His desire to surpass all artists, including Michelangelo, with these frescoes led him to fall 'far short of his own previous efforts, and so we see that when men wish to force Nature they ruin their natural endowments' (Vasari 1927, III: 254).

Evidently Vasari felt that details of everyday life – such as Pontormo's odd sleeping arrangements – gave an insight into the character of the artist and that this in turn helped us to understand the nature of his work. This might seem like an obvious point, but Borghini's letter should remind us that in the sixteenth century not everyone shared Vasari's belief that the artist's individual judgement, or '*giudizio*', was expressed through and formed by an engagement with the creative problems posed by his art. It was true that ancient historians like Plutarch had provided trivial details about the lives of statesmen like Alexander the Great – he liked to take his time over drinking a glass of wine, for example – but these helped to flesh out a portrait of the intrinsic moral characteristics of people whose actions in the political sphere had been vitally important in shaping the world. Similarly, hagiographical literature provided detailed biographical accounts of people whose calling to a saintly, spiritual life required an analysis of their personal qualities. Artists, however, were simply technicians possessing a particular skill which made them the 'efficient cause' in a process resulting in the transformation of matter by the introduction of form. Or so Aristotelian thinkers like Borghini reasoned.

Vasari was not the first person to take issue with this point of view. In fact, during the period covered by Vasari's historical account of the three-stage 'rebirth' of the visual arts – a period of progressive amelioration beginning roughly with Cimabue in the thirteenth century and culminating with Vasari's contemporary hero Michelangelo – artists had become increasingly dissatisfied with this artisanal definition of what they did. Previous artistic biographies, like Antonio Manetti's life of the fifteenth-century architect Filippo Brunelleschi, or the autobiography of the fifteenth-century sculptor Lorenzo Ghiberti, claimed for the artist an intellectual status above that of the cobbler and closer to that of the poet or mathematician. Such claims were founded on the new 'science' of

perspective that enabled artists to produce works of art more consistent with the facts of vision, and on the parallels with literary theory outlined by Leon Battista Alberti in the artist's 'composition' of a narrative or *Istoria (Della Pittura* and *De pictura*, 1435–6).

Aware of how the fame of Brunelleschi derived from his status as an innovator, artists increasingly thought of themselves as agents in a historical process, and developed a keen critical awareness of stylistic change. In aiming to make a name for themselves, artists sought to differentiate their work from the norm by creating original forms. This process fostered an awareness of diachronicity and a reappraisal of ancient art, even leading to archaeological research and the philological study of texts like Vitruvius. However, the sense of history produced by the constant search for innovation was primarily a facet of an evolving artistic identity and the past – as often as not in a quasi-mythical form – was evoked to justify the status claims of a profession in transition. In particular, the anecdotes concerning ancient artists like Protogenes, preserved in Pliny's *Natural History*, played a formative role in shaping the process which Ernst Kris (1900–57) and Otto Kurz (1908–75) called, in 1934, the 'heroization of the artist'. Vasari echoed Pliny's anecdotes of animals deceived by works of art in his writing, just as he painted these famous tales of Zeuxis, Parrhasius, Protogenes and Apelles on the walls of his house in Arezzo.[1]

Vasari was particularly well placed to draw together these developments in a comprehensive and coherent history of the visual arts. He was the beneficiary of a humanist education in the Medici household, as well as of an artistic training in the workshop of Andrea del Sarto (1486–1530). His connections with highly placed patrons like the Medici and the Farnese meant that he moved in courtly circles and was friends with intellectuals like Paolo Giovio (1483–1552) and Annibale Caro (1507–66). The historian Giovio, in particular, had been the author of biographies of Leonardo da Vinci, Raphael and Michelangelo in the 1520s, and had collaborated with Vasari in devising the frescoes celebrating the Farnese papacy in the Roman Cancelleria in 1546. The spatial arrangement of individual portraits within institutional history, flanked by allegorical figures in these frescoes, is in some ways analogous with the structure of biographies, prefaces and theoretical and technical introductions that frames the *Lives*. Vasari credited Giovio with the idea for a history of the visual arts at this time in his own autobiography, but he was the one who had the technical knowledge, the artistic connections (with the Ghiberti and Ghirlandaio families, for example), and a collection of drawings amassed since 1528 (the *Libro de' Disegni*) which made him the ideal person to research and write the *Lives*. Clearly Vasari relied heavily on earlier sources – like the

manuscript notes of the so-called *Anonimo Magliabechiano* – and the contributions of friends and well-wishers, but to suggest that Vasari was not the author of much of the *Lives*, as Charles Hope has done, is to underestimate his organizational skills and to over-emphasize the textual discrepancies in the first edition at the expense of its overall argument.

The elements of the book's argument are characteristically the concerns of Giorgio Vasari the artist: that art progresses through a commitment to standards, through hard work and competition, and because of enlightened patronage; that '*disegno*' or design manifested in drawing unifies the arts of painting, sculpture and architecture; that a good style or '*maniera*' is best formed by the eclectic imitation of antiquity and established masters (as explained in an important passage on Raphael's stylistic development added to the second edition); that the art of central Italy, and particularly Florence, exemplifies good '*disegno*' and '*maniera*'; and finally, that Michelangelo's art is the culmination of art's progress, gracefully transcending rules, and safe-guarded against ill-informed criticism by the artist's 'divine' character (Vasari 1927, IV: 108).

Contemporary readers of the *Lives*, like the Flemish scholar Domenicus Lampsonius, recognized the cogency of this argument and its bias, and attempted to get Vasari to address the contribution of artists outside of the Tuscan tradition (like Lambert Lombard, the subject of a biography by Lampsonius). The colourism of Venetian art, the vibrancy of artistic centres in northern Italy like Milan, had been neglected, and critiquing, completing or updating Vasari became the concern of writers like Giovanni Lomazzo, Alessandro Lamo, Karel van Mander or Giovanni Baglione. Art History, therefore, would subsequently react to Vasari and follow a biographical course, expanding or revising the canon but ultimately accepting the integral relationship between the artist's life and work.

Ben Thomas

Note

1 See, for example, Pliny, *Naturalis Historia*, XXXV, 65: 'In a contest between Zeuxis and Parrhasius, Zeuxis produced so successful a representation of grapes that birds flew up to the stage-buildings where it was hung. Then Parrhasius produced such a successful trompe-l'oeil of a curtain that Zeuxis, puffed up with pride at the judgement of the birds, asked that the curtain be drawn aside and the picture revealed.'

Selected bibliography

Barocchi, P. (1960–62) *Trattati d'arte del Cinquecento*, 3 vols, Bari: Laterza.
Barolsky, P. (1991) *Why Mona Lisa Smiles and Other Tales Told by Vasari*, Pennsylvania, PA: Pennsylvania University Press.

Boase, T. S. R. (1971) *Giorgio Vasari, The Man and the Book*, Princeton, NJ: Princeton University Press.

Burzer K. (ed.) (2010) *Le Vite del Vasari: genesi, topoi, recezione*, Venice: Marsilio.

Cheney, L. De Girolami (2007) *Giorgio Vasari's Teachers: Sacred and Profane Art*, New York: Peter Lang.

Collobi, L. R. (1974) *Il Libro de' Disegni del Vasari*, 2 vols, Florence: Vallecchi editore.

Frey, K. and Frey, H. W. (eds) (1930) *Der literarische Nachlass Giorgio Vasaris*, 2 vols, Munich: Müller.

Hope, C. (1995) 'Review of Patricia Lee Rubin, *Giorgio Vasari: Art and History*', *New York Review of Books*, 5 October, 10–13.

Kris, E. and Kurz, O. (1979) *Legend, Myth and Magic in the Image of the Artist: A Historical Experiment*, New Haven, CT: Yale University Press.

Pliny the Elder (1981) *Natural History. A Selection*, trans. John F. Healy, London: Penguin.

Rubin, P. L. (1995) *Giorgio Vasari: Art and History*, New Haven, CT: Yale University Press.

Thomas, B. (2008) 'Casa Vasari in Arezzo: Writing and Decorating the Artist's House', in Harald Hendrix (ed.), *Writers' Houses and the Making of Memory*, New York: Routledge, 139–48.

Williams, R. (1997) *Art, Theory, and Culture in Sixteenth-Century Italy*, Cambridge: Cambridge University Press.

LODOVICO DOLCE, *IL DIALOGO DELLA PITTURA, INTITOLATO ARETINO*, VENICE (1557)

The Italian text and English translation used here is that of Mark W. Roskill, *Dolce's Aretino and Venetian Art Theory of the Cinquecento*, New York: New York University Press, 1968.

Lodovico Dolce (1508–68) worked in Venice as editor, translator and prolific writer on a wide range of topics. The fact that he did not write the *Dialogo della pittura* as an expert on art criticism, but overtly provided a digest of the ideas of Leone Battista Alberti, Baldasarre Castiglione and Giorgio Vasari from a Venetian viewpoint, means that it is a good indication of current discourses on painting. The *Dialogue* was subtitled after its main speaker, the writer Pietro Aretino (1492–1556) who had been educated in Arezzo, Perugia and Rome, resident in Venice since 1527, and who was friend, advocate and patron of Titian. As editor of his *Letters* (1541–42) Dolce had the authority to represent Aretino's views and was in a hurry to capture the interest of Aretino's former audience

since the *Dialogue* was published in 1557, ten months after Aretino's death, in a large edition. The other speaker in the *Dialogue*, Giovanni Francesco Fabrini (1516–80) was a plausible choice to stand for Florentine views concerning excellence in painting, since he was from Tuscany and had held a post teaching at the university in Venice since 1547.

Dolce's text is the earliest book length treatment to be printed specifically for viewers to learn about the critical categories applicable to painting. It was also the earliest sustained challenge to the account of art history and the evaluation recently published by Vasari (Vasari 1550). Vasari had narrated the 'rebirth' of art from the fourteenth century onwards as the triumphal story of the lives of Florentine art makers (*artifici*) culminating in the singular excellence of the Florentine Michelangelo. By contrast Dolce offered not a history told by one writer, but a conversation discussing the differing values ascribed by educated viewers, who had seen many paintings, concerning the pictorial qualities that provide most pleasure for spectators and touch their emotions. In the exploratory mode possible in a dialogue, Dolce rehearsed the pluralist view that there are many equally valid and yet different ways of painting well, discussed the basis on which different viewers may make good judgements, and suggested that evaluations change over time. Although Aretino, as speaker, seems to veer at the end of the dialogue towards Vasari's position that there may indeed be one painter who is now declared the very best, the context in which Aretino awarded top prize to Titian undermined the claim, latent in the *Lives,* that Vasari's verdict is absolute – for all time. The *Dialogue* had argued that judgements shift over time and had shown that differing judgements may also be put forwards concurrently.

In order to question Vasari's singular focus on the prowess of Michelangelo, Aretino expanded the opinion put forward by Castiglione in *The Courtier* in 1528 that, 'each painter in his own style may be perfect' (Castiglione 1964: 148). Fabrini, the Tuscan speaker, was made to agree with him when Aretino quoted Horace's *Ars poetica* to the effect that different painters may develop different and equally excellent '*maniere*' – 'styles', because the source of their prowess, as with poets, is innate individual talent or '*ingegno*', and is never just the result of good education (Roskill 1968: 159). Dolce had Aretino praise the works of many painters (including Leonardo, Giorgione, Correggio, Raphael, Perino del Vaga, Andrea del Sarto, Giulio Romano, Polidoro da Caravaggio, Parmigianino and Pordenone) and made Fabrini reply, 'I am certainly beginning to see that Michelangelo does not stand alone in painting' (Roskill 1968: 181–83).

Aretino was represented as asserting that one's judgements relate to one's cultural experience, when he said that he expected Fabrini, 'as a man of Florence yourself' to defend Michelangelo's worth. He then

pointed out that judgements may change over time, for when Raphael was still alive most critics thought that he was the best painter because he possessed 'facility – *facilità*', that is to say he made everything he did, however difficult, look easy, and he was much more than a good draughtsman (Roskill 1968: 91). Aretino next asserted that everyone is qualified to make judgements about art, not just painters, although he stated that 'fine intelligence', knowledge of 'literature and practical experience' will improve discrimination (Roskill 1968: 101–5).

Dolce then had Aretino and Fabrini discuss the criteria which will inform judgements, claiming to summarise the ideas of the Florentines Alberti and Vasari whilst actually presenting a selection from their texts with Dolce's own emphases and adding some ideas derived from the Venetian painter Paolo Pino's *Trattato della pittura – Treatise on Painting*, 1548 (Roskill 1968: 16). Against every test Dolce had Aretino argue later in the *Dialogue* that the now dead Raphael was a fine painter in every way, that Titian is the most excellent all rounder, and the Michelangelo is sadly wanting in some areas.

Fabrini began by defining painting as seeking to achieve a convincing representation of 'the things which God has created' (Roskill 1968: 113). Aretino and Fabrini concurred that the functions of painting are to instruct viewers concerning religion and morality and excite them to good action, as well as to provide a pleasurable 'feast for the eye' and adorn houses and public buildings (Roskill 1968: 113–15). Aretino next said that, 'according to my judgement – a *mio giudicio*' (Roskill 1968: 116), painting consisted of invention, design (*disegno*) and painting with colours (*colore*). First, invention entailed the painter selecting or having selected for him a fable or story and thinking out the best way to depict it by means of appropriate and convincing actors, dress and scenery. Second, Aretino defined design as, 'the form imparted by the painter to the things he sets about imitating and it is really a winding movement of lines, which travel along various paths to give shape to the figures' (Roskill 1968: 131). Design also included understanding the proportions and structure of the body and painters of the nude needed it to represent every kind of body, both muscular and delicate ones, male and female, young and old, or those of a peasant or a lord. They also needed it to portray naked figures from any viewpoint and as if in action, where required for telling the story, and employing foreshortening, where necessary to the invention. Again painters needed it to be able to depict clothed figures in all the variety suiting any story. Third, painters required expertise in applying paints of different colours with brushes, that is 'colouring – *colorito*'. Aretino stressed that the application of different hues can 'imitate the tints and the softness of flesh [*la morbidezza*

delle carni] and the rightful characteristics of any object', so as to make paintings 'seem alive' and convey all the variety of human bodies. He admired the blending of colours which is 'diffused and unified – *sfumata e unita*' to imitate naturalistic appearances (Roskill 1968: 153). Here Aretino recalls the terms in which Vasari had praised the painting technique of Giorgione as 'soft and unified and diffused – *morbide et unite e sfumate*', and that of Correggio for its 'extreme softness in the colouring – *morbidezza colorito*' (Vasari 1986: 558, 563). Skill in colouring enabled one to imitate every kind of textile, and capture 'the glint of armour, the gloom of night and the brightness of day, lightening flashes, fires, lights, water, earth, rocks, grass, trees, leaves, flowers, and fruits, buildings and huts, animals and so on' (Roskill 1968: 15). Here Dolce elaborated on the variety of pictorial effects outlined in print by Francesco Lancilotti in 1509, Castiglione in 1528 and Vasari himself in 1550 (Roskill 1968: 300). Dolce ended his definition of painting by stating that it required *sprezzatura* and the ability to move spectators (Roskill 1968: 157). The term *sprezzatura* was coined by Castiglione to describe the apparently effortless accomplishment marking a true courtier, and in pictorial terms as used by Dolce entailed making difficult effects look easy to achieve.

In the second half of the *Dialogue* Dolce's speakers turned to considering how well various painters, especially Raphael, Michelangelo and Titian, meet these criteria. Aretino argued that in every respect, except drawing some kinds of nudes, Michelangelo was inferior to Raphael, whilst Titian has now overtaken even Raphael in all round excellence. In his view Michelangelo was unable to represent the full variety of the visual world and his grasp of invention was inadequate because he had inappropriately depicted male genitals in a chapel for the *Last Judgement* (Roskill 1968: 161–67). Although Michelangelo was '*stupendo* – stupendous' in drawing some kinds of nudes he was unable to portray delicately muscled figures or differentiate according to gender, age and station, and tended to include quantities of foreshortened figures portrayed in violent action more to advertise skill rather than to convey his subject matter (Roskill 1968: 171–73). In colouring abilities Aretino said that Michelangelo also failed and, instead of displaying *sprezzatura* by making things look effortless, drew attention to the difficulties of his art (Roskill 1968: 177–81).

Dolce's *Dialogue* was widely quoted in the sixteenth and seventeenth centuries, and the fact that translations of it were published in French and English in the eighteenth century, and in German in the nineteenth century, testify to perennial interest in a text that contested Vasari's 'absolutist' account of painting so effectively (Roskill 1968: 66–70).

Catherine King

Selected bibliography

Castiglione, B.(1964) *Il libro del cortegiano* (1528) ed. B. Maier, Turin: U.T.E.T.
Hills, P. (1999) *Venetian Colour*, New Haven, CT: Yale University Press.
Roskill, M. W. (1968) *Dolce's Aretino and Venetian Art Theory of the Cinquecento*, New York: New York University Press.
Vasari, G. (1986) *Le vite de'più eccellenti architetti, pittori, et scultori italiani da Cimabue insino a tempi nostri, Florence, 1550*, ed. Luciano Bellosi and Aldo Rossi, Turin: Einaudi.

JOHANN JOACHIM WINCKELMANN, *HISTORY OF THE ART OF ANTIQUITY [GESCHICHTE DER KUNST DES ALTERTUMS]* (1764)

The best English edition is Johann Joachim Winckelmann (2006) *History of the Art of Antiquity*, translated by H. F. Mallgrave, Los Angeles: Getty Research Institute. On other English versions, see below.

The *History of the Art of Antiquity* by Johann Joachim Winckelmann (1717–68) founded 'art history' as we know it (Potts 1994; Testa 1999; Décultot 2000; Pommier 2003). Although descended from a German tradition of philosophical aesthetics (Winckelmann had attended Alexander Baumgarten's lectures at the University of Halle), and although focused specifically on Classical Greek sculpture, Winckelmann's *History* established a paradigm for studying the visual arts in their historical and cultural context. Indeed, Winckelmann's influence transcends the study of art history altogether: he had a decisive impact on the development of eighteenth-century Neoclassicism, as well as on those German Romantic writers who followed in his wake (especially Johann Wolfgang von Goethe, Johann Christoph Friedrich von Schiller and Johann Gottfried von Herder).

The *History* is today Winckelmann's most celebrated work, although in some ways his earlier writings had greater influence in his own time.[1] The *History* itself was not translated into English – as opposed to French and Italian – until later in the nineteenth century. Giles Henry Lodge may have rendered sections of the *History* into English between 1849 and 1873. But Lodge used a revised 1776 edition of Winckelmann's text, and one on which Winckelmann continued to work until his death in 1768 (the 1776 edition is considerably expanded and contains some notable departures from the original 1764 version); what is more, Lodge's foremost aim was to update Winckelmann's account, transforming it into a nineteenth-century guide to Classical Greek sculpture. It was only

in 2006 that Winckelmann's original 1764 edition was translated into English, providing what is now the most accessible student text (Winckelmann 2006: this is the version cited below, though even this is a poor substitute for the German).

To understand the work's genesis, it is important to understand how and where it was written. Although born to a humble family in Stendal, and after struggling with a series of failed careers in the 1740s, Winckelmann became librarian to Heinrich, Graf von Bünau in 1748. Immersing himself in Greek literature, and forging the necessary political relationships, Winckelmann was able to leave Germany for Rome in 1755. The Seven Years War (1756–63) meant that Winckelmann remained in Italy longer than originally planned: a series of appointments ensued, with Winckelmann working as librarian to a succession of papal secretaries and cardinals; then, in 1763, Winckelmann eventually became prefect of antiquities for Pope Clement XIII. These various appointments enabled Winckelmann to study Rome's antiquities at first hand. Indeed, he even changed his mind on certain subjects, revising earlier, pre-1755 interpretations on the grounds of sustained first-hand analysis (Bäbler 2009).

The most innovative feature of Winckelmann's *History* is its movement from individual exemplum to larger historical narrative (the most concise and insightful introduction is Barasch 2000: 97–121). Winckelmann looked to surviving ancient objects in an effort to tell a story of systematic artistic and cultural development – the 'history of art', no less. For Winckelmann, as for almost all subsequent 'art historians', what mattered was stylistic evolution – the ways in which artistic forms changed and developed over time (Winckelmann 2006: 227–44). But what is especially remarkable about Winckelmann's account is the way in which it fuses a narrative about ancient art with one about the more recent arts of Europe. Winckelmann's supposed 'older', 'high', 'beautiful' and 'imitatory' phases of Greek art (*der ältere Stil, der hohe Stil, der schöne Stil, der Stil der Nachahmer*) explicitly prefigure the Medieval, Renaissance, Late Renaissance and Baroque styles of the post-Byzantine European west. 'The fate of art in general in more recent times is, with regard to periods, like that of antiquity', as Winckelmann puts it; 'there are likewise four major changes' (2006: 244). For Winckelmann, ancient art history is therefore fundamental to thinking about modern art history, and vice versa (Squire 2011: 46–53). Indeed, Winckelmann's whole project is premised on the idea that Greek sculpture could bring about a second 'renaissance' in contemporary eighteenth-century art, just as it had during the fifteenth century.

Winckelmann was not concerned with Greek art alone. Part One of his *History* compares Greek sculpture and painting (2006: 186–283) with

the arts of the Egyptians, Phoenicians, Persians and Etruscans (2006: 128–85), for example, together with those of the later Roman Empire (2006: 283–97). This is a story about 'antiquity' at large. Throughout, Winckelmann also brought with him a formidable knowledge of Greek and Latin literature, relating the evolution of different Greek visual 'styles' to developments in philological expression and literary form. Inscriptions were particularly important in this regard, since different letter forms could help to date and classify. Archaeology, cultural history, anthropology, comparative literature, epigraphy: Winckelmann's influence ricocheted in all of these future disciplinary directions, encompassing and uniting them all.

Winckelmann was not unaware of the paradox of writing about Greek art in Rome. Despite his conviction that the Greek constituted the highest artistic ideal, Winckelmann never visited Greece. The *History* was written at a time when 'Greece' (a provincial backwater of the Ottoman Empire) was largely inaccessible – when the 'Grand Tour' of European aristocrats meant tours of Italy (and first and foremost of Rome). Part of Winckelmann's project therefore entailed differentiating 'original' Greek sculptures from 'derivative' Roman copies, with only partial success (Marvin 2008: 103–19). Winckelmann also shifted contemporary artistic and cultural tastes away from the Roman and toward the 'Classical' Greek – perhaps his most enduring influence.

His concern with Greek 'originals' and Roman 'copies', however, was not just a question of scientific delineation. It also entailed a certain ideology of artistic replication. For Winckelmann, the material object, however beautiful, always becomes a stepping tone for a quasi-spiritual mode of reflection, transcribed into verbal discourse: Roman copies summoned up mental pictures of an emphatically *lost* and *immaterial* Greek realm – a realm, first and foremost, that occupied the subjective imagination. As recent scholarship has argued (Pommier 2003: 23–52; cf. Squire 2009: 41–57), this rhetoric of 'art' was particularly indebted to Winckelmann's Pietist upbringing in Protestant Saxony: despite his pragmatic conversion to Roman Catholicism in 1754, his highest praise of artistic 'noble simplicity and quiet grandeur' (*edle Einfalt und stille Grösse*) derives from a deeply Pietist mode of spiritual subjectivity.

Winckelmann's theological conditioning is something that twentieth-century scholars all too often underplayed, positing instead a rather straightforward association between his aesthetic predilections and his 'homosexuality'. But Winckelmann's 'ideals' did not only have to do with the 'flesh'. As he famously writes of the Apollo Belvedere:

> Go with thy spirit into the realm of incorporeal beauty [*unkörperlicher Schönheit*] … and seek to become a creator of a

heavenly nature, so that the spirit might be filled with beauties that
rise above nature.

(2006: 333)[2]

Although some have heralded Winckelmann as the 'Founding Queen'
of art history, the description shows things to have been somewhat more
complicated: his language is far removed from modern frameworks for
conceptualising 'sexuality'; indeed, Winckelmann's rhetoric evokes an
abstract, supersensory, 'incorporeal' quality – one that rises 'above
nature' (Davis 1994 and Morrison 1999).

In terms of its immediate reception in Germany, Winckelmann's
History prepared the ground for both Kantian and Hegelian aesthetics,
and hence for the disciplinary tussles within 'art history' ever since
(Seeba 1982). On the one hand, Winckelmann's founding premise that
art is a source of beauty stands at the heart of a Romantic tradition of
aesthetic enquiry. For him, as for Kant, art becomes a stimulus for
the individual workings of the subjective imagination: what matters
for the viewer, as for the artist, is the notion of individual freedom
(*Freiheit*). On the other hand, Winckelmann's self-consciously
historicising project – treating ancient art as reflecting ancient history –
informs Hegel's *Lectures on Aesthetics* in the 1820s, delivered some fifty
years later. For Hegel, as for Winckelmann, images reflect a grander
cultural history – what Hegel would call the 'History of Spirit', or
Geistesgeschichte.

It is a tribute to the intellectual richness of Winckelmann's *History* that it
has been claimed as a 'key text' for so many different art-historical modes.
His empirical concern with 'style' certainly led the way to a certain sort of
connoisseurial formalism, intent upon artistic attribution and chronological
taxonomy. While appealing to aesthetes and 'beauty-ites', however,
Winckelmann's *History* also laid the ground for a markedly different
mode of 'retrieval' art history. For late twentieth-century art historians, his
rhetoric of 'Kunst' aligns with much more modern concepts of 'visual
culture' – whereby 'art', like 'literature', provides a lens for exploring the
habitual parameters of a given social and cultural framework.

Perhaps Winckelmann's most important legacy, however, is the one
that is easiest to take for granted: namely, that the *Geschichte* was
conceived and written in German. Thanks largely to Winckelmann,
German would remain art history's *lingua franca*, at least until the
political turbulences of the 1930s, when so many German-speaking
art historians were forced to emigrate to Anglophone lands. As a
philologist of the highest calibre, the author must have grasped the
point only too well: that only German could express the combined

materialist rigour and Romantic abstraction of Winckelmann's art historical project.

Michael Squire

Notes

1 A translated selection, including Winckelmann's 1755 *Reflections on the Imitation of Greek Works in Painting and Sculpture* [*Gedancken über die Nachahmung der griechischen Wercke in der Mahlerey und Bildhauer-Kunst*], is collected in Irwin (ed.) 1972.

2 For discussion of this famous description, see Potts 1994: 118–32; Morrison 1996: 62–68; Pommier 2003: 113–16.

Selected bibliography

Bäbler, B. (2009) 'Laokoon und Winckelmann: Stadien und Quellen seiner Auseinandersetzung mit der Laokoongruppe', in D. Gall and A. Wolkenhauer (eds), *Laokoon in Literatur und Kunst*, Berlin: de Gruyter, 228–41.

Barasch, M. (2000) *Theories of Art*, 3 vols, second edition, New York: Routledge.

Davis, W. (1994) 'Winckelmann divided: Mourning the death of art history', *Journal of Homosexuality*, 27, 141–59.

Décultot, E. (2000) *Johann Joachim Winckelmann. Enquête sur la genèse de l'histoire de l'art*, Paris: Presses Universitaires de France.

Irwin, D. (ed.) (1972) *Winckelmann: Selected Writings on Art*, London: Phaidon.

Marchand, S. (1996) *Down from Olympus: Archaeology and Philhellenism in Germany, 1750–1970*, Princeton, NJ: Princeton University Press, esp. 7–16.

Marvin, M. (2008) *The Language of the Muses: The Dialogue Between Roman and Greek Sculpture*, Los Angeles: J. Paul Getty Museum.

Morrison, J. (1996) *Winckelmann and the Notion of Aesthetic Education*, Oxford: Clarendon Press.

——(1999) 'The discreet charm of the Belvedere: Submerged homosexuality in eighteenth-century writing on art', *German Life and Letters*, 52.2, 123–35.

Pommier, E. (2003) *Winckelmann, inventeur de l'histoire de l'art*, Paris: Gallimard.

Potts, A. (1994) *Flesh and the Ideal: Winckelmann and the Origins of Art History*, London: Yale University Press.

Seeba, H. C. (1982) 'Johann Joachim Winckelmann: Zur Wirkungsgeschichte eines "unhistorischen" Historikers zwischen Ästhetik und Geschichte', *Deutsche Vierteljahrsschrift für Literaturwissenschaft und Geistesgeschichte*, 56, 168–201.

Squire, M. J. (2009) *Image and Text in Graeco-Roman Antiquity*, Cambridge: Cambridge University Press, esp. 43–9.

——(2011) *The Art of the Body: Antiquity and its Legacy*, Cambridge: I. B. Tauris.

Testa, F. (1999) *Winckelmann e l'invenzione della storia dell'arte: i modelli e la mimesi*, Bologna: Minerva.

Winckelmann, J. J. (1881) *History of Ancient Art*, translated by G. H. Lodge, 2 vols, second edition, London: Sampson Low, Marston, Searle, and Rivington.
——(2006) *History of the Art of Antiquity*, translated by H. F. Mallgrave, Los Angeles: Getty Research Institute.

IMMANUEL KANT, *THE CRITIQUE OF AESTHETIC JUDGEMENT* (1790)

There are many English translations but the most accessible of the earlier ones are Immanuel Kant, *Critique of Judgment*, translated by J. H. Barnard, 1892, and Immanuel Kant, *Critique of Judgement*, translated by James Creed Meredith, Oxford, 2007 (originally published 1911). For more recent translations see Immanuel Kant, *Critique of Judgement*, translated by Werner S. Pluhar, 1987, and Immanuel Kant, *Critique of the Power of Judgment*, translated by Paul Guyer and Eric Mathews, Cambridge, 2000.

The *Critique of Aesthetic Judgement*, the first of two parts of Immanuel Kant's (1724–1804) *Critique of Judgement* of 1790, is in some ways a strange text to have achieved such an essential position in the history of art. It does not mention a single work of art by name; it looks at objects of aesthetic consideration only from the position of the spectator. It is as much concerned with natural as artistic beauty, and it was written by a philosopher whose experience of art was severely limited because he lived in, and rarely left, the remote East Prussian city of Königsberg. For Theodor Adorno (1903–69), it was one of the last major works on aesthetics to have been written by someone who did not understand anything about art (Cheetham 2001: 1). Nonetheless the book and Kant's wider philosophy have been continually invoked by artists and writers on art ever since. *The Critique of Aesthetic Judgement* has been seen as defining the principles behind the idea of art for art's sake, abstract and conceptual art, and the invocation of the sublime by post-Second World War American artists. It was the subject of a lifelong study by the late art historian Michael Podro (1931–2008), and it has been quite impossible to talk of aesthetics and aesthetic judgement since its publication without referring to it.

What Kant thought he was doing and what his contemporary and later readers thought he was doing do not always correspond. Kant's mixture of piercing clarity, endless worrying about possible objections to each proposition, occasional self-contradiction, and moral and intellectual profundity gave him immense prestige, but meant that different schools

of Kantian interpretation grew up even in his lifetime. Academics in Germany gained promotion and fame for elucidating and simplifying his philosophy. Writers like Friedrich Schiller (1759–1805) sought to adapt Kantian ideas to literature (Schiller 1982), and the art critic Carl Ludwig Fernow (1763–1808) applied Kantian principles to the creation as well as the judgement of modern sculpture (Fernow 1806). Readers in Germany and elsewhere, concerned both with the power of religious orthodoxy and the Enlightenment's threat to it, found his theories, as simplified by his interpreters like Karl Leonhard Reinhold (1757–1823), both stimulating and comforting. Kant seemed to Reinhold to reconcile the antinomies of reason and belief.

What ideas in the *Critique of Aesthetic Judgement* have been the most influential? First Kant's most fundamental ideas of human autonomy and freedom, which had such an effect on Romantic artists' ideas of independence of authority and 'genius', come from the earlier *Critiques* and are not highlighted in the *Critique of Aesthetic Judgement*. The text is divided into two parts: on the beautiful and on the sublime. The section on the beautiful does not consider the nature of works of art – indeed it concerns the perception of nature as well as art – but only the *judgement* of the beautiful (*Critique of Aesthetic Judgement,* First Moment, *Of the Judgement of Taste*). This first 'moment' argues that the perception of beauty is disinterested, that is to say wholly disassociated from the pleasure of the senses and from perfection, or indeed anything else that might be a matter of individual interest or opinion. This opens up the idea of the aesthetic as a separate faculty, independent of reason or other kinds of perception, and to the detachment of the response to art from all other forms of knowledge or feeling. This, at least in its purest form, finds a fulfilment in the late nineteenth and early twentieth centuries in the movements of art for art's sake and even of abstract art, whose theorists, like Clement Greenberg (1909–94) in his later years, often invoked Kant.

The second 'moment' or proposition is that the beautiful pleases universally without requiring a concept. It is a *judgement* of taste and furthermore it is universal, or so it is believed by all who make such a judgement. The idea of the universality of aesthetic judgement is expressed as a *sensus communis* or common sentiment. Judging the beautiful is, therefore, not a cognitive process, and in being universal is opposed to an object based on a concept and thus implicitly limited by it. This has implications for the Conceptual Art of the late 1960s and early 1970s, which Thierry de Duve (b. 1944), by substituting the word 'art' for Kant's word 'beautiful' applies to it an antithesis between the idea that 'Art is not a concept' and that 'Art is a concept' (de Duve 1996: 304). The idea of the universality

of aesthetic judgement was also invoked (with some intellectual sleight of hand) in that period by Joseph Beuys (1921–86), to claim that 'every human being is an artist' (de Duve 1996: 284).

The third 'moment' argues that the determining ground of the judgement of taste is the appearance of purposiveness without an actual purpose – *Zweckmässigkeit ohne Zweck* – because an actual purpose always implies an interest of some kind. This leads to an important distinction between 'pure' aesthetic judgements and those contaminated by 'judgements of sense', and this purity is expressed in the form and delineation of an object and not in its colour (*Critique of Aesthetic Judgement,* Third Moment). This aligns Kant with the long-standing academic belief that drawing or design is superior to colour which appeals only to the senses, and to distinguishing two kinds of beauty: free beauty – *pulchritudo vaga* – and 'merely dependent beauty' – *pulchritudo adhaerens* – which draws in a concept and purpose, but is clearly of a lower order. Pure beauty may be observed in a flower or a decorative design and dependent beauty in a representation of a human being, that is to say art as it was generally conceived in Kant's own time, and, of course, earlier and later. But there are signs of equivocation in the text as to whether absolute purity of aesthetic judgement was ultimately ever possible or even desirable in practice.

The distinction between the beautiful and the sublime that Kant makes in the *Analytic of the Sublime,* the second part of the *Critique of Aesthetic Judgment,* goes back to Edmund Burke's (1729–97) treatise on the subject (*A Philosophical Enquiry into the Origin of our Ideas of the Sublime and Beautiful,* 1757). Burke sets up the sublime and the beautiful as opposite poles to each other, and this was followed in an earlier treatise by Kant (*Observations on the Feeling of the Beautiful and Sublime,* 1764). Kant sees the sublime as like the beautiful in being also a judgement not based on sense, logic or on a concept. It is therefore also universal, but where the beautiful in nature is concerned with form and boundaries, the sublime is formless or boundless. If the beautiful is a representation of a quality then the sublime is experienced through quantity; if the beautiful invokes a positive pleasure that is compatible with charm and the play of imagination, the sublime evokes agitated emotion and gives negative rather than positive pleasure. If beauty is adapted to calm judgement, then the sublime is associated with chaos and disorder. If we must seek a ground external to ourselves for the beauties of nature, we seek the sublime only in ourselves.

Kant admits the sublime to be less important than the beautiful as it lacks the latter's intimations of the metaphysical. In general his account of the sublime has been less influential than his account of the beautiful, not least because it is associated as much with Burke as with himself.

Nonetheless it has been significant for such artists as Barnett Newman (1905–70) (Cheetham 2001: 121–23) and it has undergone a revival of interest by Jacques Derrida (1930–2004), who wrote about it in the 'Parergon' section of *The Truth in Painting* (1987), in particular about the implications of the 'boundlessness' of the sublime in relation to the 'framing' of art and philosophy.

What remains remarkable about Kant's *Critique of Aesthetic Judgement* is its refusal to remain an historical document: it continues to be about living ideas. The reason is surely that it raises, in a still suggestive form, fundamental and perhaps irresolvable questions about art that concern both its creation and its reception: can art be only about ideas or can there be an independent aesthetic response to it? How can the aesthetic and conceptual be reconciled?

David Bindman

Select bibliography

Adorno, T. (1997) *Aesthetic Theory*, Minneapolis: Continuum.

Bindman, D. (2002) *Ape to Apollo: Aesthetics and the Idea of Race in the 18th Century*, London: Reaktion Books.

de Bolla, P. (1989) *The Discourse of the Sublime: History, Aesthetics and the Subject*, Oxford: Blackwell.

Burke, E. (1958) *A Philosophical Enquiry into the Origin of our Ideas of the Sublime and the Beautiful*, ed. J. T. Boulton, London: Routledge.

Cheetham, M. A. (2001) *Kant, Art, and Art History*, Cambridge: Cambridge University Press.

Crowther, P. (2010) *The Kantian Aesthetic*, Oxford: Oxford University Press.

de Duve, T. (1996) *Kant after Duchamp*, Cambridge, MA: MIT Press.

Derrida, J. (1987) *The Truth in Painting*, Chicago: University of Chicago Press.

Fernow, C. L. (1806) *Römische Studien*, Zürich: Bei H. Gessner.

Guyer, P. (2005) *Values of Beauty*, Cambridge: Cambridge University Press.

O'Neill, J. P. (ed.) (1992) *Barnett Newman: Selected Writings and Interviews*, Berkeley: University of California Press.

Podro, M. (1982) *The Critical Historians of Art*, New Haven, CT: Yale University Press.

——(1972) *The Manifold in Perception: Theories of Art from Kant to Hildebrand*, Oxford: Oxford University Press.

Schiller, F. (1982) *On the Aesthetic Education of Man*, eds E. M. Wilkinson and L. A. Willoughby, Oxford: Clarendon Press.

Tausch, H. (2000) *Entfernung der Antike: Carl Ludwig Fernow im Kontext der Kunsttheorie um 1800*, Tübingen: Niemeyer.

Zammito, J. H. (1992) *The Genesis of Kant's Critique of Judgment*, Chicago: University of Chicago Press.

GEORG WILHELM FRIEDRICH HEGEL, *LECTURES ON AESTHETICS [VORLESUNGEN ÜBER DIE ÄSTHETIK]*, PUBLISHED POSTHUMOUSLY (1835)

The most accessible English edition is Georg Wilhelm Friedrich Hegel (1975) *Hegel's Aesthetics: Lectures on Fine Arts*, translated by T. M. Knox, 2 vols, Oxford: Clarendon Press. On the history of the text, however, see below.

Hegel (1770–1831), wrote Sir Ernst Gombrich, is the 'father of art history' (Gombrich 1977: 203). While many critics have taken issue with Hegel's specific conclusions, his use of art to write *history* remains a mainstay of the discipline: 'there remains something of the Hegelian epistemology in the work of every art historian' (Holly 1984: 30). At the same time, Hegel's *Aesthetics* laid the foundations of 'modernism' as a modern cultural movement. In the visual arts, as in other spheres, Hegel diagnosed a certain sense of 'modernist' remove – a cultural, intellectual and philosophical 'coming after' the (arts of the) past.

Hegel's art historical influence is all the more remarkable given that he left no concrete 'text' on aesthetics for later art historians to judge as 'key'. With the exception of a few pages in his *Encyclopaedia of the Philosophical Sciences* (the first edition published in 1816), we have only second-hand notes, derived from the testimonials of those who attended Hegel's lectures in Heidelberg (1818) and Berlin (during the 1820s). The most familiar edition of these lectures is the one compiled after Hegel's death by a student named Heinrich Gustav Hotho, who purportedly used his own personal lecture notes and some of Hegel's manuscripts (now lost). A first edition of the *Aesthetics* appeared in 1835, and a later revised version was published in 1841: the most accessible English translation, by T. M. Knox, stems from Hotho's second edition (Hegel 1975: page references below refer to this English edition). Some scholars have subsequently claimed that Hotho knowingly distorted Hegel's account in order to champion his own intellectual agenda (Gethmann-Siefert and Franke 2005): students, they suggest, should therefore consult a wider range of transcripts, mostly unavailable in English.

For Hegel, the history of art formed part of a much larger project of 'Idealist' philosophy, centred around the notion of self-determining reason, *die Idee.*[1] Unlike Kant, whose first and foremost concern was with the aesthetics of nature, not artistic replication, Hegel associated manmade images with a special significance of their own: 'art' (*Kunst*) reflects the workings of 'spirit' (*Geist*), and yet it does so in *material* form. Where philosophy and religion are wholly abstract and disembodied

entities, art has to be understood as the 'sensible shining forth of the *Idee*' (*das sinnliche Scheinen der Idee*) (Hegel 1975: 12). The visual arts are consequently important for what they reflect about human-kind's progressive spiritual development (*Geistesgeschichte*). Where Kant postulated a timeless aesthetics centred around 'disinterest', Hegel argues an opposite thesis: that 'every work of art belongs to its own time, its own people, its own environment, and depends on particular historical and other ideas and places' (Hegel 1975: 14).

Like Winckelmann before him, Hegel therefore argues that art reflects history – and that it does so on the grandest and most universal scale:

> in works of art the nations have deposited their richest inner institutions and ideas and art is often the key, and in many nations the same key, to understanding their philosophy and religion.
>
> (Hegel 1975: 7)

The intersection between art and religion proves critical here. Art, Hegel explains, has 'first of all to make the Divine the focus of its representations' (Hegel 1975: 175). It follows that the history of art is the history of the attempt to express the supersensory in sensory form.

Hegel's thesis starts out from the premise of a fundamental sense of modernist rupture and loss. Rather than demand worship, art today demands a more intellectual mode of appreciation and response: 'considered in its highest vocation, [art] is and remains for us a thing of the past' (Hegel 1975: 11):

> No matter how excellent we find the statues of the Greek gods, no matter how we see God the Father, Christ, and Mary so estimably and perfectly portrayed: it is no help. We bow the knee no longer.
>
> (Hegel 1975: 192)

For Hegel, this rupture can only be understood in retrospect, as part of a three-tiered narrative history, from 'Symbolic' art, through the 'Classical', to the 'Romantic' (Hegel 1975: 299–611). Art's first 'Symbolic' stage, associated with the Orient, encompasses everything that he deems 'pre-art' (*Vorkunst*). Although disparate, 'Symbolic' systems share an arbitrary relationship between form and content: in each case, art defers divinity, hiding the supersensory godhead from sight. The second, or 'Classical' stage, associated with Greek antiquity, offered the necessary (and superior) corrective: by reconciling signifier with signified, Greek art gave full sensuous expression to its conception of a supersensory divinity. But humanity has its limits – and so too must

Greek anthropomorphic art-cum-religion, which understood the gods in beautiful human form. The more perfectly ancient sculptors attempted to render the gods' humanity, the more wholly they were diverted from their divinity: the 'contradiction between loftiness and particularity, between spirituality and sensuous existence, drags classical art itself to its ruin' (Hegel 1975: 485).

This 'ruin' gave rise to both a new religion (Christianity) and to a third, 'Romantic' artistic mode. The concept of the Christian Incarnation proves crucial to both Romantic religion and art. Just as the Incarnation is premised upon a new, highly theorised relationship between God and humanity, Romantic art openly contests the relationship between the spiritual and material: where Classical art had concerned itself with the perfection of outward form, Christian viewers had to look instead to a subjective 'beauty of inwardness' (*Schönheit der Innigkeit*) (Hegel 1975: 531). The Protestant Reformation fulfilled this spiritual promise, triumphing over Roman Catholicism's fetishisation of empty matter.

So what supersedes 'Romanticism'? Our concepts of art, Hegel argues, have subsequently changed forever: 'we have got beyond venerating works of art as divine and worshipping them', as Hegel puts it: 'the impression they make is of a more reflective kind' (Hegel 1975: 10). This explains his famous prophecy about art's *Auflösung* or 'dissolution'. Discredited, art must look to philosophy for ratification, refutation and reification:

> it invites us to intellectual consideration, and that not for the purpose of creating art again, but for knowing philosophically what art is.
>
> (Hegel 1975: 11)

In terms of what this art might look like, Hegel offers some preliminary comments in the third and final part of the *Aesthetics*. Different media are best suited to different concepts of art, Hegel argues, each championed by different historical epochs: architecture is the most 'Symbolic', sculpture the most 'Classical', and painting the most 'Romantic' form. And yet in the modern, post-Romantic world, none of these media will truly satisfy: art, we might say, is (or will be) supplanted by *theory* (Danto 1986; Gaiger 2006; Speight 2009).

This is a short and selective summary. But it allows us to evaluate Hegel's larger legacy within the discipline of art history (Moxey 1998; Squire 2009: 15–89, esp. pp. 58–71). This legacy might be said to be two-fold, relating first to his comments on the future of art, and second to his ideological conceptualisation of the phenomenology or 'ontology' of the artistic object.

Hegel's prophecy about art's 'dissolution' has had a profound and enduring impact on the historiography of modern art (Wyss 1999; Gaiger 2000; Geulen 2006). Just as Hegel predicted, this is a theme which has brought together philosophers and art historians alike (Schaeffer 2000). Hegel's modernist thesis has also influenced the sorts of disciplinary narratives that modern art history has come to tell of itself – from Arthur Danto's writings on art as the 'object of its own theoretical consciousness' (Danto 1986: 111), to Georges Didi-Huberman's laments about our modernist 'forgetting' of pre-modernist visual modes (Didi-Huberman 1990: 16).

Still more important is the abiding influence of Hegelian epistemology. If Kant bestowed art history with its essentialist concept of 'art', Hegel gave the discipline its residual historicising impulse. For Hegel, as for subsequent art historians, visual objects reflect something about the broader context in which they were situated – whether social, economic, cultural, intellectual or theological. What is more, such objects are deemed best understandable in linear, chronological sequence: thinking about an image has meant contemplating its relation to what comes before and after it – whether one thinks of Jacob Burckhardt's visual cultural history, or to the subsequent stylistic emphases of Heinrich Wölfflin and Alois Riegl (not least Riegl's theory of *Kunstwollen*). There were precedents for this sort of conceptual mode, of course: Hegel's grand narrative rehearses the sorts of chronological accounts that Winckelmann constructed about Greek art. But Hegel projects such 'story-telling' onto a much grander, historical stage, using art to construct a story encompassing *all* times, places and peoples. In doing so, he not only anticipated the project of a world art history; he also laid the ground for the anthropological (and even psychoanalytical) study of image-making.

Hegel's particular narrative has always had – and always will have – its detractors. Many philosophers and art historians have taken issue with Hegel's underlying Idealist metaphysics. Late-twentieth-century critics have been no less vociferous – not least those with postcolonial agendas, criticising Hegel's Eurocentric assumptions about 'Oriental' *Vorkunst*. But in some sense all of these critical responses testify to Hegel's overarching thesis about contemporary 'art history': that art today invites *intellectual* contemplation first and foremost. This is the most important legacy of the *Aesthetics*. More than any other post-Enlightenment writer, Hegel helped transform 'art history' from a branch of German philosophical aesthetics to an autonomous academic discipline.

Michael Squire

Note

1 For two good English introductions see Bungay (1984) and Besançon (2000: 203–91).

Selected bibliography

Besançon, A. (2000) *The Forbidden Image: An Intellectual History of Iconoclasm*, translated by J. M. Todd, Chicago: University of Chicago Press.
Bungay, S. (1984) *Meaning and Truth: A Study of Hegel's Aesthetics*, Oxford: Oxford University Press.
Danto, A. (1986) *Philosophical Disenfranchisement of Art*, New York: Columbia University Press.
——(1997) *After the End of Art: Contemporary Art and the Pale of History*, Princeton, NJ: Princeton University Press.
Didi-Huberman, G. (1990) *Devant l'image. Questions posées aux fins d'une histoire de l'art*, Paris: Editions de Minuit.
Gaiger, J. (2000) 'Art as made and sensuous: Hegel, Danto and the "end of art"', *Bulletin of the Hegel Society of Great Britain*, 41, 104–19.
——(2006) 'Catching up with history: Hegel and abstract painting', in K. Deligiorgi (ed.), *Hegel: New Directions*, London: Acumen, 159–76.
Gethmann-Siefert, A. and Franke, U. (2005) 'Zur Aktualität von Hegels berliner Vorlesungen über Philosophie der Kunst oder Ästhetik', in U. Franke and A. Gethmann-Siefert (eds), *Kulturpolitik und Kunstgeschichte: Perspektiven der Hegelschen Ästhetik*, Hamburg: F. Meiner, v–xvi.
Geulen, E. (2006) *The End of Art: Readings in a Rumor After Hegel*, translated by J. McFarland, Stanford, CA: Stanford University Press.
Gombrich, E. H. (1977) 'Hegel und die Kunstgeschichte', *Neue Rundschau*, 2, 202–19.
Hegel, G. W. F. (1975) *Hegel's Aesthetics: Lectures on Fine Arts*, translated by T. M. Knox, 2 vols, Oxford: Clarendon Press.
Holly, M. A. (1984) *Panofsky and the Foundations of Art History*, Ithaca, NY: Cornell University Press, 27–45.
Houlgate, S. (ed.) (2007) *Hegel and the Arts*, Evanston, IL: Northwestern University Press.
Moxey, K. (1998) 'Art history's Hegelian unconscious: Naturalism as nationalism in the study of Early Netherlandish painting', in M. A. Cheetham, M. A. Holly and K. Moxey (eds), *The Subjects of Art History: Historical Objects in Contemporary Perspective*, Cambridge: Cambridge University Press, 25–51.
Schaeffer, J.-M. (2000) *Art of the Modern Age: Philosophy of Art from Kant to Heidegger*, translated by S. Rendall, Princeton, NJ: Princeton University Press.
Speight, A. (2009) 'Hegel and aesthetics: The practice and "pastness" of art', in F. C. Beiser (ed.), *The Cambridge Companion to Hegel and Nineteenth-Century Philosophy*, Cambridge: Cambridge University Press, 378–93.
Squire, M. J. (2009) *Image and Text in Graeco-Roman Antiquity*, Cambridge: Cambridge University Press, esp. 58–71.
Wyss, B. (1999) *Hegel's Art History and the Critique of Modernity*, translated by C. D. Saltzwedel, Cambridge: Cambridge University Press.

CHARLES BAUDELAIRE, 'THE PAINTER OF MODERN LIFE' ['LE PEINTRE DE LA VIE MODERNE'] (1863)

'The Painter of Modern Life' ('Le Peintre de la Vie Moderne') (1863) in *Selected Writings on Art and Artist*, trans. and ed. P. E. Charvet, London: Penguin Books, 1972.

Charles Baudelaire's (1821–67) most famous and influential essay on art, 'The Painter of Modern Life', was written in 1859 but not published until the end of 1863, when it appeared in two instalments in *Le Figaro*, in November and December of that year. Written during the period that saw the beginnings of Baron Haussmann's radical modernization of Paris, the essay argued for the painting of contemporary urban subjects and the renewal of art through the example of popular forms. By the time of its publication, Baudelaire had established a reputation for himself as a modern poet, translator and critic. His first novel, the autobiographical *La Fanfarlo* was published in 1847, from 1852 to 1865 he was largely occupied in translating Edgar Allan Poe's writings, in whose dark psychological imagery Baudelaire found a kindred spirit. The publication of *The Flowers of Evil* (*Les Fleurs du mal*) (1857), his great collection of poems, confirmed his reputation in the cultural intelligentsia of the Second Empire period.[1]

'The Painter of Modern Life', at first glance, is untypical of Baudelaire's art criticism. His essays on art are associated with late romanticism and in particular Eugene Delacroix (1798–1863), whom he considered the greatest artist of his age (Baudelaire 1972: 358–89). It is as an artist whose work embodies the will, desire and nervous intensity of the romantic artistic temperament that Baudelaire affirms Delacroix's position as the first among modern painters, in much the same terms as he would later champion the music of Wagner (Baudelaire 1975–76: 1205–44). Delacroix's modernity, Baudelaire argued, rested on his absolute commitment to personal values in painting and his ability to give imaginative expression to the underlying conflicts of his age. 'The Painter of Modern Life' is, however, far removed from the separation of art and life that had characterized Delacroix's mature oeuvre.

By the time he wrote the essay, Baudelaire had long rejected Gustave Courbet's (1819–77) earthy realism and vision of the socialist future as a return to rural life, in favour of an aesthetic of irony and artifice focused on the metropolis. He maintained a commitment to contemporary themes which characterized the early wave of romanticism associated

with Théodore Géricault (1791–1824), which pioneered the fluid interchange between the mysterious, sublime and exotic on the one hand and the picturesque and quotidian on the other. When he writes that the true painter is the one who can isolate from everyday life its epic and heroic character and make us understand the discreet poetry within modern life, we might substitute poet for painter and find in this project the key to Baudelaire's own poetry.

The text is dedicated to and describes the working practices of a Monsieur G., an artist whose identity remains anonymous, though is undoubtedly Constantin Guys (1802–92), a popular illustrator of the fashions, manners and street life of Paris, and friend of Baudelaire.[2] The list of types, themes and subjects in Baudelaire's article largely follows the preoccupations of Guys' oeuvre. The seriousness with which Baudelaire approaches the potentiality of popular culture as a source of renewal for modern art, and explores modern beauty and fashion for the signs of the deeper spirit of his time, would have been provocative at the time of writing, though consistent with the general train of thought within romanticism (Baudelaire 1972: 390–93).

Beyond the specific iconography of Guys' portrayal of modern life, Baudelaire's attraction to his work lies in its evocation of movement and the picturesque. The skilfully studied movement of the carriages, horses and people that populate his imagery is conveyed with an impression of speed, lightness and wit. Guys' wry, satirical humour reveals itself in his fascination with the affectations and manners of the different lifestyles of the classes his imagery documents, which range from the elegant *haute bourgeoisie* to the sequestered lives of the working classes. In his watercolour washes the artist's powers of observation and eye for detail are to the fore. It is the facility and agility of Guys' hand and his keen eye that caused Baudelaire to say: 'Curiosity can be considered as the point of departure of his genius.' This term *curiosté*, which occurs in the section 'The Artist, Man of the World, Man of the Crowds and Child' (Baudelaire 1972: 395–402), is very much the lynchpin of the essay, displacing the emphasis on *naiveté* in Baudelaire's earlier writings (House 1998: 33–57). It is invoked as a state of convalescence, modelled by allusion to the recuperation of Poe's protagonist in his short story 'The Man of the Crowd' (1840), to convey the freshness and sense of fascination and wonder evoked by anything no matter how seemingly insignificant, a receptiveness and openness to things and experiences that is characteristic of a child's relationship to the world. Genius, he goes on to argue, is childhood recaptured by will, childhood now equipped with manhood's capacities of self-expression and powers of analysis that enables it to synthesize and order the mass of raw

material that it involuntarily accumulates (Baudelaire 1972: 398). It is this *curiosité* that defines Guys' work for Baudelaire, his indiscriminate attentiveness to the visual impressions of the city, his desire to know through seeing (Baudelaire 1972: 397). It is also this term that Baudelaire chose for the collection of his art criticism: *Curiosités esthetiques* (1868).

Baudelaire's text is much more than a description of a particular artist's work; it is a vehicle for the exposition of his views on modernity. It challenges artists to seek out, as Guys had done, the characteristic and essential forms, experiences and social types of modern urban life. In its most straightforward sense, Baudelaire's essay underpinned the realist call for art to be created of one's own time and place, to record the appearances and manners of the ascendant bourgeoisie and to capture through the signs of comportment, gesture, fashion, beauty, recreation and pleasure the essence of a new bourgeois order in the process of its self-becoming. Baudelaire's reflections here owe much to his interest in German idealist philosophy and Georg Hegel's (1770–1831) historicist argument that all aspects of an age constitute a totality that reflects its inner logic or underlying spirit.

Baudelaire's essay makes it clear that modernity is something that the artist must seek out and define for himself, rather than something that already has a clear, pre-given form. His text suggests certain sites, types and themes the artist might depict, but his characterization of modernity sketches out a project of further investigation. The artist must seek to capture what he termed 'that indefinable something we may be allowed to call modernity ... the transient, the fleeting and the contingent' (Baudelaire 1972: 403). Attentiveness to the ephemeral aspects of appearances is, however, for Baudelaire only the beginning of this analysis. In one of his key passages, he invokes the artist to find amid the kaleidoscope of modern life the discreet and poetic correspondences that constitute the essential nature of modernity – the underlying forms and forces that constitute its essence.

Baudelaire's essay mentions a cast of types and experiences that the poet associates with modernity (the frock-coated bourgeoisie, soldiers, women (honest and otherwise), make-up, carriages, crowds, the child and the artist as a man of the world), but the protagonist of his text is undoubtedly the Dandy (Baudelaire 1972: 419–22). Modernity for Baudelaire is equated with the masculine presence and sensibility of the poet/Dandy, who might be described as a full time urban leisure expert who strolled the city with a view to savouring all its pleasures. For Baudelaire the Dandy is as an elite figure, curious, indifferent, a connoisseur of fashion, beauty and the city and above all a *Flâneur*. The Dandy

makes the city the cipher of his desires, exploring the secret life that lurks beneath the veneer of polite society, but also its public face, which conceals beneath its banal appearance an abundant supply of the marvellous and the strange. The street and its spectacles is the source of creative reverie and fantasy for the Dandy/*Flâneur*, who delights in its chance sightings and random encounters. Victor Fournel (1829–94) captures Baudelaire's tone well in his popular account of *Flâneurie* when he speaks of the street as an 'improvised theatre' where 'Each individual furnishes me, if I wish, with the material of some complicated novel' (Fournel 1858: 269).

'The Painter of Modern Life' was to exert a powerful influence over the work of realist and early Impressionist painting, furnishing artists with a set of motifs and themes to explore in forging an imagery of modern, metropolitan life. Its most consummate expression is, however, less their work than Baudelaire's own *The Flowers of Evil*, whose interweaving of desire, dream and contemporary life, combined with its shifting tone and imagery, is far closer to the spirit of the essay than either the work of Constantin Guys or the images of the Impressionists.

Beyond its influence on artists, Baudelaire's essay has exerted a profound influence on later cultural criticism, most notably on Walter Benjamin, whose Arcades project (*Passangenarbeit*) and writings on popular culture owe much to Baudelaire's example (Benjamin (1999 [1934]) and (1969 [1938])). T. J. Clark's seminal *The Painting of Modern Life* (1985), reaffirmed Baudelaire's importance for art historical accounts of the formation of modern art and modernity within the framework of nineteenth century metropolitan culture. Clark's description of Paris is deeply informed by the terms of Baudelaire's writings on the city. His characterization of Manet's art and, in particular, interpretations of *Olympia* (1863) and *The Bar at the Folies-Bergère* (1882) are read through the prism of Baudelairian thought (Clark 1985: 79–156, 203–58). Feminist writers, such as Griselda Pollock and Janet Woolf, among others, have critiqued the phallocentrism of Baudelaire's account of modernity focused on the male Dandy/*Flâneur*, and questioned the invisibility of women's experience within the discourses about modernity and the metropolis. More recently, within the context of post-structuralist thought, Baudelaire's writings have been reworked through the framework of Deleuze and Guatari's schizoanalysis by Eugene Holland, while in *Ways Around Modernism*, Stephen Bann has traced Baudelaire's notion of *curiosité* back to its origins in the seventeenth century in providing a revisionist account of the tradition of modern art. Bann contests the idea of 'artistic progress' central to twentieth century modernist discourses and that modern art involved a 'rupture' with the past, in favour of the notion of

art as recursive. This he argues is exemplified in much contemporary art and the way its *curiosité* contests some of the key tenets of modernism.

Jon Kear

Notes

1 *The Flowers of Evil* was republished with additional poems in 1861. The order of the poems in a somewhat provisional and arbitrary way reflected Baudelaire's desire to find a form equivalent to the experience of modernity 'The Painter of Modern Life' later expressed.
2 It is unclear why Baudelaire doesn't name Guys, whom he refers to by his initials. Guys often published work anonymously, as was customary for newspaper illustrations. It is said that the reserved Guys did not wish to be named. Whether intentionally or not, this served to create more intrigue around the artist than might otherwise have been the case.

Selected bibliography

Baudelaire, C. (1861) *Réflexions sur Quelques-uns de Mes Contemporains*, Paris.

——(1963) *Curiosités Esthéthetiques: L'art Romantique et autres oeuvres critiques*, H. Lemaire, ed., Paris: Garnier.

——(1970 [1869]) *Paris Spleen (Le Spleen de Paris)*, trans. L. Varese, 12th edition, New York: New Directions, New York.

——(1972) 'The Painter of Modern Life', in P. E. Charvet (trans. and ed.), *Selected Writings on Art and Artist*, London: Penguin Books.

——(1975–76) *Oeuvres completes* (Complete Works), ed. Claude Pichois, 2 vols, Paris: Gallimard.

——(1986) *Selected Letters of Charles Baudelaire*, trans. R. Lloyd, Chicago: University of Chicago Press.

——(1998 [1857]) *Flowers of Evil (Les Fleurs du Mal)*, trans. J. McGowan, Oxford: Oxford University Press.

——(2002) *On Wine and Hashish*, trans. A. Brown, London: Hesperus Press.

Babuts, N. (1997) *Baudelaire: At the Limits and Beyond*, Newark, DE: University of Delaware Press.

Baer, U. (2000) *Remnants of Song: Trauma and the Experience of Modernity in Charles Baudelaire and Paul Celan*, Stanford, CA: Stanford University Press.

Benjamin, W. (1997 [1938]) *Charles Baudelaire, Lyric Poet in the Era of High Capitalism*, trans. H. Zohn, London: Verso.

——(1999 [1934]) *The Arcades Project*, ed. and trans. H. Eliand and K. McLaughlin, New Haven, CT: Harvard University Press.

Bersani, L. (1978) *Baudelaire and Freud*, Berkeley: University of California Press.

Blood, S. (1997) *Baudelaire and the Aesthetics of Bad Faith*, Stanford, CA: Stanford University Press.

Carrier, D. (1996) *High Art: Charles Baudelaire and the Origins of Modernist Painting*, University Park, PA: Pennsylvania State University Press.

Clark, T. J. (1985) *The Painting of Modern Life: Paris in the Art of Manet and His Followers*, New York: Alfred A. Knopf.

Coven, J. (1993) *Baudelaire's Voyages: The Poet and His Painters*, Boston, MA: Bulfinch Press.

Fournel, V. (1858) *Ce qu'on voit dans les rues de Paris*, Paris: Dentu.

Hannoosh, M. (1992) *Baudelaire and Caricature: From the Comic to an Art of Modernity*, University Park, PA: Pennsylvania State University Press.

Hiddleston, J. A. (1999) *Baudelaire and the Art of Memory*, Oxford: Oxford University Press.

Hobbs, R. (ed.) (1998) *Impressions of French Modernity*, Manchester: Manchester University Press.

Holland, E. W. (1993) *Baudelaire and Schizoanalysis: The Socio-Poetics of Modernism*, Cambridge: Cambridge University Press.

House, J. (1998) 'Curiosité', in R. Hobbs (ed.), *Impressions of French Modernity*, Manchester: Manchester University Press.

Leakey, F. W. (1969) *Baudelaire and Nature*, Manchester: Manchester University Press.

Lloyd, R. (2002) *Baudelaire's World*, Ithaca, NY: Cornell University Press.

Peyre, H. (ed.) (1962) *Baudelaire, a Collection of Critical Essays*, Upper Saddle River, NJ: Prentice Hall.

Pollock, G. (1987) *Vision and Difference: [Femininity, Feminism, and Histories of Art]*, London: Routledge and New York: Methuen.

Raser, T. (1989) *A Poetics of Art Criticism: The Case of Baudelaire*, Chapel Hill: North Carolina Studies in the Romance Languages and Literatures.

Richardson, J. (1994) *Baudelaire*, London: St. Martin's Press.

Sanyal, D. (2006) *The Violence of Modernity, Baudelaire, Politics and the Irony of Form*, Baltimore, MD: Johns Hopkins University Press.

Smith, P. (1998) '"Le Peintre de la vie moderne" and "La Peinture de la vie ancienne"' in R. Hobbs (ed.), *Impressions of French Modernity*, Manchester: Manchester University Press.

Starkie, E. (1958) *Baudelaire*, New York: New Directions.

Thompson, W. J. (ed.) (1997) *Understanding 'Les Fleurs Du Mal': Critical Readings*, Nashville, TN: Vanderbilt University Press.

Ward, P. A. and Patty, J. S. (eds) (2001) *Baudelaire and the Poetics of Modernity*, Nashville, TN: Vanderbilt University Press.

Woolf, J. (1990) *Feminine Sentences*, Berkeley: University of Los Angeles.

WILHELM WORRINGER 'ABSTRACTION AND EMPATHY' ['ABSTRAKTION UND EINFÜHLUNG'] (1908)

Wilhelm Worringer, *Abstraction and Empathy*, Chicago: Elephant Paperbacks, 1997.

Wilhelm Worringer's 'Abstraction and Empathy' (1908) acquired an immediate topicality for practising artists of the time who were seeking new modes of expression. Wassily Kandinsky, Franz Marc and August

Macke were among those who enthusiastically endorsed an intellectual construct which seemed to support their artistic aims, even if Worringer's response to their output as artists was ambivalent. The book's influence extended further, its ideas disseminated in Britain through T. E. Hulme to the Vorticists, and later to Walter Gropius's programme in the Bauhaus. Worringer's basic premise is that in artistic creation there are two opposing tendencies, abstraction and empathy, and he suggests that it is in abstraction that modern humanity may find salvation.

Worringer defines empathy as the dominant European mode of artistic expression and appreciation, finding its fullest expression in Ancient Greece and the Renaissance. Empathy finds 'gratification in the beauty of the organic' (Worringer 1997: 4); it is the psychic correlative to the development of artistic naturalism, which consists in approximation to the 'true to life'. To appreciate empathic art is to enjoy oneself in contemplating an artwork, in empathy with it: 'Aesthetic enjoyment is objectified self-enjoyment' (Lipps, cited in Worringer 1997: 5). Where we can give ourselves over to empathic appreciation with no inward opposition, there is aesthetic pleasure – and only insofar as this activity can proceed unhindered are forms beautiful. The beauty of a beautiful Greek statue corresponds to the ideal of freedom with which we can live ourselves out in its forms; where a form is ugly this is not possible, and an inward un-freedom and constraint results. Worringer distinguishes true artistic and empathic naturalism from mere imitation of the appearance of life, arguing that naturalism develops:

> not because the artist desired to depict a natural object true to life in its corporeality, not because he desired to give the illusion of a living object, but because the feeling for the beauty of organic form that is true to life had been aroused.
>
> (Worringer 1997: 29)

Thus it is empathy which defines the vitality of naturalism as opposed to the more shallow impulse to mere imitation, which by contrast has no vitality or aesthetic value. Considering the historical conditions in which an era of naturalistic art develops, Worringer argues that the urge to empathy:

> can become free only where a certain relationship of confidence between man and the external world has developed, as the result of innate disposition, evolution, climatic or other propitious circumstances.
>
> (Worringer 1997: 45)

Naturalism results when humankind is comfortable in its surroundings and self enjoyment underpins creativity. Worringer does not define the particular set of circumstances that led European culture to privilege empathic awareness, but saw that because empathy is considered as the presupposed natural condition for artistic creation and appreciation, we are stuck with it in evaluating all art, even the non-naturalistic.

Worringer contrasts empathy with the phenomenon of abstraction, undervalued in his time by the history of art. He defines the urge to abstraction as primary, stating that it stands at the beginning of every artistic epoch and in certain cases remained the dominant tendency. The Greek acanthus motif did not originate from observation of a chance combination of an acanthus plant with a basket (as Vitruvius suggested), but developed from an entirely artistic process which begins in the abstract, and is only later subjected to naturalisation and approximation to the appearance of a leaf. Furthermore, the psychic conditions for the processes of abstraction originate in an era's disturbed feeling for the world and attitude to the cosmos:

> Whereas the precondition for the urge to empathy is a happy pantheistic relationship of confidence between man and the phenomena of the external world, the urge to abstraction is the outcome of a great inner unrest inspired in man by the phenomena of the outside world ... we might describe this state as an immense spiritual dread of space.
>
> (Worringer 1997: 15)

A culture whose art is non-naturalistic does not then seek to project itself into the things of the world and enjoy itself therein, but in order to achieve a point of stability in a terrifying and bewildering cosmos attempts to 'wrest the object ... out of its natural context, out of the unending flux of being' (Worringer 1997: 17). Worringer links this to the suppression of representational space in non-naturalistic artworks. In naturalistic space the individuality and stability of the object melts away by being relative to other objects within the same space; an object cannot become a self-contained and individual thing. In abstraction, however, depth relations are transformed into plane relations (a process carried through most intensively by the ancient Egyptians), and objects can exist as separate, absolute entities. Thus the formal aspects of naturalistic and non-naturalistic art are seen to have psychic origins. Worringer herein gives firmer definition to the meaning of style – the abstract line is stylistic in a real sense, not in the sense of style as a 'charming, childlike stammering of stylisation' (Wickhoff, cited in Worringer 1997: 44), a

mannerism or aberration from naturalistic norms; he creates a psychology of style.

Worringer felt that his own age had lost the rapport with the genuine creative instinct, resulting in the erroneous belief that the artistic process proceeds from naturalism as its first principle towards stylisation. He believed that in his time the destitution of the artistic instinct obscured the proper appreciation of the creations of the Northern European, Egyptian, Byzantine, and Oriental artistic eras. He felt that the artists of those eras employed quite different psychic processes in the act of creation, and that the resulting works had been primarily assessed in the negative – as primitive, unskilled and unsophisticated. Worringer argued that such cultures should be credited with something significantly more than the lack of ability with which they were customarily defined:

> What appears from our standpoint as the greatest distortion must have been at the time, for its creator, the highest beauty and the fulfilment of his artistic volition.
>
> (Worringer 1997: 13)

His achievement is in redeeming the non-European and Northern European from the judgement of generations of art historical disparagement, thereby clearing the ground for new forms of creativity to emerge.

Aesthetic enjoyment through either empathy or abstraction is, for Worringer, attributable to a drive to self-alienation. In empathic enjoyment we talk of the feeling of 'losing oneself' in a work of art, suggesting a detachment or alienation of the self from the world. However, with non-naturalistic art, empathy 'leaves us helpless in the face of the artistic creations of many ages and peoples' (Worringer 1997: 8). In his evaluation of these two poles of aesthetic enjoyment, Worringer comes down on the side of abstraction, arguing that it is here that humankind most strongly finds self-alienation. Furthermore, it is in abstraction that the primary artistic volition is inscribed, existing *per se* as the will to form. Worringer hereby surreptitiously builds an argument in favour of an abstraction for his own era. His times were indeed unsettling in the extreme – rapid industrialisation and social transformation reflected a civilisation in transition. Here Worringer states his position:

> Having slipped down from the pride of knowledge, man is just as lost and helpless *vis-à-vis* the world-picture as primitive man.
>
> (Worringer 1997: 18)

It is in these ideas that the Expressionists found an affirmation of their ideals.

Worringer's text, although widely influential, is not without its critics. Geoffrey Waites has commented that Worringer employs a crude empathic and rhetorical discourse to persuade the reader, and notes that Marxist critic Georg Lukács detected a nationalistic tone in Worringer's writing (Waites 1995). However, that 'Abstraction and Empathy' was vital and productive for the development of the abstract and expressionist art of the era in which it was written cannot be denied.

One hundred years later contemporary artists may not necessarily have read Worringer, nor encountered his ideas in the work of others. However, his legacy is all around: not just in the broader critical reception afforded to contemporary art and design, but also in the better understanding that diverse cultures have developed of each other.

<div align="right">Chris Hunt</div>

Selected bibliography

Gluck, M. (2000) 'Interpreting Primitivism, Mass Culture and Modernism: The Making of Wilhelm Worringer's Abstraction and Empathy', *New German Critique*, 80, 149–69.

Koss, J. (2006) 'On the Limits of Empathy', *The Art Bulletin*, 88,1, 139–57.

Waites, G.C. W. (1995) 'Worringer's Abstraction and Empathy', in Neil H. Donahue (ed.), *Invisible Cathedrals: The Expressionist Art History of Wilhelm Worringer,* University Park, PA: The Pennsylvania State University Press, 13–40.

Worringer, W. (1997) *Abstraction and Empathy*, Chicago: Elephant Paperbacks.

ANANDA K. COOMARASWAMY, *ART AND SWADESHI* (1909–11)

Ananda K. Coomaraswamy, *Art and Swadeshi*, New Delhi: Munshiram Manoharlal, 1911 (1994).

Preliminaries

Coomaraswamy first articulated his treatise on 'Swadeshi' ('self-suffi- ciency') in 1909 within a collection of *Essays in National Idealism*. He further elaborated the theme in 'Art and Swadeshi' (1911a) and 'Swadeshi: True and False' (1911b), which are short essays reproduced in

his anthology *Art and Swadeshi*, republished in 1994. The proposition that 'Art and Swadeshi' might be considered a key text for art history is premised on the idea that it represents a topic that is still socially and intellectually prescient. In addition, it can signify a form of cultural praxis, as this essay outlines. Through his early writings of 1909–11, Coomaraswamy also provided the world with an early manifestation of this. It has since transformed, and gained new meanings and presence in other texts and in other disciplines and milieus, notably Gandhian political philosophy and Indian ethnography, via Verrier Elwin.

Coomaraswamy's article on 'Swadeshi' (1909) emphasised the cultural implications of this notion as it was first mobilised via the Swadeshi movement in Bengal of 1905–8 (Sarkar 1983: 111–24). This generated a political and ideological milieu in which regional identities were reformulated according to the contemporary reality of the (anti-) colonial present (Goswami 1998), heralding a new ideo-scape for artists and writers, such as Abanindranath Tagore (Mitter 1994: 234–339). For Coomaraswamy, the idea of *swadeshi* raised questions about 'the art of living', a phrase that brought together issues of political empowerment, cultural authenticity and economic liberation (1909: 160). Through the self-realisation of *swadeshi*, Coomaraswamy contended that a 'higher swadeshi' consciousness could be achieved (1909: 161), which made the coexistence of India's heritage and its political modernity relevant to imminent patterns of de-colonisation.

Ethnographic departures

At the conclusion of his late-colonial ethnography of 'the Muria', an indigenous/tribal (Adivasi) community in central India, Verrier Elwin made an intriguing academic gesture. Invoking Coomaraswamy's writings on *Rajput Painting* (1916), and their ability to combine philosophical and ethical concerns, Elwin orchestrated a new framework for the interpretation of Adivasi aesthetics. Like Coomaraswamy's work, and indeed Rajput paintings, these aesthetics were said to reveal an 'ultimate significance' (1947: 663). Elwin thus underscored his ethnographic documentation with an implicit proposition: that Muria wall painting, domestic architecture, group dancing, spirituality, mythology, youth institutions and so on, should be comprehended via a *national art heritage* paradigm that elaborated civilisational values. This proposition enabled his conclusions to be taken up alongside those of Coomaraswamy, who was an early pioneer in the field of south Asian art historiography, and who initiated India's *national art heritage* paradigm via his statements on *Art and Swadeshi*.

Elwin fashioned possibilities for the re-interpretation of Coomaraswamy's ideas, and highlighted their applicability to ethnography. Exploring how the *desi* (popular) and the *marga* (elite) aspects of art heritage in India could coexist (Coomaraswamy 1937), Elwin demonstrated an intellectual and ethical commitment to the new national pedagogy of inter-cultural interdependence. This notion informed critical approaches to national heritage within both Indian ethnography (Roy 1938) and the history of Indian art. Elwin's central concern was to align his own mystical and political outlook with his new ethnographic persona, in order to reveal – through the representation of those ritual and aesthetic practices that elaborated 'human love; intimacy; passionate love-service' (1947: 663) – the ongoing possibilities of *Art and Swadeshi*.

An emerging field of Indian anthropology provided the institutional and intellectual contexts for this. Working to protect Adivasi heritage from disintegration, Elwin's devotion to the Gandhian ideology of *swaraj* (self-rule), and its attendant notions of *satyagraha* (truth-force) and *swadeshi* (self-sufficiency), bolstered the political efficacy of his representations (Heredia 1999: 1499). As such, Elwin reconstructed the ethnographic field as a site of national service culminating in 'all union' (1947: 663). This brought into focus for his readers and viewers the need to ascertain how the conceptual, interpretative and ideological possibilities of an, as yet unknown, *national primitivism* might concord with those of a pre-existing *national orientalism* (as evident in Coomaraswamy's work).

Swadeshi: ideals and embodiments

Swadeshi is a compound term, which has become instrumental in the making of compound histories. It explores the possibilities of unity between two realms: (i) the self (*swa*), and (ii) the rural/indigenous/folk (i.e. *desi* or *deshi*) aspects of India's civilisation. The notion of *swa* here refers to the construction of an autonomous collectivity, or national self, in the midst of colonial dispossession, global industrialisation and imperial violence: hence the dynamic relevance of Gandhian *swaraj*. The notion of *desi* relates to the diversity of India's artistic, intangible and cultural heritages, and especially those aspects that would sustain a dichotomy between 'the traditional' versus 'the modern' in linear conceptualisations of time and progress. Yet in a *swadeshi* framework this reveals symbiotic relationships between multiple (local–regional and national–colonial) modernities, and between the cultural, temporal/ mythic and political aspects of rural/agrarian/tribal experience. *Swadeshi* was (or is) therefore a modern and imaginatively inhabited subject-position.

The related concepts of *swadeshi* and *desi* pervade India's recent artistic and cultural history. As adjectives they refer to (i) local types of cultural production, exchange and consumption, (ii) the survival and revitalisation of visual traditions, performance arts and material artefacts, especially in rural contexts, and (iii) the idea that folk idioms and vernacular texts – through their syncretic re-formulation in time and space – carry with them a sense of both indigenous authenticity and national modernity.

National orientalism, as reproduced through the writings of Coomaraswamy, highlighted Hindu and Buddhist mysticism (and India's intangible cultural heritage more generally) as relevant to the realisation of a 'religious-artistic ideal' (Coomaraswamy 1911a: 5). For Coomaraswamy and other cultural nationalists the realisation of this ideal was sought to assuage the artistic, industrial and socio-political predicaments of contemporary south Asians. Mulk Raj Anand has since elaborated this living philosophy in terms of transcendence:

> beyond the ordinary self, by the intensification of the person, in profound aesthetic experience, onto the ontology of hope from the midst of world chaos.
>
> (Anand 1984: 8)

Extending the politics of *swadeshi* (as self-reliance, self-sufficiency, home industry) to the realm of art appreciation and cultural documentation, Coomaraswamy's anti-colonial imaginary was of paramount interest to Elwin. Coomaraswamy defined *swadeshi* as 'the embodiment of that enduring vision that is the Indian nation' (1911a: 6). Such notions presented real possibilities for the likes of Elwin to combine individual spiritualism with innovative epistemological endeavours.

National primitivism, as propounded by Elwin, attempted to generate a sympathetic engagement with the mytho-poetic outlook of India's Adivasis, a general term incorporating 'the Muria' and many other indingeous/tribal communities. These people were variously considered by colonialist administrators to be 'aboriginal' and by national anthropologists to be 'tribal' (Ghurye 1963). To Coomaraswamy, such 'primitive arts' were beyond the pale of national civilisation (1911c: 37), even as this concept embraced the intangible heritage and material expressions of India's folk artisans. Elwin recognised the limitations of this dominant and elitist perception and therefore – first as an experimental ethnography (in the 1930s) and later as a census ethnographer (in the 1940s) – aimed to make India's heritage discourse more inclusive.

Indeed, Elwin once claimed that the Adivasis were the 'real swadeshi products of India' (1944: 32). This statement perplexed and antagonised some non-Adivasi citizens (Ghurye 1963: 363–64). Hence his strategic invocation of Coomaraswamy's *national orientalism*, as a means to reha-bilitate Muria aesthetics or, more generally, Adivasi heritage within the national imaginary.

Both *national orientalism* and *national primitivism* were interventionist in the sense that they contested the ideological and intellectual moorings and contemporary legitimacy of colonial orientalism and colonial pri-mitivism. They each aimed to provide methodological coherence to a complex political and epistemological terrain, to facilitate crossings and creative exchanges within and between heritage and pedagogy, spiri-tuality and praxis, and anti-colonialism and the future (Anand 1984; Subramanyan 1984). Re-connecting Coomaraswamy and Elwin can enhance an understanding of how *Art and Swadeshi* – as modality and topic – has assumed prominence in differing historical, political and dis-ciplinary contexts. Elwin's ethnographic gesturing towards Coomaraswamy is a means to engage readers in the task of re-inter-preting and re-evaluating the content and limits of national cultural heritage, and can be read as an *Art and Swadeshi* moment: that is, *the inscription of an anthropologised Gandhian presence across a multifaceted and open-ended tribal/national/colonial modernity.*

Conclusions

For Elwin, a hybrid figure constantly crossing between colonial–national and national–tribal milieus, as well as between novelistic, ethnographic, welfarist and spiritualist projects, *Art and Swadeshi* was a means to make *national primitivism* workable, and readable as an ethnographic allegory. This is because it referred to a distinctly Gandhian vision of rural and de-centralised de-colonisation, and yet sought refuge under the umbrella of *national orientalism*. I propose, therefore, that *Art and Swadeshi* is a relevant topic in the re-appraisal of the linkages between art history, intangible heritage and Indian ethnography, especially as one considers how – through their 'embodiment', via the actions and texts of Coomaraswamy, Gandhi, Elwin and so on – these linkages engendered different kinds of anti-colonial position and outlook in pre-independence India (Trivedi 2003). I suggest that Elwin's ethnography of 'the Muria' can be mean-ingfully read in the terms of a *higher swadeshi*, thereby rendering his nod to Coomaraswamy highly significant.

Daniel J. Rycroft

Selected bibliography

Anand, M. R. (1984) 'Coomaraswamy Darshan', in G. M. Sheikh et al. (eds), *Paroksa: Coomaraswamy Centenary Seminar Papers*, New Delhi: Lalit Kala Akademi, 8–14.

Coomaraswamy, A. K. (1909) 'Swadeshi', in A. K. Coomaraswamy, *Essays in National Idealism*, New Delhi: Munshiram Manoharlal, 158–71.

——(1911a) 'Art and Swadeshi', in A. K. Coomaraswamy, *Art and Swadeshi*, 1–6.

——(1911b) 'Swadeshi: True and False', in A. K. Coomaraswamy, *Art and Swadeshi*, 7–18.

——(1911c) 'The Function of Schools of Art in India', in A. K. Coomaraswamy, *Art and Swadeshi*, 36–45.

——(1911 [1994]) *Art and Swadeshi*, New Delhi: Munshiram Manoharlal.

——(1937) 'On the Nature of "Folklore" and "Popular Art"', *Indian Art and Letters*, 11.2, 76–84.

Elwin, V. (1944) *The Aboriginals*, London: Oxford University Press.

——(1947 [1991]) *The Muria and Their Ghotul*, Delhi: Vanyan Prakashan.

Heredia, R. (1999) 'Interpreting Gandhi's *Hind Swaraj*', *Economic and Political Weekly*, 12 June, 1497–1502.

Goswami, M. (1998) 'From Swadeshi to Swaraj: Nation, Economy and Territory in Colonial South Asia, 1870–1907', *Comparative Studies in Society and History*, 40.4, 609–36.

Ghurye, G. S. (1963) *The Scheduled Tribes*, Bombay: Popular Prakashan.

Mitter, P. (1994) *Art and Nationalism in Colonial India: Occidental Orientations*, Cambridge: Cambridge University Press.

Roy, S. C. (1938) 'An Indian Outlook in Anthropology', *Man*, 38, 146–50.

Sarkar, S. (1983) *Modern India, 1885–1947*, Madras: Macmillan India.

Subramanyan, K. G. (1984) 'The Significance of Coomaraswamy's Ideas in Our Times', in G. M. Sheikh et al. (eds), *Paroksa: Coomaraswamy Centenary Seminar Papers*, New Delhi: Lalit Kala Akademi, 15–19.

Trivedi, L. (2003) 'Visually Mapping the "Nation": Swadeshi Politics in Nationalist India, 1920–30', *Journal of Asian Studies*, 62.1, 11–41.

WASSILY KANDINSKY, *ON THE SPIRITUAL IN ART AND PAINTING IN PARTICULAR* [*ÜBER DAS GEISTIGE IN DER KUNST INSBESONDERE IN DER MALEREI*], FIRST PUBLISHED BY R. PIPER (1911)

On the Spiritual in Art and Painting in Particular (Über das Geistige in der Kunst Insbesondere in der Malerei) in Kenneth C. Lindsay, and Peter Vergo (eds), Kandinsky, Complete Writings on Art, London: Faber and Faber, 1982.

Consideration of *On the Spiritual in Art* as a whole must take into account key moments in the chronology of its construction. Thus, it is necessary to differentiate the additions made to the book immediately prior to publication of the first edition in December 1911 and to the

second edition of April 1912 from the bulk of the book's material, which dates from August 1909 (Lindsay and Vergo 1982: 114–18). A third edition was identical to the second, and a fourth edition, for which Kandinsky wrote a manuscript headed 'Small changes to *On the Spiritual*', was not published on account of the outbreak of the First World War (Lindsay and Vergo 1982: 115). A further version of the book appeared in Russian in 1914 in the proceedings of the Pan-Russian Congress of Artists, at which a version of the text had been read aloud in St Petersburg in December, 1911. There are two further, unpublished versions of the book in Russian: the first was prepared for publication in 1914 for the Moscow publishing house *Iskusstvo*; the second is an unfinished project that dates from 1919–21 and constitutes what has been called the Soviet edition of *On the Spiritual* (trans. in Bowlt and Misler 2002: 59–115). Along with the many versions of parts of the book that have been dated back as early as 1904 (Hahl-Fontaine in Bowlt and Misler 2002: 42), these more complete drafts and published editions confirm the assertion that:

> the basic textological characteristic of *On the Spiritual* is first and foremost the heterogeneous and multilayered character of all the versions, each of which grows out of the older one with the aid of corrections and additions, absorbing more and more texts.
>
> (Podzemskaia in Bowlt and Kurchanova
> 2003: 88–89)

The book is organised into two sections, entitled 'General' and 'Painting'. The concern of the first section is to describe the circumstances which make the book necessary. These can be summarised as the urgent need to overcome the 'nightmare of the materialistic attitude' (Lindsay and Vergo 1982: 128) which for Kandinsky dominated the nineteenth century, and the creation of a spiritual 'countermovement' in its place. By 'materialistic attitude', Kandinsky means the placing of undue emphasis on those things that can be known empirically, to the detriment of those experiences that cannot be accounted for in such terms. In using the German adjective *geistig*, Kandinsky evokes an extraordinarily diverse range of possible meanings for this countermovement, from the more mystical connotations of the English 'spiritual' to the more psychological con notations of 'mind' – also a perfectly good translation of *geistig*. Kandinsky uses the term in ways that pertain to the breadth of this spectrum, and his use of 'the spiritual' – contrary to what much Kandinsky scholarship might lead us to believe – cannot by any means be reduced to the mystical and religious. That said, the opening sections of the book

are both apocalyptic in their description of the demise of materialism, and messianic in their account of the role of the artist in leading humanity on the true path.

Kandinsky calls upon the most diverse of sources to make his case, including such apparently unrelated names as Karl Marx, Helena Blavatsky, Leo Tolstoy, William Crookes, Friedrich Nietzsche and Maurice Maeterlinck. He describes the music of Richard Wagner, Claude Debussy and Arnold Schoenberg as contributing directly to the spiritual turn he describes; and the work of such painters as Paul Signac, Arnold Boecklin, Paul Cézanne, Henri Matisse and Pablo Picasso as doing the same. Romantic, theosophist, physicist, symbolist and cubist; all are, in Kandinsky's account, indices of the turn from materialism to the realm of the spirit. They are positions held by these 'authorities' and are carefully summarised and manipulated into what appears to be a unified argument, one that establishes in broad terms the task of the book that follows – foregrounding the spiritual in art. The reality, however, is that the diverse ideological positions that these names suggest lead to instabilities, even conflict in the text. This is a direct result of Kandinsky's eclecticism.

The kind of art that will contribute to development of the spiritual turns its back on naturalism, which is underscored by the materialist world view, and attends to the 'inner' rather than 'outer' aspects of things. The second section of the book, 'Painting', is an attempt to begin to establish on an 'objective scale' how the inner value of form and colour work. Most attention is paid to what Kandinsky calls the physical and psychological aspects of colour *in abstracto*, though there is also discussion of the relations between colour and basic geometrical forms, and colour and objects. He establishes a primary colour opposition between yellow and blue; these are characterised as warm and cold respectively; they tend toward the light and dark respectively; and they attract or repel the spectator. Kandinsky continues, primarily using introspection but also drawing on existent colour theory, and that of Goethe's *Theory of Colour* (1810) in particular.

The ultimate ambition of the second section of the book is to establish a kind of dictionary of the inner significances of form and colour, and rules for their combination as abstract elements in painting. In this, music seemed the model to emulate, and repeatedly the 1909 draft of the book refers to Goethe's comments on the possibility of a painterly equivalent to musical *Generalbass* (thorough-bass), according to which the musician is 'contained' by quite precise convention, but nonetheless experiences considerable freedom. The foreword to the 1912 edition reinforces this ambition, describing *On the Spiritual* as a contribution to a

future '*theory of harmony* of painting' (Lindsay and Vergo 1982: 125). The reference betrays a debt to the work of his new friend, Arnold Schoenberg, whose compositions had abandoned conventional tonality and, in his *Theory of Harmony* (published in 1911), justified this through reference to the history of musical harmony. For Kandinsky, this compared to painting's move away from conventional representation, and in *On the Spiritual* became the model for showing how art develops historically toward greater formal freedom.

The 1909 draft frequently refers to the mechanism that drives such historical change, and that determines how any true work of art from any period looks, as 'inner necessity'. In a passage dropped rather clumsily into the midst of this just before publication in 1911, Kandinsky writes that 'Internal necessity arises from three mystical sources. It is composed of three mystical necessities.' First, the artist is impelled to express what is particular to him; second, he expresses what is particular to his age; and third, he expresses what is essential to 'art in general' (Lindsay and Vergo 1982: 173). Then, to the same passage in the 1912 edition, Kandinsky added that the third moment becomes the timeless purpose of art – its spiritual content – and the first two are described as merely steps toward attaining it. These adaptations reflect Kandinsky's thinking on inner necessity as it develops and changes under the influence of the writing of Wilhelm Worringer (Short 2010: 67–73).

Such adaptations in different versions of the book occur with some frequency, and sometimes in ways that lead not to the development of ideas, but to their contradiction. An example is Kandinsky's discovery in 1911 of Schoenberg's work, which leads to passages that not only extol the importance of Schoenberg, but that criticise the achievements of Wagner and others – precisely those who in the 1909 draft (which remains in full in the published versions), are the model for the new art. But such struggle is most clear in the manuscript for the book's Soviet edition. Thus, for example, the passage that describes the three mystical sources of 'internal necessity' now reads: 'Inner necessity arises from three principles. These three principles are three necessities' (Bowlt and Misler 2002: 105). The text now completely omits reference to the mystical basis of these necessities, as Kandinsky purposefully edited them out so as not to offend the values of the new Soviet art world, which was fiercely opposed to any form of mysticism and the spiritual. In its place, Kandinsky now adopts a new vocabulary; 'the art worker' appears in place of 'personality', and the expression of what is peculiar to the artist's age becomes the issue of 'collective creativity'. However, elsewhere in the book reference to the mystical and the spirit remain.

In spite of its singular ambition to describe and contribute to the development of the new art, *On the Spiritual in Art* is no one thing; rather, it is a series of appropriations and adaptations that, in the end, is inconsistent with itself. We are reminded of the words of Roland Barthes, who wrote that a text is:

> a multi-dimensional space in which a variety of writings, none of them original, blend and clash. The text is a tissue of quotations drawn from the innumerable centres of culture.
>
> (Barthes 1977: 146)

Kandinsky considered this inevitable, having written in 1911 to Schoenberg that 'one takes what one needs without worrying from *where* one takes it' (Hahl-Koch 1984: 21). Seldom are Barthes' words more evident than in Kandinsky's *On the Spiritual in Art*.

Chris Short

Selected bibliography

Barthes, R. (1977) 'The Death of the Author', in *Image, Music, Text*, London: Fontana Press.

Bowlt, J. E. and Kurchanova, N. (eds) (2003) *Experiment: A Journal of Russian Culture. Vol. 9*, Festschrift for Vivian Endicott Barnett, Los Angeles: Charles Schlacks, Jr.

Bowlt, J. E. and Long, R. C. W. (eds) (1980) *The Life of Vasilii Kandinsky in Russian Art: A study of 'On the Spiritual in Art'*, Newtonville, MA: Oriental Research Partners.

Bowlt, J. E. and Misler, N. (eds) (2002) *Experiment: A Journal of Russian Culture. Vol. 8, Vasilii Kandinsky and the Science of Art*, Kandinsky and Soviet Academic Institutions, 1917–21, Los Angeles: Charles Schlacks, Jr.

Glew, A. (1997) '"Blue Spiritual Sounds": Kandinsky and the Sadlers, 1911–16', *The Burlington Magazine*, 139.1134, 600–15.

Hahl-Koch, J. (ed.) (1984) *Arnold Schoenberg, Wassily Kandinsky. Letters, Pictures, Documents*, London: Faber and Faber.

Lindsay, K. and Vergo, P. (eds) (1982) *Kandinsky, Complete Writings on Art*, London: Faber and Faber.

Ringbom, S. (1970) *The Sounding Cosmos: A Study in the Spiritualism of Kandinsky and the Genesis of Abstract Painting*, Abo, Finland: Academia.

Short, C. (2010) *The Art Theory of Wassily Kandinsky, 1909 – 1928: The Quest for Synthesis*, Oxford: Peter Lang.

Vergo, P. (1980) 'Music and Abstract Painting: Kandinsky, Goethe and Schoenberg' in *Towards a New Art: Essays on the background to abstract art 1910–1920*, London: Tate Gallery.

Weiss, P. (1979) *Kandinsky in Munich. The Formative Jugendstil Years*, Princeton, NJ: Princeton University Press.

HEINRICH WÖLFFLIN, *THE PRINCIPLES OF ART HISTORY [KUNSTGESCHICHTLICHE GRUNDBEGRIFFE]* (1915)

H. Wölfflin, *Principles of Art History. The Problem of the Development of Style in Later Art*, translated from 7th German edition, 1929 by M. D. Hottinger, New York: Dover Publications, 1932.

The Swiss art historian Heinrich Wölfflin (1864–1925) is one of the foundational figures of art history and his work, often referred to as the history of forms, proved highly influential during the twentieth century. Wölfflin's ideas developed in a period when art history was still in its initial phase of development and the chief contribution of *Principles of Art History (Kunstgeschichtliche Grundbegriffe)* (1915), is an evolutionary model of art history that traces stylistic development in terms of the historical determination of will or inner necessity. Rejecting the model of advance and decline that dominated accounts of Renaissance and immediate post-Renaissance art since the publication of Giorgio Vasari's *Lives of the Artists* (1550/68), Wölfflin argued that art progressed through cyclical stages in which primitive, inchoate forms of art without stylistic unity are gradually replaced by more evolved ones in which all elements are subsumed to the function of defining and objectifying the world and which in turn are replaced by less delineated styles, but ones which possess a more complex and unified transcendental vision of appearances.

In his first two books *Renaissance and Baroque* (1888) and *Classic Art* (1889) Wölfflin combined close scrutiny of art works with broad cultural analysis. In both books he explained the transition from quattrocento realism to cinquecento idealism in terms of the transformation of the mercantile middle classes into the nobility to form a new aristocratic and courtly culture. By contrast, *Principles of Art History* is chiefly concerned with developing a method of close reading focused on the form or mode of composition the artist or architect employs in visualising the world. As such it provides an account primarily of works of art rather than artists or the social, economic and political context in which art is produced. However, though *Principles of Art History* is international and impersonal in scope, Wölfflin's model was intended to provide a

framework in which national and individual elements of style might be more readily identified (Wölfflin 1932: 231–32).

Wölfflin's analysis makes little reference to the representational content of a painting and anticipates later formalist approaches to art. Yet, to describe Wölfflin's work as narrowly formalist is a misinterpretation. Wölfflin sought to write an art history of psychological perception, more precisely a history of the psychology of stylistic forms, which would account for changes in the way artists have perceived and rendered the world. In doing so he looked back to the examples of Alois Riegl (1858–1905) and his mentor Jacob Burkhardt (1818–97), whom he succeeded at the University of Basel, but most especially to the Hegelian philosophy of history and Nietzsche's Apollonian/Dionysian dualism in *The Birth of Tragedy* (1870).

The Principles of Art History takes as its object the transition from the classical style of the Renaissance to the Baroque, posing the question to what extent the work produced in any given period constitutes a totality. Each mode of apprehending the world, Wölfflin argues, is the product of the particular perceptual psychology of its age. He employed five oppositional terms to describe the differences between the Classical and the Baroque. For the sake of brevity, this commentary focuses on the articulation of these terms in relation to painting, but Wölfflin intended them to be applicable to sculpture and architecture as well.

His first and most important stylistic terms are the linear and the painterly. The linear, classic mode is essentially characterised by the use of line to control and order what it represented, and reflects a desire for definition and stability in the representation of the world. To see linearly is to seek out the sense and beauty of things first in outlines; in the linear mode the artist is concerned to apprehend things by their contours (Wölfflin 1932: 14). There is a primary concern with demarcation and the measured separation of objects and bodies from each other (Wölfflin 1932: 16).

This, Wölfflin suggested, represented a different way of looking at the world to the Baroque, painterly mode which he saw as privileging colour as the dominant means of establishing pictorial representation and which emphasised instability and movement. In the painterly mode, colour and brushwork play a much more active role in organising the picture; 'outlines become (almost) a matter of indifference as guidelines' (Wölfflin 1932: 16). The eye now perceives more by patches of light and shade and line has become depreciated. The world is represented in ways which are not as static and immediately intelligible as in the linear mode, but as a shifting semblance in which everything is in flux and where instability and movement are to the fore (Wölfflin 1932: 62–63, 68–70).

Wölfflin's second set of terms, plane surface and recessional depth, represent different ways of establishing spatial illusion. The term plane surface relates to the classic linear mode, in which the eye is led from foreground to background by a careful sequence of planes that divide the picture and provide a consistent and orderly sense of recession into depth. Intelligible relations of foreground, middle ground and background zones are evident, with figures clearly located within these zones. In the recessional mode of the Baroque, space is less easily measured and often appears indeterminate. It is difficult to divide the picture into foreground, middle and background planes, as spatial recession is more immediate and the sensation of space more ambiguous. Sometimes it appears difficult to determine the exact position of objects or bodies in space (Wölfflin 1932: 17, 67–72).

Closed (*tectonic*) form and open (*atectonic*) form, Wölfflin's third set of terms, relate to the way the spectator is positioned in relation to the work. In the closed, classic form the picture has a clear position from which it is to be viewed. Often a choric figure's outward gaze meets the viewer's and draws attention to salient features of the composition, though mostly this is achieved through the perspectival arrangement of the vanishing point. The picture is self-contained and the effect as though, in Albertian terms, you were looking through a transparent window gazing into a section of the visible world (Wölfflin 1932: 128, 133).

In the open form of the Baroque, the beholder's position is more complex. The picture's threshold appears less self-contained and objects and bodies almost seem to spill out into the viewer's space. The edge between the picture's fictive world and the actual world seems blurred. Emphasis is often on foreground elements, drawing the beholder into a close and intimate relationship to the picture, as though implicated within it. The viewer is also required to take a more active role in interpreting the picture's many ambiguities. (Wölfflin 1932: 141–42, 161–62).

Wölfflin's fourth category, multiple or composite unity and fused or uniform unity, focuses upon the degree of independence or interdependence of each compositional part. In the classic multiple or composite unity mode, it is as though each object is first conceived singularly and only afterwards pieced together to form coherent and meaningful groupings. Objects in the picture retain independence. In classical theory the compositional model was rhetoric, where arguments could be analysed in terms of components of compositional units, so a painting was conceived as something that could be composed and analysed in a similarly rational manner. In the fused or uniform unity of the Baroque, the compositional structure is more intricately interwoven (Wölfflin 1932: 187–90). Everything appears dependent on

each other, attempting to isolate details from this kind of painting often results in unintelligibility.

Wölfflin's final terms, absolute and relative clarity, essentially restate the differences in spatial and compositional articulation, though from the point of view of the subject, in terms of the contrast between the clarity in communication of and information about the subject and the arrangement of the picture to avoid such clarity (Wölfflin 1932: 197–202). The latter implies an inexhaustible act of interpretation.

Questions remain about the scope and cogency of Wölfflin's principles (Podro 1982). Are Wölfflin's terms the right ones for understanding the unique characteristics of art or are there other terms that might be substituted? To what extent can such terms be separated out from the characteristic subject matter artists were depicting? Are Wölfflin's terms primarily useful in relation to painting rather than to architecture and sculpture? Does he genuinely provide an account of the psychology of perception of the periods he analyses and to what extent is Wölfflin's account complete? These questions remain the subject of much discussion, but his contribution to the close analysis of Classical and Baroque modes of composition remains significant.

Jon Kear

Select bibliography

Adler, D. (2004) 'Painterly Politics: Wölfflin, Formalism and German Academic Culture, 1885–1915', *Art History*, 27.3, June.

——(1981) *Heinrich Wölfflin* Dissertation, University of California, Berkeley.

Hart, J. (1982) 'Reinterpreting Wölfflin: Neo-Kantianism and Hermeneutics', *Art Journal*, 42.4, Winter.

Hatt, M. and Klonk, C. (eds) (2006) *Art History: A Critical Introduction to its Methods*, Manchester: Manchester University Press.

Iverson, M. (1981) 'Politics and the Historiography of Art History', *Oxford Art Journal*, 4.1, 31–34.

Lurz, M. (1981) *Heinrich Wölfflin: Biographieeiner Kunsttheorie*, Worms am Rhein: Werner.

Podro, M. (1982) *The Critical Historians of Art*, New Haven, CT: Thames and Hudson.

Schapiro, M. (1961) 'Style' in M Philipson (ed.), *Aesthetics Today*, Cleveland, OH: World, 81–113.

Wölfflin, H. (1905) *Die Kunst Albrecht Dürers*, Munich: F. Bruckmann, Munich, 2nd edition 1908; translated 1971, *Art of Albrecht Dürer*, trans. A. Grieve, London: Phaidon Press.

——(1921) *Die Bamburger Apokalypse: Eine Reichenauer Bilderhandschriftvom Jahre1000* (The Bamburg Apocalypse: A Reichenau painter's manuscript from the year 1000), Munich: Kurt Wolff.

——(1931) *Italien und das deutsche Formgefühl* (Italy and the German sense of Form).
——(1932) *Principles of Art History. The Problem of the Development of Style in Later Art*, translated from 7th German edition, 1929, by M. D. Hottinger, New York: Dover Publications.
——(1941) *Gedenkenzur Kunstgeschichte* (Thoughts on Art History).
——(1946) *Kleine Schrifen* (Shorter Writings).
——(1953) *Classic Art. An Introduction to the Italian Renaissance*, 2nd edition, translated from the 8th German edition, 1948, by Peter and Linda Murray, London: Phaidon Press.

ADRIAN STOKES, *STONES OF RIMINI* (1934)

Published in L. Gowing (ed.) *The Critical Writings of Adrian Stokes* (3 vols), London: Thames and Hudson, 1978 and in Adrian Stokes, *The Quattro Cento and Stones of Rimini*, Aldershot: Ashgate, 2002.

Stones of Rimini was published in Britain in 1934 and was the second volume in an intended trilogy. The first volume, *The Quattro Cento*, had been published two years earlier. The third was never written. The book's title echoes Ruskin's *The Stones of Venice* (1851–53) and it begins with an evocation of Venice before moving down the Adriatic coast to Rimini. Despite this, Ruskin is not mentioned by name in the book and readers are left to figure out the relationship between the two texts for themselves. The names of Freud and Melanie Klein are similarly absent, although their ideas constitute another crucial theoretical component in Stokes' thinking, as he had been in analysis with Klein for almost five years. Indeed the book is permeated with a psychoanalytical understanding of art, but it is so generalised as to pass almost unnoticed.

Stokes is uniquely placed at the intersection of two important strands of writing about art. On the one hand he is perhaps the last of the great English aesthetic critics in a line that stretches back through Fry, Pater and Ruskin to Hazlitt. On the other hand, he stands at the beginning of a tradition of psychoanalytic writing on art. His work looks back to an older, more connoisseurial mode and also anticipates a more contemporary, theory-based approach to art. Psychoanalysis enabled him to bring to the aesthetic tradition a thorough exploration of the subjective bases of spectatorship.

At the heart of the book is a reading of a set of marble reliefs made by Agostino di Duccio for the Tempio Malatestiano in Rimini in the 1450s. Stokes believed them to epitomise a particular tendency or sensibility within fifteenth century Italian art, which he termed 'Quattro Cento', splitting the normal word into two so as to distinguish it from

a merely chronological description. For Stokes, '"Quattro Cento" art means fifteenth-century Italian art in which fantasies connected with material (always in the last resort, stone) are emphatically expressed' (Stokes 1978: 188). He describes it as a spatial art, the opposite of chiaroscuro where space is punctuated by the rhythm of light and dark.

However, Stokes does not write immediately of the reliefs; he must prepare the reader thoroughly first, and in this he is like Ruskin, though his aim is rather different. In what is probably the central insight of the book, Stokes writes:

> If we would understand a visual art, we ourselves must cherish some fantasy of the material that stimulated the artist, and ourselves feel some emotional reason why his imagination chose, when choice was not altogether impelled by practical, social and technical considerations, to employ one material rather than another.
>
> (Stokes 1978: 186)

His notion of fantasy is not identical with Freud's, but it is broad enough to include it. Stokes is keenly aware, for instance, that both choice of material and the method of working it, have a pronounced, if unconscious, sexual component. So great a stress does Stokes lay on this notion of fantasy that the first part of the book is entirely devoted to elucidating its various features. This entails a geological, geographical and cultural history of the Mediterranean, of limestone and of marble in particular as a sculptural material. It anticipates key aspects of cultural geography that only began to be written some fifty years later, and shows how the concept of the Mediterranean as an element of European culture is constructed and maintained. Stokes has no interest in demystification: for him fantasy is inescapable; he is concerned instead with exploring its poetic resonance.

Stokes draws a distinction between carving and modelling; terms borrowed from traditional art history where they were used simply to distinguish between two methods of making sculpture, such that a carved work is made through the removal of material and a modelled work through its accumulation. Stokes' fundamental innovation was to extend them so as to include the effect of such work upon a viewer. Thus he writes:

> Whatever its plastic value, a figure carved in stone is fine carving when one feels that not the figure, but the stone through the medium of the figure, has come to life. Plastic conception [modelling], on the other hand, is uppermost when the material with

which, or from which, a figure has been made appears no more than as so much suitable stuff for this creation.

(Stokes 1978: 230)

The two positions should be considered as poles with most sculptural practice occupying a place somewhere in between. Effectively, Stokes' interest in the viewer's feelings undoes the rigidity of the traditional distinction, because, as quickly becomes evident, he finds that much sculpture made through the removal of material *feels* nevertheless like modelling. It is also characteristic of Stokes that he directs the reader's attention not so much to the design of the work as to the relation of this design to the medium. In modelling work this relation is slight: the material just suffices to support the design, but is not felt to contribute to the significance of the piece. In the best carving work, by contrast, the relation between the design and the medium is so rich that it is the medium itself that becomes the focus of the viewer's attention. 'The limestone layers are the waters' (Stokes 1978: 254) he writes of one of Agostino's reliefs, linking the process of carving and the subject matter of the relief to the material history of the stone itself. It is also significant that Stokes uses the word 'medium' in relation to carving, and 'material' in relation to modelling. The idea of a medium presupposes a relation between the things that it mediates which the idea of material does not.

Carving and modelling relate to Klein's developmental schema, similarly structured around two positions. According to Klein, the newborn baby, lacking any firm sense of self, cannot distinguish itself from its environment and so is subject to fantasies of blissful oceanic merger and universal persecution that provoke boundless rage. This oscillation establishes a primal rhythm. However, as the baby grows it learns to separate itself from other objects and to bestow a value on separateness as such. Its fears centre on fantasies of loss rather than persecution, and the beginning of feelings of guilt, which Klein sees as creative since they stimulate reparative fantasies and acts. In *Stones of Rimini* modelled works are held to evoke in the viewer these same oceanic fantasies, whilst carved work heightens the sense of the object's separateness. Modelling is associated with a 'magical' way of working, whereby the force of the artist's will overcomes any resistance in the material and the final form appears as if from nowhere. In carved work, by contrast, the resistance of the stone is not to be overcome, but rather ornamented by the artist's labour understood as a form of love.

In the 1930s Stokes was a staunch partisan for carving, and had written supportively of Hepworth and Moore (1933). Carving represented

health and maturity in contrast to modelling, which was viewed as regressive and infantile. This was a judgement he gradually revised. While the fantasies associated with modelling are very primitive, they are an essential part of the human endowment, and Stokes later acknowledged, in *Michelangelo* (1955) and *The Invitation in Art* (1965), that fantasies of merger and separation are inextricably intertwined in all art. Modelling fantasies constitute the incantatory and hypnotising element of art; they form the 'invitation' that the artwork extends to the viewer, without which it could have no claim on a viewer's emotional life.

The reason why Stokes' work marks a significant moment in art historical thinking and retains its relevance today, is that it outlines a theoretical account of the nature of the medium in art within a psychoanalytical context. Freud and Klein saw the content of artworks as determined by specific fantasies and avoided the question of the medium as such, believing this to be merely a technical matter. But without a theory of the medium they were unable to distinguish artworks from other phenomena, such as dreams or children's drawings. Stokes shows how fantasy is as present in the way artists conceive of and use their material as it is in the figures they depict. An artist who can teach a viewer to love stone is greater than those who merely use stone to realise a design, however impressively it is done.

Jonathan Clarkson

Selected bibliography

Bann, S. (ed.) (2007) *The Coral Mind: Adrian Stokes's Engagement with Architecture, Art History, Criticism and Psychoanalysis*, University Park, PA: Pennsylvania State University Press.

Carrier, D. (1998) *England and its Aesthetes: Biography and Taste*, London: Routledge.

Kite, S. (2009) *Adrian Stokes: An Architectonic Eye*, London: MHRA and Maney Publishing.

O'Pray, M. (1986) 'Pater, Stokes and Art History: the Aesthetic Sensibility', in F. Borzello and A. L. Rees (eds), *The New Art History*, London: Camden Press, 125–32.

——(2004) *Film, Form and Phantasy: Adrian Stokes and Film Aesthetics*, Basingstoke: Palgrave Macmillan.

Potts, A. (1996) 'Carving and the Engendering of Sculpture: Adrian Stokes on Barbara Hepworth', in D. Thistlewood (ed.) *Barbara Hepworth Reconsidered*, Liverpool: Liverpool University Press, 43–52.

Read, R. (2002) *Art and its Discontents: The Early Life of Adrian Stokes*, Aldershot: Ashgate.

Sayers, J. (2007) *Freud's Art: Psychoanalysis Retold*, London: Routledge.

Smith, P. (2002) 'Wittgenstein, Description, and Adrian Stokes (on Cezanne)', in P. Smith and C. Wilde (eds), *A Companion to Art Theory*, Oxford: Blackwell, 196–213.

Stokes, A. (1934) *To-night the Ballet*, London: Faber and Faber.

——(1943) *Stones of Rimini* in Gowing, L. (ed.) (1978) *The Critical Writings of Adrian Stokes*, 3 vols, London: Thames and Hudson.

——(1965) *The Invitation in Art*, London: Tavistock Publications.

——(1973) *A Game That Must be Lost*, Cheadle: Carcanet Press.

——(2002) *The Quattro Cento and Stones of Rimini*, Aldershot: Ashgate.

Wollheim, R. (ed.) (1972) *The Image in Form: Selected Writings of Adrian Stokes*, Harmondsworth: Penguin.

MARTIN HEIDEGGER, 'THE ORIGIN OF THE WORK OF ART' ['DER URSPRUNG DES KUNSTWERKES'] (1935)

Martin Heidegger 'The Origin of the Work of Art', in *Basic Writings*, New York: Harper Perennial, 2008, 139–212.

> What ... is art that we rightly call it an origin?
>
> (Heidegger 2008: 196)

Martin Heidegger (1889–1976), author of *Being and Time* and one of the major philosophical figures of the twentieth century, wrote 'The Origin of the Work of Art' in the Germany of the 1930s. The essay is concerned with the way in which truth is manifested in art. Heidegger refutes the idea of a metaphysical or essential truth, but allows truth as something with historical origins, created by man. The difficulty and poetics of Heidegger's ideas are not readily summarised; the essay, in a sense, enacts the ideas it attempts to describe. Its simple, clear language belies a tightly formed, subtle and demanding thesis, the reading of which is complicated by the fact that at the time it was written, Heidegger was a member of the Nazi Party.

Heidegger's first task is to understand what kind of a thing a work of art is. His particular brand of phenomenology refutes the notion that an object can be thought about as an entity separate from human beings. A hammer can be transformed into an abstract set of properties by thinking about it, but in order to reveal its essence, it must be considered in a way proper to its being – as something people use. Rather than abstract it into measurements or metaphysical ideas, we must attend to its nature as equipment. However, art is rightly defined as a different kind of thing

to equipment – it is separate from the world of everyday things like hammers in that it allows us space for reflection about the world. It is in this reflective space that, to cite Heidegger's example, Van Gogh's *A Pair of Shoes* (1886) can let us know what things are in truth – what they mean and how they belong in their world. The shoes are items which belong to a world of meaning which itself is revealed in the painting. In Van Gogh's shoes:

> the toiling tread of the worker stares forth … [they are] pervaded by uncomplaining worry as to the certainty of bread … the trembling before the impending childbed and shivering at the surrounding menace of death.
>
> (Heidegger 2008: 159)

These resonances suggest that the world is something imbued with meaningful sensations, not just an array of objects into which meaning is projected. Heidegger's other example, a Greek temple, opens a world wherein 'birth and death, disaster and blessing, victory and disgrace, endurance and decline acquire the shape of destiny [of a] historical people' (Heidegger 2008: 167). A work of art itself defines and gives shape to humankind's sense of itself as historical, but it can never fully define or encapsulate a historical world, thereby rendering the world a thing partially concealed – not fully in truth.

The world, imbued with meaning, is grounded in earth. Earth is in itself worldless – it stands for nothing in particular:

> If we … [break] open the rock, it still does not display in its fragments anything inward that has been opened up. The stone has instantly withdrawn again into the same dull pressure and bulk of its fragments … Earth thus shatters every attempt to penetrate it.
>
> (Heidegger 2008: 172)

Earth is essentially impenetrable, hidden from our view; even more so than the world, it remains concealed. The work of art manifests a relationship between world and earth in which they are brought to bear on one another in a way that impels them to reveal or 'unconceal' themselves in their fullness. Whereas equipment 'disappears into usefulness', the Greek temple does not cause the matter it is made of nor the matter around it to disappear, but rather to come forth in a new clarity. The temple gives definition to its immediate surroundings by contrast with them – it 'gives to things their look and to men their outlook

on themselves' (Heidegger 2008: 168). Art makes earth and world shine forth in a new brilliance.

It is in this relationship between earth and world in the work of art that Heidegger defines the question central to his discussion – that of truth in art. Heidegger locates the origin of truth in art itself. This is not the truth or otherwise of particular assertions, but more like the truth inferred by 'true friend' – true, unconcealed *being*. He states that:

> Truth does not exist in itself beforehand, somewhere among the stars, only subsequently to descend elsewhere among beings ... the happening of truth ... is historical in multiple ways.
>
> (Heidegger 2008: 186)

Truth happens as a result of a historical process of work. The work that forms the painting or the temple is of a special nature, one which instigates *strife* – a kind of wrenching away from settled norms wherein earth and world complement each other harmoniously. Strife manifests in the work of art as an antagonism or *rift* between earth and world, and it is here that something new and previously unknown to us makes its presence felt. The rift between earth and world provides an open region for each to force the 'unconcealment' of the other and, in the process, for the work of art to give truth its historical definition. This process 'happens in the midst of beings' (Heidegger 2008: 180), and thus brings out something of the 'truth of being' in the world around and outside the work of art. Van Gogh's peasant's shoes:

> make unconcealment as such happen in regard to beings at a whole. The more simply and essentially the shoes are engrossed in their essence, the more directly and engagingly do all beings attain a greater degree of being along with them.
>
> (Heidegger 2008: 181)

In this sense, art itself is an origin of truth in the world: art creates truth.

The encounter with Heidegger's thought has raised the debate about whether his philosophy is in some way reflective of his involvement with the Nazi Party. For some, the notion of truth is in itself, inherently totalitarian or fascistic – an assertion which is central to much postmodern theory. When Heidegger states that truth manifests not just in art but also in the founding of a political state or through an essential sacrifice, there can be little doubt that he is thinking of the formation of Hitler's Germany of the 1930s. Indeed, Heidegger's insistence that 'as a world opens itself up, it submits to the decision of a historical humanity

the question of victory and defeat ... mastery and slavery' (Heidegger 2008: 186), suggests that the historical process of unconcealment involves the subjugation of others. The critic Andrew Benjamin notes that Heidegger:

> hoped to disclose the political mission that derived from this insight: the creation (not production) of art was the history-founding act of a people, very much on a par with the founding of a state or with the poiesis of philosophical leadership.
>
> (Benjamin 2005: 76)

The philosopher Slavoj Žižek agrees that Heidegger's assertion of man's decision to assume his place in a historical situation as the key to the sense of being 'locates the historico-political act of decision in the very heart of ontology itself' (Žižek 2000: 20). But rather than seeing Heidegger's project as inherently fascist, Žižek argues that what this kind of criticism of Heidegger rejects:

> as proto-Fascist decisionism is simply the basic condition of the political. In a perverted way, Heidegger's Nazi engagement was therefore a 'step in the right direction'.
>
> (Žižek 2000: 21)

The dangers of Heidegger's philosophy are evident, but there is a concomitant danger in being noncommittal and abstaining from truth claims because of concerns about their totalising potential. The danger here would be mere acceptance of a liberal status quo which confers an automatic relativisation of the authentic in art. With a close reading and an awareness of the dangers of his philosophy, the revolutionary potential of art to revitalise belief in the world is perhaps detectable in Heidegger's ideas.

Chris Hunt

Selected bibliography

Benjamin, A. (2005) *Walter Benjamin and Art*, London: Continuum.
Bolt, B. (2004) *Art Beyond Representation: The Performative Power of the Image*, London: I. B. Tauris and Company.
Heidegger, M. (2008) 'The Origin of the Work of Art', in *Basic Writings*, New York: Harper Perennial, 139–212.
Inwood, M. (2000) *A Very Short Introduction to Heidegger*, Oxford: Oxford University Press.
Wrathall, M. (2005) *How to Read Heidegger*, London: Granta Books.

Žižek, S. (2000) *The Ticklish Subject: The Absent Centre of Political Ontology*, London: Verso.

WALTER BENJAMIN, 'THE WORK OF ART IN THE AGE OF MECHANICAL REPRODUCTION' (1936)

Originally published in the *Journal for Social Research* (*Zeitschrift für Sozialforschung*) of the Frankfurt School, edited by Max Horkheimer. Although a translation into English of an earlier version is included in H. Eiland and M. Jennings (eds), *Walter Benjamin, Selected Writings, Volume 3: 1935–1938*, London: Routledge, 2006, the references here are to the English translation of the essay by Harry Zohn from H. Arendt (ed.), *Walter Benjamin, Illuminations*, London: Fontana, 1992, 211–44.

Modernism is often understood in terms of the purity of geometric abstraction, a formalist art for art's sake that allowed painting and sculpture to break away from representation. The role of the political in shaping avant-garde movements tends to be forgotten in this kind of account. Walter Benjamin's (1892–1940) 'The Work of Art in the Age of Mechanical Reproduction' (1936) is crucial in this context, beyond its pioneering critique of photography and cinema. Benjamin does not stop at describing the aesthetics of art made under the conditions of new technology, but investigates the political consequences of its evolution. In providing a detailed account of the formal qualities of reproducible artwork, he demonstrates how these qualities are always already political. In doing so, he draws conclusions which remain relevant today in helping to understand the ways in which the production of art continues to change in the wake of the digital revolution, with new forms and platforms emerging constantly.

Benjamin identified the impact of the emerging medium of cinema and the essay is one of the earliest attempts to systematically understand the difference between moving images and other forms of representation, in terms of both structural construction and audience relationship. He helped found the sociological study of popular forms of culture, from shop displays to advertisements to drug use, popular music and films, but the essay's real focus is the consideration of a broader process of the democratisation of art's production and consumption. Benjamin understood that modern art was defined by an incessant drive to widen its formal and social base, incorporating new subjects, methods and audiences. He recognised the deep ambivalence that lies at the heart of

this process of democratisation: the more art strives to extend its reach and to destabilise elitist notions of authorship, skill and uniqueness, the more it loses the ground on which it stands. In other words, Benjamin was aware of the paradox of democratisation, which has since become an important question for postmodern writing on the production of art.

Benjamin begins his account with the loss of the 'aura' of uniqueness that defines the singular artwork. He defines the 'aura' as the 'presence in time and space' of the artwork; 'its unique existence at the place where it happens to be' is synonymous with the object's status as an authentic original and locates it within a specific history, context and geography (1992: 214). With the advancement of reproductive technologies, the 'aura' disappears: the original no longer exists in one place, in time and space. The artwork is only manifest through iterations that can exist in several places at the same time, like a film being screened in many cinemas at once. In an observation that anticipates Michael Fried's famous notion of theatricality (1967), Benjamin notes that it is the viewer's encounter with the art object that becomes a singular performance, standing in for the lost singularity of the art work:

> that which withers in the age of mechanical reproduction is the aura of the work of art. … the technique of reproduction detaches the reproduced object from the domain of tradition. By making many reproductions it substitutes a plurality of copies for a unique existence. And in permitting the reproduction to meet the beholder or listener in his own particular situation, it reactivates the object reproduced.
> (Benjamin 1992: 215)

A nostalgic pessimism could be read into this, but Benjamin also celebrates the artwork's liberation from rarefied singularity.

Benjamin's relationship to modernity was complex: unlike his friend Theodor Adorno (1903–69), who was damning of popular culture, Benjamin clearly observed the creative potential within embryonic forms of consumer culture and technology in the early twentieth century. However, his excitement was tempered by a concern regarding Europe's political direction, particularly the rise of Fascism in the 1930s. In the essay's epilogue, Benjamin is decidedly ambivalent about the possibilities opened up by the withering away of the aura (1992: 234). Without a fundamental change to the property relations between social classes, the democratic potential of art's mechanical reproduction could only result in a subordination of the political to the aesthetic, that is, Fascism – a movement built around mobilising the image, power and spectacle of the masses without opposing divisions of wealth in society:

The masses have a right to change property relations; Fascism seeks to give them an expression while preserving property. The logical result of Fascism is the introduction of aesthetics into political life ... This is the situation of politics which Fascism is rendering aesthetic. Communism responds by politicizing art.

(Benjamin 1992: 234–35)

Benjamin foresaw film's extensive use as a propaganda tool, but the consequences for the artists of the second half of the twentieth century have been even more profound. The text revolves around two major arguments, largely concerned with the problems of authorship and spectatorship. The first argument considers the transformation of the work of the actor in cinema as compared to theatre. The second argument deals with the changes to modes of consumption of the reproduced artwork. Benjamin describes the theatre actor as one who operates 'with his whole living person', fully personifying the essence of a character in every aspect of his behaviour, in comparison to the film performer, whose acting for the camera is alienated and mechanised (1992: 223). As the cinematic camera zooms in and out, the human body placed in front of it is broken down to its components: even the smallest intimate gesture becomes significant when magnified. The film's end product is not an embodied performance, but an edited collage of body parts, expressions and movements that constructs a narrative by eliminating the apparatus of construction, the machines surrounding these bodies in motion (Benjamin 1992: 226). Under these conditions, traditional notions of authorship are challenged. Since a film is collaboratively produced and its effect is determined more by the skilful splicing together of disjointed shots than through the mimetic qualities of the actor, this new form of art distributes authorship more equally than the medium of painting (to which Benjamin makes an explicit comparison) (Benjamin 1992: 226–28).

Mechanical reproduction introduces a gap between concept and execution, as the actor, alienated from his own labour, is no longer the only author of its product. The delegated, outsourced fabrication that characterises so much contemporary art – from Jeff Koons to the Chapman brothers – is the logical conclusion of this process. Many of the art movements and critical concepts arising after the publication of Benjamin's essay echo the questions of authorship presented here: from Pop Art to conceptualism to recent trends towards relational aesthetics, artists and writers have persisted in their attempts to realise the democratic potential opened up by the diffusion of authorship. Since Benjamin's premature death in 1940, artists have challenged the explicitly elitist value system attached to the 'aura', a singular luxury commodity exposed to the speculation of the art

market. In doing so, they ultimately conform to existing structures of ownership and commodification, which require art to be critical and to resist the market. For example, the inherently reproducible art of Andy Warhol is subjected to the examinations of the Warhol Art Authentication Board, which alone has the authority to certify an 'original' Warhol made in the artist's presence in his 'Factory'. These attempts therefore inevitably fail to circumvent the democratic paradox to which Benjamin's text alludes.

Benjamin identifies the ways in which the distribution of authorship also affects the reception of the work of art. The viewer of a film, presented with a sequence of moving images that he is powerless to stop in order to contemplate at any length, becomes a distracted critic (Benjamin 1992: 234). In this condition, an audience is receptive to shocking material that they would otherwise reject. The repulsion occasioned by Dada and Surrealism is suppressed by the absent-minded public when confronted with equally shocking imagery of slapstick comedy (Benjamin 1992: 230–32). These observations become more pertinent when applied to recent cultural forms: the distracted voter of a reality television programme or the audience of a YouTube clip epitomise Benjamin's modern viewer. The new user-generated content platforms that define the artwork in the digital age erode the boundaries between the fragmentary producer and the inattentive audience in ways that both conform to and exceed Benjamin's analysis, replacing older modes of authorship with new methods of appropriation and collaboration.

Despite its focus on technological innovation, Benjamin's text is not technologically determinist. The possibilities heralded by the camera are mediated by new cultural ideas and social forces. The onus is on the audience and contemporary cultural practitioners to harness these tools and their propagandist potential for political engagement rather than a withdrawal into the aesthetic. Jacques Rancière (b. 1940) has attempted to reframe the debate around politics and aesthetics by inverting Benjamin's concern about the aestheticisation of politics and analysing the politics of aesthetics, the way in which art forms reorganise the distribution of the sensible and challenge political norms of acceptability (2006: 13). However, in showing how formal aspects of artistic production are inseparable from political consequences, Rancière is entirely indebted to Benjamin. 'The Work of Art in the Age of Mechanical Reproduction' presents us with a tightly woven narrative where form and content, technique and critique, individual artistic merit and mass sociological factors are inextricably intertwined in a groundbreaking endeavour to understand the transformations of art in the twentieth century.

Pil and Galia Kollectiv

Select bibliography

Benjamin, W. (1992) 'The Work of Art in the Age of Mechanical Reproduction', trans. Harry Zohn, in H. Arendt (ed.), *Walter Benjamin, Illuminations*, London: Fontana, 211–44.

——'The Artist as Producer', *Collected Writings*, vol. 2, Cambridge, MA: Harvard University Press, 1999.

——(2002) *The Arcades Project*, Cambridge, MA: Belknap Press of Harvard University Press.

Benjamin, W. et. al. (2007) *Aesthetics and Politics*, London: Verso.

——(2009) *One-Way Street and Other Writings*, London: Penguin.

Berger, J. (1990) *Ways of Seeing*, London: Penguin.

Bourriaud, N. (2007) *Postproduction*, Berlin: Sternberg.

Buck-Morss, S. (1991) *The Dialectics of Seeing: Walter Benjamin and the Arcades Project*, Cambridge, MA: MIT Press.

Debord, G. (1997) *The Society of the Spectacle*, New York: Zone Books.

Eisenstein, S. (1969) *Film Form: Essays in Film Theory*, Harcourt.

Fried, M. (1967) 'Art and Objecthood', *Artforum* 5, June, 12–23.

Gilloch, G. (1997) *Myth and Metropolis: Walter Benjamin and the City*, Oxford: Polity.

Grech, J. (ed.) (2007) 'Walter Benjamin and the Virtual: Politics, Art, and Mediation in the Age of Global Culture', *Transformations*, 15, November, available at: www.transformationsjournal.org/journal/issue_15/editorial.shtml (accessed 9.6.10).

Groys, B. (2008) 'From Image to Image File – and Back: Art in the Age of Digitalization', in *Art Power*, Cambridge, MA: MIT Press.

Horkheimer, M. and Adorno, T. W. (1972) 'The Culture Industry: Enlightenment as Mass Deception', in *Dialectic of Enlightenment*, New York: Herder and Herder.

Kracauer, S. (1997) *Theory of Film*, Princeton, NJ: Princeton University Press.

Rancière, J. (2006) *The Politics of Aesthetics*, London: Continuum.

Scholem, G.G. (2003) *Walter Benjamin: The Story of a Friendship*, New York: NYRB Classics.

Vertov, D. (1992) *Kino-Eye: The Writings of Dziga Vertov*, Berkley: University of California Press.

PAUL VALÉRY, 'THE CENTENARY OF PHOTOGRAPHY' ['DISCOURS DU CENTENAIRE DE LA PHOTOGRAPHIE'] (7 JANUARY 1939)

Paul Valéry, 'The Centenary of Photography', trans. Roger Shattuck and Frederick Brown, in Alan Trachtenburg (ed.), *Classic Essays in Photography*, New Haven, CT: Leete's Island Books, 1980, 191–98.

It is surprising that 'The Centenary of Photography' (1980) does not hold a more prominent place in the history of photography or in

Valéryan studies, considering the momentous occasion in which it was delivered. It raised important issues concerning photography's relationship to language and literature and its role in western thought. On 7 January 1939, to mark the one hundredth birthday of photography, the French poet, essayist, philosopher, art and literary critic Paul Valéry (1871–1945) was invited by the French Society of Photography and Cinema (*La Société française de la photographie et de la cinématographie*) to deliver a lecture at the University of Paris. Amongst those present in the grand amphitheatre of the Sorbonne, were the members of the French Academy and the President of France, Albert Lebrun. The event was covered extensively by newspapers and the radio, reflecting the importance accorded to photography and its perception as an embodiment of French scientific and cultural achievement and a source of national pride.[1] Amélie Lavin notes that the text has strangely faded into obscurity; other than an inclusion in a collection entitled *Vues* (La Table ronde, Paris, 1948) and an abridged version, which appeared in the journal *1'Arc* (21, Spring, 1963), it is also absent from the Pléiade collection of Valéry's work (Lavin 2001).[2]

In many ways, 'The Centenary of Photography' harks back to an earlier speech made by the physicist Dominique François Arago on 3 July 1839. Arago announced in the Chamber of Deputies, the invention of the daguerreotype, which he described as France's gift to the world (Arago 1980: 24). One is struck by a similar display of patriotism and national pride in Valéry's discourse, for he lauds the birth of photography as a 'truly French invention', claiming that the French were the first to have discovered the means to fix an image with light (Valéry 1980: 192). Although Valéry does not make any explicit references to the French inventors of photography – Louis Jacques Mandé Daguerre (1787–1851), Nicéphore Niépce (1765–1833), or Hippolyte Bayard (1807–87), he does, at a later point in the text, attribute to Daguerre the birth of the 'photographic vision' which 'spread by singular leaps and bounds throughout the world' (Valéry 1980: 193). Already in Valéry's opening sentence, one notes the problems that arise concerning the origins of the photographic medium, since the French are not the only ones who have discovered photography.[3] In fact, it is the Englishman Henry Fox Talbot's 'calotype' which is generally considered to be the precursor of analogue film photography. Unlike the daguerreotype which produces a single and unique image, the calotype is a paper negative, which allows for infinite reproduction of the photographic image.

It is not surprising that Valéry, as a writer, would begin his speech by enquiring into photography's influence on literature. He observes that it

appears as if photography has little in common with literature, unlike its relationship with other art forms such as painting or drawing. Alluding to the motion study photographs of Eadweard Muybridge (1830–1904), he comments on how these images have helped artists in their accurate depictions of horses in mid-gallop and birds in flight (Valéry 1980: 192). However, he notes that there are stronger links between photography and literature, and underlines the threat that photography may pose to the writer. He declares that 'bromide proves stronger than ink' (Valéry 1980: 193), given the unreliability of language, its 'arbitrary transmissions' (Valéry 1980: 192) and its capability for rendering in a most precise manner, a record of an event or a description of a person or object. Valéry observes:

> The writer who depicts a landscape or a face, no matter how skillful he may be at his craft, will suggest as many different visions as he has readers.
>
> (Valéry 1980: 192)

His discussion of the rivalry between photography and literature is evocative of an earlier work by the French poet Charles Baudelaire (1821–67), whose essay 'The Modern Public and Photography' (1859) examined the emergence of the new technology in the nineteenth century and its invasion into the realm of fine art. Valéry offers a very different viewpoint from Baudelaire's criticism of photography. Whereas the latter blames photography for corrupting the powers of the imagination and restricting art to realism, Valéry recognises in photography a means to restore literature to its sole purpose. With the help of photography, literature can 'purify itself' (Valéry 1980: 193); relieved of the cumbersome need for realistic description, the writer can concentrate on poetry and the expression of abstract thought through language.

It is interesting to note the various definitions of photography which appear in the text. Valéry is probably referring to the light of the sun when he describes photography as 'the means of reproducing natural and living appearances through a simple transformation of physical energy' (Valéry 1980: 192). His remark on the 'power of the sensitized plate to capture forms instantaneously' highlights the mechanical nature of the medium (Valéry 1980: 192). He also acknowledges its chemical origins, referring to photography as 'a new kind of reagent' (Valéry 1980:195). This duality of photography – the mechanical and the chemical – is explored by Roland Barthes in *Camera Lucida* (1981). For Barthes, the ways in which light interacts with certain surfaces belong to

the chemical order, whereas the physical involves the photographic camera, 'the formation of the image through an optical device' (Barthes 1981: 10). It is the chemical aspect of photography that interests Barthes, as he writes, 'A sort of umbilical cord links the body of the photographed thing to my gaze, light: though impalpable, is here a carnal medium' (Barthes 1981: 81).

Light plays a prominent role in 'The Centenary of Photography'. It is present in the opening sentence, where photography is defined as 'fix [ing] an image of visible objects by employing the very light those objects reflect' (Valéry 1980: 192). For Valéry, light is the thread that connects photography with philosophy. As he suggests:

> [T]here are other, very intimate and very ancient, affinities between light and Philosophy ... What would become of philosophy if it did not have the means of questioning appearances?
>
> (Valéry 1980: 197)

Photography or 'the mere notion of photography' (Valéry 1980: 195) is capable of bringing to the forefront questions about truth and illusion, reality and semblance. Valéry's allusion to the constellation reminds one of the moment in Plato's *Republic* Book VII, when the escaped prisoner lifts his head to look at the stars in the night sky.

In a remarkable passage, Valéry compares the dark chamber of the Platonic cave[4] to a photographic camera:

> If Plato had reduced the mouth of his grotto to a tiny hole and applied a sensitized coat to the wall that served as his screen, by developing the rear of the cave he could have obtained a gigantic film, and heaven knows what astounding conclusions he might have left regarding the nature of our knowledge and the essence of our ideas.
>
> (Valéry 1980: 197)

Light floods through the aperture of the camera-cave and fixes the dancing shadows on the walls, exposing the dark shapes for what they are, copies disguised as originals. If Plato's cave was a giant camera, one wonders what kind of pictures it might take.

Although 'The Centenary of Photography' is not as widely known as other essays written in the same period, such as Walter Benjamin's 'A Short History of Photography' (1931), Valéry's text is important in many ways – it demonstrates how photography is implicated in various areas of human knowledge by investigating the relationship between

literature and photography and examining the latter's contribution to our understanding of the universe. One can argue that an underlying theme of the text is the question of how a philosopher would view photography. Towards the end of the discourse, Valéry leads us from the Platonic cave to another dark chamber. Inside the darkroom, underneath a 'diabolical red light' (Valéry 1980: 198), the photographer-philosopher eagerly awaits the development of the image. Describing this moment of anticipation as a 'deeply philosophical' experience (1980: 197), Valéry draws parallels between the appearance of the *latent image* (1980: 198) in the developing fluid and the imaging power of the mind – the fixing of certain memories and the distillation of poetic thought, 'the creation of certain rare lines of verse' from 'the chaos of our inner speech' (Valéry 1980: 198). He acknowledges photography for its contribution to knowledge, rendering the planets and stars visible to the human eye. Valéry concludes his text with a reference to astronomy, comparing the grain of the film to the stars in the sky. The silver grains that are immersed in the developing fluid gradually come into view and are transformed into identifiable shapes, just like the 'first stutterings of awakening consciousness' (Valéry 1980: 198).

<div style="text-align:right">Junko Theresa Mikuriya</div>

Notes

1 See Lavin's discussion of the event in 'Annexe' (2001) and Taminiaux, *The Paradox of Photography* (2009: 142).

2 The Bibliothèque de la Pléiade (Gallimard) published four volumes of Valéry's work: *Oeuvres I* (1957), *Oeuvres II* (1960), *Cahiers I* (1973) and *Cahiers II* (1974).

3 In *Burning with Desire*, Geoffrey Batchen examines the conditions which brought about the emergence of photography. Highlighting the ambivalent nature of the origins of photography, he shows us that what is assumed to be of a fixed origin, the discovery of photography, in fact possesses multiple beginnings and cannot be attributed to a single individual (Batchen 1997).

4 In the famous passage known as 'The allegory of the cave', in Book VII of Plato's *Republic*, Socrates describes to Glaucon the following scenario: There are prisoners living inside a dark cave, chained so that they are forced perpetually to look at the walls in front of them, where shadows in the forms of humans and animals move about. These shadows are cast by the firelight and belong to marionettes that are carried by performers hiding behind a parapet. Often the performers will emit some noise, which the prisoners, having known nothing but the reality of the shadows, mistake for sound coming from these shifting forms.

Selected bibliography

Arago, D. F. (1980) 'Report', trans. E. Epstean, in Alan Trachtenburg (ed.), *Classic Essays in Photography*, New Haven, CT: Leete's Island Books, 15–25.

Barthes, R. (1981) *Camera Lucida: Reflections on Photography*, trans. Richard Howard, New York: Farrar, Strauss and Giroux.

Batchen, G. (1997) *Burning with Desire: The Conception of Photography*, Cambridge, MA: MIT Press.

Baudelaire, C. (1980) 'The Modern Public and Photography', trans. Jonathan Mayne, in Alan Trachtenburg (ed.), *Classic Essays in Photography*, New Haven, CT: Leete's Island Books, 83–89.

Brunet, F. (2009) *Photography and Literature*, London: Reaktion Books.

Lavin, A. (2001) 'Annexe et notes', in Paul Valéry, 'Discours du centennaire de la photographie' *Etudes Photographiques*, 10, November, Paris: Société Francaise de Photographie, 89–106. http://etudesphotographiques.revues. org/index920.html (accessed 23.8.11).

Taminiaux, P. (2009) *The Paradox of Photography*, Amsterdam: Rodopi.

Valéry, P. (2001) 'Discours du centennaire de la photographie', *Etudes Photographiques*, 10, November, Paris: Société Francaise de Photographie, 89–106. http://etudesphotographiques.revues.org/index920.html (accessed 23.8.11).

——(1980) 'The Centenary of Photography', trans. Roger Shattuck and Frederick Brown, in Alan Trachtenburg (ed.), *Classic Essays in Photography*, New Haven, CT: Leete's Island Books, 191–98.

FRANCIS D. KLINGENDER, 'MARXISM AND MODERN ART: AN APPROACH TO SOCIAL REALISM' (1943)

All references are to the first edition published by Lawrence and Wishart. There was also a 1977 reprint by the original publishers.

Francis Klingender (1907–55) was a Marxist art historian, sociologist, cinéaste and, for many years, a Communist activist who played a for-mative role in the development of cultural studies in the United Kingdom. Born of British parents abroad he was part of the early Weimar diaspora and émigré community, reaching London in 1926/27.[1] Klingender stu-died economics and sociology at the LSE between 1927 and 1934, completing a doctorate which was subsequently published as *The Condition of Clerical Labour in Britain* (1935). His most well known works include *Money Behind the Screen* (with Stuart Legg, 1937), *Hogarth and English Caricature* (1944), *Art and the Industrial Revolution* (1947) and *Goya in the*

Democratic Tradition, actually written during the Spanish Civil War in the 1930s but published in 1948.

From the early 1930s until the late 1940s, when Stalin denounced President Tito, Klingender remained an active member of the Communist Party of Great Britain (CPGB). He knew at least three of the 'Cambridge Five' (Anthony Blunt professionally, Donald Maclean from his activist student days and Guy Burgess through membership of the CPGB).[2] Redacted MI5 surveillance files confirm that Klingender was subject to routine surveillance from 1931 until his death, attention that was renewed after Guy Burgess and Donald Maclean fled to Moscow in 1951.[3] Directly recruited by John Grierson to research aspects of the film industry, Klingender also played a more clandestine role in seeking to propagate and extend Soviet cinema screenings in London, working through the Soviet Trade Legation and other pro-Comintern organisations.[4] Until recently, Klingender's art historical and intellectual legacy has received fragmentary and passing attention.[5] Perceptions of his 'outsider' status, a somewhat peripatetic professional life and early death during the initial stages of the Cold War might be inferred as contributory reasons. Towards the end of his life, Klingender was also geographically (and politically) isolated from many of his erstwhile, London-based CPGB peers. The preservation and recent retrieval of a major archive and library, thought lost, but diligently kept by his late wife, Winifred, promises to provide a fuller picture of Klingender's life, work and associations than has hitherto been possible.[6]

Marxism and Modern Art, authored during the highpoint of Allied–Soviet détente, was the third essay in a series of booklets, exploring aspects of Marxism for the general public commissioned to mark the sixtieth anniversary of Marx's death.[7] Although perhaps not the most well known or even quoted of Klingender's long essays, it crystallises at a specific conjunction of international events, his key critical concerns. These include the commitment to particular forms of realism and antagonism to formalist theory; the perceived obligations of the (progressive) artist; and the central role of art in developing human consciousness and social agency. It reprises and develops ideas initially published in the earlier essay 'Content and Form in Art' in *5 on Revolutionary Art* (1935). As significantly, the essay's sub-title, 'An approach to Social Realism' also identifies its author's reservations towards the Soviet model of Socialist Realism which had been the officially sanctioned cultural style within the Soviet Union and its territories since 1934.

A substantial section of *Marxism and Modern Art* critiques the formalism associated with Roger Fry and the Bloomsbury coterie (Klingender 1943: 5–18). For Klingender, Fry's idealist aesthetic had obscured the

more authentic legacy of the chroniclers of 'contemporary social life' such as Hogarth, Gillray and Rowlandson (Klingender 1943: 11). By contrast, the clear paradigm for cultural practice is the realism associated with the Russian critic Nikolai Chernishevsky, whose *The Aesthetic Relation of Art to Reality* (1855) is seen as having re-defined the artist's social and moral obligations. For Klingender, he was a 'great forerunner of Russian revolutionary socialism' whose belief in the necessity of art's social and political engagement provided the template for contemporary practice (Klingender 1943: 25).

Throughout the text, the art that most approximates to these injunctions is realist painting, folk art and satire, rather than the established and canonical forms of fine art or the post-Impressionist aesthetic of Fry. Klingender argues that Marxist judgements of aesthetic value should be inflected by the 'relative' basis of the art work's origins and the social class that its outlook exemplifies. Quoting Lenin, the text claims a 'continuous tradition of realism' as 'the only standard which can bring art back to the people today' (Klingender 1943: 48–49). Discussing the importance of a socially based art history, and the transformative power of images, Klingender continues:

> Marxist criticism consists in discovering the specific weight within each style, each artist and each single work of those elements which reflect objective truth in powerful and convincing imagery ... the images of art reveal reality in its infinite diversity and many-sided richness.
>
> (Klingender 1943: 48)

As with much of Klingender's writing, external events were not just formative of its content but contributed to the timing of publication. By 1943, Soviet Russia was in active alliance with the Imperial European powers and America in the 'Great Patriotic War' against Germany. Klingender's essay coincided with record membership of the CPGB, buoyed by the successful defence of Stalingrad and the encirclement and subsequent surrender of the German Sixth Army to Soviet forces in the January of that year. Militarily, Stalingrad destroyed the myth of the Wehrmacht's invincibility and is widely regarded as one of the decisive turning points in Allied fortunes in the Second World War (Beevor 1999: 396–405).

It is evident that Klingender perceived the 'modern' in the essay's title as a more historicised phenomenon since examples of contemporary practice from the 1940s (of which he was very knowledgeable, including film and cinema), are not featured. While the quoting of Soviet antecedent and authority looks unimpeachable – Lenin, Lunarcharsky, Plekhanov and Stalin

are all mentioned – there is no clear endorsement of Soviet Socialist Realism per se. What is evident is Klingender's clear ideological and personal preference for national forms of popular or folk art.[8] Relative to some of his earlier if qualified endorsements of abstract photographic practice by the Bauhaus designer László Moholy-Nagy and photomontage by John Heartfield (authored for Comintern publications), the emphasis on figurative practice alone implies a degree of diplomatic self-censorship in the interests of broader Allied–Soviet cultural rapprochement.[9]

But if there are some convenient omissions and rationalisations here, *Marxism and Modern Art* is also indicative of an increasingly independent and at times dogmatic frame of mind and a refusal to arbitrarily conform to imposed Soviet or CPGB diktats. This position earned him formal criticism and censure from the Soviet Academy of Sciences, which new archival evidence has recently brought to light.[10] If such a formal criticism of his work had also been circulated or notified to his CPGB peers, it may explain the particular timing of his move from his London milieu to Hull University College and what appears to have been a gradual if discrete dis-association from the CPGB after 1948.[11] Also appreciable at this time is the apparent de-politicisation of Klingender's late work, which includes a remarkable essay on the iconography of 'St Francis and the Birds of the Apocalypse' (1953).

Klingender's memoirs and personal correspondence reveal a conflicted personality, but also a man deeply committed to a more humanist-inflected Marxism, one liberally influenced by British exemplars – William Morris is quoted with particular conviction at the end of *Marxism and Modern Art*. The western Marxist tradition resulted from the failure to internationalise the Bolshevik struggle. As a Marxist Leninist, Klingender belonged to a generation which was compelled to witness the rolling back of any prospect of western Marxism and the entrenchment of Stalin's 'Socialism in One Country'. At a time of capitalist crisis and accelerating international conflict, Klingender melded a practical Marxism with func-tionally adaptive view of culture, originally derived from formative early LSE mentors, principally the pioneer anthropologist Bronislaw Malinowski and the émigré sociologist Morris Ginsberg (Pooke 2008: 39–46).

Although reductive sociological analysis and over determined readings of art are in evidence across Klingender's oeuvre, this was a more broadly pervasive feature of an empirical Anglophone tradition, distanced from the critical theory that was being developed by members of the Frankfurt School. Throughout Klingender's writing, there are striking and incisive juxtapositions of image, metaphor, allegory and meaning which animate the cadences of otherwise silent sentences. *Marxism and Modern Art* is not an unthinking or unreflexive re-statement of Soviet

orthodoxy. Regardless of its omissions, the intervention was sympto-
matic of Klingender's profound conviction in reclaiming for men and
women the ability to fashion and determine their own futures – and the
formative role of art and a common visual culture in envisioning the
Enlightenment project of human (re-) emancipation.

Grant Pooke

Notes

This commentary has been prepared with reference to unpublished primary
material and correspondence from the Klingender archive and Library,
courtesy of Jessica, Jonathan and Tim Klingender.

1 The exact arrival date is a matter of conjecture, but available archival records
in Goslar and London suggest a departure between late 1926 and early 1927.
Klingender is registered at the LSE for the start of term that year.

2 See: the former MI5 redacted file KV2/2159 (1950–55), Public Records
Office, Kew, London 2008.

3 Francis Klingender's security file 1931–55 was released and indexed as KV2/
2155–56 in 2007, Public Records Office.

4 These would include organisations such as the Artists International
Association, the League Against Imperialism, the Marx Memorial Library,
the Society for Cultural Relations between the British Commonwealth and
the USSR (SCR) and the Workers' Film and Photo League.

5 More recently, David Bindman's essay (2006) was the first detailed attempt
to address a particular aspect of Klingender's work. Previously, the most
detailed source of information was the entry in John Saville's and Joyce
Bellamy's *Dictionary of Labour Biography*, vol 3. London: Macmillan, 1993.

6 The existence of the archive and library was not publicly known until it was
consigned for auction at Bonhams, Oxford, in February 2010.

7 Other contributors to the series included the Cambridge Marxist historian,
Maurice Dobb, the classics scholar George Thompson, the geneticist J. D.
Bernal and the so-called 'Red Dean' of Manchester and then Canterbury
Cathedral, Hewlett Johnson.

8 This had been the explicit rationale behind Klingender's earlier exhibition
catalogue, *Russia: Britain's Ally 1812–1942* (1942) and what followed as
Hogarth and English Caricature in 1944.

9 See for example Klingender's 'Review of Art in the USSR', *The Eye: The
Martin Lawrence Gazette*, 1.2, 17 October 1935, 2–4.

10 Typed fifteen page review from Professor Alexei Alexeyevich Sidorov,
Corresponding member of the USSR Academy of Sciences, dated 7 March
1949, Klingender Archive. Its contents were initially discussed at a meeting
of the Research Institute of the Theory and History of Fine Arts for which
the work was commissioned. The covering letter, dated 15 June, and type
signed by Konstantin Yuon, Director of the Research Institute of the
Academy of Arts (1948–50), summarises Sidorov's review. Although broadly

applauding the monograph, Klingender is criticised for his insufficiently articulated 'class analyses' (p. 5) and the 'immanentism' (sic) of his approach (p. 12) – used to suggest an over-determination of one artistic example onto another. The context of the letter was the virulent campaign and aftermath which had been orchestrated by the then late Andrei Zhdanov, effectively Stalin's Commissar for Culture, enforcing 'official norms' in art (Cullerne Bown: 1991: 205–6).

11 Interviews with John Saville, Westbourne Avenue, Hull, 28 July 2002 and 14 October 2005.

Selected bibliography

Beevor, A. (1999) *Stalingrad*, London: Penguin Books.

Bindman, D. (2006) 'Art as Social Consciousness: Francis Klingender and British Art', in Andrew Hemingway (ed.), *Marxism and the History of Art: From William Morris to the New Left*, London: Pluto Press, 67–88.

Cullerne Bown, M. (1991) *Art Under Stalin*, Oxford: Phaidon.

Klingender, F. D. (1935) 'Content and Form in Art' in Betty Rea (ed.) *5 on Revolutionary Art*, London: Lawrence and Wishart, 25–44.

——(1943) *Marxism and Modern Art*, ed. Benjamin Farrington, London: Lawrence and Wishart.

——(1953) 'St Francis and the Birds of the Apocalypse', *Journal of the Warburg and Courtauld Institutes*, 16.1 /2, 13–23.

Morris, L. and Radford, R. (1983) *The Story of the Artists International Association 1933–53*, Oxford: The Museum of Modern Art.

Pooke, G. (2008) *Francis Klingender 1907–1955: A Marxist Art Historian Out of Time*, London: Gill Vista Marx Press, Marx Memorial Library.

SIR ERNST H. GOMBRICH, *THE STORY OF ART* (1950)

First published in 1950, *The Story of Art* has been produced in English in sixteen editions and over thirty-five reprints in the UK and USA; in at least twenty-two European languages, some with several editions and reprints; and in at least eight languages from around the world including Japanese (1972), Turkish (1976), Chinese (1986) and Russian (1998). A new pocket edition was published in 2006.[1] The 1995, sixteenth edition is generally used for reference here.

Sir Ernst Gombrich's (1909–2001) *The Story of Art* has been a foundational text for the general reader and student of art history for the last sixty years. It has been criticised for the absence of female artists (Parker and Pollock 1981: 6 and Pollock 1999: 5), its teleological approach (Collins 1989: 92–95) and for the scant treatment of both 'primitive' and

'Oriental' art (Elkins 2002: 57, 65).[2] In *The New Art History: A Critical Introduction*, Jonathan Harris articulates how Gombrich's work supported a canonical structure in art history which was no longer tenable in the face of 'new' and 'radical' approaches employing, since the 1970s, methods drawn from Marxism, feminism, psychology and semiotics (Harris 2001: 7, 37). Harris critiques the assumption of 'Gombrichian art history' which asserts that:

> The canon of great art, and its confirmation in, and by, art history, are ... integral parts of the humanism of western liberal-democracy.
> (Harris 2001: 37–39)

However, despite this long-standing recognition of its limitations and omissions, its continued popularity as an art history primer and its widespread translation suggest that it is still providing many with an introduction to European art history's visual, methodological and conceptual coverage.[3]

Gombrich outlined his early art historical influences in inter-war Vienna through an autobiographical sketch delivered at Rutgers, State University of New Jersey in 1987. He described how two German monograph series on the 'masters' of European art, published in the late nineteenth and early twentieth centuries, were 'formative influences' (Gombrich 1987: 125).[4] Vardan Azatyan has recently explored how, after 1939 when Austria was annexed by Germany and his 'beloved' teacher Julius von Schlosser had died, Gombrich's:

> art-historical work can be seen as explicitly engaged in the exilic work of mourning to 'fight' against myth, which blurs and distorts the memory of great masters.
> (Azatyan 2010: 130; Gombrich 1957: 110)

These 'great masters' can be identified not only by their prominence in the formative monographs of Gombrich's youth but also by the extensive space which they are allotted in *The Story of Art*. At the forefront are those listed at the beginning of chapter 15:

> The beginning of the sixteenth century, the *Cinquecento*, is the most famous period of Italian art, one of the greatest periods of all time. This was the time of Leonardo da Vinci and Michelangelo, of Raphael and Titian, of Correggio and Giorgione, of Dürer and Holbein in the North.
> (Gombrich 1995: 287)[5]

These two sentences effectively provide the rationale for *The Story of Art*. It is the assumed 'greatness' of these 'masters' – their 'efflorescence of genius' – on which the book pivots. Gombrich perceived the role of the art historian as authenticating the 'objective reality of the canon'; art historians were 'custodians of the canon', their professional vocation was to recognise the 'quality' of these peaks of artistic achievement and defend their status (Harris 2001: 37; Moxey 1995: 397).

Gombrich's *The Story of Art* is a journey in search of 'great art'[6] which he perceives as the perfectly beautiful and harmonious representation of nature achieved by artists of genius:

> [The artist] was a master, who could not achieve fame and glory without exploring the mysteries of nature and probing into the secret laws of the universe.
>
> (Gombrich 1995: 287)

He characterised the artist's task as solving a series of almost pre-determined problems, frequently describing successful innovations as discoveries, as though the route to 'great art' was already laid out with each stage building upon the previous. For example Brunelleschi's calculation of single point perspective is described as a 'momentous discovery in the field of art' (Gombrich 1995: 226). The 'greatest artists', such as Michelangelo, Dürer or Rembrandt, met the challenge with innovations which raised art to new heights. Some artists, such as Botticelli, recognised the challenge but did not necessarily achieve perfection. Of *The Birth of Venus*, Gombrich says:

> Botticelli's Venus is so beautiful that we do not notice the unnatural length of her neck, the steep fall of her shoulders and the queer way her left arm is hinged to the body. Or, rather, we should say that the liberties which Botticelli took with nature in order to achieve a graceful outline add to the beauty and harmony of the design.
>
> (Gombrich 1995: 264)

For Gombrich, although beauty could compensate for imperfections, the goal was the representation of a perfectly harmonious nature.

The pursuit of the perfect representation of nature combined with the innovative and inventive, sometimes heroic, solutions which artists achieved provided the gauge for Gombrich to judge 'great art' and 'great artists'. The book's chapter headings signal how successful each period was in pursuit of this goal. For the achievements of the classical world there is 'The Great Awakening' and 'The Realm of Beauty'; for the Renaissance of the fifteenth and early sixteenth centuries there is

'The Conquest of Reality', 'Tradition and Innovation' and 'Harmony Attained'. For periods when relatively little progress is achieved chapter headings suggest veiled criticism or avoid artistic comment all together: so there is 'A Parting of the Ways' for Byzantine art; 'Courtiers and Burghers' for the fourteenth century; 'A Crisis of Art' in the late sixteenth; and 'Permanent Revolution' in the nineteenth. The book explicitly maps out the achievements of 'great artists' against a background of artistic endeavour which for various reasons doesn't make the grade.[7]

Gombrich rejected the concept of relativism, whereby value systems such as the canon of great art were contingent on social context; however his judgements are embedded with subliminal political and social meaning (Harris 2001: 37; Bakoš 2009). In several places in *The Story of Art*, the advancement of artistic achievement is associated with freedom. Developments in art in the fifth century BCE are described as 'The great awakening of art to freedom' having 'wisdom and skill in the distribution of figures' and 'the character of grace and ease' (Gombrich 1995: 94–99). The individuality and free will of artists to create 'great art' was rationalised as a conscious choice:

> Donatello's generation in Florence became tired of the subtleties and refinements of the International Gothic style and longed to create more vigorous, austere figures.
>
> (Gombrich 1995: 235)

The achievement was the artist's alone who 'no longer needed to accommodate their works to the whims and fancies of their employers' (Gombrich 1995: 288). The ability and opportunity to innovate and successfully represent nature are therefore perceived as signifiers of freedom and liberation.

In this respect, *The Story of Art* has recently been analysed in the political context of the Cold War.[8] Published within a year of the ending of the Berlin Air Lift (1948–49), it has been interpreted as engaging in an 'ideological battle' against the historicism and totalitarianism which, for Gombrich, were conceptually linked (Azatyan 2010: 129–33).[9] Azatyan argues that *The Story of Art* and Karl Popper's *The Open Society and Its Enemies* (1945) 'should be considered as intellectual weapons of these authors in their war of ideas against "totalitarian philosophies"' (2010: 129–30). Both he and Andrew Hemmingway explore the theoretical connections between Gombrich and Popper (who were friends), drawing on their shared anti-totalitarian perspectives and experiences as Austrian exiles from Nazism (Hemingway 2009; Azatyan 2010).

In 1968, Perry Anderson described Gombrich as part of a 'white counter-revolutionary emigration' from Vienna, leaving the instability of

post-Hapsburg Austria in 1936 as National Socialism further consolidated power in Germany (Anderson 1968: 18). He groups Gombrich with other intellectual émigrés of the period who came to Britain in search of a haven from the political upheavals and 'ruinous contagion' of Europe. For Anderson, the academic and theoretical works of Gombrich and his émigré contemporaries filled a vacuum – 'The Absent Centre' – in the conceptual framework of British political, cultural and social sciences in the inter- and post-war years (1968: 3–20 and 38–39). In this regard, *The Story of Art's* enduring popularity may be founded on the value system which it promotes – one of individual freedom and artistic quality as signifiers of British and western liberal-democracy.

The premise of *The Story of Art* might be further critiqued as its essentialist value system excludes and downgrades many forms of practice which do not conform to its criteria for 'greatness'. The exclusion of female artists has been noted and Gombrich's ambivalent response to both modernism and a nascent post-modernism is also apparent. In later editions, Gombrich added a final chapter, titled 'A Story without End' in which twentieth century art which does not achieve the required standard of 'greatness' is associated with 'fashion' (Gombrich 1995: 599–626). He describes some twentieth century artists, such as Marcel Duchamp (1887–1968) and Joseph Beuys (1921–86), as 'return[ing] to the mentality of children' (Gombrich 1995: 601). In this final section he highlights artists who continue to pursue naturalism such as Giorgio Morandi (1890–1964) and Lucien Freud (1922–2011) and in a concluding paragraph he maintains his position against relativism and for the identification of 'towering masters' (Gombrich 1995: 626).

In the twenty-first century, Gombrich's absolute judgements of 'great art' may seem rooted in a past art historical, conceptual and political era. Set against the pluralism of contemporary art practice and the imperatives of a postcolonial and globalised world, they might seem regressive. At one point, all 'Oriental' art – apparently including Byzantine, the ancient Middle Eastern, Chinese and Indian – is described as follows:

> Western Europe always differed profoundly from the East. In the East these styles lasted for thousands of years and there seemed no reason why they should change. The West never knew this immobility. It was always groping for new solutions and new ideas.
>
> (Gombrich 1995: 185)

This statement is a gross oversimplification and dismissal of millennia of complex artistic endeavour. From the perspective of Edward Said's *Orientalism* (1978), it suggests *The Story of Art* encodes a deeply

embedded hegemony of western naturalistic forms of art, the legacy of which remains, both prominent and contested.

Diana Newall

Notes

1 From J. B. Trapp, *E.H. Gombrich: A Bibliography*, London: Phaidon Press, 2000, publication details in the sixteenth edition and the Phaidon website, June 2011, www.phaidon.co.uk/.

2 The linear progression of Gombrich's art history is clearly visible in the chronological Tables at the end of the book where no complicated parallel activity is allowed to confuse the elegant sweep of artistic development (Gombrich 1995: 656–63). A recent volume of the journal *Human Affairs* titled 'Relativism Versus Universalism and Ernst Hans Gombrich' was devoted to exploring and critiquing Gombrich's work more widely: volume 19, number 3, September 2009.

3 It is still features on secondary school and undergraduate reading lists and core texts.

4 Gombrich specifically mentions *Klassiker der Kunst in Gesamtausgaben (The Complete Works of Classic Art)*, published in 38 volumes, Stuttgart and Berlin: Deutsche Verlags-Anstalt, 1904–37 and *Knackfuss Kunstler-Monographien (The Knackfuss Artists' Monographs)* published in 109 volumes, Bielefeld and Leipzig: Velhagen and Klasing, 1895–1914 with further editions published until 1941.

5 Of these eight artists seven were prominent subjects, along with Rembrandt, Rubens, Velázquez, Donatello and Giotto, of the two German monograph series, with many editions for each in the early twentieth century. Gombrich described them as 'the greatest' (Donatello p. 230 and Rembrandt p. 420), 'genius' (Giotto p. 201), having 'unrivalled gifts' (Rubens p. 400) and producing 'some of the most fascinating pieces of painting the world has ever seen' (Velázquez, p. 407).

6 The terms 'great art' and 'great artist' are drawn from Gombrich's descriptions of the artists in *The Story of Art*. In his 'Preface' he outlines the criteria for selecting art works using terms such as 'real works of art', 'the works illustrated represent the highest standard of perfection' and 'masterpieces', and throughout the book describes artists and their works as 'greatest' or 'great'.

7 Gombrich alludes to this in a lecture in 1973 by describing the maintenance of the canon as 'offer[ing] points of reference, standards of excellence which we cannot level down without losing direction' (1975: 54).

8 Gombrich describes how he quickly completed the text after the war ended in 1945; he had worked for the BBC monitoring service between 1939 and 1945 and wanted to finish the book before returning to research (Gombrich 1987: 131–32).

9 The term 'historicism' here refers to the concept that the nature of historical phenomenon, such as art, are contingent on the context in which they are created.

Selected bibliography

Anderson, P. (1968) 'Components of the National Culture', *New Left Review*, 50, July–August, 3–57.

Azatyan, V. (2010) 'Ernst Gombrich's Politics of Art History: Exile, Cold War and The Story of Art', *Oxford Art Journal*, 33.2, 127–41.

Bakoš, J. (2009) 'Gombrich's Struggle Against Metaphysics', *Human Affairs*, 19, 239–50.

Collins, B. R. (1989) 'Review', *Art Journal*, 48.1 'Nineteenth-Century Art Institutions', Spring, 90–93, 95.

Elkins, J. (2002) *Stories of Art*, New York: Routledge.

Gombrich, E. H. (1950) *The Story of Art*, London: The Phaidon Press.

——(1957) 'Art and Scholarship', in *Meditations on A Hobby Horse, and Other Essays on the Theory of Art*, Chicago: Chicago University Press, [1963] 1985, 105–19.

——(1987) 'Sir Ernst Gombrich: An Autobiographical Sketch and Discussion', *Rutgers Art Review*, 8, 123–41.

——(1995) *The Story of Art*, 16th edition, London: Phaidon Press.

Harris, J. (2001) *The New Art History: A Critical Introduction*, London: Routledge.

Hemingway, A. (2009) 'E. H. Gombrich in 1968: Methodological Individualism and the Contradictions of Conservatism', *Human Affairs*, 19, 297–303.

Moxey, K. (1995) 'Motivating History', *Art Bulletin*, 77.3, September, 392–401.

Parker, R. and Pollock, G. (1981) *Old Mistresses: Women, Art and Ideology*, London: Pandora Press.

Pollock, G. (1999) *Differencing the Canon: Feminist Desire and the Writing of Art's Histories*, London: Routledge.

Said, E. (1978) *Orientalism*, London: Penguin Books.

Trapp, J. B. (2000) *E.H. Gombrich: A Bibliography*, London: Phaidon Press.

FRANTZ FANON, *BLACK SKIN WHITE MASKS* (1952)

Frantz Fanon, *Black Skin White Masks*, 2nd edition, London: Pluto Press, 2008.

For the black man there is only one destiny. And it is white.

Frantz Fanon, 1952

Black Skin White Masks (1952) is a book that is full of fire and fury. It explores colonialism and the behemoth of racism – that of the victim, the perpetrator and the ontology that surrounds them. It is a critique of colonial oppression which has had a foundational resonance for the exploration of black identity, experience and cultural discourse. On reading at times one may be misdirected into thinking that this text is

the lexis of white supremacy: 'I will say that the black is not a man' (Fanon 2008: 1). However, whilst this book does deal with the consequential negation of freedom and the suppression of spirit for the black race, it also speaks of the civilisation of humankind. *Black Skin White Masks* explores the psychology of the conquered and colonised and the stasis of the coloniser:

> I seriously hope to persuade my brother, whether black or white, to tear off the livery put together by centuries of incomprehension.
>
> (Fanon 2008: 5)

Fanon specifically states his Antillean perspective for the book and yet its universality is still relevant and poignant in the contemporary aftershock of 'Colonial Empire'. Hope threads itself through the passages like a surgical knife analysing each pound of flesh:

> society cannot escape human influences. Man is what brings society into being. The prognosis is in the hands of those who are willing to get rid of the worm eaten roots of the structure.
>
> (Fanon 2008: 4)

Through the text's analysis, its use of psychoanalysis and refusal, it assesses the nature of blackness and whiteness – 'civilisation' and what it is to be.

Frantz Omar Fanon (1925–61) was born in Fort-De-France in the French colony of Martinique. Significantly, his father was a descendent of African slaves and his mother was of mixed French ancestry. From the educated middle class, Fanon attended the Lycée Schoelcher – its founder Victor Schoelcher had been a significant 'voice' in the abolition of slavery in the French Third Republic. He studied under the radical poet and writer Aimé Césaire (1913–2008), who was a key founder of *Negritude*, a movement which affirmed and celebrated 'blackness'. Césaire was a significant influence on Fanon and in turn Fanon's work the *Wretched of the Earth* (1961), which scrutinised the social psychology of colonialism, was a 'call to arms' and a great radicalising influence on the Black Power movement of 1960s America.

Césaire was vehement and vocal in the denunciation of colonialism and the affirmation of black pride. He explored this theme in his poem *Cahier d'un retour au pays natal* (1947):

> my negritude is not a stone, nor a deafness flung against the clamor of the day

my negritude is not leukoma of dead liquid over the earth's dead eye
my negritude is neither tower nor cathedral
it takes root in the red flesh of the soil
it takes root in the ardent flesh of the sky

Cahier d'un retour au pays natal was celebrated by the Surrealist André Breton (1896–1966) in his introduction, 'A Great Black Poet', where he describes Césaire as the 'the greatest lyrical monument of our time' (Breton 1947: xiii). However, Fanon was scathing of this introduction to Césaire's poem and he returns 'dignity' to Césaire by re-writing Breton's words, inserting the 'man' omitted by Breton. So 'Here is a black who handles the French language as no white man today can' (Breton 1947: xii), becomes for Fanon, 'Here is a black man who handles the French language as no white man today can' (Fanon 2008: 26).

This connection to Césaire was a major influence on Fanon, who notes the paradoxical implication of racism in Breton's statement. He writes:

> But we should be honoured, the blacks will reproach me, that a white man like Breton write such things.
>
> (Fanon 2008: 27)

Fanon agitated against the Vichy regime, supporting the French resistance against the occupying forces of Nazi Germany. He was awarded the Croix de Guerre for bravery during his subsequent service in the *Forces Françaises Libres* ('*Free French Forces*'). Fanon was the victim of racism throughout this time in the army and many of his observations in later writings such as *Black Skin White Masks* and *The Wretched of the Earth* arose from these experiences. In 1943 Fanon studied medicine and psychiatry in Lyon and ten years later his time working in Blida-Joinville Psychiatric hospital in Algiers was to prove significant to his ethos for writing *Black Skin White Masks*.

Fanon's books became part of the driving power against colonialism and racism at a time when France was becoming the centre of revolutionary philosophy. The impetus for this was from homespun intellectuals as well as 'imported' intellectuals, such as Fanon, from its colonies. This French philosophy was greatly influenced by a plurality of student voices from its colonial outposts such as India, Senegal, Vietnam and the Caribbean. Edward Said noted this influence of:

> expatriates, dissidents, exiles and refugees, who paradoxically work better in the heart of the empire than in its far-flung domains.
>
> (Said 1993: 292)

The Algerian fight for independence became a focus for both French revolutionary philosophy and for Fanon's own writings. The Algerian War (1954–62) was a bloody and vicious conflict which galvanised French intellectuals into pressuring the French government to directly face the consequences of its actions. The *Manifeste des 121* (*Manifesto of the 121*) was published in 'Verite – Liberte' in 1960 in an open letter for the government to recognise the legitimacy of the Algerian struggle for independence. It was signed by 121 intellectuals, among them Guy Debord, Jean-Paul Satre, Francois Truffaut and the Surrealists André Breton and André Masson.

Black Skin White Masks enabled Fanon to begin to develop his ideas about re-examining and therefore re-defining black identity through his findings as a psychiatrist. This exploration is monumental, it examines black language and how it is entangled in the process of assimilation mediated through colonialism. It scrutinises the desire for acceptance by the new world, looking beyond stereotypical slogans such as 'sho good eatin' which played a part in defining the black man. Fanon speaks of a black and white world as he searches for universal totality, yet the 'voice' is one of energy, anger and hope:

> Yes to life. Yes to love. Yes to generosity. But man is also a no. No to scorn of man. No to degradation of man. No to exploitation of man. No to the butchery of what is most human in man: freedom.
>
> (Fanon 2008: 172)

Fanon also explores the black 'questing' for a white mask and a whitening skin. He examines this in relation to the sexual myth presenting both black male and black female perspectives. First, he considers black female desire:

> a wonderful night, a wonderful lover, a white man. ... What they must have is whiteness at any price.
>
> (Fanon 2008: 34)

Second, he characterises black male desire:

> who but a white woman can do this for me? By loving me she proves that I am worthy of white love. I am loved like a white man.
>
> (Fanon 2008: 45)

Fanon reveals an uncomfortable stance and thus identifies the complexities of colonialism and the desire of the colonised for acceptance. He

continues to explore and deconstruct colonialism and its 'complex web of relations' (Gibson 2003: 7).

Through his role as a psychiatrist and using evidence from his psychiatric patients, Fanon was able to further delve into perceived neuroses and the condition of a black inferiority complex. He writes:

> The Negro enslaved by his inferiority, the white man enslaved by his superiority alike behaves in accordance with a neurotic orientation.
>
> (Fanon 2008: 42)

By its very nature Fanon's examination of colonialism dissects the effect of the imposition of a new rule by force on another race and the consequences of the willingness of the colonised to accept and assimilate.

> He becomes whiter as he renounces his blackness, his jungle.
>
> (Fanon 2008: 9)

Herein lies a paradox and weakness that is questioned and unearthed in *Black Skin White Masks*. The text challenges the view of the 'colonially enlightened' 'noble savage' and the apparent tendency to edify and ordain the black man which this implies. This issue is further explored in Edward Said's *Culture and Imperialism* (1993), where he speaks of:

> the patently important influence they [non European cultures] had on modernist artists like Picasso, Stravinsky and Matisse and on the very fabric of society that largely believed itself to be homogenously white and Western.
>
> (Said 1993: 292)

Black Skin White Masks charges the reader to re-evaluate and widen its reading of histories – histories such as that of Modernism and the indebtedness that it has to the non-west. The appropriation of the artefact from Africa in some ways mirrors the act of colonialism.

Fanon presents the notion that the black man has one desire – to become like his master, and through his evidence and examination of the perceived foundations of colonial black identity in *Black Skin White Masks*, he seeks to transcend racial categories. At the book's heart is the conviction that racism is within the blueprint of society, and he calls on that society to resolve it. Just as the Code Noir of 1685, an edict by the French King Louis XIV setting out 60 articles and conditions of slavery, *Black Skin White Masks*, through its meticulous examination of the

conditions of colonialism, sets out to eradicate the very mindset and attitudes of those enslaved, to break the chains of their subjugation.

Black Skin White Masks has to be contextualised through the time and place of its conception, and its author's gender, experience of racism and role as psychoanalyst. Fanon's intervention contributes to the struggles of political liberation – of women and of Black Feminism. These struggles against colonialism, poverty and racism have analogies with the aspiration and political trajectory of *Black Skin White Masks*. The essence of the book is to recognise the mask of oneself and the skin of choice that one wears. Fanon's book can be seen as an antecedent of subsequent critical interventions that address, situate and mediate black culture.

Mavernie Cunningham

Selected bibliography

Achebe, C. (1989) *Arrow of God*, London: Anchor.

Baldwin, J. (2010) 'Introduction' by R. Kenan, *The Cross of Redemption: Uncollected Writings*, New York: Pantheon.

Benjamin, J. (1997) *The Shadow of the Other*, London: Routledge.

Bhabha, H. (1990) *Nation and Narration*, London: Routledge.

Breton, A. (1947) 'A Great Black Poet', in *Cahier d'un retour au pays natal*, Aimé Césaire, New York: Brentano.

Césaire, A. (1947) *Cahier d'un Retour au Pays Natal*, New York: Brentano.

Eshleman, C. and Smith, A. J. (1983) *'Aimé Césaire the Collected Poetry'*, Berkeley: University of California Press.

——(2001) *Notebook of a Return to the Native Land*, Middletown, CT: Wesleyan University Press.

Fanon, F. (1990) *The Wretched of the Earth*, London: Penguin.

——(2008) *Black Skin White Masks*, 2nd edition, London: Pluto Press.

Gibson, N. C. (2003) *'Fanon: the Post Colonial Imagination'*, London: Polity Press in association with Blackwell.

James, A. (1981) *Modernism and Negritude The Poetry and Poetics of Aimé Césaire*, Cambridge, MA: Harvard University Press.

Memmi, A. (1991) *The Colonizer and the Colonized*, Boston, MA: Beacon Press.

Said, E. W. (1993) *Cultural Imperialism*, London: Chatto and Windus.

LAWRENCE ALLOWAY, 'THE LONG FRONT OF CULTURE' (1959)

'The Long Front of Culture' first appeared in *Cambridge Opinion*, 17, 1959, 24–26.[1] It has been reprinted on a number of occasions, notably in John

Russell and Suzi Gablik, *Pop Art Redefined*, London: Thames and Hudson, 1969, 41–43; Brian Wallis, Patricia Phillips and Thomas Lawson (eds), *Modern Dreams. The Rise and Fall and Rise of Pop*, Cambridge, MA: MIT Press, 1988, 30–33, and Richard Kalina (ed.), *Imagining the Present: Context, Content, and the Role of the Critic*, London: Routledge, 2006, 61–64.

In a year when 11 million viewers watched the final episode of BBC television's science fiction serial *Quatermass and the Pit*, attendances at British cinemas numbered almost 600 million, and sales of popular music, in the form of seven-inch 45rpm singles, reached almost 52 million, Lawrence Alloway's (1926–90) essay 'The Long Front of Culture' was a timely re-evaluation of changing cultural circumstances. It was a significant point in the development of ideas Alloway had been formulating in other published pieces[2] and in discussion with friends and colleagues at the Institute of Contemporary Arts (ICA) in London.[3] In small part, it was a critical attack on 'the traditionally educated custodian of culture' (Alloway 1959: 25), but more importantly it represented an affirmation of the impact of mass communications and the resulting evolution of new forms of popular culture.

'The Long Front of Culture' opens with a few waspish comments about traditional culture and those Alloway perceived as protecting and maintaining it, calling them 'keepers of the flame', 'an élite' and, later, 'humanists' (Alloway 1959: 25). However, it quickly takes up a discussion about the role of popular art forms generated by mass communication media and their relationship to traditional art practices, suggesting a revision of how culture should be understood.[4] Alloway's model for this was a 'fine art/pop art continuum', a paradigm which had been referred to in earlier texts.[5] In 'The Long Front of Culture' he outlined:

> a shift in our notion of what culture is. Instead of reserving the words for the highest artifacts and noblest thoughts of history's top ten, it needs to be used more widely as the description of 'what society does'. Then, unique oil paintings and highly personal poems as well as mass-distributed films and group-aimed magazines can be placed within a continuum rather than frozen in layers in a pyramid.
>
> (Alloway 1959: 25)

The analogy of a pyramid, with an apex that accommodates a relatively narrow and numerically small amount of 'Art', and a base that allows a

quantity and range of other cultural phenomena, notably pop art (pop-ular art), is a hierarchical model that privileges certain forms of culture over others. Alloway's alternative was to locate cultural phenomena in a level band or field, where fine art occupies one position and popular culture another, thereby indicating their difference but not the super-iority of one over the other. Whilst 'The Long Front of Culture' was Alloway's first published exposition of this idea, it had been formulated much earlier,[6] and was made even more explicit two years later in an essay entitled 'Artists as Consumers':

> Instead of a pyramid with Picasso at the top and Elvis at the bottom, we need a more flexible principle. For one thing, taste-pyramids are forever toppling: Picasso is already slipping and the appearance of Adam Faith has moved Elvis up a bit. Instead of the hierarchy, we would use the idea of a continuum. Then, at least, the spectator can go to the National Gallery by day and the London Pavilion by night, without getting smeared up and down the pyramid.
>
> (Alloway 1961: 15)[7]

The continuum was an expanded view of culture, on a long front, as the essay's title indicates, but whilst it was liberal and accommodating, it still separated popular, or low, from elite, or high, forms. Despite Alloway's cultural interests embracing Hollywood movies, mass circulation magazines and advertising, he did not advocate adopting sensibilities that would give 'Art' the popular appeal of mass culture; there was a designated position in the continuum for presentations at the National Gallery and another, different one for those at the London Pavilion. It may seem then, that he was proposing little more than an acceptance of those forms of popular culture that had evolved as the corollary to a burgeoning mass communications media. But the essay did more than this by presenting reasons why such cultural manifestations had value.

Alloway observed that those who wished to maintain a hierarchical interpretation of culture 'acted as taste-giver, opinion-leader, and expected to continue to do so', but that their role was now 'clearly limited' because they had failed:

> to handle technology, which is both transforming our environment and, through its product the mass media, our ideas about the world and about ourselves.
>
> (Alloway 1959: 25)

This transformation, he claimed, arranged knowledge in a non-hierarchical way, as in disciplines such as sociology and anthropology, making the media 'crucial [as a] general extension of interpretation outwards from the museum and library into the crowded world', and 'a manual of one's occupancy of the twentieth century' (Alloway 1959: 26). Illustrating his point with references to women's magazines, Alfred Hitchcock's 1959 film *North by Northwest*, and 'the brilliant women's films from Universal-International' (Alloway 1959: 25),[8] he argued that the media acted 'as a guide to life defined in terms of possessions and relationships', its heroes, for example, becoming not only symbols of our aspirations, but also 'an index of the atmosphere of opinion of the audiences, as complex as a weather map' (Alloway 1959: 25). But this audience was never 'mass' in the strictest sense, never 'an arena of standardized learning' as he put it (Alloway 1959: 26). Alloway identified the term 'mass audience' as 'a convenience', asserting that:

> the audience today is numerically dense but highly diversified ... specialized by age, sex, hobby, occupation, mobility, contacts, etc. Although the interests of different audiences may not be rankable in the curriculum of the traditional educationalist, they nevertheless reflect and influence the diversification which goes with increased industrialization.
>
> (Alloway 1959: 25)

Therefore, whilst the media was directed at a 'numerically dense' audience, within it were groups that preserved their own integrity and individuals who maintained their independence. In this way, he affirmed, the mass media was 'like a competitor of the fine arts in its capacity for condensing personal feelings', substantiating this with a reader's reaction to a science fiction magazine cover:

> I'm sure Freud could have found much to comment and write on about it. Its symbolism, intentionally or not, is that of a man, the victor; woman, the slave. Man the active; woman the passive. Man the conqueror; woman the conquered. Objective man; subjective woman; possessive man, submissive woman! ... What are the views of other readers on this? Especially in relation with Luros' backdrop of destroyed cities and vanquished men?
>
> (Alloway 1959: 25)[9]

When it was written, Alloway's essay outlined a radically inclusive understanding of culture in the modern industrial age. In part based on his antipathy to 'keepers of the flame' (Alloway 1959: 25),[10] in part the

result of his own broad cultural interests, and in part a pragmatic response to a rapidly changing social and cultural situation engendered by a growing and influential mass media, 'The Long Front of Culture' is prophetic and inadequate in equal measure. On the one hand, Alloway's concept of the 'fine art/pop art continuum' anticipates that increasingly indistinct boundary between art and the marketplace so familiar today, and his fundamentally sociological methodology aligns with current academic disciplines such as media studies and semiotic theory. Moreover, his understanding of the contradictions inherent in the idea of a mass audience that in fact has diversity, resulting in personal interpretation, is postmodern in concept. On the other hand, 'The Long Front of Culture' puts its faith in 'knowing consumers', those able to keep pace with a rapidly expanding system of mass communications and, if necessary, disassociating themselves from the manipulative intentions and persuasiveness of a materialist culture. It might be argued that the 'knowing consumer' was, and still is, in a minority.

Ultimately, Alloway leaves us with an image of an increasingly complex culture, no longer led by a coterie of the elite but augmented by an 'expendable multitude of signs and symbols' (Alloway 1959: 25), a pluralism which must be dealt with as judiciously as possible.

Graham Whitham

Notes

1 *Cambridge Opinion* was a student journal. The themes of Issue 17, which was edited by Robert Freeman, a student of English Literature who had a contact with the ICA, were noted on the title page as 'The Definition of the Avant-Garde', 'The Impact of Sociology on the Humanities', 'Communications Research' and 'The Iconography of the Mass Media', all discussed at the ICA in the 1950s (see note 3).

2 Between 1956 and 1961, Alloway published a number of essays in various journals about the significance of mass media and popular culture. They are listed in the Selected Bibliography.

3 Alloway was a prominent figure in the so-called Independent Group, a loose affiliation of people who sometimes organized meetings at the ICA. Around the time he became Assistant (later Deputy) Director of the ICA in July 1955, more formal meetings of the Independent Group, which were not part of the public programme, embraced topics such as advertising, sociology in popular arts and popular music. The public programme itself, probably influenced by Alloway and some of his Independent Group colleagues, also reflected these interests, with talks on science fiction, advertising and the arts, and western films.

4 Popular art, notably that created by film, TV, magazines and other media of mass communication, was abbreviated by Alloway and his Independent Group colleagues to pop art. This is not to be confused with Pop Art, a form of fine art evolving in the later 1950s and early 1960s, much of which drew its inspiration from the products of mass media pop art.

5 For example, in Alloway 1958a: 85: 'There is in popular culture a continuum from data to fantasy'.

6 John McHale had noted his Independent Group colleague's use of the term as early as 1955: 'to quote Lawrence Alloway, "a fine art/pop art continuum now exists," and so, where the Bauhaus had its amateur jazzband and kite festivals – we have bop and Cinemascope' (McHale 1955: 3).

7 Adam Faith was a British pop singer and the London Pavilion was a cinema.

8 Whilst Alloway does not name the films, he adds that they provide 'lessons in the acquisition of objects, models for luxury, diagrams of bedroom arrangement'. Such films as *Written on the Wind* (1956), *The Tattered Dress* (1957) and *Flood Tide* (1958) might fit the bill.

9 The magazine was *Science Fiction Quarterly* (May 1951); its cover, illustrated by Milton Luros, was reproduced in 'The Long Front of Culture' (Alloway 1959: 24).

10 In 'Personal Statement' (1957b), Alloway records: 'Alan Clutton-Brock told me once that he read science fiction (English SF, of course) but, like the *Times*-man he then was, he did not let it show when writing "seriously".' In the same essay, he cites Bernard Berenson, Roger Fry, Herbert Read and Basil Taylor, then librarian and reader in general studies at the Royal College of Art, implying that they were 'keepers of the flame'.

Selected bibliography

Alloway, L. (1956) 'Technology and Sex in Science Fiction. A Note on Cover Art', *Ark*, 17, Summer, 19–23.

——(1957a) 'Communications Comedy and the Small World', *Ark*, 20, Autumn, 41–43.

——(1957b) 'Personal Statement', *Ark*, 19, March, 28–29.

——(1958a) 'The Arts and the Mass Media', *Architectural Design*, 28.2, February, 84–85.

——(1958b) 'Symbols Wanting', *Design*, 113, May, 23–27.

——(1959) 'The Long Front of Culture', *Cambridge Opinion*, 17, December, 24–26.

——(1960) 'Notes on Abstract Art and the Mass Media', *Art News and Review*, 27 February–12 March, 3 and 12.

——(1961) 'Artists as Consumers', *Image*, 3, 14–19.

Kalina, R. (ed.) (2006) *Imagining the Present. Context, Content, and the Role of the Critic*, London: Routledge.

Massey, A. (1995) *The Independent Group: Modernism and Mass Culture in Britain 1945–59*, Manchester: Manchester University Press.

McHale, J. (1955) 'Gropius and the Bauhaus', *Art* (London), 1, 3 March, 3.

Robbins, D. (ed.) (1990) *The Independent Group: Postwar Britain and the Aesthetics of Plenty*, Cambridge, MA: MIT Press.

Sun-Young, Lee (1991) 'The Critical Writings of Lawrence Alloway', *Studies in Art Education*, 32.3, Spring, 171–77.

CLEMENT GREENBERG, 'MODERNIST PAINTING' (1960)

'Modernist Painting' first appeared as a *Forum Lecture* radio broadcast (Washington DC: *Voice of America*) and a pamphlet to accompany the talk in 1960. It was then published in a slightly revised form in *Art and Literature*, Lugano: Spring 1965, 193–201. Since then, it has been reprinted in a number of journals and books, most notably John O'Brian (ed.), *Clement Greenberg. The Collected Essays and Criticism. Volume 4: Modernism with a Vengeance, 1957– 1969* Chicago: The University of Chicago Press, 1995, 85–93 and Charles Harrison and Paul Wood (eds), *Art in Theory 1900–2000. An Anthology of Changing Ideas*, Oxford: Blackwell, 2003, 773–79. Greenberg added a post-script when it was published in Richard Kostelanetz (ed.), *Esthetics Contemporary*, New York: Prometheus Books, 1978, 195–201.

A decade into the twenty-first century, contemporary sensibility is ever more sceptical of rationales that claim to explain and legitimise artistic practice. Ever since Jean-François Lyotard expressed his 'incredulity towards meta-narratives', it has become increasingly difficult to believe that developments in art can be understood in relation to an over-arching theory (1979: 7). Consequently, Clement Greenberg's (1907–94) once hugely influential text 'Modernist Painting', which is undoubtedly a meta-narrative, has come to be regarded as something of an anachronism. Even before its claims are scrutinised, the two word title signals now dated concepts. 'Modernist' conjures up, amongst other things, ideas of aestheticism, high seriousness and crusading zeal, all of which have become unfashionable and unappealing. Similarly, 'Painting' is no longer the pre-eminent art form, having been supplanted by a range of pluralistic and hybrid practices in other media. But has the postmodern condition, as Lyotard identified it and art's evolution as both a response and con-tribution to it, really made Greenberg's ideas inconsequential? Put another way, is it believable that what was once such an authoritative and significant text is now irrelevant to our understanding of art?

In the early 1960s, Greenberg's essay not only offered an attractive, persuasive and apparently credible explanation of modern art's

development but it also provided a reasoned philosophy that under-pinned its evolution. The seeds were sown in Greenberg's earlier writing. In 1939, when fellow left wing critics were debating whether avant-garde art would ever gain popular acceptance, he claimed that it had evolved 'to create art and literature of a high order' (Greenberg 1988a: 10) in the face of *kitsch*, that mass culture of modern life characterised by magazines, advertisements, movies, popular songs and even academic art.[1] The means by which he believed the avant-garde maintained this 'high order' were sketched out in 'Avant-Garde and Kitsch' (1939) and developed a year later in 'Towards a Newer Laocoon' (1940). In this essay he defended 'pure' abstract painting, which he considered as the best art of his day, claiming that the avant-garde exists to preserve the specific identity of each art, defined by the peculiarity of the discipline which its medium imposes. Greenberg explained:

> Purity in art consists in the acceptance, willing acceptance, of the limitations of the medium of the specific art ... The arts, then, have been hunted back to their mediums, and there they have been iso-lated, concentrated and defined. It is by virtue of its medium that each art is unique and strictly itself.
>
> (Greenberg 1988a: 32)

It was another twenty years before Greenberg was to expand sig-nificantly on this idea in 'Modernist Painting'. When the essay appeared, the influence of Abstract Expressionism, much of which he considered to epitomise his position, was waning, and the concurrent challenge of Robert Rauschenberg's 'combines', Allan Kaprow's hap-penings and environments, and other so-called neo-avant-garde practices seemed to contest his interpretation. Perhaps it was time to defend his position and the *Voice of America's Forum Lectures* gave him the opportunity.

At the heart of Greenberg's thesis is the conviction that the preserva-tion of artistic standards and excellence had to be achieved through art's 'purity', just as he had described in 'Towards a Newer Laocoon'. But, in 'Modernist Painting', he expanded on this idea:

> The essence of Modernism lies, as I see it, in the use of characteristic methods of a discipline to criticize the discipline itself, not in order to subvert it but in order to entrench it more firmly in its area of competence.
>
> (Greenberg 1995b: 85)

Greenberg called this 'self-criticism', which he defined as the elimination:

> from the specific effects of each art any and every effect that might
> conceivably be borrowed from or by the medium of any other art.
> Thus, each art would be rendered 'pure', and in its 'purity' find the
> guarantee of its standards of quality as well as of its independence.
> 'Purity' means self-definition, and the enterprise of self-criticism in
> the arts became one of self-definition with a vengeance.
>
> (Greenberg 1995b: 86)

Whilst Greenberg's text addresses painting, his argument was meant to
hold true for all arts.[2] Consequently, to attain purity and maintain
quality, each art had to identify and exploit those attributes which were
intrinsic to it alone. In the light of the work Greenberg was championing
at the time, much has been made of his claim that the 'unique and
irreducible' characteristics of painting were 'the flat surface, the shape of
the support, the properties of the pigment' (Greenberg 1995b: 86). It is
not difficult to see paintings by Kenneth Noland, Morris Louis and Jules
Olitski, all artists Greenberg championed, as either meeting his criteria
for excellence or responding to them. But he was under no illusion that
'the flat surface' was a finite property. 'The flatness towards which
Modernist painting orients itself can never be an absolute flatness,' he
noted, qualifying this by adding:

> The Old Masters created an illusion of space and depth that one
> could imagine oneself walking into, but the analogous illusion cre-
> ated by the Modernist painter can only be seen into; can be traveled
> [sic] through, literally or figuratively, only with the eye.
>
> (Greenberg 1995b: 90)

This was an important distinction for Greenberg. If quality in art was to
be upheld, its purity must be maintained, which meant fully exploiting
the medium's inherent potential. Painting could not compromise its
integrity as a visual, two-dimensional discipline by laying claim to char-
acteristics that were the province of other media, such as sculpture's inherent
three-dimensionality or literature's dependence on narrative. Thus, paint-
ings by Piet Mondrian, Jackson Pollock and Kenneth Noland, where
form and content were effectively indistinguishable, fitted the bill.

For Greenberg 'Modernist Painting' can be seen as a justification for
the abstract art of his day, claiming that this was the natural result of its
search for 'independence as an art' (Greenberg 1995b: 88).[3] He argued
that its autonomy from other artistic disciplines, notably sculpture, was

to be found in sixteenth-century Venetian art, seventeenth-century painting in Spain, Belgium and the Netherlands, and in the work of Jacques-Louis David and Jean-Auguste-Dominique Ingres, calling the latter's portraits:

> among the flattest, least sculptural paintings done in the West by a sophisticated artist since the fourteenth century.
>
> (Greenberg 1995b: 88)

He explained this unconventional analysis of Ingres by asserting that the Old Masters were aware of the flatness 'underneath and above the most vivid illusion of three-dimensional space' and that Modernists equally recognised this contradiction but 'have reversed its terms' (Greenberg 1995b: 87). Such continuity with the past is a significant component of 'Modernist Painting'. Greenberg did not see the forms of modern art that he judged to have criteria for excellence as a break with previous standards; 'Modernist art continues the past without gap or break' (Greenberg 1995b: 92), he wrote, concluding his essay with the observation that:

> Nothing could be further from the authentic art of our own time than the idea of a rupture of continuity ... Lacking the past of art, and the need and compulsion to maintain its standards of excellence, such a thing as Modernist art would lack both substance and justification.
>
> (Greenberg 1995b: 93)

Contemporary discourse regards 'Modernist Painting' as an unsustainable meta-narrative, a rational but fundamentally dogmatic assertion of what constitutes 'good' art. It is also considered to be an elitist position, although Greenberg rebuffed such an accusation, claiming that to maintain 'standards of excellence' was an absolute necessity.[4] The essay's inflexible position, together with the claims for modern art's continuity with the past and an imprecise appropriation of Kant (Greenberg 1995b: 85–86),[5] contributed to the spuriousness of his argument for many and led to him becoming the target of unrelenting criticism both before and after his death in 1994.

Despite Greenberg's apparent doctrinaire philosophy and seeming obduracy to shift his position as once established standards began to lose their significance from the later 1950s onwards, it should not be thought that 'Modernist Painting' is without value. At the very least, it continues to operate as a catalyst for meaningful argument, as well as being a significant articulation of an aesthetic position. Moreover, it might cause

theorists to contemplate the replacement of standards that once identi-
fied artistic quality with a more permissive outlook, where one form of
art is so often indistinguishable from another and where quality no
longer seems to be a criterion of significance.

Graham Whitham

Notes

1 In a letter (February 1939) to his fellow critic Dwight Macdonald, Greenberg
wrote: 'Chromeotypes, popular music and magazine fiction reflect and take
their sustenance from the academicized simulacra of the genuine art of the past.
There is a constant seepage from top to bottom, and Kitsch (a wonderful German
word that covers all this crap) is the common sewer' (Greenberg 1988a: xxii).
2 'Modernist Painting' begins: 'Modernism includes more than art and litera-
ture. By now it covers almost the whole of what is truly alive in our culture'
(Greenberg 1995b: 85).
3 Greenberg goes on to argue that 'painting has had above all to divest itself of
everything it might share with sculpture, and it is in its effort to do this, and
not so much … to exclude the representational or literary, that painting has
made itself abstract.'
4 'To quarrel with necessity by throwing about terms like "formalism",
"purism", "ivory tower" and so forth is either dull or dishonest' (Greenberg
1988a: 10).
5 See Clewis (2008), Crowther (1985), Gaiger (1999) and Rajiva (2008).

Selected bibliography

Clewis, R. (2008) 'Greenberg, Kant, and Aesthetic Judgments of Modernist
Art', *Canadian Aesthetics Journal: The Electronic Journal of the Canadian Society for
Aesthetics*, 14, Summer, www.uqtr.ca/AE/Vol_14/modernism/Clewis.htm
(accessed 24.8.11).
Crowther, P. (1985) 'Greenberg's Kant and the Problem of Modernist
Painting', *British Journal of Aesthetics*, 25.4, 317–25.
De Duve, T. (2004) *Clement Greenberg. Between the Lines*, Paris: Dis Voir.
Gaiger, J. (1999) 'Constraints and Conventions: Kant and Greenberg on
Aesthetic Judgement', *British Journal of Aesthetics*, 39.4, 379–91.
Greenberg, C. (1988a), *Clement Greenberg. The Collected Essays and Criticism.
Volume 1: Perceptions and Judgments 1939–1944*, ed. John O'Brian, Chicago:
The University of Chicago Press.
——(1988b), *Clement Greenberg. The Collected Essays and Criticism, Volume 2:
Arrogant Purpose 1945–1949*, ed. John O'Brian, Chicago: University of
Chicago Press.
——(1995a), *Clement Greenberg. The Collected Essays and Criticism Volume 3:
Affirmations and Refusals 1950–1956*, ed. John O'Brian, Chicago: University of
Chicago Press.

——(1995b), *Clement Greenberg. The Collected Essays and Criticism Volume 4: Modernism with a Vengeance 1957–1969*, ed. John O'Brian, Chicago: University of Chicago Press.

Jones, C. A. (2008) *Eyesight Alone: Clement Greenberg's Modernism and the Bureaucratization of the Senses*, Chicago: University of Chicago Press.

Lyotard, J.-F. (1979) *La Condition Postmoderne: Rapport sur le Savoir*, Paris: Les Editions de Minuit.

Marquis, A. G. (2006) *Art Czar: The Rise and Fall of Clement Greenberg*, Boston, MA: Museum of Fine Arts.

Rajiva, S. (2008) 'Art, Nature, and Greenberg's Kant', *Canadian Aesthetics Journal: The Electronic Journal of the Canadian Society for Aesthetics*, 14, Summer, www.uqtr.ca/AE/Vol_14/modernism/Rajiva.htm (accessed 24.8.11).

Rubenfeld, F. (1997) *Clement Greenberg. A Life*, New York: Scribner.

www.sharecom.ca/greenberg (accessed 24.8.11).

CAMILLA GRAY, *THE RUSSIAN EXPERIMENT IN ART 1863–1922* (1962 AND 1971)

Gray's text was originally published in 1962 as *The Great Experiment: Russian Art 1863–1922*. It was revised and re-titled as *The Russian Experiment in Art 1863–1922* in 1971 and subsequently reprinted in 1986 with notes by Marian Burleigh-Motley.

In the spring of 1971, a strange, red, helical tower loomed over the river Thames, adjacent to London's Hayward Gallery. This reconstruction of Vladimir Tatlin's *Monument to the Third International* heralded the arrival of the landmark exhibition *Art in Revolution: Soviet Art and Design since 1917*.[1] Subsequently acknowledged as highly influential, this Arts Council show owed its inception and ultimate execution in large part to the efforts of Camilla Gray, author of *The Great Experiment: Russian Art 1863–1922*.[2] This groundbreaking book was praised for the hitherto largely unknown, yet 'remarkable' story it told (Bowness 1962: 19). Today, figures such as Tatlin, Malevich, Popova, Rodchenko, El Lissitzky, Larionov and Goncharova are familiar to students of art history and the story of the Russian avant-garde has been re-established alongside the development of modernism. But when Gray's pioneering text was originally published, the scope of this period of artistic exploration remained largely obscure, known only to experts in the west. Even at the time of *Art in Revolution*, it was still a subject shrouded in mystery (Bowlt 2002: 82).

Gray was a passionate young art historian, the daughter of Basil Gray, curator of Oriental Antiquities at the British Museum, and the art scholar and historian of lettering, Nicolete Gray (Stuart 1972: 81). She first travelled to the USSR in 1955, to pursue her ballet training, where she learned Russian. In 1957, aged 21, she began her research into Russian art (Burleigh-Motley 1986: 6–7).[3] Such research was difficult. Travel to the USSR was highly restricted during the Cold War: as John E. Bowlt reminisces, the 'bureaucratic impediments to studying the avant-garde were formidable' (Bowlt 2002: 82).[4] The artistic movements that Gray wished to investigate were condemned by the Soviet authorities. Soviet art historians sidestepped the 'formalist' art of the revolutionary period, portraying it as a misguided, artistic dead end (Lindey 1990: 17). Western scholars had some slight advantage in overcoming the 'formidable' hindrances to researching such art and were permitted to access certain 'illicit' publications forbidden to native researchers (Bowlt 2002: 82). Nonetheless, documentary material on the period was incredibly elusive. Gray explained:

> There has been almost no general account of the period 1910–20 in Russian art and I have had to turn to newspaper articles, unpublished memoirs, recollections of those artists still living – so often contradictory – exhibition catalogues, random references in published memoirs and occasional references in literary histories of the period.
> (Gray 1962: 7; 1986: 280)

She was able to piece together this fragmentary and complex information gleaned from surviving artists, their families and works hidden in family archives (Stuart 1972: 81).

The original 1962 publication was a lavish, large format book, densely illustrated with colour and black and white plates of paintings, graphic design, sculptures, theatre sets, architecture, photography, typography, ceramics, film and costume that were a revelation to readers. It was the first monograph dedicated to the Russian avant-garde; previous histories, such as Tamara Talbot Rice's *Russian Art* (1949) included brief mention of the developments of the Revolutionary period. Alfred H. Barr, the director of the Museum of Modern Art – who offered support to Gray in her writing – had written briefly on the Russian avant-garde in the catalogue for the 1936 exhibition *Cubism and Abstract Art* (Jones 1978: 55). In the 1971 reprint of Gray's book, illustrations were reduced and the biographies and artists' statements removed, though the text remained unaltered. This version was reprinted in 1986 as a small paperback with endnotes placing Gray's findings in the context of more recent scholarship.

Gray's work was inspired by her encounters with the art and ideas of Suprematism and Constructivism. She described her book as 'an attempt to trace back to the roots the ideas which culminated in the pioneer work of Malevich and Tatlin' (Gray 1962: 7; 1986: 280). It follows a broadly chronological structure, the first two chapters summarising the period up to 1905 and the subsequent six chapters focusing in more depth on the years 1905–22. She locates the origins of the modern movement in Russia with the 'Wanderers' and their insistence that art could generate social reform, before moving on to the 'World of Art' (*Mir Iskusstva*) movement and a detailed investigation into the numerous societies and artistic groupings that sprang from it. What follows is the (then largely forgotten) story of new movements – Rayonnism, Constructivism, Futurism, Neoprimitivism and Suprematism – the turbulent relationships between their protagonists, and the creation of a Russia 'in which art was no longer a dream-world ... but became the very stuff of [man's] life' (Gray 1962: 252; 1986: 269).

On publication, it was met with praise for its 'refreshing' contribution to art history, a 'hurly burly' tale of Russian creativity that challenged simplistic narratives of the development of modernism in western Europe, despite its biases (Lindsay 1963/4: 184). Reviewers were grateful to Gray for her determined investigation into a highly productive yet largely ignored phase of artistic endeavour. It helped to re-establish the long-underplayed relationship between European and Russian artists in the first decades of the twentieth century (Weidlé 1963: 564). Much of this material was new: Gray introduced lesser-known figures such as Popova and Rosanova and was commended for her ingenuity in making sense of the complex interactions between different artists (Lindsay 1963/4: 182). Against the background of the Cold War, the Russian avant-garde became celebrated in the west as a short-lived but glorious period of artistic creativity, which was contrasted sharply with the restrictive socialist realism that was to follow (Caute 2003: 12).

Unsurprisingly, given the pioneering nature of its research, there were criticisms of *The Russian Experiment*. The rare and conflicting material diligently analysed by Gray was complicated not only by difficulties of interpretation, but also by the myths created by the artists themselves. Later commentators sympathised with this 'excessively frustrating and thankless task' (Vergo 1976: 531–32). Gray had been aware that there were inevitable errors and generalisations in her writing. She was nonetheless encouraged to publish by Barr, who reassured her that it would form an invaluable basis for future scholarship (Burleigh-Motley 1986: 6). Even at the time of publication, reviewers corrected certain aspects of

her chronology and translations (Chamot 1963: 37) and there were complaints that these inaccuracies were not revised in later editions (Bird 1971: 676; Vergo 1976: 531). The timeframe was questioned, in particular the curtailment of the narrative in 1922. Ending at a triumphant moment in the early 1920s, the book not only implies that the artistic 'experiment' was halted at that date (Taylor 1991: xii), but also omits the 'last sad part of the story' (Bowness 1962: 19). There is a relative absence of émigré artists like Kandinsky whose stories have been assimilated into the art histories of their new homelands (Chamot 1963: 37). Commentators were split between the accessibility of Gray's writing (Lindsay 1963/4: 182) and overly detailed passages and digressions that would have benefited from greater selectivity (Bimholz 1973: 455–56). As Gray did not hold a university degree, it seems unfair to compare her style to the more academic texts that followed.[5] However, Gray's simplified account of a unified group of Constructivists has since been challenged by Lodder's more sophisticated analysis which identifies various interdependent and contrasting versions of the movement (Lodder 1983). Similarly, Gray's limited engagement with the complex theoretical statements of these Russian artists is supplemented by later translations (Bowlt 1988).

Given these reservations, is *The Russian Experiment* still relevant today? It was an innovative first step towards an understanding of a convoluted and obscure episode in the development of modern art (Bowlt 2002: 86). It prompted not only important exhibitions like *Art in Revolution* but also interest in George Costakis' astonishing private collection (Rudenstine 1981). The Russian avant-garde was to become much studied and exhibited in the decades to follow, with major shows like *Paris – Moscou 1900–1930* (Pompidou 1979) extending Gray's timescale. Despite Gray's tragically early death at 35 from hepatitis, shortly after her marriage to Oleg Prokofiev, she is still remembered. In 2009, the Annely Juda Gallery staged the exhibition *The Great Experiment: Russian Art: Homage to Camilla Gray* which celebrated her contribution to art history and the inspiration she provided for the gallery's series of *Non-Objective World* exhibitions from the early 1970s. Whilst some aspects of Gray's book, such as her analysis of Constructivism, have been superseded, she is still praised for her contribution to other movements such as Neoprimitivism. Recent authors have singled out her role in asserting the importance of Goncharova and Larionov (Parton 2010: 467; Sharp 2006). Read in the context of recent, more accurate, publications, it remains an eye-opening and courageous introduction to a captivating subject.

Verity Clarkson

Notes

1 This exhibition later toured the USA and Europe in reduced form.
2 Gray originally proposed it in 1966. Archive of Art and Design, Victoria and Albert Museum ACGB/121/40.
3 Gray had already published on Malevich in *The Times* in 1958. In 1959 she assisted in the preparation of the catalogue for the first British exhibition on Malevich (Whitechapel Art Gallery) and published an article on the then 'forgotten' El Lissitzky. In May 1960 she contributed the article 'The Russian Contribution to Modern Painting' to *The Burlington Magazine*. Gray and Mary Chamot assisted in a retrospective of Goncharova's and Larionov's paintings and theatre designs for the Arts Council in 1961.
4 Bowlt had been a graduate student of Russian culture in Moscow in the late 1960s.
5 This affected Gray's career. Her publisher asked her to write a further book on Constructivism, but although she won a Leverhulme scholarship the British Council couldn't arrange for her student status in Russia without a degree.

Selected bibliography

Annely Juda Gallery (2009) *The Great Experiment: Russian Art: Homage to Camilla Gray*, 29 October–18 December 2009, London: Annely Juda Fine Art.
Bimholz, A. C. (1973) 'Review', *Soviet Studies*, 24.3, January, 455–56.
Bird, A. (1971) 'Review', *Burlington Magazine*, 113.824, November, 676.
Bowlt, J. E. (1988), *Russian Art of the Avant-Garde: Theory and Criticism 1902–1934*, 2nd edition, London: Thames and Hudson.
——(2002) 'Keepers of the Flame: An exchange on art and western cultural influences in the USSR after World War II', *Journal of Cold War Studies*, 4.1, 81–87.
Bowness, A. (1962) 'Why Russian Art Died', *Observer*, 15 July.
Burleigh-Motley, M. (1986) 'Introduction to the Revised Edition', in C. Gray, *The Russian Experiment in Art 1863–1922*, London: Thames and Hudson, 6–8.
Caute, D. (2003) *The Dancer Defects: The Struggle for Cultural Supremacy During the Cold War*, Oxford: Oxford University Press.
Centre Georges Pompidou (1979) *Paris – Moscou 1900–930*, Paris: The Centre.
Chamot, M. (1963) 'Review', *Burlington Magazine*, 113, January, 37–38.
Gray, C. (1962) *The Great Experiment: Russian Art, 1863–1922*, London: Thames and Hudson.
——(1986) *The Russian Experiment in Art 1863–1922*, revised and enlarged edition by Marian Burleigh-Motley, London: Thames and Hudson.
Hayward Gallery (1971) *Art in Revolution: Soviet Art and Design Since 1917*, London: Arts Council.
Jones, E. (1978) 'A Note on Barr's Contribution to the Scholarship of Soviet Art', *October*, 7, Winter, 53–56.

Lindey, C. (1990) *Art in the Cold War: From Vladivostok to Kalamazoo, 1945–1962*, London: Herbert.

Lindsay, Kenneth C. (1963/4) 'Review', *Art Journal*, 23.2, Winter, 182–84.

Lodder, C. (1983) *Russian Constructivism*, New Haven, CT: Yale University Press.

Parton, A. (2010) *Goncharova: The Art and Design of Natalia Goncharova*, Woodbridge: Antique Collectors' Club.

Rudenstine, A. Z. (ed.) (1981) *Russian Avant-Garde Art: The George Costakis Collection*, London: Thames and Hudson.

Sharp, J. A. (2006) *Russian Modernism between East and West: Natal'ia Goncharova and the Moscow Avant-garde*, Cambridge: Cambridge University Press.

Stuart, J. (1972) 'Camilla Gray – Obituary', *Design*, April, 81.

Taylor, B. (1991) *Art and Literature under the Bolsheviks. Vol.1, The Crisis of Renewal, 1917–1924*, London: Pluto Press.

Vergo, P. (1976) 'Review', *Burlington Magazine*, 118.880, July, 531–35.

Weidlé, W. (1963) 'Review', *Slavic Review*, 22.3, September, 562–64.

JOHN SZARKOWSKI, *THE PHOTOGRAPHER'S EYE* (1966)

John Szarkowski, *The Photographer's Eye*, New York: The Museum of Modern Art, 1966.

From the mid-1960s to the mid-1980s, John Szarkowski was, as the photo historian Joel Eisinger puts it, 'the most powerful person in American photography' (Eisinger 1999: 210). Szarkowski was appointed director of the photography department at New York's Museum of Modern Art in 1962 and in the book *The Photographer's Eye* he set out his first theoretical statement about photography, in which he presents a formalist approach.[1] Echoing Clement Greenberg's medium-specific account of painting, Szarkowski declared photography was to be understood only in terms of qualities unique to photography.

He described the book's purpose as 'an investigation of what photographs look like, and of why they look that way' (Szarkowski 1966: 6). Szarkowski likened photography to a natural rather than cultural phenomenon; independent, unique, its identity understood not through any relation to traditional pictorial and aesthetic categories, but through its inherent properties – 'Like an organism, photography was born whole' (Szarkowski 1966: 11). The history of photography – which is seen as centrifugal, not linear and consecutive – is approached in terms of 'photographers' progressive awareness of characteristics and problems

that have seemed inherent in the medium' (Szarkowski 1966: 7). *The Photographer's Eye* identifies five such issues: 'The Thing Itself', 'The Detail', 'The Frame', 'Time' and 'Vantage Point'. These core formal categories structure the grouping of the pictures in the book and help 'the formulation of a vocabulary and a critical perspective more fully responsive to the unique phenomena of photography' (Szarkowski 1966: 7).

Painting and photography are thus separate and distinct for Szarkowski. In setting up an opposition, he implies a distinction in subject matter – photography was suited to more everyday and commonplace subject matter, it pictured a world of things often ignored by painters:

> Painting was difficult, expensive, and precious, and it recorded what was known to be important. Photography was easy, cheap and ubiquitous, and it recorded anything: shop windows and sod houses and family pets and steam engines and unimportant people.
>
> (Szarkowski 1966: 7)

Once photographed, the everyday and lowly was nevertheless seen to be given distinction: 'trivial things took on importance' (Szarkowski 1966: 7).

The book cover of *The Photographer's Eye* shows an anonymous picture, circa 1910, of a bedroom interior. It is rich in the kind of everyday, commonplace details that marked photography out as distinct: the chipped metal bedstead, the brush, candle, books and ornaments on the dresser, the arrangement of family photographs on the wall, the towels over the small sink and the more incongruous detail of the eye chart pinned to the back of the door, a detail which reiterates the import given to seeing in the book's title. It is one of twenty-five anonymous photos that are included among the 172 gravure illustrations in the book. Such anonymous and vernacular photographs are integral to Szarkowski's thesis, giving visual support to his claim that photography is possessed of an aesthetic intrinsic to the medium, derived from its unique formal and physical properties. Photography's inherent characteristics could be discovered in any kind of photograph. During the nineteenth century, as Szarkowksi points out, most of the best work was done by artistically untrained photographers. Traditional pictorial standards were believed to hinder the photographer's capacity to learn from the medium itself. Szarkowski thought the more meaningful photography came from the amateur, because it was the 'artistically ignorant, who had no old allegiances to break' (Szarkowski 1966: 6).

Interest in vernacular photographs is also related to John A. Kouwenhoven's 1948 study *Made In America*, acknowledged in the

introduction to *The Photographer's Eye*. Kouwenhoven argued for a uniquely American vernacular culture, characterised by a plain and simple functional aesthetic. Szarkowski said it was Kouwenhoven's book that suggested that 'the study of photographic form must consider the medium's "fine art" tradition and its "functional" tradition as intimately interdependent aspects of a single history' (Szarkowski 1966: 4).Yet this ignores the fact that Kouwenhoven distinguishes between a vernacular 'functional' American aesthetic and ornate European design. While Szarkowski mixes photographs by established and emerging art photographers with pictures by unknown amateurs, studio portraitists, reporters and jobbing photographers, he nevertheless excludes such pictorialist and 'fine art' photographers as Peter Henry Emerson, Hill and Adamson, Alfred Stieglitz and Ansel Adams. The art photography he celebrates – the work of Lee Friedlander, Garry Winogrand, Robert Frank, Walker Evans, André Kertész, Paul Strand and Henri Cartier-Bresson – accords with his idea that 'The photographer's vision convinces us to the degree that the photographer hides his hand' (Szarkowski 1966: 12). In his 1971 book on Walker Evans, a photographer that very much came to epitomise Szarkowski's aesthetic, he said how 'artiness refers to an exaggerated concern for the autographic nature of a personal style' (Szarkowski 1971: 10).

Greenberg's formalism championed abstract painting, an art that avoided reference to the outside, social world. Szarkowski's formalism is fundamentally different in that his argument is put forward in relation to a medium that was dependent upon actuality. Photography's salient characteristic is to do with its close relationship to the phenomenal world and its 'terrible truthfulness' (George Bernard Shaw quoted in Szarkowski 1966: 23). Szarkowski disdained manipulated photographs, pointing out in the introduction, how photographic artifice, the elaborate montages of Henry Peach Robinson and Oscar Rejlander, were all 'recognised in their own time as pretentious failures' (Szarkowski 1966: 9).

In the section 'The Thing Itself', Szarkowski suggests the photographer had to learn 'that the world itself is an artist of incomparable inventiveness' (Szarkowski 1966: 8). Of course, the photographer's pictures are a different 'thing' than the reality itself: 'Much of the reality was filtered out in the static little black and white image' (Szarkowski 1966: 8). But what photography enabled was a greater attention to the details of things in the world: while trained artists might draw a head or hand from a dozen perspectives, the photographer 'discovered that the gestures of a hand were infinitely various, and that the wall in the sun was never twice the same' (Szarkowski 1966: 9).

One of the key arguments Szarkowski puts forward is that photography cannot narrate. In the section 'The Detail' he references works by Roger Fenton of the Crimean War and the Brady group of the American Civil War, and describes how the photographers could not explain what was happening. Tied to the facts of things, the photographer cannot, outside the studio, pose the truth, he can only:

> record it as he found it, and it was found in nature in a fragmented and unexplained form – not as a story, but as scattered and suggestive clues.
>
> (Szarkowski 1966: 9)

The photograph cannot narrate, because the photographer 'could not assemble these clues into a coherent narrative', all they can do is to 'isolate the fragment, document it, and by so doing claim for it some special significance, a meaning which went beyond simple description' (Szarkowski 1966: 9). Recourse to the symbolic detail becomes the photographer's only means of commenting on what is depicted.

Photographs quote out of context – they are not conceived but selected, the subject is thus 'never wholly self-contained' (Szarkowski, 1966: 9). 'The Frame' deals with the implications and importance of the framing edge within photography – the importance of what is in and out of frame and how this edge 'defines content' (Szarkowski 1966: 70). Here, Szarkowski reviews the probable influence on late nineteenth century painting of photography through the awareness of the edge as a cutting device – even suggesting that if the Japanese print might explain painters' recourse to the frame as a cropping edge, it was the photographic image that had prepared the ground for an appreciation of Japanese prints!

Photography's uniqueness is that 'it describes only that period of time in which it was made' (Szarkowski 1966: 10). Photography can allude to the past and future 'only in so far as they exist in the present, the past through surviving relics and the future through prophesy visible in the present' (Szarkowski 1966: 10). In this section, 'Time', with examples drawn from science, art and documentary, he makes the point that we have misunderstood Henri Cartier-Bresson's 'decisive moment'. The particular effect of such photographs is primarily formal:

> a pleasure and a beauty in this fragmenting of time that had little to do with what was happening. It had to do rather with seeing the momentary patterning of lines and shapes that had been previously concealed within the flux of movement.
>
> (Szarkowski 1966: 10)

Thus the 'decisive moment' is not about understanding an event, the isolation of a moment out of the temporal flow, is not 'a dramatic climax' but a visual climax: 'The result is not a story but a picture' (Szarkowski 1966: 10).

In the last category, 'Vantage Point', Szarkowski's selection illustrates things depicted from differing perspectives and viewing positions. As well as the differing ways in which photographers have obscured or concealed their subject matter in their pictures, it celebrates photography's impact on our ordinary habits of vision, showing that 'photography's ability to challenge and reject our schematized notions of reality is still fresh' (Szarkowski 1966: 11).

It is very much the wonderment and surprise that photography can entail that excites Szarkowski. Freed from the constraints of context and history, photographs are chosen from a century and a quarter of its history very much according to Szarkowski's own aesthetic criteria.

In the introduction to *Looking at Photographs* (1973), where he discusses his choice of 100 pictures from the collection of MoMA, he defines photography's difficulty for traditional art historical study. This concerns '[t]he commonplaceness of photography' and 'the radical differences between it and the traditional arts' (Szarkowski 1973: 9). In *The Photographer's Eye* Szarkowski shaped a particular formalist approach to the medium, concentrating on what he felt defined photography as photography. His essay is valuable in establishing and shaping what was to become an extraordinarily influential approach to photography, one which helped establish and secure its status within the museum. It also marked the curator's emergence as a powerful authorial figure and arbiter of value. Szarkowski's approach was nevertheless always partial and selective: a bias revealed in *The Photographer's Eye* with its clear preference for a certain kind of photography, non-arty, unembellished, close to the everyday and commonplace in subject matter, and the unpretentious, unassuming pictures made by the journeyman worker or Sunday hobbyist.

Mark Durden

Note

1 The book was based on an exhibition of the same name held at MoMA in 1964.

Selected bibliography

Durden, M. (2006) 'Eyes Wide Open: Interview with John Szarkowski', *Art In America*, May, 94.5, 83–87, 89.

Eisinger, J. (1999) *Trace and Transformation: American Criticism of Photography in the Modernist Period*, Albuquerque: University of New Mexico Press.

Green, J. (1984) *American Photography: A Critical History: 1945 to the Present*, New York: H. N. Abrams.

Kowenhoven, J. A. (1948) *Made in America*, New York: Doubleday.

Malcolm, J. (1997) *Diana and Nikon: Essays On Photography*, New York: Aperture.

Phillips, C. (1989) 'The Judgment Seat of Photography', in Richard Bolton (ed.) *The Contest of Meaning*, Cambridge, MA: MIT, 15–47.

Szarkowski, J. (1966) *The Photographer's Eye*, New York: The Museum of Modern Art.

——(1971) *Walker Evans*, New York: The Museum of Modern Art.

——(1973) *Looking at Photographs*, New York: The Museum of Modern Art.

GUY DEBORD, *THE SOCIETY OF THE SPECTACLE* [*LA SOCIÉTÉ DU SPECTACLE*] (1967)

Guy Debord, *The Society of the Spectacle*, London: Rebel Press, 2005.

The Society of the Spectacle was as an avant-garde polemic against western capitalist society and its increasing commodification. Guy Debord (1931–94) adapted a Marxist framework, re-fashioning it as a cultural critique of contemporary society. The book's subversive tone echoed the disruptive and critical strategies of early modernist movements and their manifestos, such as the 'classic avant-gardes' Dadaism, Surrealism and Constructivism (Plant 1992: 3; Bürger 1984: 58). It simultaneously described revolutionary events and society with academic aplomb, whilst melodramatically prescribing the remedy for society's ills. The book comes to life as an oppositional textual 'performance', presenting the reader with the problematic of how to handle its differing authorial voices.

Debord's polemic railed against capitalism and its relationship with the hegemonic phenomena of the 'media' as an autonomous spectre of control. It accurately predicted commodity consumption as part of a 'counterfeit life' relating the things we have, our behaviours, relationships and aspirations within the theatre of visual culture (Debord 2005: 24). The text relentlessly criticises the inter-relationship of the media and capitalism and their slow erosion of an authentic human subjectivity. It stigmatises a culture of passive, sedated, gorging and satiated viewers, defined by representations: spectacles of artificiality that engulf and insidiously become our desires. For Debord such desires played out a pseudo-life within the closed-circuit structures of capitalism and our social subjectivity (Plant 1992: 68).

Debord's 'spectacle' exists within 'representation' and is closely asso-
ciated with what is visually communicated through the arts, media and
advertising. His central conviction is that spectacle represents something
where implicit and explicit concepts or ideologies are treated as 'real' by
the viewer. Consequently, human interaction and behaviour becomes
'reified'. The spectacle's effect on the viewer is primarily to create
desire – to be or to have in relation to what is seen (Debord 2005).
Roland Barthes used the idea of the spectacle in his structuralist essay
'The World of Wrestling' (1972) in which the spectacle is tied to the
coded drama represented by the play acting of wrestlers in a ring. He
unpicks the theatrical scene presented to the audience, commenting on
how the image produces 'a light without shadow' which 'generates an
emotion without reserve' – the audience getting all worked up over
'nothing' (Barthes 1993: 15).

Debord associates the notion of the spectacle with the Baroque. For
example, the drama of Bernini's *Ecstasy of St Theresa* (1647–52) is
orchestrated by a type of 'spot light' built into the chapel's structure
within which it resides, where natural light illuminates the enraptured
figure carved from hard, cold marble. The iridescence of this visual
mirage is hypnotic; time stands still as the viewer becomes paralysed by
the scene's iconography. For Debord, structuralism is a sort of fruitless
'frigid dream'. His metaphor connects with Bernini's Baroque treatment
of religious vision and ecstatic martyrdom as 'religious illusion' (Plant
1992: 12). He conceives the inherent ideology connected to structural-
ism (like Bernini's sculpture) as a sham of connivance and seemings,
ultimately revealing nothing (Debord 2005: 111). Sadie Plant highlights
the manner in which Debord identifies how the church uses devices
within arts and culture which:

> encourage the separation of body and soul, the demands of sacrifice
> and deferred gratification which marked pre-capitalist society are
> now redeveloped to produce the same experiences of removal,
> alienation and mystification.
>
> (Plant 1992: 12)

Debord also links the spectacle's relationship to cultural celebrity where
'the star' of the show becomes a 'homogenised' product of culture and
an 'enemy of individuality' (Debord 2005: 29). Such ideas can be found
in the recent phenomena of Saturday Night TV entertainment such as
The X Factor, where the audience is complicit with the simulated reality
of televisual spectacle. These are contemporary reminders of how
Debord's ideas remain prescient and relevant. The 'carved out'

contestants become subjects of a 'fad' which disappears as quickly as it is born. This analogy might be extended to the fashion for 'blockbuster' art exhibitions and film releases, part of a global 'culture industry' (Adorno and Horkheimer 1947 [1986]). For Debord such developments evidenced a culture in stasis, the viewing public having become pathologised as the 'undead' in whom 'the spectacle is a concrete inversion of life, an autonomous movement of the unliving' (Debord 2005: 7). The artist Peter Halley's (b. 1953) essay 'The Frozen Land' (1984) parallels Debord's notion of a surrounding spectacle with the idea of society trapped in a tundra of simulated and hollow visual images. In this scenario, the 'undead' comprise an audience visually transfixed, glued to the 'telly' in a type of 'seizing away of lived experience' (Halley 1984: 1).

Debord was involved with The Situationist International (SI), a 'proletariat' of artists, agitators and political theorists. The SI critiqued consumerism, art, architecture, urbanism and contemporary culture, although its adherents were often reluctant to rationalise their activities and writing. Such refusals are evident in the reading of Debord's text and may be understood as the book's deliberate strategy of ideological and textual 'offence'. The deliberate evasion which situates issues of intention, is a prominent tactic deployed as an attack against the hegemony of representation and meaning within culture. This accounts for some of the difficulties the reader is presented within the text's content and its often playful, contradictory forms.

The terms '*dérive*' and '*détournement*' are central to Debord's text. For him, '*dérive*' is a type of aimless drifting and '*détournement*' a diversionary strategy where the subversive use of art and ideas, as a type of 'ironic quotation', is used to challenge authority (Plant 1992: 86). These terms are theoretical scaffolds that shape the book's meaning and structure and which have informed subsequent interventions in art and criticism such as those found in Nicolas Bourriaud's *Relational Aesthetics* (1998 and 2002). The book's format deploys an approach which is relevant to the concept of the '*dérive*', comprising a series of enigmatic chapters with lengthy passages or dualistic and elliptical incidental commentary which on first reading are evasive and difficult to grasp. An example is where he discusses the spectacle as 'true in a moment of the false' (Debord 2005: 9). In this instance, there is a sense of play, understood in its true sense of drifting and ambiguity (Winnicott 1991). Debord employs other writing strategies to keep up the game; for example, some short sections fragment the flow of ideas. This decadent 'incidental form' and the split of content between more concrete discussion, allows the reader to approach the book more informally, to dip in and out of ideas or to meander through its plethora of associations. The reader is encouraged

to mirror the cultural activities which Debord critiques – window shopping and channel hopping, or the aesthetic effects of Surrealist automatism, collage and bricolage (Plant 1992: 59). From this rather artificial activity of reading as drifting – the *'dérive'* – comes a sort of 'foam' of knowledge, a pollutant and subject to dispersal. As a result the text becomes what it is trying to describe – a 'monopolizing force' (Debord 2005: 8).

Flickering in the sidelines of the book's 'timbre' and commentary are the voices of the avant-garde – the aggressive rallying cries of manifestos and statements – variously appropriated to different ends and degrees. Plant also recognises that it is 'full of Hegelian turns of phrase and vaguely familiar transpositions of the work of Marx and Lukács' (1992: 8) Plagiarism becomes an anarchic practice proclaiming the revolution; theory is subject to practice, history and vices, and is effectively legitimised – 'Plagiarism is necessary, progress depends on it' (Debord 2005: 114). This attachment to plagiarism as a form of contest and revision of cultural structures echoes many of the debates Debord uses to emphasise or critique notions of originality as a 'grand narrative' (Lyotard 1984) and in relation to the idea of the 'text' as a type of empty copy or layering of quotations (Barthes 1978).

The Society of the Spectacle's epigrammatic format foregrounds many other themes and trajectories within postmodern discourse. In particular, Debord's text relates to structures of representation (Owens and Bryson 1994) and interpretations of reality (Baudrillard) (Ward 1997). Since publication, his intervention has become ever more relevant to a commodified culture. Frequently self-referential, sub- and popular cultural forms, including art and art writing, have responded to, and mediated, aspects of Debord's text. In turn these have been 'recuperated' (as Debord 'recuperated' 'the rhetoric of the revolution' (Plant 1992: 85)) and have been wrapped up in a populist conversation that acknowledges the power and extent of representation within lived experience. The ways in which Debord's book and its message have been used as theoretical, critical, artistic and commercial leverage have been revised and updated by culture's incessant outpouring and are often highly relevant to political epistemes. Some of the best and most pertinent commentaries can be found in Sadie Plant's book on the Situationists (1992). One example of biographical coverage is Kaufmann (2006).

Debord's original disorderly tract, re-considered after its author's suicide in 1994, has been mediated through a communal nostalgia for the revolution predicted in its form and content. What this implies for the future is still in 'production'.

Kath Abiker

Selected bibliography

Adorno, T., and Horkheimer, M. (1947[1986]) *Dialectic of Enlightenment*, London: Verso.

Barthes, R. (1978) *Image, Music, Text*, New York: Hill and Wang.

——(1993) *Mythologies*, London: Vintage.

Bourriaud, N. (2002) *Relational Aesthetics*, Paris: Les Presses du Reel.

——(2002) *Post Production*, New York: Lukas and Sternberg.

Bürger, P. (1984) *Theory of the Avant-Garde*, trans. Michael Shaw, Minneapolis: University of Minnesota.

Debord, G. (2005) *The Society of the Spectacle*, London: Rebel Press.

Halley, P. (1984) 'The Frozen Land', *ZG*, 12, November, New York, www.peter halley.com/ARTISTS/PETER.HALLEY/FROZEN.LAND.FR2.htm (accessed 24.8.11).

Kaufmann, V. (2006) *Guy Debord: Revolution in the Service of Poetry*, trans. Robert Bononno, Minneapolis: University of Minnesota.

Lyotard, J. F. T. (1984) *The Postmodern Condition: A Report on Knowledge*, Manchester: Manchester University Press.

Owens, C. and Bryson, S. (1994) *Beyond Recognition: Representation, Power and Culture*, Berkeley: University California Press.

Plant, S. (1992) *The Most Radical Gesture: The Situationist International in a Postmodern Age*, New York: Routledge.

Taylor, B. (2005) *Art Today*, London: Laurence King.

Ward, G. (1997) *Teach Yourself Postmodernism*, London: Hodder Headline.

Winnicott, D. W. (1991) *Playing and Reality*, New York: Routledge.

Situationist International Anthology, www.bopsecrets.org/SI/index.htm (accessed 24.8.11).

MICHAEL FRIED, 'ART AND OBJECTHOOD' (1967)

Michael Fried, 'Art and Objecthood', *Artforum*, 5, June 1967, 12–23. Reprinted in G. Battcock (ed.), *Minimal Art: A Critical Anthology*, New York: E. P. Dutton, 1968, 116–47.

Few texts of the last half-century have been so frequently anthologised or discussed as this powerful and eloquent essay, published in June 1967 in the New York journal *Artforum*, at that time and subsequently perhaps the most closely followed English-language journal for critical debate about new art, albeit one with a focus on achievements in American art of both East and West coasts, as well as European modernism. By no means the earliest of Michael Fried's (b. 1939) statements on the art of his time, 'Art and Objecthood' found its voice both in what it supported and in what it wished to oppose.

Published at a time of maximum intensity in New York debate, 'Art and Objecthood' defends the work of Frank Stella, Anthony Caro and others against what Fried saw as a pervasive tendency to treat art-works as objects, specifically objects that address a beholder in a manner that he calls 'theatrical'. His immediate targets were the art and writing of two influential contemporaries working outside the traditional confines of painting and sculpture: Donald Judd's (1928–94) floor pieces and his essay 'Specific Objects' (1965), and Robert Morris's plywood sculptures and the first two of his 'Notes on Sculpture' essays (1966). Both artists had shunned what they termed 'relational' or 'compositional' art in the European mould in favour of fairly mute symmetrical 'things' whose main function, in Judd's terminology at least, was to be 'interesting'. Those artists had recently been dubbed 'Minimalists'. Fried here calls them 'literalists', and complains that literalist art is concerned solely with the circumstances in which the beholder encounters the work; that the experience of art is of an object *'in a situation* – one that, virtually by definition, *includes the beholder*' (Fried 1968: 125), whereas genuinely modernist art distinguishes itself by seeking a new relation to the beholder in which an appeal to the beholder's presence (Fried never quite says it in 'Art and Objecthood') is one in which acknowledgement of that presence is at the same time, and paradoxically, obviated or denied. It is in that sense, he argues, that the limited purpose of literalist art is to espouse objecthood as such, which 'amounts to nothing other than a plea for a new genre of theatre; and theatre now is the negation of art'.

A second emphasis in 'Art and Objecthood' is that 'literalist' art distorts or degrades modernism by addressing the beholder in the medium of real time, that of 'duration', unlike painting and sculpture of the highest quality in modernism that through its 'self-imposed imperative ... defeats or suspends its own objecthood through the medium of shape' (Fried 1968: 125). A modernist painting must 'compel conviction as shape' (Fried 1968: 120): Fried's reference here is to the recent shaped canvases of Frank Stella, and the relation of surface to margin in the paintings of Kenneth Noland (1924–2010) and Jules Olitski (1922–2007). In order to defeat literalism, modernist painting and sculpture must convince, and do so 'instantaneously'. It should aspire to 'the condition ... of existing in, indeed of secreting or constituting, a continuous and perpetual *present*' (Fried 1968: 140). The term Fried does not use, but would do subsequently, is 'absorption': a work's self-containment and very lack of theatricality that is the basis of its address to a modernist beholder.

Fried's own background as a critic is relevant here. He and the young Frank Stella were students together at Princeton in the late 1950s, and with the encouragement of the painters Walter Darby Bannard (b. 1934)

and Stephen Greene (1917–99) came to know and admire the writings on art of Clement Greenberg, then and subsequently, for Fried, the most important critic of painting and sculpture in America. Time spent in Europe in the early 1960s acquainted Fried with the practice of the British sculptor Anthony Caro, the writings of Maurice Merleau-Ponty (1908–61), and paintings of the French tradition. He returned to the USA to study art history and to write further criticism, now stimulated by a friendship with the philosopher Stanley Cavell, himself in thrall to the later works of the Austrian philosopher Ludwig Wittgenstein (1889–1951), notably the *Philosophical Investigations*, published in English in 1958. In his early years as a critic, Fried wrote shorter pieces on Caro, Larry Poons, Donald Judd and others, and wrote the influential catalogue for *Three American Painters: Kenneth Noland, Jules Olitski, Frank Stella* for the Fogg Art Museum, Harvard, in 1965. Fried has said of his writing at the time of 'Art and Objecthood' that 'my dream was to bring together Merleau-Ponty's concern with modes of being in the world with a savour of Wittgenstein's "grammatical" investigations'. This might be understood as referencing Wittgenstein's interest in the relation between 'essences' and 'criteria' for things, and the ordinary grammatical conventions of a language and culture that reveal deep structures of thought (Fried 1998: 31). Against that backdrop, 'Art and Objecthood' can be seen as part of an attempt to achieve through philosophical reasoning as well as the experience of new art what relativising or anti-essentialising criticism denied and still denies, namely the existence of 'one or more basic conventions within a pictorial or sculptural tradition' (Fried 1998: 33).

From the date of its publication, 'Art and Objecthood' has attracted commentary from some of the foremost critics and writers of Fried's generation, including Robert Smithson (1938–73), Stephen Melville, T. J. Clark, Rosalind Krauss, W. J. T. Mitchell, and the philosopher Robert Pippin: a selection of their responses is listed below. A persistent theme of this commentary has been the relation between art-criticism and Fried's growing commitment to art history. Fairly soon after 'Art and Objecthood' was published Fried became demonstrably interested in problems of historical French modernism, going on to publish an important trilogy on French painting from the time of the emergence of Jean-Baptiste Greuze (1725–1805) in the mid-1750s to Édouard Manet (1832–83) and the Impressionists in the 1860s and 1870s: namely *Absorption and Theatricality: Painting and Beholder in the Age of Diderot* (1980), *Courbet's Realism* (1990) and *Manet's Modernism, or, the Face of Painting in the 1860s* (1996). To the accusation that his art-critical and historical writings are preoccupied with the same relation, that of the 'absorbed' work of art and its appeal to the viewer by paradoxically

seeming to deny that the viewer is there, Fried's response has been to strenuously deny the connection. This distinction between the values of art history and those of art-criticism derive from Greenberg. There is, Fried says, 'an unbridgeable gulf between the historian of the French anti-theatrical tradition and the author of "Art and Objecthood"' (Fried 1998: 51): the former assembles facts and makes no judgements, the latter evaluates and responds. By his own admission, the watershed was 'around 1960 ... [when] time undergoes a twist' (Fried 1998: 52) and historical turns into contemporary art. This now appears a somewhat arbitrary date, given the weight of importance attached to the question. Says Fried a little more candidly, at the time of 'Art and Objecthood' and related essays, 'I was a Diderotian critic without knowing it' (Fried 1998: 2).

On any account, to read 'Art and Objecthood' today is to reprise and resume a powerful debate on the nature of the modernist art-object, its surface in the case of paintings and its material in the case of sculptures, and the relation of the properties of both to the viewer's apprehension of the work – all concerns, incidentally, that had been fully rehearsed by the Russian Constructivists between 1918 and 1921 and then largely forgotten. Perhaps 'Art and Objecthood' will now seem dated to some, in as much as its emphasis on 'shape' no longer echoes the concerns of painters or sculptors working now. Second, the unmistakeably gendered language of Fried's attack on 'literalism' will give rise to misgivings amongst feminists and others. 'Someone has merely to enter the room in which a literalist work has been placed ... as though the work in question has been *waiting* for him', Fried wrote in the article:

> And inasmuch as literalist work *depends* on the beholder, is *incomplete* without him, it *has* been waiting for him. And once he is in the room the work refuses, obstinately, to let him alone – which is to say, it refuses to stop confronting him, distancing him, isolating him.
>
> (Fried 1968: 140)

Fried seems to conflate the kind of presence offered by a literalist work with that offered by a seductive woman to a predatory male. Third, at least to those in thrall to an idea of the 'radical globalisation' of recent art, 'Art and Objecthood's obvious dialectical relation to a single cultural tradition, that of France, will appear a limitation as much as a source of insight – as if the canon of European modernism remains where it always was.

To Fried's defenders, meanwhile, 'Art and Objecthood' can be credited with having successfully launched concerns about the appeal of the

modernist art-work and the temporality of the artistic encounter that still have by no means been resolved. Robert Smithson cleverly wrote of Fried in 1967:

> He is a naturalist who attacks natural time. Could it be there is a double Michael Fried – the atemporal Fried and the temporal Fried?
> (Smithson 1967: 104)

By any measure, 'Art and Objecthood' remains a landmark text from an important era in American art, written at a suitably high level of abstraction, in which philosophical concerns and the practical experience of art come forcefully together. Fried has recently extended his interest in 'absorptive' visual effects to the genre of wall-mounted photographic art by the likes of Cindy Sherman, Jeff Wall, Thomas Struth and Hiroshi Sugimoto.

Brandon Taylor

Selected bibliography

Cavell, S. (1962) 'The Availability of Wittgenstein's Later Philosophy', reprinted (1969) in *Must We Mean What We Say? A Book of Essays*, New York: Scribner.

Clark, T.J. (1982) 'Clement Greenberg's Theory of Art', *Critical Inquiry*, September, 139–56.

Fried, M. (1966), 'Shape as Form: Frank's New Paintings', *Artforum*, 5, November, 18–27.

——(1968) 'Art and Objecthood', in G. Battcock (ed.), *Minimal Art: A Critical Anthology*, New York: E. P. Dutton, 116–47.

——(1998) 'An Introduction to my Art Criticism', in *Art and Objecthood: Essays and Reviews*, Chicago: University of Chicago Press, 1–74.

——(2008) *Why Photography Matters As Art As Never Before*, New Haven, CT: Yale University Press.

Melville, S. (1981) 'Notes on the Reemergence of Allegory, the Forgetting of Modernism, the Necessity of Rhetoric, and the Conditions of Publicity in Art and Criticism', *October*, 19, Winter, 55–92.

Merleau-Ponty, M. (1960) 'Indirect Language and The Voices of Silence', in *Signs*, trans. R. C. McCleary, Evanston, IL: Northwestern University Press, 39–83.

Mitchell, W. J. T. (1996) 'What Do Pictures *Really* Want?', *October*, 77, Summer, 71–82.

Pippin, R. (2005) 'Authenticity in Painting: Remarks on Michael Fried's Art History', *Critical Inquiry*, 31, Spring, 575–98.

Smithson, R. (1967) 'Letter to the Editor', *Artforum*, October, reprinted in J. Flam (ed.) (1996), *Robert Smithson: The Collected Writings*, Berkeley: University of California Press, 103–4.

JULIA KRISTEVA, 'LA JOIE DE GIOTTO' ['GIOTTO'S JOY'] (1972)

Julia Kristeva 'La joie de Giotto' *Peinture*, 2/3, January 1972, 35–51. The English translation used is in Julia Kristeva *Desire in Language*, New York: Columbia University Press, 1980, 210–36.

Julia Kristeva's article, 'Giotto's Joy', first published in French in *La Peinture* in January 1972, is one of the clearest expositions of her account of revolutions in the history of art based in her theory of the semiotic. She developed this theory in the course of graduate work with the Romanian philosopher and sociologist, Lucien Goldman, and with the French literary theorist and semiotician, Roland Barthes.

Also crucial to Kristeva's theory of the semiotic is her interest in Freudian and post-Freudian psychoanalysis of which she is now a practitioner in Paris. Psychoanalytic influences on her theory include Freud's (1900) theorisation of the transformation of primary, wish-fulfilling, unconscious mental process into secondary, reality-orientated, conscious mental process in the creation of dreams; Freud's (1910) illustration of this transformation in recounting the genesis of Leonardo da Vinci's painting, *Madonna and Child with St Anne*; Freud's (1911) account of the transformation of unconscious fantasy into art; Freud's (1930) account of the infant's illusory oneness with its mother's breast; Lacan's (1949) theory of the infant's entry into language via illusory oneness with its reflected mirror image; and Winnicott's (1953) claims regarding infant babbling and other bodily phenomena as pre-symbolic precursors of art.

Kristeva begins 'Giotto's Joy', however, with the precursors of the revolution brought about by Giotto in the history of art. She notes, for instance, thirteenth century Byzantine mosaics in St Mark's Church in Venice depicting 'detailed scenes and sequences of dramatic and pathetic scenes without any comprehensive narrative to seal the entire fate of a particular character' (Kristeva 1980: 212). She then turns to the revolutionary aspect of Giotto's frescoes, completed in about 1305 along the side walls of the Scrovegni or Arena Chapel in Padua, showing a sequence of scenes depicting the fate of particular characters, namely the birth, life, and death of the Virgin Mary and Jesus.

Kristeva then contrasts these depictions of 'narrative symbolic sequence' with the emergence of unconscious fantasy in the form of 'naked bodies, violence, sex, death' in Giotto's depiction of hell on the Arena Chapel's end wall, where outlines of figures are 'blurred', colours

'disappear' 'weaken' or 'darken', and the 'distinct architecture' of Giotto's frescoes on the chapel's side walls gives way to 'discontinuity, curves, and chaos' (Kristeva 1980: 213).

Giotto's revolution in the history of art also included, Kristeva continues, bringing the semiotic together with the symbolic through uniting colour with narration, shaped by the 'theological norm' of his time (Kristeva 1980: 215). Pointing this out, she also explains that aesthetic norms can become tired and lifeless. Freud (1915) noted a similar fate befalling philosophical abstraction and schizophrenic fixation to words and symbols as things. He attributed their lifelessness to thought, based in words, becoming divorced from the 'perceptual residues' of the energy attached to things in the unconscious before they are attached to words in the preconscious mind. When this happens, he argued, these perceptual residues can only become conscious through acquiring new perceptual 'qualities' (Freud 1915: 201, 202).

Quoting this approvingly, Kristeva argues that colour provides the necessary 'qualities' in painting (Kristeva 1980: 217). Through colour Cézanne, Matisse, Mondrian, and Rothko sought to bring life back to painting. Hence, she adds, Matisse's claim that, when painting's means of expression become too attenuated, this necessitates a 'return to the essential principles which made human language', namely, said Matisse, 'beautiful blues, reds, yellows – matters to stir the sensual depths in men' (Matisse 1936: 74). 'As the dialectical space of a psycho-graphic equilibrium, color therefore translates an oversignifying logic in that it inscribes instinctual "residues" that the understanding subject has not symbolized', Kristeva comments (1980: 221).

No wonder, therefore, that the blue of Giotto's frescoes is the first colour to strike visitors entering the semi-darkness of the Arena Chapel. For blue is one of the first colours to appear before sunrise. It is also one of the first colours we perceive as babies. Blue thus returns us to the semiotic process of becoming an individual by breaking away from 'instinctual, biological (and also maternal) dependence' before entering the mirror stage postulated by Lacan as a precondition of psychological entry into the symbolic (Kristeva 1980: 225).

Elsewhere Kristeva argues that Artaud, Mallarmé, and other avant-garde writers revolutionised writing in the early twentieth century with their use of 'instinctual drive, phonic differentials, intonation, and so on' (Kristeva 1980: 174). In 'Giotto's Joy' she argues that Giotto similarly revolutionised Christian painting in the early fourteenth century by using not phonic, of course, but colour differentials. She illustrates this with Giotto's depiction in the Arena Chapel of scenes from the life of the Virgin Mary:

The blue field dominates the scenery. The oblique or frontal planes of the blocks stand out from this background either through the use of colors close to blue (green, grayish-green: for example, in *The Annunciation to Anna*) or contrasting with it (rose and pinkish gray, for example, in *The Meeting at the Golden Gate*; or gold and golden-rose in *The Betrothal of the Virgin*). ... [T]he antagonistic space of the overlapping, fragmented blocks is achieved through the confrontation of colored surfaces: either through colors of the same hue with the addition of complementary tones (for example, the pink roof in *The Annunciation to Anna*), or directly through complementary chromatic scales.

(Kristeva 1980: 229)

To this illustration of Giotto's revolutionary use of colour differentials, Kristeva adds a similar use of these differentials in his fresco, *The Massacre of the Innocents*, in Assisi.

She ends 'Giotto's Joy' by returning to its starting point in Christian symbolism prior to Giotto as both source of, and context of the revolution he achieved with his early fourteenth century frescoes in Padua and Assisi. She thereby seeks 'to encourage a return to the ("formal" and ideological) history of painting's subject within its contemporary production; to present the avant-garde with a genetic-dialectical reflection on what produced it and/or that from which it sets itself apart' (Kristeva 1980: 233).

Kristeva included 'Giotto's Joy', together with her article, 'Motherhood according to Bellini', in her book, *Desire in Language* (1980). To this she added in her book, *Tales of Love* (1987), an article linking her experience of becoming a mother on the birth of her son, David, with the historical and revolutionary context of Piero della Francesca's paintings of motherhood. She had meanwhile explored recovery of illusory oneness with the mother, prior to the development of the semiotic, via the experience of the sublime, writing:

When the starry sky, a vista of open seas or a stained glass window shedding purple beams fascinate me, there is a cluster of meaning, of colors, of words, of caresses, there are light touches, scents, sighs, cadences that arise, shroud me, carry me away, and sweep me beyond the things that I see, hear, or think. The 'sublime' object dissolves in the raptures of a bottomless memory.

(Kristeva 1982: 12)

This, however, is often overlooked in favour of attending to her account in the same book, *Powers of Horror* (1982), of the counterpart to the

sublime in the revolution achieved by the avant-garde writer Céline's 'struggle with an "abject" maternal body which both fascinates and horrifies' (Oliver 2003: 169).

She followed this with an exploration of the role of the semiotic in freeing psychoanalytic patients from melancholia (see e.g. Kristeva 1989), from fixation to ossifying symbolism (see e.g. Kristeva 1995), as source of feminine genius (Kristeva 2001–4), and as a means of becoming a creative writer herself (see e.g. Kristeva 2006). Ironically, however, her writing is often as difficult to fathom as the work of some of the revolutionary artists whose work she celebrates. Psychologising the source of their revolution in art in infantile development from semiotic to symbolic modes of communication also leaves out many factors central to the history of art.

Nevertheless, with her exploration of abjection via the avant-garde work of Céline, Kristeva has inspired a revolutionary movement in the history of art today. She has given impetus to the development of abject art which has been celebrated in many exhibitions, including at the Whitney Museum in New York (Houser and Taylor 1993) and the Louvre in Paris (Kristeva 1998), and in writing about art (e.g. Creed 1993). This, in turn, has been criticised, not least for celebrating the abject to the neglect of attending to the effects on women of being the objects of abjection (see e.g. Tyler 2009). It has also brought about a new orthodoxy in art insofar as artists slavishly adopt her attention to abjection and melancholia in, for instance, her account of Holbein's painting, *The Body of the Dead Christ in the Tomb* (excerpted in Kul-Want 2010). Hence the focusing of this commentary on the lively counterpart of abjection, Kristeva's article, 'Giotto's Joy'.

Janet Sayers

Selected bibliography

Creed, B. (1993) *The Monstrous-Feminine*, London: Routledge.

Freud, S. (1900) *The Interpretation of Dreams. Standard Edition, Volumes IV and V,* London: Hogarth, 1953.

——(1910) *Leonardo da Vinci and a memory of his childhood. Standard Edition, Volume XI,* London: Hogarth, 1957, 59–137.

——(1911) *Formulation on the two principles of mental functioning. Standard Edition, Volume XII,* London: Hogarth, 1958, 213–26.

——(1915) *The Unconscious. Standard Edition, Volume XIV,* London: Hogarth, 1957, 159–204.

——(1930) *Civilization and its Discontents. Standard Edition, Volume XXI,* London: Hogarth, 1961, 57–145.

Houser, C. and Taylor, S. (1993) *Abject Art: Repulsion and Desire in American Art*, New York: Whitney Museum of American Art.

Kristeva, J. (1972) 'La joie de Giotto' *Peinture*, 2/3, January, 35–51. English translation in *Desire in Language*, 210–36.

——(1980) *Desire in Language*. New York: Columbia University Press.

——(1982) *Powers of Horror*. New York: Columbia University Press, www.csus. edu/indiv/o/obriene/art206/readings/kristeva%20-%20powers%20of% 20horror%5B1%5D.pdf (accessed 24.8.11).

——(1987) *Tales of Love*, New York: Columbia University Press.

——(1989) *Black Sun*, New York: Columbia University Press.

——(1995) *New Maladies of the Soul*, New York: Columbia University Press.

——(1998) *Visions capitales*, Paris: Réunion des musées nationaux.

——(2001–4) *Hannah Arendt, Melanie Klein, Colette*, New York: Columbia University Press.

——(2006) *Murder in Byzantium*, New York: Columbia University Press.

Kul-Want, C. (2010) *Philosophers on Art from Kant to the Postmodernists*, New York: Columbia University Press.

Lacan, J. (1949) 'The mirror stage as formative of the function of the I', in *Écrits*, London: Tavistock, 1977, 1–7.

Matisse, H. (1936) *Matisse on Art*, New York: Phaidon.

Oliver, K. (2003) 'Julia Kristeva', in C. Murray (ed.), *Key Writers on Art*, London: Routledge, 167–73.

Tyler, I. (2009) 'Against abjection', *Feminist Theory*, 10.1, 77–98.

Winnicott, D. W. (1953) 'Transitional objects and transitional phenomena', *International Journal of Psycho-Analysis*, 34, 89–97.

LAURA MULVEY, 'VISUAL PLEASURE AND NARRATIVE CINEMA' (1975)

The original publication was in *Screen*, 16.3, 1975, 6–18. The edition used here is Laura Mulvey, 'Visual Pleasure and Narrative Cinema', in *Visual and Other Pleasures*, 2nd edition, Basingstoke: Palgrave Macmillan, 2009, 14–27. An alternative source is M. Merck (ed.), *The Sexual Subject: A Screen Reader in Sexuality*, London: Routledge, 1992, 22–34.

Originally written in 1973 as a piece of polemic and first published two years later in the journal *Screen*, a prominent incubator of psycho-analytically informed critiques of the visual and especially the moving image, 'Visual Pleasure and Narrative Cinema' is Laura Mulvey's most influential essay. The fact that its reception is characterised by so many oversimplifications and misunderstandings (Evans and Gamman 1995), suggests that this text is perhaps cited more often than it is actually read. Mulvey's complex argument has often been reduced to an

emblem of early second-wave feminist thought that subsequent commentators strive to refine or disprove. In her introduction to an anthology of her writings from the 1970s and 1980s, Mulvey describes this essay as having:

> acquired a balloon-like, free-floating quality. I hope that publishing it here will not explode it, but bring it back to earth.
>
> (Mulvey 2009: xxviii)

The most recent edition of this anthology, *Visual and Other Pleasures*, includes an updated introduction that helpfully places the essay in its political, cultural, biographical and technological context, as well as a new chapter; all previously published essays have been deliberately reprinted without changes.

In the context of the collection *Visual and Other Pleasures*, 'Visual Pleasure and Narrative Cinema' is presented as the culmination of developments in feminist activism, a critique of art and visual culture informed by semiotics, post-structuralism, Marxism and psychoanalysis, and avant-garde poetics, from the perspective of an activist and a theoretically engaged, practising film maker. The collection opens with a reflection on the now famous feminist protest against the Miss World competition in London in 1970 and moves on to a theoretically confident psychoanalytic interpretation of Allen Jones's *Women as Furniture* series (1969), where Mulvey's thesis on the role of visual culture in the subjugation of women is introduced through the concept of fetishism, namely the deployment of 'woman as spectacle' as a phallic substitute for the male narcissistic fear of castration: although (symbolically and literally) castrated, woman's objectified body beautiful paradoxically comes to stand for the phallus, namely not the male member *per se*, but its symbolic function as a signifier of desire. Whimsically titled 'Fears, Fantasies and the Male Unconscious, or "You Don't Know What is Happening, Do You Mr Jones?"' (Mulvey 2009: 6–13), the essay evokes the chorus of Bob Dylan's 'Ballad of the Thin Man' (1965), a withering countercultural putdown to the media establishment.

'Visual Pleasure and Narrative Cinema' begins by explicitly articulating a project that is already in evidence in these two earlier essays: the appropriation of psychoanalysis 'as a political weapon' (Mulvey 2009: 14) for feminism. As Mulvey and others have observed in retrospect, this political use of psychoanalysis simultaneously followed and contributed to the almost alchemical fusion of Marx and Freud in the cultural politics of the New Left (Mulvey 1996: 1–6; Pollock 1999). Mulvey proceeds to map out a sexual economy shaped by fetishism, where woman

is 'tied to her place as bearer, not maker, of meaning' (Mulvey 2009: 15). As well as representing the status quo, mainstream narrative cinema also serves to support and perpetuate it by 'cod[ing] the erotic into the language of the dominant patriarchal order' (Mulvey 2009: 16).

In cinema, 'scopophilia', the primordial love of looking, is entertained through 'screening and narrative conventions [that] give the spectator an illusion of looking in on a private world' (Mulvey 2009: 17). Yet looking isn't only associated with pleasure but also (mis)recognition, identification and desire. According to Jacques Lacan's formulation of the mirror stage, the moment when a child recognises itself in the mirror is crucial in its development, even though this first recognition is overlaid by the child's projection of a more complete, ideal ego onto the reflected image compared to its own imperfect body as experienced from within. Like the rest of patriarchal culture, scopophilia is ordered by an active/male–passive/female division of labour that is embedded in cinematic plot structures: the beautiful face of an actress fills the screen and arrests the flow of the plot, until it gets replaced by the active male figures and the narrative speeds up again. Women on screen become the erotic object of two mutually reinforcing voyeuristic gazes; that of male characters and, in the auditorium, that of the male spectator (Mulvey 2009: 19–20). When the female character is finally seduced by the male protagonist, she is also vicariously possessed by the spectator who identifies with the man on screen (Mulvey 2009: 21).

Mulvey cites Jean Douchet's reading of Hitchcock's *Rear Window* (1954) as a metaphor for cinema itself, in which wheelchair-bound photojournalist 'Jeff' Jeffries stands for the audience and the block of flats opposite his for the cinema screen (Douchet 1961). Jeffries' relationship with girlfriend Lisa, in whom he originally shows little interest, is suddenly reinvigorated when she crosses the boundary from his bedside across the way and into his field of vision, thus casting each of them respectively in the voyeuristic and exhibitionist roles of the patriarchal scopophilic scenario (Mulvey 2009: 24). 'Going far beyond highlighting a woman's to-be-looked-at-ness, cinema builds the way she is to be looked at into the spectacle itself' (26).

For all this to change, what is required is no less than a 'new language of desire' (Mulvey 2009: 16), exemplified in Mulvey's own avant-garde filmmaking practice, notably in *Riddles of the Sphinx* (1977), co-created with long-term collaborator Peter Wollen. The evocation of the Oedipus myth in the title signposts the makers' ambition to revisit and challenge the Freudian narrative of sexuation, namely the acquisition of masculine and feminine positions in the gender economy, which pivots on the differentiated paths followed by boys and girls into the Oedipus complex and its resolution. The

film intersperses scenes from the everyday life of a young working mother with appearances of feminist conceptualist artist Mary Kelly and Mulvey herself, speaking about the semiotic and ideological workings of the cinematic apparatus. 'What recurs overall is a constant return to woman, not indeed as a visual image, but as a subject of inquiry' (Mulvey 2009: 130).

Feminist criticisms of 'Visual Pleasure and Narrative Cinema' originally focused on the perceived exclusion or even impossibility of a female spectator (Bergstrom and Doane 1989), an issue that Mulvey herself addressed repeatedly in the aftermath of this essay's publication:

> for women ... trans-sex identification is a *habit* that very easily becomes *second nature*. However, this Nature does not sit easily and shifts restlessly in its borrowed transvestite clothes.
>
> (Mulvey 2009: 35)

Certain genres such as the melodrama and the flapper films of the 1920s do 'upset the opposition male/active versus female/passive ... while, however, reiterating the central regime of desire' (Mulvey 2009: 230). It has also been argued that not only do women obviously partake in the consumption of narrative cinema but arguably do so with a difference, as active, resistant and often subversive interpreters of the cinematic spectacle. Queer theorists have, moreover, pointed out the assumption of heteronormative perspectives in Mulvey's essay and noted that queer subjects successfully produce queer readings even of the most mainstream cinema (Evans and Gamman 1995). Amelia Jones extends Joan Copjec's rejection of theoretical models that assume a unidirectional and disembodied perspective to Mulvey's formulation of the male gaze (Jones 2006: 7–9). Drawing on Lacan, Copjec posits that the subject is never completely outside the picture, because the:

> visual field ... consists not only of what the spectator sees, but ... that which the spectator contributes to what she sees.
>
> (Copjec 2000: 39)

Thus 'the desiring (viewing) body of the subject [is implicated] in every image' (Jones 2006: 9). Others have pointed out that Mulvey's dissection of 'scopophilia' advocates a 'scopophobic' stance (a neologism coined by Harris 2001: 15), exemplified in her avant-garde practice, which favours only the most austere types of Conceptualism and whose complexity threatens to sabotage its progressive politics by alienating all but the most intellectual audiences.

Mulvey's aim was never to exclude female spectators or suggest that looking is exclusively and permanently gendered masculine, but rather to underline the point that specific media and genres come with certain modes of spectatorship encoded within them ('cinematic codes create a gaze', Mulvey 2009: 26). Similarly the visual culture industry has the power to shape its audiences ideologically. This is an exemplary case of a key text falling victim to its own success: while often fetishised as a totem upon which established and new academics cut their teeth, its important insights now make up the concealed foundations of most contemporary understandings of the ideological function of the visual, thus appearing to lose some of their original radical vigour. Still entirely worthy of close reading, 'Visual Pleasure and Narrative Cinema' demonstrates the inextricable links between gender and genre, forms of practice and conventions of spectatorship. It also exemplifies the fraught but fruitful dialogue between feminism, Marxism and psychoanalysis.

Alexandra M. Kokoli

Selected bibliography

Bergstrom, J. and Doane, M. A. (eds) (1989) *The Spectatrix*, special issue of *Camera Obscura*, 7, 2–3.

Copjec, J. (2000) 'The Strut of Vision: Seeing's Corporeal Support', in C. B. Gill (ed.), *Time and the Image*, Manchester: Manchester University Press, 35–47.

Douchet, J. (1961) 'Hitch and His Public', *New York Film Bulletin*, 7. Reprinted in Marshall Deutelbaum and Leland Poague (eds) (2009), *A Hitchcock Reader*, 2nd edition, Oxford: Blackwell, 17–24.

Evans, C. and Gamman, L. (1995) 'The Gaze Revisited, or Reviewing Queer Viewing', in P. Burson and C. Richardson (eds), *A Queer Romance: Lesbians, Gay Men, and Popular Culture*, London: Routledge, 12–56.

Gamman, L. and Makinen, M. (1994) *Female Fetishism: A New Look*, London: Lawrence and Wishart.

Harris, J. (2001) *The New Art History: A Critical Introduction*, London: Routledge.

Jones, A. (2006) *Self/Image: Technology, Representation and the Contemporary Subject*, London: Routledge.

Mulvey, L. (1996) *Fetishism and Curiosity*, Bloomington: Indiana University Press / London: BFI.

——(2009) *Visual and Other Pleasures*, 2nd edition, Basingstoke: Palgrave Macmillan.

Pollock, G. (1999) 'Still Working on the Subject: Feminist Poetics at its Avant-Garde Moment', in S. Breitwieser (ed.), *Reading the Post-Partum Document: Mary Kelly*, Vienna: Generali Foundation, 236–60.

——(2001) 'Trouble in the Archives', in *Looking Back to the Future: Essays on Art, Life and Death*, Amsterdam: G+B Arts, 23–39.

HÉLÈNE CIXOUS, 'THE LAUGH OF THE MEDUSA', REVISED VERSION (1976)

The edition used here is the revised version, Hélène Cixous 'The Laugh of the Medusa', translated by Keith Cohen and Paula Cohen, *Signs*, 1.4, 1976, 875–93. The original publication was 'Le rire de la Méduse', *L'arc*, 1975, 39–54. Alternative sources are E. Marks and I. de Courtivron (eds), *New French Feminisms: An Anthology*, New York: Schoken Books, 1980, 245–64 and R. Warhol and D. Price Herndl (eds), *Feminisms: An Anthology of Literary Theory and Criticism*, New Brunswick, NJ: Rutgers University Press, 1991, 331–49.

As with much of French poststructuralist theory, the difficulty and fascination exercised by Cixous' writing emanates from her poetic, playful and richly polysemous use of language. Her pronouncements should be read as highly evocative metaphors that, however, refuse to renounce their literal signification entirely. 'If only this were a metaphor', the nameless narrator repeats in *Angst*, a novel that expands on her non-fictional explorations of *écriture féminine* (feminine writing) (Cixous 1985: 11). Never straight-forwardly defined and resistant to any explication or coding, feminine writing is continuously performed in Cixous' oeuvre: although its agenda is clearly feminist and despite an ongoing insistence on gendered embodiment, this type of articulate inscription against the grain is not reserved for women. Rather, it pinpoints the possibility and necessity for the systematically and systemically silenced to speak out, to make their own mark in their own terms – otherwise.

Heinrich von Kleist, James Joyce, Jean Genêt and, principally, Brazilian writer Clarice Lispector, have all been discussed in terms of feminine writing, among others. Feminine writing is what happens when the culturally repressed return with a vengeance, when the (presumed) impossible erupts into language and the world, transforming it into 'chaosmos' (Cixous 1976: 888). Over her long career, Cixous has built a vocabulary, or rather a semiotic universe, in which common words have acquired specific connotations, such as 'breath' (a kind of revolutionary momentum), 'death' (the result of silencing), *'la Vivante'* (the vital or, better, alive woman – who writes), as well as neologisms like 'sext', a hybrid of 'sex' and 'text' and the untranslatable *'voler'*, chosen for its double meaning, to take flight and to steal. Patriarchy, capitalism, rationalism, and religion are all seen as mutually implicated and complicit in the murderous silencing of the marginalised.

It is important to point out that Cixous' exploration of *écriture féminine* unfolds across nearly the whole of her oeuvre. Although 'The Laugh of

the Medusa' is perhaps the most cited exposition of this concept – and, crucially, it combines a reflection on, with an inspired performance of, feminine writing – interested readers should also consult Ian Blyth's informative overview (2004: 18–34). Additionally, they might study 'Sorties', Cixous' contribution to *The Newly Born Woman*, a landmark collaboration with Catherine Clément and a thorough exploration of the sexual politics of psychoanalysis and its potential for feminist appro- priation (Clément and Cixous 1986: 63–132). 'Coming to Writing' is one of her more explicitly autobiographical texts about her early life in Algeria; her encounters with anti-Semitism; European fascism and colonialism, thus shedding light on the significant postcolonial (as well as feminist) implications of her project (Cixous 1991). More than any of these texts, 'The Laugh of the Medusa' bears the characteristics of a manifesto: engagingly fervent, angry and joyful, this is '"incandescent" action writing' at its best (Marcus cited in Caws 2001: xix).

The text begins with the imperative for woman to 'write her self: must write about women and bring women to writing' (Cixous 1976: 875). The difficulty arises from the recognition that, while woman has to break her externally imposed and internalised silence, language itself, which is more often than not inseparable from reason, as the Greek term 'logos' suggests, is already gendered by/as her dominant other. Social oppression is compiled and consolidated by cultural and symbolic repression that makes writing not only prohibited but unthinkable. For woman, writing is censored even before it begins to take shape, just as her warm, fertile polymorphously erotic body is confined and twisted into a bowdlerised spectacle that serves to simultaneously entice and appease man. Cixous evokes psychoanalytic theorists Freud and Lacan repeatedly when addressing the silencing effects of fetishism, castration anxiety and 'phallogocentrism', a composite of phallocentrism and logocentrism that underlines their interdependence.

According to Jacques Derrida, philosopher, long-time friend and occasional collaborator, logocentrism 'gives independent existence to concepts, which are no more than an effect of linguistic difference ... find[ing] the guarantee of truth outside language'. Phallocentrism stands for 'the order of the masculine and the symbolic', namely the order of language and culture, 'where masculine is ... privileged' and 'woman is placed on the side of negativity and lack' (Belsey and Moore 1997: 255). Woman must break out of this order to finally make 'her shattering entry into history' (Cixous 1976: 880): she 'un-thinks the unifying, regulating history that homogenises and channels forces, herding con- tradictions into a single battlefield' (882). Controversially asserting that 'in women there is always more or less of the mother' (882), Cixous is

pointing out a markedly different social and ethical predisposition in women that doesn't strictly involve procreation, but that tends to be far less invested in individualism, culturally and historically. The Greek mythical monster Medusa, famously discussed by Freud in reference to the castration complex, becomes a cipher for intrepid femininity that makes 'an explosive, *utterly* destructive, staggering return' (886). This return does not amount to any simple turning of the tables, with woman on top, but rather ushers in a new order of things, where domination and possession are replaced with flying/stealing (*voler*):

> we've lived in flight, stealing away, finding ... narrow passageways, hidden crossovers. ... women take after birds and robbers just as robbers take after women and birds.
>
> (887)

One of the most persistent criticisms directed against Cixous is that she is a biological essentialist (Bray 2004: 29). She does indeed suggest that feminine writing springs from the – female – body and speaks of 'a universal woman subject' (Cixous 1976: 875) but, as has been suggested, femininity in this context is more complex than an innate and immutable gender identity. For Cixous, and other French feminists like Julia Kristeva and Luce Irigaray, it is not simply the case that the feminine is repressed but, conversely and even more importantly, that the repressed is gendered feminine. Others have challenged the assumed correlation between radical poetics and the potential to effect social change, arguing that the notion of the disruptive feminine should not be conflated with femin*ism* (Felski 1989; Jones 1994).

Predictably, Cixous' writings on visual art do not only make up a small part of her oeuvre but also tend to focus on narrative aspects of painting ('Bathsheba', Cixous 2005b: 3–24), or discuss drawing as a form of pre- or non-linguistic mark-making akin to her perception of *écriture* (e. g. 'Without end, no, State of drawingness, no, rather: The Executioner's taking off', 2005b: 25–40). Although her impact on the theoretical analysis of the arts has been mostly indirect (Wright 1998: 173), it should not be underestimated. Cixous' radical poetics outline a template for subversive creativity, for inscriptions against the grain, in any context and medium, from the position of the socio-politically excluded as well as the culturally repressed. Since feminist theory appears to have found a fairly comfortable home in the academy rather than society at large, the relevance of Cixous' rigorous *tours de force* to contemporary women's movements is a matter for debate. However, her anti-Cartesian insistence on the lack of separation – let alone contradiction – between the body

and intellect, flesh and writing, has contributed greatly to the affirmation of embodied subjectivity in theory and practice. Her admonition to take flight from tradition, steal from the canon selectively, and write without fear and inhibition, will continue to inspire.

Alexandra M. Kokoli

Selected bibliography

Belsey, C. and Moore, J. (eds) (1997) *The Feminist Reader*, Oxford: Blackwell.

Blythe, I. with Sellers, S. (2004) *Hélène Cixous: Live Theory*, London: Continuum.

Bray, A. (2004) *Hélène Cixous*, Basingstoke: Palgrave Macmillan.

Caws, M. A. (ed.) (2001) *Manifesto: A Century of -isms*, Lincoln: University of Nebraska Press.

Cixous, H. (1976) 'The Laugh of the Medusa', trans. Keith Cohen and Paula Cohen, *Signs*, 1.4, 875–93.

——(1981) 'Castration or Decapitation?', trans. Annette Kuhn, *Signs*, 7.1, 41–55.

——(1985) *Angst*, trans. Jo Levy, London: John Calder.

——(1991) 'Coming to Writing', in *'Coming to Writing' and Other Essays*, ed. Deborah Jenson, Cambridge, MA: Harvard University Press, 1–58.

——(2005a) 'K-A Notebook (Vera's Room)', in *Vera's Room: The Art of Maria Chevska*, London: Black Dog Publishing, 73–129.

——(2005b) *Stigmata*, London: Routledge.

Clément, C. and Cixous, H. (1986) *The Newly Born Woman*, trans. Betsy Wing, Minneapolis: University of Minnesota Press.

Felski, R. (1989) *Beyond Feminist Aesthetics*, Cambridge, MA: Harvard University Press.

Jardine, A. (1985) *Gynesis: Configurations of Woman and Modernity*, Ithaca NY: Cornell University Press.

Jones, A. (1994) 'Postfeminism, Feminist Pleasures, and Embodied Theories of Art', in J. Frueh, C. L. Langer and A. Raven (eds), *New Feminist Criticism: Art, Identity, Action*, New York: IconEdition/HarperCollins, 16–41.

Moi, T. (2002) *Sexual/Textual Politics: Feminist Literary Theory*, 2nd edition, London: Routledge.

Wright, E. (1998) *Psychoanalytic Criticism: A Reappraisal*, 2nd edition, Cambridge: Polity Press.

BRIAN O'DOHERTY, *INSIDE THE WHITE CUBE: THE IDEOLOGY OF THE GALLERY SPACE* (1976)

Brian O'Doherty, *Inside the White Cube: The Ideology of the White Space*, Berkeley: University of California Press, 1999.

Brian O'Doherty's *Inside the White Cube: The Ideology of the Gallery Space* originated as three articles published in *Artforum*. It is currently published

as an expanded edition with an additional essay written ten years later, which shows how modernism's history can be 'correlated with changes' in the white cube gallery space and in the way we see that space. We have arrived at a moment, he claims, 'when we see not the art but the *space* first' (O'Doherty 1999: 14).

This 'evenly lighted "cell"', where the walls are painted white, windows are usually sealed off and the ceiling becomes the source of light, is described as providing us with 'the archetypal image of twentieth century art' (O'Doherty 1999: 14). The essays were one of the first serious considerations of the specific contexts of display for the modernist artwork. They were, at the same time, written in response to the art of the 1960s and 1970s, an art that sought to sabotage the formalist space of the modern gallery, which had come to be seen as an essentially bourgeois space, constructed to exclude political realities.

Much of his first essay demonstrates how the ideology of the white cube gallery space is integral to the formalism and abstraction of modernist and late modernist art. O'Doherty provides a brief overview of the development and emergence of the white cube – the break with easel painting and the wall-to-wall display of pictures in the salon. O'Doherty's text explores the different display format demanded by the assertion of the picture plane by modernist painters.

The white cube rationale is that the 'Outside world must not come in'; that the art displayed in the gallery:

> exists in a kind of eternity of display, and though there is lots of 'period' (late modern) there is no time.
>
> (O'Doherty 1999: 15)

The space takes art out of time and in doing so alienates and estranges what is put within it. When Lucas Samaras (b. 1936), for example, transferred the contents of his studio-bedroom from his New Jersey address to the Green Gallery in New York City, *Room 1* (1964), the gallery was made to 'impersonate', as he put it, other spaces (O'Doherty 1999: 49). In this 'extension of collage' – for it is collage that first brought the real world into the white gallery space – objects literally taken from the living environment of the artist were transformed by the context of display (O'Doherty 2008: 5).

O'Doherty wrote at a specific transitional moment, characterised by both the ends of modernism – epitomised for him by the installation shot of Colour Field paintings – and the emergence of a postmodern, mixed-media, non-hierarchical art, which contested the value systems of its context of display. He described modernist display as 'the suave

extensions of the space, the pristine clarity, the pictures laid out in rows like expensive bungalows' (O'Doherty 1999: 29).

The white cube 'allowed modernism to bring to an endpoint its relentless habit of self-definition' (O'Doherty 1999: 80). Context became content in late modernism. O'Doherty indicates the importance of Frank Stella's early shaped canvases, from his 1960 Castelli show, in their activation of the wall as an 'aesthetic force', developing 'every bit of the wall, floor to ceiling, corner to corner' (O'Doherty 1999: 29). The modernist co-dependency of artwork and white cube was taken to a witty extreme in William Anastasi's 1967 show at the Dwan Main Gallery, New York, for which he photographed the empty gallery walls, including electrical sockets and fixtures, and silk screened the images on canvases slightly smaller than the gallery walls they covered. It is useful to link this with photo-conceptualism, for example Victor Burgin's 1969 *Photopath*, in which a line of black and white photographs covered the area of the gallery floor that they depicted. Although not mentioned in *Inside the White Cube*, this work is integral to the extension of 'Minimalist' artists' engagement with the gallery space.[1]

Considering the art viewer, O'Doherty splits the self that enters the gallery between two faculties. First the 'Eye', which represents the rarefied and disembodied faculty that deals with a purely formal vision – a mode of viewing that, as he says, is no 'good at all for looking at cabs, bathroom fixtures, girls, sports results' (O'Doherty 1999: 41). Second the 'Spectator', associated with the physical body, which:

> [s]tumbles around between confusing roles: he is a cluster of motor reflexes, a dark-adapted wanderer, the vivant in a tableau, an actor manqué, even a trigger of sound and light in a space land-mined for art.
>
> (O'Doherty 1999: 41)

If the picture plane holds dialogue with the white walls of the gallery, cubism and collage affect and alter its physical space: what was significant about Picasso's 1911 collage of oil cloth printed with chair caning on canvas, was that the picture space was no longer cut off from that of the spectator. An art that preserves the picture plane is seen as an art for the 'Eye', while the 'Spectator' stands in space 'broken up by the consequences of collage' (O'Doherty 1999: 42). While modernism's picture plane is likened to 'an exclusive country club, keep[ing] reality out and for good reason', collage and cubism bring messy and unruly reality back into the white space:

Reality does not conform to the rules of etiquette, subscribe
to exclusive values, or wear a tie; it has a vulgar set of relations
and is frequently seen slumming among the senses with other
antithetical arts.

(O'Doherty 1999: 38)

The opposition between late modernism and the anti-formalist art of
Happenings, tableaux, performance and installations from the 1960s and
1970s, is drawn up very much in class terms. The white cube gallery is
not neutral but an elitist space of privilege and class distinction:

Isolated in plots of space, what is on display looks a bit like valuable
scarce goods, jewelry, or silver: esthetics are turned into com-
merce – the gallery space is *expensive* ... Never was a space, designed
to accommodate the prejudices and enhance the self-image of the
upper middle classes, so efficiently codified.

(O'Doherty 1999: 76)

Late modernist art is said to be 'inescapably dominated by the assump-
tions – mostly unconscious – of the bourgeoisie' (O'Doherty 1999: 77).
'The specialized surface of the modern canvas' is as 'aristocratic an
invention as human ingenuity ever evolved' (O'Doherty 1999: 36).

In his later 1986 essay 'The Gallery as Gesture', O'Doherty looks at
the way artists have used the gallery 'whole'. The artists' strategy
points in two directions: it 'comments on the "art" within ... and it
comments on the wider context – street, city, money, business – that
contains it' (O'Doherty 1999: 87). His discussion begins with Yves
Klein's 1957 Galerie Iris Clert exhibition of an empty gallery *Le Vide
(The Void)*. This transcendental space was countered by Arman's ges-
ture at the same gallery by *Le Plein (The Full)* in 1960, filling the
white cube, ceiling to floor and wall to wall, with rubbish and exclud-
ing the spectator through excess. Other work explored includes Andy
Warhol's filling of the Castelli Gallery in 1966 with floating silver
pillows; Daniel Buren's sealing off Milan's Galleria Apollinaire in
1968 with his signature stripes of canvas glued on its doors; Robert
Barry's closure of an LA gallery for his 1970 show and the Rosario
Group's more hostile act of locking spectators inside a gallery in
Argentina.

The apotheosis of such gestures for O'Doherty is the Christo and
Jeanne-Claude's wrapping of Chicago's new Museum of
Contemporary Art in 1969. The project was important because it
pressed 'esthetic issues to their social context' (O'Doherty 1999: 103).

Its realisation necessarily opened out art and the gallery into specific relationships within its social and economic environment – plans had to be drawn up, environmental reports sought, opposition identified and met, construction workers employed and so on. Christo and Jeanne-Claude's gesture revealed the hidden processes of white cube ideology and importantly, as O'Doherty says:

> negotiated a deeper understanding of a major theme of the '60s and '70s: the isolation, description and exposure of the structure through which art is passed, including what happens to it in the process.
>
> (O'Doherty 1999: 106)

Brian O'Doherty's *Inside the White Cube* is integral to a critical moment in art practice, when art shifted from self-referentiality to its social and economic context; when it seemed the white walls of the modernist space, as he puts it, 'were turning to glass' and letting reality in (O'Doherty 1999: 96). Lively, witty, polemical, it lacks the restraint and distance from the object of study that can characterise the more academic discourses of art history. His writing is important because of its close relationship to the 'elusive and dangerous art' of the 1960s and 1970s and his understanding of what such art had to say about the power structure and ideology of the white cube gallery (O'Doherty 1999: 113). That he was also an artist and exhibiting work under the name of Patrick Ireland is not insignificant in this respect.

In a 2006 lecture 'Studio and Cube: On the Relationships between where art is made and where art is displayed', we get a splendid update of his argument from *Inside the White Cube*. A mixed-media contemporary art practice in alliance with popular culture is seen to have upped the ante of 1960s and 1970s art. It aggressively intensified the 'anti-white cube mentality' to the point where O'Doherty speaks of the white cube now being an 'irrelevance': art is no longer transformed by the gallery but itself transforms the context of its display and does so very much on its own terms (O'Doherty 2008: 40).

Mark Durden

Note

1 The 'Minimalist' artists Donald Judd and Robert Morris were among Victor Burgin's teachers at Yale.

Select bibliography

Moore-Mcann, B. (2009) *Brian O'Doherty/Patrick Ireland*, London: Lund Humphries.

O'Doherty, B. (1967) *Object and Idea: An Art Critic's Journal, 1961–7*, New York: Simon and Schuster, 1967.

——(ed.) (1972) *Museums in Crisis*, New York: Braziller.

——(1973) 'Rauschenberg and the Vernacular Glance', *Art in America*, September–October, 83–87.

——(1982) *American Masters: the Voice and Myth in Modern Art*, New York: Dutton Books.

——(1999) *Inside the White Cube: The Ideology of the White Space*, Berkeley: University of California Press.

——(2008) *Studio and Cube*, New York: A Buell Center/FORuM Project Publication.

GILLES DELEUZE AND FÉLIX GUATTARI, *A THOUSAND PLATEAUS* [*MILLE PLATEAUX*] (1980)

The edition used here is Gilles Deleuze and Félix Guattari, *A Thousand Plateaus*, London: Continuum, 2004.

> Become clandestine, make rhizome everywhere, for the wonder of a nonhuman life to be created.
>
> (Deleuze and Guattari 2004b: 211)

Gilles Deleuze and Félix Guattari's *A Thousand Plateaus*, first published in 1980, is the second book after *Anti-Oedipus* (1972) in the *Capitalism and Schizophrenia* series, a key work in post-structuralist thought. Arising from its authors' involvement in the revolutionary events of May 1968, and theorising a *modus operandi* in reaction to the inevitable 'return to the status quo', *A Thousand Plateaus* is philosophically profound and wickedly surreal. It draws the reader into a parallel universe where everything familiar and fixed – the everyday world of faces, objects and propositions – is detached from its moorings and cast adrift into new territories. Its own identity as a book is cast aside – the premise is that it is not a book at all. Each chapter is a 'plateau' of intensities which the reader will experience on its own merits. Nor is it a work to be *understood*, being rather 'a tool for which a new use must be invented' (Deleuze and Guattari 2004b: 209); a work which, by its authors' own admission, will reward being dipped into as much as being read cover-to-cover. Its demo-cratic, political and practical nature has made it an important work for artists,

architects and philosophers. John Rajchman notes that *A Thousand Plateaus* proposes:

> a style of thought that might be called 'empiricist' or 'pragmatist'. It puts experimentation before ontology, 'And' before 'Is.' ... Deleuze and Guattari declare that multiplicity, more than a matter of logic, is something one must make or do, and learn by making or doing.
>
> (Rajchman 2000: 6)

This 'and' of connectivity is captured by one of the defining images in *A Thousand Plateaus* – the *rhizome*. The rhizome spreads by accretion, multiplication and underground connections. It is '... and ... and ... and ...' in nature. In contrast to the 'arborescent' growth of ideas, which depends on the centrality of the tree-trunk from which concepts grow like branches, rhizomatic growth implies no such centrality. For a work of art, the centralising reference point may be the purity of an artistic medium. A rhizomatic approach, however, would not hesitate to connect with other media, or even other areas of practice outside of art. The rhizomatic web of connectivity Deleuze and Guattari propose constitutes a pattern or potential for creative, philosophical and political action.

Since the publication of *A Thousand Plateaus*, its philosophy has supported an extra-disciplinary art aesthetic, insofar as such practice is liberated from the historical confines of traditional media and modes of production and consumption. Art forms new relations with other art and non-art forms, establishes new territories and new ways of thinking, acting and becoming. An example of this approach is found in the work of the Swiss artist Thomas Hirschhorn, whose temporary *Bataille Monument* (2002) in Kassel incorporated a library, snack bar, TV studio and webcams, as well as a signature cardboard and packing tape sculpture. 'I am not interested in "quality",' says Hirschhorn. 'I am interested in "energy"' (quoted in Rappolt 2003). Here, real affects are the result of artistic practice – a practice which furthermore does not lead purely into exegesis, but which physically manifests the potential of its politics. This becomes a materialist and grounded art, one which prioritises practice over theory, and pragmatics rather than dogma.

For Deleuze and Guattari rhizome development works by undermining co-ordinates as soon as they manifest as settling and confining tendencies. In this process, we are on a 'line of flight' which leads to unforeseen possibilities:

art is never an end in itself; it is only a tool for blazing life lines ... all those real becomings that are not produced only *in* art.

(Deleuze and Guattari 2004b: 208)

However, in contrast to enhanced contexts and potentialities for art, tyrannical potentialities of and for art and philosophy are defined by Deleuze and Guattari in various ways. One such definition is through the *face* and *faciality*. The *face* is a 'monstrous hood' which acts as a 'deviance detector':

it is not the individuality of the face that counts but the efficacy of the ciphering it makes possible ... [a face] is a man *or* a woman, a rich person or a poor one, an adult or a child, a leader or a subject, an 'x' or a 'y'.

(Deleuze and Guattari 2004b: 194, 196)

The *face* is metaphor, but also real, performing and creating its historical function with every new manifestation of itself – it is the 'abstract machine of faciality' (Deleuze and Guattari 2004b: 196). It has historical co-ordinates: the birth of the *face* is Year Zero, the year of Christ, with which the depiction of the white man's face appears and goes into mass production. The *face* monopolises relations and turns them into power relations. For Deleuze and Guattari, the tendency towards *faciality*, towards binary definitions which constrain new growth and subordinate 'deviance', must be fought against. *Faciality* colonises even the activity of the rhizome if the rhizome becomes a kind of dogma, a strategy to be imposed or 'applied'. Even the rhizomatic position of there being 'no right position to take' can ossify into a rigid stance or predetermined procedures. But the tyranny of *faciality* can become a starting point to move from, or the humus within which the rhizome evolves. In *Francis Bacon – the Logic of Sensation* (2005) Deleuze draws an affirmative philosophy of face-becoming-animal, face-becoming-imperceptible out of Bacon's work (thereby avoiding the rhetoric of angst and alienation in discussions of Bacon's work). 'Yes, the face has a great future, but only if it is destroyed, dismantled' (Deleuze and Guattari 2004b: 190). Rajchman (2000: 214) notes that in Bacon's effaced portraits, Deleuze discovers an intention to express something which exists prior to fig uration, illustration, or narrative. Deleuze and Guattari propose a kind of abstract empiricism, in which art manifests something that exists before codes, subjects and significations are formed.

A Thousand Plateaus is a political, ethical, social and aesthetic critique, in which different disciplines are continually made to interpenetrate one

another. Deleuze famously spoke of 'approaching an author from behind and giving him a child that would indeed be his but would nonetheless be monstrous' (Deleuze and Guattari 2004b: ix). This image of a discipline giving birth to something alien to itself suggests that an artistic idea may mutate into something beyond its initial frame of reference. This notion of 'becoming' is employed in artistic and wider contexts by Deleuze and Guattari.

In addition to the *face* and rhizome, a panoply of metaphor, reference and concepts are employed in *A Thousand Plateaus*. There is an eclectic breadth to the book: geology, D. H. Lawrence, H. P. Lovecraft, mathematics, Spinoza, textiles, Antonin Artaud, nomads, war machines and birdsong are amongst the numerous themes layered into a colourful, cumbersome and bewildering array of dazzling passages. *A Thousand Plateaus* does not attempt to become a canonical, central work with which to approach art and ideas. Nor does it attempt to explain the ways things are, as if from a position of authority. This would be to contradict its own premise. Rather, in presenting itself as a singular creation to be taken on its own merits, it challenges the reader to do something with it, to make an affect. By asserting the creative against the judgmental, Deleuze and Guattari avoid proposing a rule or system by which art or affects can or should be measured.

There is a 'call to arms' quality in the book – we are urged to 'get past the wall and get out of black holes' (Deleuze and Guattari 2004b: 189). New practices of art and thought, less constrained by the tyrannies of arborescence, *faciality*, state philosophy or representational thinking are suggested. The aesthetics that *A Thousand Plateaus* calls for are of real consequence:

> the stakes here are indeed the negative and the positive in the absolute: the earth girded, encompassed, over-coded, conjugated as the object of a mortuary and suicidal organisation surrounding it on all sides, *or* the earth consolidated, connected with the Cosmos, brought into the Cosmos following lines of creation that cut across it as so many becomings.
>
> (Deleuze and Guattari 2004b: 562)

The proliferation of 'over-coding' in theoretical discourse can threaten to smother creative vitality: art can be filled at every turn with interpretation and association of ideas that are highly variable in productiveness and significance. Perhaps, as philosopher Slavoj Žižek (2003) suggests, the time is ripe to take Deleuze at his word. Artists should take Deleuze and Guattari from behind to create vitally new or

monstrous becomings that short-circuit over-coding and representational thinking.

Chris Hunt

Selected bibliography

Colebrook, C. (2002) *Gilles Deleuze*, London: Routledge.
Deleuze, G. (2005) *Francis Bacon – The Logic of Sensation*, London: Continuum.
Deleuze, G. and Guattari, F. (2004a) *Anti-Oedipus*, London: Continuum.
——(2004b) *A Thousand Plateaus*, London: Continuum.
Massumi, B. (1992) *A User's Guide to Capitalism and Schizophrenia*, Cambridge, MA: MIT Press.
Rajchman, J. (2000) *The Deleuze Connections*, Cambridge, MA: MIT Press.
Rappolt, M. (2003) *Studio: Thomas Hirschhorn*, www.tate.org.uk/magazine/issue7/hirschhorn.htm (accessed 24.8.11).
Sutton, D. and Martin-Jones, D. (2008) *Deleuze Reframe: A Guide for the Arts Student*, London: IB Tauris.
Zepke, S. and O'Sullivan, S. (eds) (2010) *Deleuze and Contemporary Art*, Edinburgh: Edinburgh University Press.
Žižek, S. (2003) *Organs Without Bodies: On Deleuze and Consequences*, London: Routledge.

ARTHUR DANTO, *THE TRANSFIGURATION OF THE COMMONPLACE. A PHILOSOPHY OF ART* (1981)

Arthur C. Danto, *The Transfiguration of the Commonplace. A Philosophy of Art*, Cambridge, MA: Harvard University Press, 1981.

The Transfiguration of the Commonplace is generally considered one of the most important works of philosophical aesthetics of the twentieth century. In this book, Arthur Danto not only develops a methodology that has proven very influential (his so-called method of 'indiscernibles'), but he also makes a substantial and original contribution to a wide range of philosophical debates, including those focusing on the nature of depiction, artistic interpretation, the notion of style, and most notably, the definition of art. While each of these topics will be of interest to art historians who wish to reflect on their own discipline, there are (at least) three additional reasons why this philosophical milestone deserves a broad cross-disciplinary readership.

First, Danto's philosophy of art is deeply historicist in that he emphasises and builds upon the fundamental contextual and historical nature of art. Second, he presents a wealth of examples, drawn from both traditional and contemporary art, to illustrate and corroborate his theories, thereby manifesting his profound engagement with, and knowledge of, the history of art and the world of contemporary art. Third, Danto is an

exceptionally gifted writer, making *The Transfiguration* one of those rare philosophical interventions that is thoroughly engaging for non-philosophers and philosophers alike. It is indicative that, shortly after publishing *The Transfiguration*, Danto became a successful and celebrated art critic.

Andy Warhol's transfiguration of a commonplace 'Brillo Box' into a work of art, in 1964, was a moment of revelation for Arthur Danto. It convinced him that a mere reliance on perceptual or aesthetic features is insufficient to separate artworks from other worldly objects, or from what Danto calls 'mere real things' (Danto 1981: *passim*). As such, Warhol's *Brillo Box* revealed the appropriate form for the philosophical question regarding the definition of art, namely: what distinguishes a work of art from a 'mere real thing' when they are visually indiscernible from one another? This is the issue of indiscernibles – a problem that has various guises and that arises, according to Danto, in every area of philosophy. Philosophy, he argues, addresses its subject matter (knowledge, action, art, morality, etc.) by seeking the conditions that make the things under scrutiny the kinds of things they are. Danto believes that the appropriate way of seeking these conditions is to examine how the thing, whose essence it is the task of philosophy to reveal, differs from an object or event that is perceptually indiscernible from it. Therefore, one will find the definition of action by considering how an action differs from a visually indiscernible bodily movement, like a tic or a spasm. Similarly, one will arrive at the definition of art by considering the distinction between an artwork and its visually indiscernible counterpart.

The notion of the 'art world' is one of the key elements in Danto's explanation of the distinction between artworks and mere real things. Objects are art not because of some intrinsic perceptual quality they possess, but by being connected to the theoretical atmosphere of the art world. In the end, it is a theory of art that takes Warhol's *Brillo Box* up into the world of art and keeps it from collapsing into the real object which it also is. The crucial role that is assigned to a broad, theoretically informed art world ties in significantly with another central feature of *The Transfiguration* – its emphasis on the contextual and historical nature of art. For Danto, art is essentially a historical undertaking, in the sense that there are historical constraints on what sorts of objects can be considered art at given historical moments. This is an aspect of art that, in Danto's opinion, receives its most illuminating expression in Heinrich Wölfflin's claim that 'not everything is possible at every time' (Danto 1981: 44). For example, the equivalent of Warhol's *Brillo Box* could not have been an artwork in fifteenth century Florence, since a certain kind of historical development in the theoretical atmosphere of the art world was needed before an object of that kind could be considered a proper candidate for art-status.

Danto's focus on the historical and contextual nature of art has had a decisive and lasting impact on the way the definition of art has been approached in twentieth century aesthetics. Within this field it became widely accepted that a definition of art could not be built on formal or intrinsic perceptual qualities alone, and that historical and contextual factors had to be incorporated. George Dickie in particular was inspired by Danto's ideas and he developed his own Institutional Theory of Art on the basis of his reading of Danto's notion of the art world. However, Danto has repeatedly distanced himself from Dickie's account, and in the introduction of *The Transfiguration*, one finds some sarcastic comments on Dickie's Institutional definition of art. One of the most striking inadequacies of the latter, according to Danto, is precisely its lack of historical depth.

Danto's conception of art's historical nature is also evident in the view of interpretation he formulates in *The Transfiguration*. The idea that not everything is possible at every time does not merely characterise the artist's condition, but it extends to concern the interpretation of art as well. The theoretical atmosphere of the art world determines what sorts of meanings artworks may embody at given contexts. Since the possible meanings artworks may possess are historically conditioned in this way, there are also constraints on interpretations, which are supposed to track what those meanings are.

While *The Transfiguration* has become strongly associated with works of conceptual art construed broadly, it is important to observe that Danto does not consider the distinction between artworks and mere real things solely by way of discussing the differences between conceptual artworks and their real world indiscernible counterparts. The problem of indiscernibles is also evident in Danto's account of the characteristic features of an artwork's manner of representing, which he contrasts with the form of representation typical of maps and diagrams. In the final and seventh chapter of *The Transfiguration*, Danto analyses the concepts of metaphor, expression and style in order to explain how a work of art's manner of representing is not transparent with respect to its content (as is the case with maps, diagrams and other more 'mundane' vehicles of representation). A work of art always expresses something about its content by way of showing it in a certain light. Unlike representations attempting a full transparency, works of art invoke in their viewers a particular attitude towards the content of representation. Therefore, it is not surprising that Danto compares the effective characteristic of art's representational impact to the powers of rhetoric, with metaphor as one of its most important devices.

Style, according to Danto, is the artist's way of seeing. As he puts it in a discussion of Giotto's frescoes: 'what I call "style" must have been less what Giotto saw than the way he saw it' (Danto 1981: 162). Style is often

something which the artist, together with the contemporary audience, may be unaware of and which only becomes perceptible with the passage of time. Again, Danto illuminates this aspect of style by referring to Giotto. He writes: 'I have little doubt that the contemporaries of Giotto, astounded at the realism of his paintings, should have seen men and women and angels in those paintings and *not* a way of seeing men and women and angels which we now recognise as Giotto's way of seeing' (Danto 1981: 42–43).

In his more recent work, *The Abuse of Beauty* (2003), Danto observes that together with *The Transfiguration* and *After the End of Art* (1997), *The Abuse of Beauty* forms a trilogy. In the first work, he outlines a general philosophical theory of art, in the second an ambitious philosophy of art history, and in the third a theory of aesthetics (Danto 2003: 14). This trilogy makes up one of the most ambitious philosophical accounts of art within any strand of contemporary aesthetics. Its starting point, however, is remarkably simple. It all begins with the question of how a work of art differs from its visually indiscernible counterpart. The multifarious and wide-ranging ideas Danto develops in *The Transfiguration* just show how far such a seemingly simple question can carry.

Kalle Puolakka and Hans Maes

Selected bibliography

Danto, A. C. (1981) *The Transfiguration of the Commonplace. A Philosophy of Art*, Cambridge, MA: Harvard University Press.

——(1997) *After the End of Art. Contemporary Art and the Pale of History*, Princeton, NJ: Princeton University Press.

——(2003) *The Abuse of Beauty. Aesthetics and the Concept of Art*, Chicago: Open Court.

Gall, M., Neufeld, J. and Soucek, B. (eds) (2007) *Arthur Danto's Transfiguration of the Commonplace – 25 Years Later*. Online Conference in Aesthetics, http://artmind.typepad.com/onlineconference/ (accessed 24.8.11).

Haapala, A., Levinson, J. and Rantala, V. (eds) (1997) *The End of Art and Beyond. Essays after Danto*, Atlantic Highlands, NJ: Humanities Press.

Rollins, M. (ed.) (1993) *Danto and His Critics*, Oxford: Basil Blackwell.

ROZSIKA PARKER AND GRISELDA POLLOCK, *OLD MISTRESSES: WOMEN, ART AND IDEOLOGY* (1981)

Rozsika Parker and Griselda Pollock, *Old Mistresses: Women, Art and Ideology*, London: Pandora, 1981.

Thanks to its precocious theoretical sophistication and insightful articulation of feminist issues in cultural practice that are still not merely current but pressing, *Old Mistresses* enjoys the status of a widely read feminist art historical classic, comparable in significance to Kate Millet's *Sexual Politics* (1977). This is one of numerous collaborations between authors Rozsika Parker and Griselda Pollock, founders of the Women's Art History Collective. Both trained art historians, Parker, one of the original members of the editorial collective of *Spare Rib* (1972–80) who subsequently became a practising psychotherapist, and Pollock, prolific academic and a key figure in feminist art history and cultural theory, present this book as 'the product of the Women's Liberation Movement' (1981: xxi). Both acknowledge the impact of the feminist second wave and place their contribution in its historical and political context. No longer at its first steps, feminism's scholarly engagement with art history provided a 'solid foundation of research and documentation' upon which 'a more searching analysis of women's position in culture' could begin to be produced (Parker and Pollock 1981: xviii).

The book introduces its central thesis in the brilliant irony of its title: 'there is not a female equivalent to the reverential "Old Master"' (Parker and Pollock 1981: 7). Rather than asserting that there have indeed been great women artists, the authors aim to examine how and why women's significant contributions to the history of art have been consistently misrepresented, devalued, or ignored. The discipline and institutions of art history have been instrumental in the ideological operations that have resulted in this state of affairs:

> This is not simply to accuse art historians themselves of bias or prejudice, but concerns the significance of the typical forms of art history, the survey history of art's evolution independent of social forces, the *catalogue raisonné* and the monograph on a single artist's work.
>
> (Parker and Pollock 1981: xviii)

The very tools of the discipline implicitly 'privilege the named creative individual and certain forms of art over all other expressions of creativity' (Parker and Pollock 1981: xviii). Differently put, 'the denigration of women by historians is concealed behind a rigidly constructed view of art history' (Parker and Pollock 1981: 7).

The first chapter examines the ideological discourses in which the stereotype of femininity was constructed and circulated. From its

beginnings, art history has been subject to, and the creator of 'powerful myths about the artist' – myths that were implicitly gendered masculine (Parker and Pollock 1981: 3). It is interesting that, as women claimed more rights and freedoms in society, the surveillance of the definitions and limits of femininity in art history became increasingly rigorous. Thus the 'characterisation of women's art as biologically determined or as an extension of their domestic and refining role in society, quintessentially feminine, graceful, delicate and decorative,' (Parker and Pollock 1981: 9) reached its peak in the 19th century, against the backdrop of women's suffrage campaigns, growing access to education and the professions and property law reforms.

The second chapter interrogates the origins of the hierarchical division between fine art and craft and the ways in which this division maps out in terms of gender and class, to further subordinate women and the working class. In the third chapter, the authors turn to the modern concept of the artist which, since Romanticism, accrued a number of characteristics, ranging from the divine to the profoundly and exclusively male: 'Flaubert ... called the artist "a *fouteur* who feels his sperm rising for an emission"' (Parker and Pollock 1981: 83). In this context, the 'woman artist' had to be cast as an entirely separate, somewhat para-doxical and surprisingly resilient category that remained unchallenged by non-conformity for a long time (Parker and Pollock 1981: 113).

The fourth chapter begins with a comparison between female nudes by male artists and self-portraits of female artists such as Suzanne Valadon, a working-class painter who also posed for Renoir. Parker and Pollock demonstrate how women artists resist existing codes of representation and create their own, in which the depiction of an active and creative female subjectivity becomes possible. The final chapter is devoted to the impact of the Women's Liberation Movement on women's art practice, noting that 'there is no more a homogeneous category of feminist art than there was a single category of women's art' (Parker and Pollock 1981: 157). The authors do not attempt any neat classifications here, as many others have done (cf Section IV, Parker and Pollock 1987: 261–339). They do, however, evaluate different feminist strategies, concluding that art practices that speak of women's lives and experiences from a female point of view and 'validate women's domestic labour, private and taboo areas of female sexuality and the craft traditions' may have an important role to play. However, they are ultimately 'open to misinterpretation and can run the risk of appearing merely to reconfirm traditional associations of woman with the body, the home and the needle' (Parker and Pollock 1981: 158). Similarly, works that aim to 'reappropriate and valourise women's sexuality ... have a very limited

effectivity' because they 'are easily retrieved and co-opted by a male culture' (Parker and Pollock 1981: 130). Related to the British conceptualist avant-garde of the 1970s, the work of Mary Kelly is taken as an example of a practice that challenges 'conventional notions of the art object' (Parker and Pollock 1981: 163). Most significantly, Kelly does not thematise womanhood nor does she visually represent women, but interrogates the feminine as a product of discourse and ideology that may therefore be contested and recoded within and through art practice.

Three years after the first publication of *Old Mistresses*, Parker's *The Subversive Stitch* suggests an altered and slightly more inclusive view of different types of creative practice. Although the role of embroidery in the construction of the ideology of femininity is critically interrogated, Parker proposes that domestic crafts have also marked out a protected and enabling space of woman-to-woman sociality, validated an otherwise denigrated women's world and even, under certain circumstances, enabled alternative and empowering redefinitions of what it meant to be a woman. In the concluding chapter of the book, 'A Naturally Revolutionary Art?', Parker notes that thoroughly feminist uses of the crafts co-exist with conservative ones, which, however, do not undermine the former, but may even throw their subversiveness into relief.

It is as important to recognise the necessity of taking up strong critical positions – and to celebrate the courage required to do so – as it is to acknowledge their implications, whether they were foreseen or not. Janet Wolff argues that, in certain art critical quarters in the 1990s, the diversity of feminist art practice was reduced to a divide between 'theory-based art practices (including the so-called "scripto-visual" tradition) and humanist or celebratory image-making' (Wolff 1995: 14). Although classifications may be hard to resist and might even prove temporarily useful, these should never be calcified into mutually exclusive, opposing camps, not only for political and strategic reasons, but also because, upon careful consideration of the works and practices in question, such divisions usually turn out to be misleading and inaccurate (Wolff 1995: 14; Robinson 2001: 523–39; Kokoli 2008). Norma Broude and Mary Garrard, prominent American feminist art historians and editors of a noteworthy trilogy of feminist art history and theory, appear to operate along these rigid oppositions when they accuse French and especially British feminist art historians and theorists, including Pollock and Lisa Tickner, for complicity with postmodernism and for undercutting 'the possibility of women's agency' (2005: 1–11). Broude and Garrard call for a return to basics: a re-reading of history against the grain to uncover and discover those who 'spoke out', in terms of both

social relations and representation. As well as painting postmodernism and certain strands of feminist art theory and history in unhelpfully broad brushstrokes, Broude and Garrard advocate a retreat to the kind of art history that Parker and Pollock sought to build on, but also over-come and interrogate. As a prominent international figure in academic art history, Pollock has often been targeted from conservative quarters for allegedly undermining the discipline itself by 'substitut[ing] a battery of political tests for questions about truth and quality, rendering such issues off limits' (Florence 2001: 5). Rather than a serious criticism of her approach, however, such accusations are symptomatic of wider debates within the discipline regarding its changing practices, role and remit, in which feminist art history and theory has been steadily gaining ground.

Nearly thirty years since its first publication, *Old Mistresses* remains as central to feminism as to art history, for demonstrating that the prac-tice of historiography and criticism is always imbricated with theory, politics and ideology. A landmark in the ongoing self-criticism of the discipline of art history and the emergence of 'new art history', this intervention constitutes a model for unearthing, analysing and thus challenging the tacit ideological workings of art institutions, disciplines and practices.

Alexandra M. Kokoli

Selected bibliography

Broude, N. and Garrard, M. D. (eds) (2005) *Reclaiming Female Agency: Feminist Art History After Postmodernism*, Berkeley: University of California Press.
Florence, P. (2001) 'Introduction', in G. Pollock, *Looking Back to the Future: Essays on Art, Life and Death*, Amsterdam: G+B Arts, 1–8.
Kokoli, A. (2008) 'Fetishism and the Stories of Feminist Art', in A. Kokoli (ed.) *Feminism Reframed: Reflections on Art and Difference*, Newcastle: Cambridge Scholars Press, 206–26.
Millett, K. (1977) *Sexual Politics*, London: Virago.
Parker, R. (2010) *The Subversive Stitch: Embroidery and the Making of the Feminine*, rev. edn, London: IB Tauris.
Parker, R. and Pollock, G. (1981) *Old Mistresses: Women, Art and Ideology*, London: Pandora.
——(eds) (1987) *Framing Feminism: Art and the Women's Movement 1970–1985*, London: Pandora.
Pollock, G. (1996) 'The Politics of Theory: Generations and Geographies in Feminist Theory and the Histories of Art Histories', in G. Pollock (ed.), *Generations and Geographies in the Visual Arts*, London: Routledge, 3–21.

——(1999) *Differencing the Canon: Feminist Desire and the Writing of Art's Histories*, London: Routledge.

——(2007) *Encounters in the Virtual Feminist Museum: Time Space and the Archive*, London: Routledge.

Robinson, H. (ed.) (2001) *Feminism-Art-Theory: An Anthology, 1968–2000*, Oxford: Blackwell.

Wolff, J. (1995) 'The Artist, the Critic and the Academic: Feminism's Problematic Relationship with "Theory"', in K. Deepwell (ed.), *New Feminist Art Criticism*, Manchester: Manchester University Press, 14–19.

MICHAEL BAXANDALL, *PATTERNS OF INTENTION. ON THE HISTORICAL EXPLANATION OF PICTURES* (1985)

Michael Baxandall, *Patterns of Intention. On the Historical Explanation of Pictures*, New Haven, CT: Yale University Press, 1985.

Michael Baxandall's memoir, *Episodes*, describes his doubts about the approach to interpreting art in Hans Sedlmayr's 1950s Munich lectures. Sedlmayr, a member of the New Vienna School of Art History, had connected particular works of art and artistic styles with larger historical forces: 'for me it was a matter of language I found I could not negotiate in a reputable way' (Baxandall 2010: 107). Baxandall's pointed use of the term 'reputable' referred to the methodology of an ex-Nazi as it was being deployed in a Cold War context. Later, Baxandall even described his own attempt to establish a 'one-to-one relation' between Ambrogio Lorenzetti's fresco of *Good Government* (1338–39) and the social facts of medieval Siena, as 'meretricious' (Baxandall 1985a: 39). The practice of art criticism – which Baxandall described as 'a heroically exposed use of language' – had ethical implications, requiring the art historian to be scrupulous.

Sedlmayr posed two fundamental methodological problems for Baxandall: the incommensurability of language and image, and the relationship between the work of art and the society that produced it. Baxandall's concern to find a 'reputable' way of negotiating these difficulties informs all his work – from the analysis of rhetorical language in humanistic commentary on early Renaissance art to the brilliant critique of Tiepolo's 'pictorial intelligence' developed with Svetlana Alpers (Baxandall 1971; Alpers and Baxandall 1994). Baxandall addressed these issues in two articles: 'The Language of Art History' (1979), a characteristic refusal to participate in recriminations concerning the

discipline's alleged lack of ideological or philosophical cogency, and 'Art, Society, and the Bouguer Principle' (1985b), which grew out of the perceived failure to provide a social historical explanation for Lorenzetti's fresco.

Baxandall interpreted the inadequacy of this attempt to relate 'art' to 'society' as resulting from the fact that these two terms were analytical constructs deriving from incompatible systems. In relating incommensurable things – words and pictures; art and society – Baxandall suggested a procedure, devised by the eighteenth-century scientist Pierre Bouguer (1698–1758), for establishing the relative brightness of lights:

> in the event of difficulty in establishing a relation between two terms, modify one of the terms till it matches the other, but keeping note of what modification has been necessary, since this is a necessary part of one's information.
>
> (Baxandall 1985a: 41)

In mobilising 'social facts' to explain 'pictorial peculiarities', the art historian modifies 'society' to something resembling 'culture' while remaining alert to the methodological distance travelled in doing so.

Patterns of Intention is Baxandall's most sustained analysis of these fundamental methodological problems. Consisting of four relatively discrete case studies, the book must be read as a whole to appreciate its experimental nature. Explanatory models painstakingly outlined in one chapter are skilfully disassembled in the next. With its punning title, it has a playful and ironic quality resulting from the application of the 'Bouguer Principle', so that exemplary problem pictures recur differently framed. It confirms Baxandall's expressed ease with a 'manifold plurality of differing art histories' (Baxandall 1979: 454). Concepts like 'the period eye' or 'cognitive style', from Baxandall's most widely read publication *Painting and Experience in Fifteenth-Century Italy* (1972), are not dogmatically developed beyond their *quattrocento* application, but rather the more flexible approach of 'inferential criticism' is advanced.

It begins by examining *ekphrasis* or descriptive writing about pictures. Analysing a classic *ekphrastic* exercise by the fourth-century CE writer Libanius, he concludes that while 'description is the mediating object of explanation … it would not enable us to reproduce the picture' (Baxandall 1985b: 1–3). As a result much art history and criticism is 'ostensive', implicitly pointing towards the work of art accessible in reproduction. He argues that descriptive writing about pictures represents 'thought after seeing a picture', and consequently when we talk or write about a work of art, description and interpretation fuse. Art historians therefore need to be aware

of how the conventions of critical writing about art – cause words, effect words, comparison words – shape thoughts about pictures.

To demonstrate how the circumstances of a historical object's creation might be reconstructed, Baxandall deliberately uses the non-artistic example of the Forth Bridge, where practical problems of engineering outweigh aesthetic choices. He describes the 'charge' and 'brief' as constituting a problem to which the bridge was the solution, addressing 'why at all and why this?' 'Cause-suggesting' features of a narrative of the bridge's construction range from the remote – Scotland's estuaries, geology, winds and tides – to specifics – the engineer's technical competence. This exemplar situates Baxandall's interest in *Patterns of Intention* far from the 1980s debates about authorial intention and reader response in literary studies arising from the writings of Roland Barthes and Michel Foucault.

Like the Forth Bridge, Baxandall understands pictures as solutions to problems – explaining a picture requires reconstructing the problem and the historical circumstances in which it was solved. This is not the same as identifying the work's meaning with the author's notional intention. For Baxandall this is not 'a historical set of mental events in the head of Picasso', because this is lost. Rather it is a 'relation between the object and its circumstances' that Baxandall aims to recover through an inferential process that takes into account the 'forward-leaning look of things' (Baxandall 1985b: 42).

Next, Baxandall further explores the model of 'charge' and 'brief' by considering Picasso's cubist portrait of his dealer Kahnweiler (1910). In this object, 'intentional visual interest' was the principal concern, so the work's 'why' and 'how' cannot be kept apart. Picasso's 'brief' is less clear than the commission for a railway bridge. Both artist and sitter record conflicting accounts of intention: Kahnweiler saw cubism as a form of scientific research posing a series of paradigm-shifting questions, while Picasso stated that he was more concerned with finding solutions.

Baxandall argues that Picasso's 'brief' was partly self-constructed through his awareness of the particular moment his art occupied in the history of painting, and how his likes and dislikes as a painter related to fundamental questions of representation. The 'brief' also emerged from the cultural interaction of painters, dealers, collectors and art critics, like Apollinaire, where choices made by each party had reciprocal impact. Baxandall described this as like an economic market model for the exchange of goods for money. Because Picasso's cultural exchange involved less tangible things like reputation, however, Baxandall preferred to use the looser French term of *troc*, implying a type of cultural bartering. The choice of the portrait of Kahnweiler

for analysis is significant, therefore, in symbolising the economic and cultural *troc* between artist and critic and as the record of a process in which design and execution interpenetrate. What emerges is a subtle critique of economic or political determinism as a facet of the social history of art.

Baxandall then argues forcefully against the prevailing view of one artist influencing another as a passive relationship. Rather Cézanne's influence on Picasso should be understood as Picasso using Cézanne's art as a resource for solving pictorial problems, and in the process transforming historical perceptions of it. These few pages can be profitably read by anyone tempted to explain art historical phenomena by reference to 'sources' and 'influences'. 'Influence' can be seen rather as 'intentional visual interest' so that through 'a numberless sequence of developing moments of intention' the artist moves towards a point when the work is relinquished not so much as a problem solved as a problem restated (Baxandall 1985b: 58–63).

Next, Baxandall explores the 'visual interest' of pictures and its relationship to the 'systematic thought' of the culture in which they are produced. He studies the affinity between Chardin's (1699–1779) aesthetic and empirical philosophy deriving from John Locke (1632–1704), through their shared awareness of the complexity of perception. Considering Chardin's *A Lady Taking Tea* (1735), Baxandall seeks to explain the peculiarities of the picture – notably differing levels of finish – by scouring sources beyond the unsatisfactory salon criticism of the day. Achieving critical 'purchase' on these pictorial peculiarities came through constructing an alternative enlightenment art criticism derived from vulgarisations of Locke and scientific treatises on optics. Lyrically, Baxandall describes his scholarly efforts to create these persuasive connections as like a 'Lockean Apollo and Daphne' – a poignant description of coming to terms historically with what may be a painting of Chardin's wife shortly before her death.

The final chapter, on Piero della Francesca's *Baptism of Christ* (c. 1455), extends the critique of 'influence' and is also a riposte to the type of iconographical analysis practiced following Erwin Panofsky (1892–1968). Baxandall shows that many interpretations of this picture, advanced on the basis of fifteenth-century texts, are causal in the weakest possible sense, only reconstituting a culture receptive to Piero's art. In the absence of persuasive social historical explanations, he argues that Piero's specific style and characteristic concern for 'commensurazione' – a precise period term – are strongly causal of the formal properties of this problem picture. Baxandall is reviving here the formalism of Roger Fry from within the Warburg tradition. As he said in an interview with Alan Langdale, 'I still think

of myself as doing Roger Fry, you know, in a different way' (Langdale 2009: 19).

Reviews of *Patterns of Intention* reflect the complexity of Baxandall's thought. Some note similarities with post-structuralism, such as 'the emphasis on the unattainability of the object of criticism' (Iversen 1986), while others welcome or condemn it as a product of neo-positivist humanism (Kemp 1987; Rifkin 1986). Recent attempts to align this book with postmodern relativism miss the point: the irrecoverable nature of the past was not the occasion for postmodern melancholy but rather an optimistic self-exertion towards greater critical acuity. Baxandall was alert to what we choose to attend to and what we overlook when viewing a picture. He was deeply concerned with how cultural circumstances of viewing enhanced or obscured our focus – the combination of physiology and culture he called the 'period eye'. What is consistent is that the object of historical explanation remains the particular qualities of the work of art. It is that patient attentiveness that remains exemplary. As Carlo Ginzburg has aptly put it, Baxandall was 'an independent mind, who left an indelible mark on art history and beyond' (Baxandall 2010: 7).

Ben Thomas

Selected bibliography

Bann, S. (1986) 'Review of Michael Baxandall, *Patterns of Intention* (1985)', *Word and Image*, 2.4, 384–88.

Alpers, S. and Baxandall, M. (1994) *Tiepolo and the Pictorial Intelligence*, New Haven, CT: Yale University Press.

Baxandall, M. (1971) *Giotto and the Orators*, Oxford: Clarendon Press.

——(1972) *Painting and Experience in Fifteenth-Century Italy*, Oxford: Oxford University Press.

——(1979) 'The Language of Art History', *New Literary History*, 10.3, 453–65.

——(1985a) 'Art, Society, and the Bouguer Principle', *Representations*, 12, 32–43.

——(1985b)*Patterns of Intention. On the Historical Explanation of Pictures*, New Haven, CT: Yale University Press.

——(2010) *Episodes. A Memorybook*, London: Frances Lincoln.

Campbell, S. (2006) 'Review of Michael Baxandall, *Words for Pictures* (2003)', *The Art Bulletin*, 88.1, 178–81.

Danto, A. C. (1986) 'Review of Michael Baxandall, *Patterns of Intention* (1985)', *The Burlington Magazine*, 128.999, 441–42.

Iversen, M. (1986) 'Review of Michael Baxandall, *Patterns of Intention* (1985)', *Oxford Art Journal*, 9.2, 71–72.

Kemp, M. (1987) 'Review of Michael Baxandall, *Patterns of Intention* (1985)', *Zeitschrift für Kunstgeschichte*, 50.1, 131–41.

Langdale, A. (2009) 'Interview with Michael Baxandall, February 3rd, 1994, Berkeley, CA', *Journal of Art Historiography*, 1, 1–31.

Rifkin, A. (1986) 'Brief Encounters of the Cultural Kind', *Art History*, 9.2, June, 275–78.

——(ed.) (1999) *About Michael Baxandall*, Oxford: Blackwell.

Sirridge, M. (1986) 'Review of Michael Baxandall, *Patterns of Intention* (1985)', *The Journal of Aesthetics and Art Criticism*, 45.1, 94–95.

VICTOR BURGIN, 'THE END OF ART THEORY' (1986)

Victor Burgin 'The End of Art Theory', in *The End of Art Theory*, London: Macmillan, 1986, 140–204.

Victor Burgin's 'The End of Art Theory' – a long essay, running to sixty-four pages, that ends a book of his essays under the same name, first published in 1986 – stems from various informal talks given to art students in the US and UK, from 1984 to 1985. This context is important in understanding the essay's argument. Burgin challenges assumptions that for him remained uncritical in art institutions in the 1980s: the art school was no longer a site of radicalism but was seen as conservative and anti-theoretical. The essay was also written against 'the trivialisation of the idea of the "postmodern"' and with the intention to establish a critical position for a postmodernist left art practice (Burgin 1986b: 163).

With the insistence on something being at an end, the essay's and the book's title typify the grand claims that marked certain writings about postmodernism. In some ways the title is misleading. What is *at an end* is not theory, but the romantic theory of art that sees the artist as an expressive individual; an end signalled by the implications of what he refers to as 'a *post*-Romantic aesthetics', informed by psychoanalysis, Marxism, semiotics and feminism (Burgin 1986b: 204). Burgin's essay contains citations from what is now a familiar canon of theorists associated with postmodernism: Louis Althusser, Roland Barthes, Jean Baudrillard, Pierre Bourdieu, Guy Debord, Jacques Derrida, Michel Foucault, Jürgen Habermas, Jean-François Lyotard and Fredric Jameson.

Burgin attacks the then pervasive romantic belief that the artwork originated in the thoughts and feelings of its maker:

> The artist does not 'create', innocently, spontaneously, *naturally* – like a flowering shrub which blossoms because it can do no other.
>
> (Burgin 1986b: 158)

Instead, he argues, the artist inherits a role handed down by a particular history, through particular institutions. In this respect, Burgin's essay is in line with a wider postmodern discourse that countered expressivity and authorship. But speaking of the postmodern end of 'grand narratives', does not mean that he can ignore personal experiences integral to his social and psychic formation: his working-class childhood, his sense of what social injustice is and his social and political allegiances. Postmodernism does not mean, as he carefully points out, 'the end of either morality or *memory*' (Burgin 1986b: 198).

For Burgin, what 'is most commonly encountered as art criticism presents itself as operating with, and within "common sense" (rather than what it tends to disparage as "intellectualisations")'. But what is taken as 'common sense' is 'as he shows' 'nothing more than the congealed residues of the intellectualisations of past ages' (Burgin 1986b: 141). The problem with much art criticism and reviewing is its denial that it involves theoretical presuppositions.

The essay begins with an outline of the shift in art's meaning from classical antiquity, when art was allied with manual as opposed to intellectual work. It continues with an exploration of how art, in the modern sense, begins in the early Renaissance, with the elevation of painting to the liberal arts and the recognition of its having a theoretical as well as a utilitarian practice:

> in order to construct scenes true to perspective, nature and history, the painter must command geometry, anatomy and literature.
>
> (Burgin 1986b: 143–44)

The eighteenth century saw the foundation of a modernist specificity, a purely visual art which was relieved of narrative function. Burgin argues that it was then that we had the necessary external conditions and institutions for the support of the autonomy of the aesthetic, which culminated in high modernism in the mid-twentieth century. This was the legacy inherited by the dominant discourse on art in the 1980s and which Burgin identifies as being made up of three strata: realist, expressionist and formalist. These are only rarely encountered as separate from one another. In this legacy, romanticism, where art is the expression of feeling, combines with the mimetic tradition in the form of expressive realism, which begins with John Ruskin and was still felt to inform much left-humanist art theory and practice in the west. For Burgin, this 'expressive realist' position is nowhere stronger than when legitimising documentary photography – Donald McCullin is 'seen as the "expressive realist" artist, *par excellence*' (Burgin 1986b: 157). But the dominant

manifestation, shared by most art journalists, is that of 'expressive form-alism', the belief 'that artists "express themselves" by means of beautiful shapes and colours' (Burgin 1986b: 157).

Burgin had written critically about Greenbergian Modernism in the opening two essays of the book – opposing his proposal that art withdraws completely from the actual world of social and political struggle. Remnants of modernism and romanticism are felt to persist within art schools and art criticism in the 1980s, despite the emergence of what was then 'new' theory, associated with such journals as *Screen* and *New Left Review*. In the second essay, 'The Absence of Presence', Burgin went so far as to speak of the obsolescence of painting and argued that a form of art truly involved in the terms of a society needs to work with photography. A turn away from the old 'high art' hierarchy of mediums was also being endorsed by the 'new' theory, with photography and film given import over literature and painting, which were seen as part of a broader and antecedent spectrum of representational practices.

The polemic against painting is to be understood in the context of the revival of large-scale expressionist paintings that characterised the 1980s. Burgin is also writing at the time of a rampant art market, a time when particular trends within art criticism had become indistinguishable from fashion writing – he disparagingly refers to art criticism as 'consumer information' and then compares passages from *Vogue* and a painting review from the *Guardian* to demonstrate their interchangeability (Burgin 1986b: 174–75).

In such a context, the artist's subversive gesture cannot escape the market. Burgin cites Pierre Bourdieu on such work as Piero Manzoni's tins of artist's shit, works which while seemingly negating the system that feeds it, are actually readily assimilated by it:

> Because they expose the art of artistic creation to a mockery already annexed to the artistic tradition by Duchamp, they are immediately converted into artistic 'acts', recorded as such and thus consecrated and celebrated by the makers of taste.
>
> (Bourdieu cited in Burgin 1986b: 189)

The cultural value that critics bestow on such work will be transmuted into economic value.

Towards the close of 'The End of Art Theory', Burgin holds up to critique an important narrative emerging in the 1970s, that of 'art for the people' or 'art for all'. Having already dismantled the liberal humanist idea of the expressive artist, he turns to the:

ultra-leftist critical position which advocates 'working outside the [art] institution' as, *a priori* the privileged, the *only*, politically progressive strategy.

(Burgin 1986b: 191)

The idea that you can work outside the art institution – 'Romantic "outsider*ism*"' – fails to acknowledge that there is no outside, only another institution (Burgin 1986b: 192). To make art for a trades union is simply to move art into another institution, with its own specific conditions and determinations. Working within such a context, artists risk 'abandoning a struggle to which they could bring some experience and expertise, for one to which they are novices'. Art on the street or in the factory is still inscribed within dominant discourses. The gallery is thus no more 'irretrievably bourgeois' than the cinema or the classroom (Burgin 1986b: 192).

Burgin identifies himself with Foucault's Gramscian idea of 'specific' intellectuals:

no longer purveyors of the general, the 'good for all time', they now engage the particular conditions of their everyday professional and social lives.

(Burgin 1986b: 201)

Therefore he sees himself as not working for '"posterity", "the people", "truth" … , "the general public"', but 'on those particular projects which seem *critical* at a particular historical conjuncture' (Burgin 1986b: 201).

Dismantling 'the modernist ideal of art as a sphere of "higher" values, independent of history, social forms and the unconscious' and exposing a 'common sense' criticism that denied recognising art as a theoretical practice, Burgin seeks new forms of politicisation within the institutions of art (Burgin, 1986b: 204). And it is in relation to this that the cultural theory of the 1960s and 1970s becomes so important. It showed that:

art is not 'outside' of the complex of other representational practices and institutions with which it is contemporary – particularly, today, those which we so problematically call the 'mass media'.

(Burgin 1986b: 204)

Instead of art theory, 'understood as those independent forms of art history, aesthetics and criticism which began in the Enlightenment and culminated in "high modernism"', Burgin calls for us to take up:

the objectives of *theories of representations* in general: a critical under-
standing of the modes and means of symbolic articulation of our
critical forms of sociality and subjectivity.

(Burgin 1986b: 204)

This sentence, Burgin's closing statement in his essay, was essentially a
justification of what he was doing as an artist with the 'mixed system' of text
and photographs (Burgin 1986b: ix). Burgin saw his role as an essay writer
as determined by his other work as an artist and a lecturer. And it his identity
as an artist that very much drives the polemics of this essay. Much as it
represents an important politicising of postmodernism at a time of critical
slackening, it also serves to bolster and defend his own position as someone
speaking from the left within both academia and the art gallery.

Mark Durden

Select bibliography

Burgin, V. (ed.) (1982) *Thinking Photography*, London: Macmillan.
——(1986a) *Between*, Oxford: Blackwell.
——(1986b) 'The End of Art Theory', in *The End of Art Theory*, London:
Macmillan, 140–204.
——(1996) *In/Different Spaces: Place and Memory in Visual Culture*, Berkeley:
University of California Press.
——(1996) *Some Cities*, Berkeley: University of California Press and London:
Reaktion Books.
——(2008) *Components of a Practice*, Milan: Skira.
Evans, J. (1994) 'Victor Burgin's Polysemic Dreamcoat' in John Roberts (ed.),
Art Has No History! London: Verso, 200–29.
Green, D. (1987) 'Burgin – History/Ideology/Psychoanalysis' *Ten*, 8.26, 30–36.
Roberts, J. (1998) *The Art of Interruption: Realism, Photography and the Everyday*,
Manchester: Manchester University Press.
Streitberger, E. A. (2010) *Situational Aesthetics: Selected Writings by Victor Burgin*,
Leuven: Leuven University Press.

PETER FULLER, *THEORIA: ART AND THE ABSENCE OF GRACE* (1988)

Peter Fuller, *Theoria: Art and the Absence of Grace*, London: Chatto and
Windus, 1988.

Peter Fuller (1947–90) began his career influenced by the Marxist art
critic and author John Berger (b. 1926). Under the impact of the British

School of Object Relations, Psychoanalysis and the works of John Ruskin (1819–1900), Fuller's views changed radically and he came to believe that the aesthetic response to art had normative standards grounded in the relatively constant biological character of human beings. Fuller promoted what he described as the 'British Higher Landscape Tradition' and, whilst maintaining his non-belief, began to explore the possibility of a form of pantheistic transcendentalism mediated through landscape painting. In 1988 he became founder editor of the *Modern Painters* magazine in which he promoted his opinions. Whilst often controversial, Fuller's views offered a stimulating alternative to much contemporary cultural analysis. Peter Fuller was killed in a car accident in April 1990.

Theoria: Art and the Absence of Grace was Fuller's last book. Its title came from John Ruskin's concept of theoria – 'A response to beauty with one's whole moral being … the full comprehension of the Beautiful as a gift of God' (Ruskin 1903–12 vol. XX: 208). Whilst the book detailed how scientific discoveries had destroyed the Natural Theology on which Ruskin's project was founded, *Theoria* is actually an autobiographical account of Fuller's own intellectual development. It delineates his disillusionment with contemporary Marxist ideas, his controversial belief of collusion between the cultural Left and Right that had lead to British artists relinquishing aesthetics, and his search, as a non-believer, for a re-establishment of humankind's wonderment before the natural world based on modern-day science.

Fuller's text started with a comparison of Charles Collins' *Convent Thoughts* (1850) – a highly naturalistic depiction of a nun within a walled garden 'Redolent with laboured symbolic intent' (Fuller 1988c: 1) – with *Praying Garden* by Gilbert and George (1982). In contrast to Collins, he suggested that the latter artists '[could not] rise above their obsessive preoccupation with urban violence, lumpen philistinism, sexual products and organs, and personal depravity' (Fuller 1988c: 3). Fuller continued:

> We may stand on the far shore of a collapsed modernity, but our most acclaimed artists have not resolved the spiritual and aesthetic crisis which, however unsuccessfully, Collins endeavoured to confront.
> (Fuller 1988c: 3–4)

Fuller's art and cultural criticism was grounded in Marxist discourse, but his Marxism remained humanistic rather than doctrinaire and he reacted against what he saw as the dehumanising aspects and legacies of 1960s structuralist thought. Fuller believed that Marx's early writing offered 'A vision of a new sensuous aesthetic relationship between man and the

world' (Fuller 1988c: 128), whilst doctrinaire Marxists were 'Dissolving [Marx's] sensuous, living, loving potentially fully human being, into a sea desert of decentred linguistics' (Fuller 1986b: 118). Fuller wrote that by the mid-1970s:

> I found myself drawn into the aesthetically conservative and yet profoundly radical universe of Ruskin.
>
> (Fuller 1988a: 118)

Widely dismissed by the 1970s, John Ruskin had been both an art critic and a social commentator. He perceived art as a social indicator and was vehemently opposed to the effects of Victorian *laissez-faire* capitalism and mass production. Ruskin believed that the medieval Gothic era had embodied a spiritual, moral and socio-economic climate in which the building of the cathedrals had been 'Executed by men who design[ed them]' (Ruskin 1903–12 vol. XVI: 215–16). He argued that the Gothic sculptor's depictions of forms of plants and flowers were both a celebration of the craftsman's innate love of decoration and his spiritual response before a God-created world (Fuller 1988c: 52–65).

Ruskin's beliefs foundered with the scientific discoveries of the 1850s that destroyed faith in the Biblical account of the Creation, but Fuller considered that Ruskin offered a holistic approach to the place of art and aesthetics in an industrial society. He noted:

> Ruskin's importance today lies in the fact that he saw the ethical and aesthetic objections to industrial capitalism – and not the narrow economic and political one pursued by Marxists and socialists.
>
> (Fuller 1986a: 24)

Fuller contrasted Ruskin's celebration of the individualised decorative aspects of Gothic art with that of Marx who, Fuller suggested, dismissed the 'Display of imaginative or spiritual symbolism' of the Gothic as 'primitive fetishism' and instead proposed that under communism 'Work itself would become increasingly aesthetic' (Fuller 1988c: 102–12). Fuller suggested that a Victorian contemporary of Ruskin, William Morris (1834–96), had set out a Marxian vision of such a realised communitarian society in *News from Nowhere* (1891), but the result was a sterile environment where the inhabitants experienced no aesthetic pleasure in their existence (Fuller 1988c: 130–43).

Fuller noted that many twentieth century *avant-garde* movements set out to denigrate individuality and ornamentation, instead celebrating the

machine aesthetic of modernism. He cited Adolf Loos (1870–1933), who had argued that ornamentation was immoral, degenerate and 'wasted labour'; the Italian Futurist movement that glorified machinery, speed and violence; the Soviet Constructivists who believed that 'Art has no place in modern life'; and the Dadaists who proclaimed 'Down with art … Art is dead' (Fuller 1988c: 175–83).

Fuller suggested that the core of these ideas was a search for a 'materialist aesthetic' and this had become 'official' arts policy. The consequence of this thinking was that by the 1970s many artists were content with merely reproducing the 'mega visual' images of mass culture and had turned their backs on the natural world such that 'The celebration of the new productive forces almost entirely replaced any sense of aesthetic sensibility'. The outcome of this was 'The aesthetic wasteland of late and post-modernism' (Fuller 1988c: 175–83). He placed much of the blame for this on his erstwhile mentor John Berger and his collaboratively authored *Ways of Seeing* (1972), which he claimed had promoted the 'diminution of art'. Fuller argued that Marxist and socially conservative approaches that disparaged high art had resulted in 'Marxist and Tory Party approaches to art [which] dissolved into an indistinguishable mélange'. It was against this background that artists such as Gilbert and George, with their 'contempt for high art and aesthetic values', had thrived with the support of 'today's nouveau riche' (Fuller 1988c: 202–15).

By contrast, Fuller argued that 'The best art in Britain this [twentieth] century has depended for its originality on its denial rather than its espousal of modernity' claiming that this 'otherness' of British art as represented by, amongst others, Henry Moore and Ben Nicholson, showed 'a sense of continuity with a British tradition' (Fuller 1988c: 184–201). Fuller continued by asserting that such artists' ability 'To create major pictures in an imaginative response to the natural world … may point beyond the impasse of post-modernism' (Fuller 1988c: 216–24).

In conclusion, Fuller claimed that the writings of contemporary scientific thinkers such as Richard Dawkins in *The Blind Watchmaker* (1986), Benoit Mandelbrot in *The Fractal Geometry of Nature* (1982) and E. O. Wilson in *Biophilia* (1984), offered a form of secular theology that, whilst contrary to Ruskin's Natural Theology, vindicated Ruskin's views (Fuller 1988c: 225–34). Although some of the arguments of *Theoria* are flawed, Fuller's conviction that aesthetic experience was diminished if it denied any concept of the spiritual has merit. His argument for the reintroduction of a spiritual dimension into art through secular science, however, is not convincingly made. He

ignored the international heritage and influences on the British artists he praised and his criticism of John Berger for the apparent excesses of the later twentieth century art market are unwarranted. Yet despite such flaws, the overall contribution and arguments of *Theoria* cannot be dismissed.

Fuller's attempt to establish a secular spirituality mediated through contemporary science is unsustainable, but it is not in this area that his legacy lies. Fuller believed in art as an antidote to mass culture and in *Theoria* he raised important questions about humankind's creative imperative: what art may signify within our contemporary secular society, our relationship with the environment and the transcendental and redemptive possibilities of art. Ruskin wrote 'No function can possibly be today more honourable or needful than that of a candid and earnest art-critic' (Ruskin 1903–12 vol. XXlV: 608). Fuller attempted to fulfil that role in the later part of the twentieth century.

Peter McMaster

Selected bibliography

Berger, J. (1972) *Ways of Seeing*, London: British Broadcasting Corporation and Penguin Books.

Clark, K. (1967) *Ruskin Today*, London: Penguin Books.

Fuller, P. (1980a) *Art and Psychoanalysis*, London: Hogarth Press.

——(1980b) *Beyond the Crisis in Art*, London: Writers and Readers Publishing Cooperative.

——(1980c) *Seeing Berger: A Revaluation*, 2nd edition, London: Writers and Readers Publishing Cooperative.

——(1983a) *The Naked Artist*, London: Writers and Readers Publishing Cooperative.

——(1983b) *Aesthetics After Modernism*, London: Writers and Readers Publishing Cooperative.

——(1985) *Images of God*, London: Chatto and Windus, London.

——(1986a) *The Australian Scapegoat: Towards an Antipodean Aesthetic*, Crawley: University of Western Australia.

——(1986b) *Marches Past*, London: Chatto and Windus.

——(1988a) 'Goodbye to all That', *New Society*, 26 May, reprinted in Fuller 1988b.

——(1988b) *Seeing Through Berger*, London: The Claridge Press.

——(1988c) *Theoria: Art and the Absence of Grace*, London: Chatto and Windus.

Morris, W. (1891) 'News from Nowhere', in Clive Wilmer (ed.), *News from Nowhere and Other Writings*, London: Penguin Classics (1993, 1998, 2004), 41–230.

Ruskin, J. (1903–12) *The Works of John Ruskin*, ed. E. T. Cook and A. Wedderburn, 39 vols, London: George Allen.

RASHEED ARAEEN, *THE OTHER STORY: AFRO-ASIAN ARTISTS IN POST-WAR BRITAIN* (1989)

Rasheed Araeen (ed.) *The Other Story: Afro-Asian Artists in Post-war Britain*, London: Arts Council of Great Britain, 1989, catalogue for the exhibition at The Hayward Gallery, London (1989); Wolverhampton Art Gallery (1990); and Manchester City Art Gallery (1990).

Rasheed Araeen's (b. 1935) catalogue to the exhibition entitled *The Other Story*[1] (1989) presented to the British public for the first time the contribution to British art of artists who worked in Britain and had either begun life abroad as colonised subjects before the end of empire (such as Ronald Moody (1900–984)) or who were descendants of colonised peoples (like Sonia Boyce (b. 1962)). Araeen introduced the latest post-colonial theories to explain why such artists had not been properly acknowledged in the history of post-war Modern Art. Now was the time to tell the full story so that never again would it be necessary to have an exhibition, selected on the undesirable 'basis of racial origin' (Joanna Drew in Araeen 1989: 5). By showing the British public how colonised peoples and their postcolonial children had been mis-represented, demoted and illogically corralled as 'Afro-Asian artists', inequality might be ended.

The Hayward Gallery, South Bank Centre (opened 1968) was the largest exhibiting space available in London to the Arts Council of Great Britain. Inaugurated in 1945, the Council was the most powerful state-funded organisation unattached to a museum, aiming to assist the development of British art. In this capacity it exhibited works by recent British artists such as the *Hayward Annual* (1977–85), as well as international art forms past and present (e.g. *Camille Pissarro* 1980 and *In the Image of Man: Indian Perception of the Universe* 1982).

Araeen's authority to speak was based on his commitment to his practice as a Minimalist sculptor and politically engaged artist; and on leadership in cultural politics evident in his founding with Guy Brett (b. 1942) of the journal *Black Phoenix* (1978–79) and the editing and founding of the quarterly *Third Text* (1987–the present).

In order to publicise his agenda, Araeen exploited the pejorative and positive meanings of the term 'other' in his title. Simone de Beauvoir (1908–86) had employed the concept (derived from psychoanalytical accounts of the way selfhood is defined by contrast with some 'other') to explain how the fiction of an essential masculinity was sustained by imagining 'woman' possessing 'other' weaker characteristics by contrast with those of 'man' (1949). Frantz Fanon (1925–61) had transposed the

term to explain how colonisers had defined themselves as natural gov-
ernors, over those 'others' whose lands they had captured and who
needed governing (1952). The colonial subject, like 'woman', was
regarded (according to such new ideas) by those with the power to do
the defining, not as just another similar person (in the psychoanalytical
usage) but as a 'subordinate other'. These were negative connotations.
But theories of cultural representation linked with movements advocat-
ing politico-social equality from the 1960s onwards had taken the term
and valued positively the viewpoints, actions and products of those
designated 'others', for their own sake and for the insight they provided
concerning the way ruling institutions worked. It was in this context
that Araeen set out to tell:

> a story of those men and women who defied their 'otherness' and
> entered the modern space that was forbidden to them, not only to
> declare their historical claim on it but also to challenge the framework
> which defined and protected its boundaries.
>
> (Araeen 1989: 9)

Postcolonial and feminist theorists had questioned the concept of a single
correct (Art) History and argued that there was no one perfectly objective
account of the past but rather that there were as many interpretations of
what happened in (art) histories as there were observers, since historians'
interpretations depended on their socio-cultural and temporal locations as
perceivers. All reliable historians gathered data accurately and interpreted
facts cogently. However, which facts were judged important to verify, and
how data might be interpreted, varied according to the writer's knowl-
edge and interests. A plurality of such reliable stories could provide
varied views of what happened. Therefore Araeen affirmed that he was
obeying Edward Said (1935–2003) whom he quoted as urging historians,
'to tell *other stories* than official sequential or ideological ones produced
by institutions of power' (my italics) (Said 1983; Araeen 1989: 9).

Official histories were, it was argued, researched by white, male,
middle-class scholars who controlled gallery display, the art market,
publishing and education, and represented the political interests of gov-
erning classes. Araeen proposed that official art history, 'is an ideological
presentation of Western civilization', which he explained in Marxist
terms, denoted a falsification of the socio-economic relations in which
art was produced (Araeen 1989: 11). Referring to the theories of
Roland Barthes (1915–80) (1975) Araeen asserted that this official nar-
rative could be interrogated 'to reveal the underlying myth which dis-
guises those contradictions inherent in its claim of objective superiority,

both historical and epistemiological' (what counts as an historically sig-
nificant fact and what is considered true of art) (Araeen 1989: 11). '*The
Other Story*' was important then, because it supplied missing data and
revealed the institutional levers hitherto controlling 'The History of
Modern British Art'.

Araeen pointed to the importance of historiographical studies for an
understanding of how imperialist ideologies had encouraged European
scholars and critics to write of the art produced by colonised peoples
before and after imperial rule as if they were incapable of the artistic
leadership or self-generated progress achieved naturally by colonisers'
artists. Araeen stated:

> what we face here is the dominant ideology of an imperial civiliza-
> tion for which the racial or cultural difference of the colonized
> constitutes Otherness. And of course the Other is part of its history
> as long as it stays outside the master narrative.
>
> (Araeen 1989: 9)

Araeen referred to the research of Partha Mitter in quoting John
Ruskin's description of objects made in India and the Pacific Islands as
'grotesque' by comparison with the arts of Ancient Greece, and the
account by Georg Wilhelm Friedrich Hegel (1770–1831) of the art in
India as a story of decline or stasis (1977). The imperialist 'master nar-
rative' by contrast had traced the story of self-renewing artistic progress
stretching from Ancient Greece to Modern Europe. Araeen lamented
that even the well-meaning attempt at *A World History of Art* (1982) by
Hugh Honour and John Fleming, whilst trying to include all cultures
and treat them equally up to the nineteenth century, had nevertheless
related the history of Modern Art in the twentieth century as the
exclusive achievement of Europeans: 'The West then shines alone this
century, the whole world reflected in its image' (Araeen 1989: 10). The
supremacy of imperialist culture could, Araeen argued, only be main-
tained whilst the colonised and their descendants were designated as
outside 'the dynamics of art historical continuity', adding: 'is not the
history of art still being written according to the Hegelian framework
in which only the Western subject is privileged?' (Araeen 1989: 10). The
myths of empire had encouraged misleading descriptions of the work
of artists labelled as 'Afro-Asians' working in Britain so that, 'their
Otherness was constantly evoked as part of the discussion of their
work' (Araeen 1989: 13). For example Araeen cited the way the paint-
ings of Aubrey Williams were said in 1959 by Jan Carew to 'express in
essence a sense of being which differs from that of the European in the

same way that a spinet differs from the rhythm of a drum' (Araeen 1989: 32).

Araeen's catalogue also publicised new or revived forms of (art) history prized by postcolonial and feminist theorists. Araeen declared that he was an amateur historian, confessing in his first paragraph, 'my lack of proper expertise and insufficient discipline'. However his artistic experience gave unique understanding: 'My own struggle as an avant garde artist has been fundamental to my realization of the issues' (Araeen 1989: 9). When professional historians had disparaged art as unworthy of history, artists like Giorgio Vasari (1511–74) had stepped in. Araeen rejected the idea that he offered 'the only story', presenting the catalogue as 'exploratory' and collective – including six further accounts entitled 'Other Voices'. He avoided the aloofness of master narratives, sometimes adopting intimate tones: 'I have lost all the papers about Parvez. I feel angry with myself' (Araeen 1989: 34). The accounts provided were 'fragmentary' because the artists concerned had been considered unimportant, unlike the smooth sequence of records available in official history (Araeen 1989: 9). Nor did *The Other Story* claim to be disinterested. It was overt about its political hopes ('advancement towards a truly multi-racial and multi-cultural society'), yet tentative ('only an initiative') and reflexive ('we have included only four women artists which is regrettable') (Araeen 1989: 106)

Araeen's text marked the moment when the unofficial stories and modes of story telling associated with postcolonial theory were acknowledged by a key institution belonging to the largest former European colonial power.[2]

Catherine King

Notes

1 The allusion may be to Ernst Gombrich's '*The Story of Art*' (1956) and the recent use of 'Her Story' in for example June Sochen, *Herstory: A Woman's View of American History* (1974).

2 Hostile and enthusiastic reviews may be sampled in King (1999: 263–76).

Select bibliography

Araeen, R. (ed.) (1989) *The Other Story: Afro-Asian Artists in Post-war Britain*, London: Arts Council of Great Britain.
Barthes, R. (1957) *Mythologies*, Paris: Editions du Seuil.

de Beauvoir, S. (1949) *Le Deuxième Sexe*, Paris: Gallimard.

Fanon, F. (1952) *Peau noire, masques blancs*, Paris: Editions du Seuil.

Gombrich, E. H. (1956) *The Story of Art*, London: Phaidon.

King, C. (1999) 'Views of Difference: Different Views of Art', in S. Edwards (ed.), *Art and its Histories: A Reader*, New Haven, CT: Yale University Press, 263–76.

Mitter, P. (1977) *Much Maligned Monsters: A History of European Reactions to Indian Art*, Oxford: Oxford University Press.

Said, E. (1983) 'Opponents, Audience, Constituencies and Community' in Hal Foster (ed.), *The Anti-Aesthetic: Essays on Postmodern Culture*, Seattle, WA: Bay Press, 135–59.

Sochen, J. (1974) *Herstory: A Woman's View of American History*, New York: Alfred Publishing Company.

GEORGES DIDI-HUBERMAN, *CONFRONTING IMAGES: QUESTIONING THE END OF A CERTAIN ART HISTORY [DEVANT L'IMAGE : QUESTIONS POSÉES AUX FINS D'UNE HISTOIRE DE L'ART]* (1990)

The English translation used is Georges Didi-Huberman, *Confronting Images: Questioning the End of a Certain Art History*, Philadelphia: Pennsylvania State University Press, 2005.

Confronting Images: Questioning the End of a Certain Art History, originally published in French in 1990, is an uncompromising questioning of the closed and conclusive certitude which is perceived to pervade the discipline of art history. It is a book that shows Didi-Huberman to be the innovator and excavator against a settled expectation and presupposition about the image within art history – he investigates the 'blind spot' in reading an image between what it is – what it means and what I see. Not only is it an interrogation of the 'tone of certainty that prevails so often in the beautiful discipline of art history', it is a challenge to the 'Academician' (Didi-Huberman 2005: 2).

Georges Didi-Huberman (b. 1953) is a French art historian and philosopher. He teaches at the École Des Hautes Études en Sciences Sociales in Paris, an institution whose past and present faculty members include Jacques Derrida, Milan Kundera, Roland Barthes and Jaques Lacan. Didi-Huberman follows in a tradition of the art historian as critic, as connoisseur, revolutionary and conservator, upturning and exploring the 'underside' of the image (Didi-Huberman 2005: 112).

Confronting Images explores the reading of *Kunstgeschichte* (art history), through a re-examining of such ideological founding fathers of art historical writing as Giorgio Vasari (1511–74), in particular his *Le Vite dei più eccellenti pittori, scultori e architetti* (*Lives of the Most Eminent Painters, Sculptors and Architects*) 1550 and 1568, and the writing on the Renaissance and medieval by the German art historian Erwin Panofsky (1892–1968). It is presented in four chapters – *1*. The History of Art within the Limits of Its Simple Practice; *2*. Art as Rebirth and the Immortality of the Ideal Man; *3*. The History of Art within the Limits of Its Simple Reason; and *4*. The Image as Rend and the Death of God Incarnate.

Didi-Huberman explores the Vasarian conclusions on the glorification of antiquity, the 'decay' of the Middle Ages and the revival of thought and thinking of the High Renaissance (*rinascita*). He asks: 'To what ends did Vasari invent the history of art? And above all: To what inheritance have these ends condemned us?' (Didi-Huberman 2005: 55).

He acknowledges and challenges the 'crack' in Vasari's *Lives*, whereby, through its encyclopedic documentation of the life of the artist in fifteenth-century Italy, art became a device for knowledge rather than art, or the image, remaining as a vehicle of thought (Didi-Huberman 2005: 70):

> As for the knowledge about art whose field it opened up, it resolved henceforth to envisage or accept only an art conceived as knowledge.
>
> (Didi-Huberman 2005: 82)

He recognises the flaws in the *Lives* whilst accepting the necessity to fabricate and invent history as a 'rhetorical strategy of the album' (Didi-Huberman 2005: 71), where what is presented as fact becomes 'faction':

> but he [Vasari] wove all this knowledge together with the thread of plausibility, which, it should be clear, has but little in common with truth.
>
> (Didi-Huberman 2005: 70)

Didi-Huberman situates the contemporary emphasis and focus on the artist's life and the cult of the personality, and the 'obsession with the monograph' as a legacy of Vasari:

> the history of art is still massively recounted as a history of artists – works of art being called upon more often as illustrations than as objects of the gaze and of interrogation.
>
> (Didi-Huberman 2005: 86)

He makes way for art criticism to be subjective as well as objective.

In 'Studies in Iconology' (1939), Panofsky based his art historical understanding of images on three principles: first, that of knowledge of primary subject matter – a basic understanding of a work; second, knowledge of a conventional subject matter or *Iconography*, which includes an understanding of the cultural context of the work, and finally the principle of *Iconology*. This latter reveals (or the viewer is aware of) the intrinsic context of the making of the work, as well as the content of the image. From this analysis an answer can be formulated to the question of what the meaning behind the work is. Didi-Huberman rejects the concreteness of this interpretation:

> from this point of view, Panofsky's work bears the stamp of an emphatic closure, a veritable buffer zone meant to protect the discipline against all imprudence and impudence: in other words, from all hubris, from all immoderation in the exercise of reason.
>
> (Didi-Huberman 2005: xvi)

Didi-Huberman thus charges us with a critical re-reading of Panofsky:

> this is not, to be sure, a reason to exorcize Panofsky himself, only an incitement to read him and re-read him – but critically as true admiration requires.
>
> (Didi-Huberman 2005: xxv)

In *Confronting Images*, Didi-Huberman encounters and dissects Panofsky's two fold aspect of humanism to distinguish between 'the sphere of *nature* and the sphere of *culture*' (2004: 112) to ascertain a further meaning behind the image. *Confronting Images* challenges Panofsky's dependence on iconology and his perpetual insistence on the symbiotic relationship of the subject matter to an allegorical syntax of meaning:

> the Renaissance will become law for other periods of history, and humanist knowledge will itself become that *organic situation* henceforth assimilable, for the reader, to an absolute model of knowledge.
>
> (Didi-Huberman 2005: 113)

Panofsky's treatise on meaning in an art historical context is one that pervades and is celebrated in western art historical thinking:

> it was this insistence on, and search for, meaning – especially in places where no one suspected there was any – that led Panofsky to

understand art, as no previous historian had, as an intellectual endeavor on a par with the traditional liberal arts.

(Lavin 1995: 6)

Didi-Huberman challenges this stance throughout *Confronting Images*; the notion that 'knowledge' is in the eye of the beholder – the art historian's posture is continually put into question.

> Rend, then, will be the first word, the first approximation with which to renounce the magic words of art history. This will be the first way of challenging Panofsky's notion that the naïve beholder differs from the art historian in that the latter is conscious of the situation.

(Didi-Huberman 2005: 140)

Confronting Images is occidental in its endorsement; its focus is predominately Judaeo-Christian. Its consideration does not reference a wider cultural exploration of artists' biographies, for instance: Mustafa Ali's 'Manaqib-I hunarvaran' ('The Wonderful Deeds Of The Artist') (1587), an Islamic compliment to the Vasarian enquiry into the lives of artists; or Xie He in sixth century China and his 'Six Principles For Great Art' written in his book *Gu Huapin Lu* ('Classified Paintings of the Pas'), which rates and categorises twenty-seven painters into three classes of merit based on the major principle or hierarchy of *qi yun shen dong* ('spirit resonance') and creativity, which sought to define and structure great Chinese art. He does seek, however, a universal re-reading of the established schemes that define art history.

His discourse places importance essentially on a non-positivist[1] and *a priori* knowledge, that is to say responding before knowledge and rationalism determines to explain. By this explication Didi-Huberman seeks to halt us at the very moment before we are conscious enough to cipher meaning in a work. This approach contradicts Kantian thinking whereby something that is conveyed is governed by accepted parameters:

> The universal communicability of a pleasure carries with it [the requirement] that this pleasure must be a pleasure of reflection rather than one of enjoyment arising from mere sensation.

(Kant 1987: 173)

It is the leaving open of the 'crack' so that we can, like Lacan, gaze and feel 'sensation' and not close down an interpretation of an image.

In *Confronting Images* Didi-Huberman seeks to un-pick the founda-
tions of the reading of western art history and in particular challenges
Panofsky's three tier approach to the 'deflowering' of image and
instead urges, as a complement, the reading of image through Sigmund
Freud and his concept of dream work in *Interpretation of Dreams* (*Die
Traumdeutung*, 1913).

This complex stance marks a shift in a traditional reading of art
historical work. In the dream state, logic does not necessarily prevail;
objects, scenes are 'represented' yet the dream state is illogical, though it
still has meaning and it is still understood. 'Paintings are of course not
dreams. We see them with open eyes, but this may be what hinders us
and makes us miss something in them' (Didi-Huberman 2005: 156).

It is an examination of perception, a prospect for a new meaning, a
newer interpretation that is pursued in *Confronting Images*. There is
something else that is represented in dreams: '"it shows" in dreams
because "it presents itself"' and Didi-Huberman attempts to apply the
same questioning to figurative painting (Didi-Huberman 2005: 156):

> Our hypothesis is at base quite banal and quite simple: in a
> figurative painting 'it represents' and 'it sees itself' – but something
> just the same, shows itself there, too, looks at itself there, looks at us
> there. The whole problem of course being to discern the economy
> of this *just the same* and to think the status of this *something*.
>
> (Didi-Huberman 2005: 156)

This continues as a re-opening of the question of image: 'we must by
opening the box, open its eye to the dimension of an expectant gaze:
wait until the visible takes and in this waiting try and put a finger on the
virtual value of what we are trying to apprehend under the term visual'
(Didi-Huberman 2005: 141).

Confronting Images, in questioning the end of a certain art history,
prepares the foundations for a new way to understand the image that
sees representation as moving and indefinite – one that in anthro-
pological terms returns the viewer back to him- or herself and his or her
gaze. Yet what is reflected back is the image identified.

Mavernie Cunningham

Note

1 Positivism seeks a knowledge based on authenticity and scientific
verification.

Selected bibliography

Didi-Huberman, G. (2005) *Confronting Images: Questioning the End of a Certain Art History*, Philadelphia: Pennsylvania State University Press.

Kant, I. (1987) *Critique of Judgement*, translated by Werner S. Pluhar, Cambridge, MA: Hackett.

Lavin, I. (1995) 'Panofsky's History of Art', in *Meaning in the Visual Arts: Views from the Outside*, Princeton, NJ: Institute for Advanced Study.

Vasari, G. (1996) *Lives of the Painters, Sculptors and Architects, Volumes I and II*, New York: Everyman's Library.

HOMI BHABHA, *THE LOCATION OF CULTURE* (1994)

Homi Bhabha, *The Location of Culture*, London: Routledge, 1994.

Homi Bhabha's collection of essays published as *The Location of Culture* (1994) is widely regarded as one of the key texts of postcolonial theory, a field that was opened up by the publication of Edward Said's book *Orientalism* in 1978. Said's argument that texts written about the 'Orient' could not be regarded as disinterested but had to be seen as tied to the political aims of imperial powers inaugurated a field that, along with feminism and queer theory, played a key role in re-thinking some central tenets of art history, such as the construction of the canon, and what modernism encompassed.

A number of Bhabha's essays, particularly in the first half of the book, tease out the complexity of the colonial encounter and especially concepts such as 'hybridity', 'ambivalence' and 'liminality'. The essays in the second half of the book use these concepts to articulate different ways of thinking about modernity and the space occupied by writers and artists whose cultural origins lie outside the west. The essays are characterized by a dense, elliptical and poetic style that often creatively interprets source material. This source material is primarily documents that pertain to the colonial rule of Britain in India, literary texts and occasionally art works. The essays in the *The Location of Culture* do not set out to offer any sustained account of any art. Indeed, it is more plausible to suggest that Bhabha uses art, as he does literature and colonial texts, as props for the articulation of a series of highly suggestive theories, which have subsequently found much currency with art historians, curators and artists.

Bhabha's concepts articulated in *The Location of Culture* have had an influential effect on two significant areas. First, they have fed into either

the making of, or the interpretive framework around, works made by a number of artists of colour who emerged in the 1990s, such as Chris Ofili, David Hammons, Yinka Shonibare and Renée Green. As their work began to emerge in exhibitions through the 1990s it was clear that it stood in contrast to those of an earlier generation of artists of colour. These earlier artists were allowed to occupy very narrow parameters. They were sometimes seen as exotic, but derivative versions of western modernism; a good example is the 1960s British critical reception of the Indian painter F. N. Souza. Or subsequent to that they were seen as articulating a political point; the critical reaction to artists such as Rasheed Araeen and Keith Piper illustrate this well. However, artists such as Ofili and Shonibare in Britain, and David Hammons in the USA were able to approach ethnicity in a much more ambivalent mode, using irony, humour and the deliberate violation of taboos. It is arguable that this shift was caused by the rise to prominence of the postcolonial theory associated with Bhabha and others such as Paul Gilroy and Stuart Hall. However, the concept of hybridity, which seemed particularly relevant to the works of artists such as Ofili and Shonibare, was mostly associated with Bhabha's *The Location of Culture*. Bhabha returns to hybridity through the book and ascribes a number of facets to it:

> Hybridity is the sign of the productivity of colonial power, its shifting forces and fixities. It is the name for the strategic reversal of the process of domination through disavowal (that is, the production of discriminatory identities that secure the 'pure' and original identity of authority). Hybridity is the revaluation of the assumption of colonial identity through the repetition of discriminatory identity effects.
>
> (Bhabha 1994: 159)

Central to Bhabha's concept is his argument, which draws on the writings of Jacques Lacan and Frantz Fanon, that the incompleteness of identity can productively fracture the way the colonizer relates to the colonized and vice versa. The notion of hybridity was challenged by a number of commentators who were concerned with what use it might have in terms of political agency, but in terms of art practice, it was undoubtedly enabling. Chris Ofili's deliberate 'hyper-blackness' in his early works and Yinka Shonibare's use of 'African' fabrics that were in fact manufactured in South London can both be productively understood with reference to hybridity.

However it is arguable that the more important legacy of *The Location of Culture* was to thinking around art history and exhibition-making rather than its usefulness in understanding the works of individual artists. A number of Bhabha's ideas have been particularly influential. In the chapter 'Dissemination: Time, narrative and the margins of the modern nation', Bhabha builds on the work of theorists such as Benedict Anderson and Edward Said, both of whom re-thought ideas around the nation and the national to develop ideas such as the 'liminality of the nationspace' and the idea of 'writing the nation'. Both of these ideas locate the idea of the 'national' somewhere in between the pedagogy of received narratives about the national and performativity. Bhabha's ideas pre-figure the deconstruction of essentialist ideas of the nation in exhibition-making which has taken place since. This includes the re-thinking of exhibitions themed around the 'national' types of art. Recent examples of this include 'Modern British Sculpture' at the Royal Academy (2010) which included works from the non-west that influenced British modernist sculptures. Bhabha and his fellow theorists' insistence on the performativity of the national feeds into decisions such as the choice of the British artist Liam Gillick as the representative of the German National Pavilion in the 2009 Venice Biennale and the Israeli-born, Dutch-based artist Yael Bartana as the representative of the 2011 Polish Pavilion.

A number of the essays in the book, such as 'The Postcolonial and the Postmodern', question mainstream discourses of multiculturalism, and instead argue for the presence of the incommensurable in place of the idealistic notion of the 'melting pot'. The implications of such an argument for art history in an age of increasing globalization were profound. From the late 1980s onwards, art historians debated how to think and write about art produced outside the west and one of the starting points of this debate was the 1989 exhibition 'Magiciens de la Terre' staged in Paris in 1989. The exhibition is regarded as the first attempt to draw together contemporary art on a truly global scale and paved the way for many large-scale exhibitions after. Yet it was criticized for being ethnocentric, that is exhibiting works made by non-western artists in a way that defined them solely in comparison to conceptually unrelated western counterparts. A key example was the positioning of an Indigenous Australian ('Aboriginal') ground sculpture, 'Yarla' next to Richard Long's 'Mud Circle' on the basis of some formal similarity. This had the effect of reducing the specific conditions of making, and possible range of meanings, of the former. Bhabha's ideas, from the productive misreadings of colonial texts that underpin his notion of hybridity through to his insistence of the presence of the

incommensurable within western modernity, helped open up a space in which art historians could start to think about works made outside the West, without simply folding them into a linear art historical narrative. As Bhabha argued: 'The time for "assimilating" minorities to holistic and organic notions of cultural value has dramatically passed' (Bhabha 1994: 175).

This insistence on the incommensurable that is located within western modernity through the history and legacy of colonialism leads to one of Bhabha's most complex, and yet for the purposes of art history, most suggestive ideas: the time-lag. This idea has its roots in his very specific reading of Frantz Fanon which brings out the latter's idea that the colonized is always positioned in a state of belatedness. Most simply put this idea suggests that the colonized subject is only belatedly recognized as a subject by the colonizer. Bhabha uses this to positive ends, by arguing that this 'time-lag' in subjectivity opens up spaces within modernity that the formerly colonized can not only occupy, but from where they can point to the incompleteness of modernity by highlighting those narratives, such as the role of the non-west in the construction of modernity through the history of empire, which have been previously erased. From an art historical perspective this opened up the possibility of modernism not being a singular narrative solely exemplified in avant-garde works of early to mid-twentieth century western artists but something which also happened elsewhere and, crucially, at a later time, without being merely derivative. So, art historians have been able to research and write about Brazilian modernism and Indian modernism, for example, and both these areas of research have lead not only to a critical re-appraisal of a number of artists and museum exhibitions, but also to a commercial boom in both of these areas (something perhaps that Bhabha would not have foreseen!). The key thing here is that Bhabha's use of Fanon again opens up a space for new art historical thinking: this time a way of articulating what has sometimes been termed 'other modernities'.

The Location of Culture attracted a fair share of controversy after publication. Some postcolonial theorists pointed to Bhabha's tendency to mostly reference western thinkers (such as Lacan and Barthes), others argued that Bhabha's ideas contained little or no practical solutions for the political problems associated with colonialism. Another strand of criticism concerned his concept of individual agency. However it now seems that many of these criticisms seem to want too much from a book that is deliberately dense, elliptical and even poetical. And from an art historical viewpoint, many of these rather dense ideas have been used to provide an interpretative framework for contemporary art made in the

age of globalization and furthermore enable conceptual frameworks for exhibiting them.

Niru Ratnam

Selected bibliography

Bhabha, H. (1994) *The Location of Culture*, London: Routledge.
Buchloh, B. and Martin, J. H. (1989) 'Interview', *Third Text*, 6, Spring, 19–28.
Hall, S. and Maharaj, S. (2001) 'Modernity and Difference: A Conversation', in S. Hall and S. Maharaj, *Modernity and Difference*, London: Institute of International Visual Arts, 36–57.
Parry, B. (1994) 'Signs of Our Times: Discussion of Homi Bhabha's *Location of Culture*', *Third Text*, 28–29, Autumn/Winter, 1–24.
Magiciens de la Terre (1989) exhibition catalogue, Centre Georges Pompidou, Paris.
Moore-Gilbert, B. (1997) 'Postcolonial Theory: Contexts, Practices, Politics', London: Verso.
Ratnam, N. (2003) 'Exhibiting the "other": Yuendumu community's *Yarla*', in J. Gaiger (ed.), *Frameworks for Modern Art*, New Haven, CT: Yale University Press in association with The Open University Press, 207–51.
Said, E. (1978) *Orientalism*, London: Penguin.

KOBENA MERCER, *WELCOME TO THE JUNGLE: NEW POSITIONS IN BLACK CULTURAL STUDIES* (1994)

Kobena Mercer, *Welcome to the Jungle: New Positions in Black Cultural Studies*, London: Routledge, 1994.

Kobena Mercer's first book *Welcome to the Jungle* is a collection of essays that constitute new approaches in arguing for, and understanding, the impact of the diasporic imagination on notions of multi-ethnicity and cultural difference in Britain. In his close analysis of visual art, pop music, style, and independent black British film, Mercer examines various ways in which minority ethnic groups express resistance in the struggle over the politics of race and representation. By going beyond essentialist thinking and binary differences to include the narratives of the silenced, the marginalized, and the displaced 'Other', Mercer also challenges the traditional disciplinary framework of western art history. Far from simply adding on that which is excluded from the dominant art historical discourses, his critical strength is in broadening the theoretical

parameters of rethinking the categories of race and sexuality within a politics of representation.

Several of the essays included in this volume, written between 1986 and 1992, previously appeared in journals such as *Artforum* and *Screen*, which helped establish the emerging field of black cultural studies. Writing at a time when the notion of national identity came under ideological and political strain by the increasing visibility of ethnic minorities, Mercer insists that his membership of this group was a key factor in the development of his theoretical position and attributes this to his participation with the Gay Black Group, 'a small nucleus of gay men of Asian, African, and Caribbean background, which formed in London in 1981' (Mercer 1994: 10). The sense of belonging set out by Mercer stands in sharp contrast to the growing civil unrest and debates on the racialization of politics during Thatcherism.

Welcome to the Jungle was instrumental in conceptualizing the shift that took place in black visual culture in 1980s Britain. This shift was first articulated by Stuart Hall in his important lecture *New Ethnicities* (Hall 1989), delivered at the *Black Film – British Cinema* conference at the ICA (Institute of Contemporary Art, London). Hall spoke about the 'end of the innocent notion of the essential Black subject' (Hall 1989) as a way to signal the socially constructed character of identity, formed out of a set of processes whereupon the dynamics of visibility and invisibility play an integral role.

Commenting on the circulation of negative representations of the black male as the dangerous 'Other' in the public sphere at this time, Mercer contends that it was indicative of 'not merely a social identity in crisis [but] also a key site of ideological representation upon which the nation's crisis comes to be dramatized, demonized and dealt with' (Mercer 1994: 160). Elsewhere, Mercer argues that the 'cultural production of a certain racism structurally depends on the regulation of black visibility in the public sphere' (Mercer 1994: 235). Here, Mercer's conceptual framework shares affinities with feminist critiques of art history. In her analysis of the relative absence of women in the historical emergence of the western art canon, *Why have there been no Great Women Artists?* Linda Nochlin (1988) stresses how the exclusionary character of the canon could not be fully addressed by the *inclusion* of women artists. Mercer's analysis goes further than argue for the inclusion of diasporic cultural forms. Rather, what *Welcome to the Jungle* underscores is the relevance of thinking about cultural expression in terms of relations of power, and of the practices and processes of subordination.

Mercer's emphasis on the dialogic, following Mikhail Bakhtin (1981), in his approach to visual culture means his analyses are frequently

focused on reading the unfixed and ambivalent relations between historically specific cultural forms and contexts. It is important also to consider an undercurrent of themes of solidarity and affiliation, of reparation and reconciliation within this dialogue. For Jean Fisher, it is not only 'a question of constructing a counter narrative to the dominant one, but of testing the limits and limitations ... through a critical self-reflexivity and "interruptive" strategies of disarticulating and rearticulating the language of hegemony' (Fisher 2008: 204). Mercer puts it another way:

> the critical difference in the contemporary situation thus turns on the decision to speak *from* the specificity of one's circumstances and experiences, rather than the attempt, impossible in any case, to speak *for* the entire social category in which one's experience is constituted.
>
> (Mercer 1994: 92)

These dynamics of opposing values are played out in a surprising way in an essay 'Reading Racial Fetishism: The Photographs of Robert Mapplethorpe' (Mercer 1994). The essay is composed of two separate analyses of a series of photographs depicting black male nudes by the white photographer Robert Mapplethorpe. In his first reading, Mercer considered the representations of black male nudes by Mapplethorpe to be fully consistent with the racist codes of identification inherent in the colonial gaze, arguing that they reproduce and reinforce essentialist notions of black male identity as that which 'lies in the domain of sexuality' (Mercer 1994: 174).

The second part of the essay, written after the death of Mapplethorpe in 1986, is a partial revision of the previous interpretive model, now focusing on 'a subversive deconstruction of the hidden axioms of the nude in dominant traditions of representation' (Mercer 1994: 194). To a large extent, the context of Mercer's revision was dependant on his repositioning of Mapplethorpe as a gay white male. What Mercer demonstrates in this interpretive turn is how the practice of reading a text, in this case a series of photographs, is subject to being caught in a similar set of ambivalent structures which it aims to critique. As such, Mercer, in his decision to lay bare the evolution of his criticism, expresses the urgent need for a level of intellectual transparency rather than fixed ideological positions. Gayatri Chakravorty Spivak (1996) exemplifies how for the postcolonial critic there is always the danger of falling into the same imperialist traps. Therefore to speak from the position of the colonized can be deemed colonial in gesture, thereby

re-using and re-energizing the essentialist tendencies that it seeks to dispel. To examine the discourse of the colonial subject then means taking into account the large matter of positioning, and perhaps to apply methodological transparency even if the object of study is as obscure as the 'postcolonial subject'.

Since *Welcome to the Jungle* was published in 1994, Mercer has delineated the term 'multicultural normalization' to describe how the over-saturation or integration of cultural difference into the public sphere is analogous to a decrease in political agency. How can we resist this normalization or erasure as a result of the increased visibility, indeed, *hypervisibility*, of black identities, Mercer asks, when the question of 'difference was almost unmentionable' (Mercer 2000: 196)? How might Mercer's model be applied to related contemporary concerns? In view of global trends of migration, how does it translate in the study of representation of migrant subjects, who are characterized by a similar unfixity and invisibility? While predominantly focusing on the dialogue with black British visual culture, Mercer also states the aim to forge the view of 'displacement of nation as a basis of collective identity' (Mercer 1994: 27). His continued questioning of the categories on the margins of western art history: migration, exile, and diaspora, especially in the climate of resurging interest in nationalisms and changing politics of identity, indicate that this is an ongoing project further subject to re-definition of the terms.

Patricia Chan

Selected bibliography

Bakhtin, M. (1981), *The Dialogic Imagination*, Austin: University of Texas Press.

Fisher, J. (2008) 'Diaspora, Trauma and the Poetics of Remembrance', in K. Mercer (ed.), *Exiles, Diasporas and Strangers*, INIVA (Institute of International Visual Arts), London: MIT Press.

Hall, S. (1989) 'New Ethnicities', in Kobena Mercer (ed.) *Black Film, British Cinema*, London: BFI/ICA Documents 7, 27–31.

Mercer, K. (1986) 'Monster-Metaphors: Notes on Michaels Jackson's Thriller', *Screen*, 27.1, January–February), 26–43.

——(1988) 'Diaspora Culture and the Dialogic Imagination: The Aesthetics of Black Independent Film in Britain', in Mbye Cham and Claire Andrade-Watkins (eds), *Blackframes: Critical Perspectives on Black Independent Cinema*, Cambridge, MA: MIT press, 50–61.

——(ed.) (1988) *Black Film, British Cinema*, London: Institute of Contemporary Arts (ICA).

——(1990) 'Welcome to the Jungle: Identity and Diversity in Postmodern Politics', in Jonathan Rutherford (ed.), *Identity, Community, Culture, Difference*, London: Lawrence and Wishart.

——(1992) 'Engendered Species', *Artforum*, 30, Summer, 74–77.

——(1992) '1968: Periodizing Politics and Identity', in Lawrence Grossberg, Cary Nelson and Paula Treichler (eds), *Cultural Studies*, New York; Routledge.

——(1994) *Welcome to the Jungle: New Positions in Black Cultural Studies*, London: Routledge.

——(2000) 'Ethnicity and Internationality', in Nicholas Mirzoeff (ed.), *The Visual Culture Reader*, 2nd edition, London: Routledge.

——(ed.) (2008) *Exiles, Diasporas & Strangers*, Annotating Art's Histories 4, INIVA (Institute of International Visual Arts), London: MIT Press.

Nochlin, L. (1988) (ed.) *Women, Art, and Power: And Other Essays*, New York: Harper and Row.

Spivak, G. C. (1996) 'Can the Subaltern Speak?', in B. Ashcroft, G. Griffiths and H. Tiffin (eds), *The Post-colonial Studies Reader*, London: Taylor & Francis, 28–37.

PARTHA MITTER, *ART AND NATIONALISM IN COLONIAL INDIA* (1994)

Partha Mitter, *Art and Nationalism in Colonial India, 1850–1922: Occidental Orientations*, Cambridge: Cambridge University Press, 1994.

The discipline of art history, initiated in the late eighteenth century, came burdened with the epistemological and ideological goals of the modern academy – to arrive at a coherent classification of art as an aspect of total human knowledge and to utilize this knowledge for the enterprise of establishing standards of taste and thus of 'civilization'. As with other humanistic disciplines,[1] this 'world-wide' ambition, coinciding with the Age of Colonization, resulted in a Eurocentric 'world picture', dividing the world into 'western' and 'non-western' cultures related in gradations of civilized and primitive expressions. Not that the definition of the centre was uncontested, but whether classical or romantic, Greek, Latin, Renaissance or Rococo, 'western' art was discursively present to art history, while 'non-western' peoples couldn't properly be granted admission within this civilized discourse, their visual culture meriting the attention only of archaeology and anthropology and at most the peripheries of art history – design, ornament, craft. The struggles of non-western peoples against colonialism has included the efforts of artistic expressions and art histories to contest these canonical constructs, an effort that continues within the disciplinary institutions of the discourse, in academies of art pedagogy and art historical knowledge

production, in print journalism and museology. Nationalism in South Asia introduced its own resistant or variant responses to this discourse on visual taste and civilization, a chapter in the ongoing assimilation and production of modernity.

With the growth of historiography, the canonical narratives of art history have been increasingly critiqued and alternate standards and selections of art have been articulated within new cultural histories. Partha Mitter's *Much Maligned Monsters* (1977) marked a watershed in this regard, as a history of western responses to Indian art, viewed mostly as monstrous, obscene and lacking in emotional significance. Mitter concluded his book with an account of orientalist and nationalist revisions leading to the modern acceptance of Indian art into the art historical canon. Here he also pointed to the problematic nature of this revisionary enterprise, carried out by personalities such as E. B. Havell (1861–1934) and Ananda Coomaraswamy (1877–1947). Responding to ideological constructs, the success of Coomaraswamy, largely considered the father of Indian Art History, rested on metaphysical essentialisms and said little about the social conditions of art production. Mitter thus also spelt out the desirable trajectory for a future postcolonial art history, in seeing art in terms of the expression of human agency in its social and cultural contexts.

Much Maligned Monsters was published in 1977, a year before the publication of Edward Said's *Orientalism*, and thus may be considered prescient, especially in its conclusions. In the twenty years between *Monsters* and Mitter's next book, *Art and Nationalism in Colonial India 1850–1922: Occidental Orientations* (1994), Said's work as well as that of a number of writers on nationalism (Gellner 1983; Kedourie 1993 [1960]; Hobsbawm and Ranger 1983; Anderson 1983) had revolutionized the world of colonial scholarship. These studies, following in the wake of Michel Foucault's Nietzsche-inflected discourse analysis (Foucault 1970, 1972), focused on the invention of collective identities and their normalization through the colonial–national interchange. Mitter's work is one of the earliest examples of the application of such an approach in art history, through a fine-grained study of visual culture in the processes leading to the invention of national identities in South Asia. However, where Mitter breaks new ground once more, is in his attention to social agency of the artist within the bounding contexts of British imperialism, orientalism, modernity and other invented traditions of a resistant order, whether pan-Asianist or nationalist. Laying out his theoretical bases in his Prologue, Mitter is explicit in his critique of both 'Orientalists and their critics' who, though 'diametrically opposed to each other, essentially treat the history of colonizers rather than the colonized' (Mitter 1994: 6–7).

Mitter opposes this 'stereotype of the passive oriental', seeking rather to make visible 'the individual responses of the colonized to the historical situation in which they found themselves' (Mitter 1994: 6–7). This indeed is the drift of the phrase 'Occidental Orientations' in his subtitle.

If *Much Maligned Monsters* ends with a study of how orientalist and nationalist art critics and historians used idealist categories to establish an alternate canon for Indian art, *Art and Nationalism* is a detailed consideration of visual culture in its variety of manifestations and interchanges in the complex contestations for taste and identity in colonial India. Mitter's text here is bounded by two major exhibitions: at the start, the Great Exhibition of London in 1851 which marked the zenith of British colonial empire and industry and launched internal debates which were to impact colonial art production and culture in complex ways; and at the end, the exhibition of Bauhaus artists in Calcutta in 1922–23, ringing the symbolic end of nationalist art and inaugurating new internationalist concerns for an India poised to enter the world stage of modernity. The book is divided into three parts. The first consists of the Prologue; the second, roughly spanning the period from 1850 to 1900, establishes the dissemination of western art pedagogy in India along with social transformations in the progress of modernity; and the third, stretching from the start of the twentieth century to 1922, deals with cultural nationalism and its resistant strategies in art and art historical practices. The Epilogue draws a close to the chapter of national identity politics with the disenchantment of some of its founders and the entry of new concerns in art and art criticism, marked by the Bauhaus exhibition of 1922–23 in Calcutta.

Among the greatest strengths of *Art and Nationalism* must be counted its highly nuanced character, articulating the ambiguous nature of each act of visual culture. The Great Exhibition of London, meant to bolster national pride in the Empire, led to debates on the declining state of design at home vis-à-vis its living vitality in the colonies and the need to harvest the same through the institution of art schools in regions like India. Again, this establishment of Indian art schools in the late 1850s and 1860s combined a distaste for the possibility of native mimesis of 'fine arts' (along with the desire to restrict art pedagogy to design and craft) with the 'white man's burden' of civilizing Indians, leading to conflicted art policies in these schools. Moreover, except in stray instances, the artisan classes did not gravitate towards these art schools, instead a new class of 'modern' Indians sought admission in order to learn painting or sculpture in the preferred British style of academic naturalism. The cultural capital of being a recognized artist in British

society spawned similar aspirations in the new class of 'civilized' Indians, leading to the appearance of the gentleman painter, participating in exhibitions and salons and catering to the elite tastes of British or Indian patrons. Mitter draws out the examples of prominent turn-of-the-century Indian painters in this genre from the Bombay and Calcutta art schools, such as Pithawala, Bomanji, Pandurang, Dhurandhar, Trinidade, Rahiman, Mhatre, Hesh, Bose and Gangooly. Mitter does not view these painters as passive copyists in a derived colonial discourse but as original native artists seeking creative expression and social visibility within the changing discourse of modernity.

Mitter's stated purpose in the Prologue to write an art history geared towards restoring agency to the Indian artist finds its best illustration in his treatment of Raja Ravi Varma (1848–1906), who he characterizes as 'the artist as charismatic individual' (Mitter 1994: 179). The artist as hero, genius or prophet is a peculiarly modern notion in the occidental canon and seeing Ravi Varma in these terms places him at the head of an 'Indian modernism'. This, of course, raises the difficult question of whether Mitter sees an 'Indian modernism' as an admission into the Eurocentric discourse, a variation of the western canon or an altogether alternative canon. Mitter's book was written before the prominence of the dialogic paradigm of Mikhail Bakhtin (1895–1975) (Bakhtin 1981), brought into culture studies by Homi Bhabha (Bhabha 1994), but his treatment of Ravi Varma could be seen as a pointer in that direction. The self-taught elite Indian artist, exercising his creativity to master oil painting, the preferred medium and technique of the colonizer, yet depicting Hindu mythological themes, widely popularized among Indians through prints, found a place and independent lives in two cultural universes. Mitter notes how Lord Curzon, the patronizing British Viceroy, pronounced Varma's paintings a 'happy blend of western technique and Indian subject and free from Oriental stiffness' (Mitter 1994: 180), while the prominent Bengali poet and Indian cultural icon Rabindranath Tagore applauded Varma for 'restoring to [Indians] their own inheritance' (Mitter 1994: 218).

Art and Nationalism is also remarkable as an art historical text in its prominent inclusion of the printed image and acknowledgement of the power of print journalism in disseminating ideas and opinions in modern times. Mitter presents a rich array of cartoons and satirical images to draw out both the British ridicule of Indians mimicking Englishmen in magazines such as *Punch* and the Indian critique of colonial oppression as well as native hypocrisy, by cartoonists such as Gaganendranath Tagore (1867–1938). The third part of the book details the joint strategic operations of art history, art criticism, art pedagogy, print journalism and

art making in orchestrating a cultural politics leading to the creation of a 'national' art canon and a 'modern' Indian art. It is here that Mitter draws most strongly on the studies in nationalism and the intimate orientalist–nationalist relationship which had marked the scholarship of the decade preceding the publication of his book; yet his work is of pioneering significance in applying these theories to art history and drawing out the close and mutually authorizing transactions between art and nationalism. The transnational polemical activities of art historians and critics such as E. B. Havell, Ananda Coomaraswamy, Sister Nivedita (1867–1911) and O. C. Ganguly (1881–1974), the Japanese cultural ideologue Okakura Kakuzo (1862–1913), the artist Abanindranath Tagore (1871–1951) and his disciples of the Bengal School, Ramananda Chatterjee (1865–1943), the publisher of art journals in English and Bengali and a host of other *dramatis personae* are traced in a detailed and engaging performative history along with the voices of their critics at each stage of the normalization of a nationalist art in India.

Two decades have passed since the publication of *Art and Nationalism*, but it continues to hold its ground as an encyclopedic resource as well as a standard of theoretical and critical scholarship for art in the colonial–national encounter. Tapati Guha Thakurta's more focused study *The Making of a New 'Indian' Art* (Guha-Thakurta 1992), published two years before *Art and Nationalism*, covered much of the same ground as the third part of Mitter's book, and has also stood well the test of time, though Mitter's work stretches much wider in its trans-national scope and context. Several threads of the rich tapestry of *Art and Nationalism* have seen elaboration, such as further work on Kalighat paintings (Jain 2006) or on Ravi Varma (Neumayer and Schelberger 2003; Chawla 2010). As touched on earlier, postmodern and postcolonial scholarship, such as the theoretical considerations of cultural hybridity (Bhabha 1994), or subaltern studies and its varied trajectories (e.g. Chatterjee 1993; Chakrabarty 2000), have intervened in the meantime to produce more complex representations of colonialism and its aftermaths.

My own recent work on Abanindranath Tagore (Banerji 2010) follows these theoretical concerns and builds on Mitter's work to expand a hybrid agency in the artist, resting on negotiations between lived and imagined worlds and their cultural histories. Mitter himself has gone on to publish two more books on South Asian art history, an overview of Indian Art (Mitter 2001) and a follow-up to *Art and Nationalism*, extending the study up to the year of Indian independence in 1947 (Mitter 2007). Undoubtedly, there is still much that needs to be explored in pursuing the doors opened by Mitter in *Art and Nationalism*

and we can look forward to a long train of scholarship yet to come, inspired by its epic effort.

Debashish Banerji

Note

1 Humanism here is understood as part of the post-Enlightenment discourse which is behind both 'the humanities' and 'the human sciences' in the academy. The modern academy is an Enlightenment construct in which the 'humanistic' disciplines further the academic goals of 'humanism' – that is, to arrive at a definition of the human. The knowledge enterprise of the Enlightenment moved in two directions – a knowledge of the world (the object) and a knowledge of the human (the subject). In the latter case, 'the Humanities' approached the human through its subjective expressions while 'the human sciences' were focused on objective features. These definitions inform the use of the term 'the humanistic disciplines'.

Selected bibliography

Anderson, B. (1983, 1991) *Imagined Communities: Reflections on the Origin and Spread of Nationalism*, London: Verso.

Bakhtin, M. M. (1981) *The Dialogic Imagination: Four Essays*, ed. Michael Holquist, trans. Caryl Emerson and Michael Holquist, Austin: University of Texas Press.

Banerji, D. (2010) *The Alternate Nation of Abanindranath Tagore*, New Delhi: Sage.

Bhabha, H. (1994) *The Location of Culture*, London: Routledge.

Chakrabarty, D. (2000) *Provincializing Europe: Postcolonial Thought and Historical Difference*, Princeton, NJ: Princeton University Press.

Chatterjee, P. (1993) *The Nation and Its Fragments: Colonial and Postcolonial Histories*, Princeton, NJ: Princeton University Press.

Chawla, R. (2010) *Raja Ravi Varma: Painter of Colonial India*, Ahmedabad: Mapin Publishing.

Foucault, M. (1970) *The Order of Things: An Archaeology of the Human Sciences*, New York: Pantheon.

——(1972) *The Archaeology of Knowledge*, New York: Pantheon.

Gellner, E. (1983) *Nations and Nationalism (New Perspectives on the Past)*, New York: Cornell University Press.

Guha-Thakurta, T. (1992) *The Making of a New 'Indian' Art: Artists, Aesthetics and Nationalism in Bengal, c.1850–1920*, Cambridge: Cambridge University Press.

Hobsbawm, E. J. and Ranger, T. (1983) *The Invention of Tradition*, Cambridge: Cambridge University Press.

Jain, J. (2006) *Kalighat Painting: Images from a Changing World*, Ahmedabad: Mapin Publishing.

Kedourie, E. (1993 [1960]) *Nationalism*, Oxford: Wiley-Blackwell.

———(1971) *Nationalism in Asia and Africa*, London: George Weidenfeld and Nicolson.

Mitter, P. (1977) *Much Maligned Monsters: A History of European Reactions to Indian Art*, Oxford: Clarendon Press.

———(1994) *Art and Nationalism in Colonial India, 1850–1922: Occidental Orientations*, Cambridge: Cambridge University Press.

———(2001) *Indian Art (Oxford History of Art)*, Oxford: Oxford University Press.

———(2007) *The Triumph of Modernism: India's Artists and the Avant-garde, 1922–47*, London: Reaktion Books.

Neumayer, E. and Schelberger, C. (2003) *Raja Ravi Varma and the Printed Gods of India*, New Delhi: Oxford University Press.

Said, E. (1978) *Orientalism*, New York: Pantheon Books.

GEETA KAPUR, 'WHEN WAS MODERNISM IN INDIAN ART?' (1995)

Geeta Kapur, 'When Was Modernism in India Art', *Journal of Arts and Ideas*, 27–28, 1995, 105–26.

A reading: possibilities for world art studies

My engagement with Geeta Kapur's article 'When Was Modernism in Indian Art' (1995) is premised on its relevance to a consideration of the following hypothesis. Via their annotated presence in a school of *world art studies*, the fields of (a) *Indian modernism*, (b) *new art history* and (c) *world anthropologies* coexist. Through their coexistence they become inter-dependent, and through their inter-dependence they transform into something else: an entity that might be called *world art*. This entity is not an art historical object, or set of things, in the sense that it cannot be owned, packaged, curated, displayed, restored and so on. Rather, it is a (post-) 'new art historical' subject. As such, this subject – conceptualised either as a pedagogic field, or as an emerging and contested discipline, or as an individual agent/researcher/writer – represents possibilities for inter-cultural approaches to knowing and unknowing, to learning and unlearning. I would contend that 'When Was Modernism in Indian Art' is a pivotal text for this subject.

Its title refers to a lecture given by Raymond Williams in 1987, 'When Was Modernism?', which provoked a highly engaging response by Kapur, an internationally renowned art critic, art historian and curator. The text has assumed various forms, from its initial publication in *South Atlantic Quarterly* (92.3, 1993), to its appearance in the *Journal of*

Arts and Ideas (27–28, 1995) and its re-publication as one of a series of essays in Kapur's compilation, *When Was Modernism* (New Delhi: Tulika, 2000). The *Journal of Arts and Ideas* article forms the basis of my current 'reading'. This is where I first encountered the text and, taken together with other papers written by Kapur and her colleagues in that journal, has shaped its vital presence in a taught module on 'Modern Art in India' (formerly known as 'De-colonisation and Visual Culture in India'), at the School of World Art Studies and Museology, UEA. As such, the text is imbricated in an ongoing dialogue between universal and particularist approaches to art and its histories/futures.

For Kapur, the question 'when was modernism?' pertains to a radical art historical imperative to document and interpret the 'parallel aesthetics' (1995: 105) of contemporary art in India vis-à-vis dominant modes of (western) thinking, making and writing. Kapur focuses on the creative, political and intellectual currents of diverse artistic practices in twentieth-century India, incorporating oil painting, architectural murals, monumental sculpture, literature, communist performance and Bengali art film. The concept of 'the modern' broaches the 'pre-modernism' of the self-orientalising Bengal School, the 'proto-modernism' of the heritage-conscious Santiniketan School, the 'primary modernism' of the cosmopolitan Amrita Sher-Gil, the 'modernism' of the internationalist Bombay Progressives and the 'post-modernism' of the mytho-poetic Baroda School (Kapur 1995: 106). Taken together, these diverse components become integrated within a 'cultural symbiosis' that resonates across the artistic and cultural heritages of India (Kapur 1995: 111). The modern is therefore characterised as 'a somewhat tenuous affair' (Kapur 1995: 107). Kapur argues that issues of *national self-collectivisation* and *politico-cultural autonomy* remained more prominent than formal considerations, or rather that these modernist issues were framed according to the contemporary realities as experienced by the artists. This history prompts the author to adopt a complex position as art-historian-cum-contemporary-exponent of the praxis in question, striving to realise 'the imminent aspect of our own complex cultures' (Kapur 1995: 105).

Whilst each of the fields of (a), (b) and (c) are engaging in their own right, and are often shaped by the production and reception of art works, art histories and even art worlds, I would contend that via their re-situation and re-routing – across uneven inter-disciplinary and inter-cultural terrains – they acquire new significations, which disrupt existing maps of meaning (Gaonkar 2000). Through their transformation, old and new themes emerge and coalesce as a non-identifiable patterning. In the case of 'When Was Modernism?' this patterning contains traces of (a) *Indian-ness*, suggested by the term 'Indian modernism', (b) an

interventionist modality, of a globalised art history (Elkins 2007) and (c) the *re-interpretation* of dominant social texts and histories of inter-cultural representation, as considered in terms of both the colonial encounter and the position of the subaltern within anti-colonial 'texts', such as nationalism and other facets of modernity and modernism in India.

In my opinion, *world art*, as an inter-lacing of political, intellectual and creative strands, stitches together this post- or trans-disciplinary patterning as a pedagogic fabric. It also prompts opportunities for the making of new patterns. Given the inherent instability of any one strand in relation to the others, and the contested historicity of the textures involved, this elaborate fabric may be re-read as a set of historical entanglements or *knots*. In themselves these knots are indicative of the limits of *universal knowledge, trans-cultural understanding* and *post-modern representation* (Chakrabarty 2004). Unravelling will therefore occur as these knots are undone, or as the wider fabric is re-made to reveal a new patterning. Some strands will be discarded, others woven in. World art therefore aims for new subjectivism: to question the relationship between multiple subjects and subjectivities, and to realise possibilities for inter-subjective positioning and repositioning.

'When Was Modernism?' has a similar emphasis on subjectivity. It combines various theoretical and critical strands. In terms of (a) Indian modernism, the text charts a narrative of origins, schools, movements, key figures, key moments and so on to fashion a critical engagement with issues of selfhood, subjectivity and spatiality. As a manifestation of (b), 'When Was Modernism?' ushers into the art historical orbit a lexicon of Marxian analysis that also characterised post-colonial interventions in fields of critical theory, cultural studies, international relations and post-development. Keeping in view the relevance of related historiographic movements such as subaltern studies – which emerged within the framework of (b) as a post-colonialist moment – Kapur addresses the field of (c) somewhat tangentially, in terms of the artist as alienated modern subject, attempting to reconcile him or herself with India's subaltern and 'folk/tribal/popular' heritage (1995: 108).

This renders the text somewhat problematic, as the subaltern figure gains recognition only through its artistic representation, leaving to one side the wider politico-historical processes that brought about its conditions of in/visibility. This is where *world anthropologies* might contribute to an elaboration of post-colonial art histories. Emphasising the encounters between multiple temporalities – such as those experienced by subaltern communities, modernist artists and other de-colonising imaginaries – a world anthropologies approach moves across the conceptual limitations of art history. These multiple temporalities refer to

the contested constructions and articulations of time, heritage, history and so on in movements against colonialism, imperialism and oppression worldwide (Rycroft 2006a). This is where Kapur's text becomes indicative of a wider ethnographic refusal within new art history. It must be noted that world anthropologies is something other than a plural version of 'world anthropology'. It is, rather, the reflexive critique of the imperial ideologies and colonial pasts that have supported the emergence of anthropology in post-colonial and post-western contexts (Ribeiro and Escobar 2007). It refuses to privilege universal temporal frames, such as those invoked by western anthropology, Marxism, modernism or historicism. It prefers instead to question how post-western subjectivities have re-configured temporal and conceptual elements in their re-making of the present, the future and so on, and of other forms of artistic, cultural and political expression.

Such a conceptual re-configuration is integral to an understanding of *alternative modernisms*, the temporal and ideological complexities of which cannot be meaningfully grasped if western, rather than post-western, frameworks are deployed. As an anti-imperialist writer, Kapur is attentive to the problem of representing historical and art historical patterns in a way that does not conform to euro-centric paradigms. Yet as a post-modernist thinker, she would not necessarily present herself as an exponent of 'alternative modernism'. These related enquiries involve and yet do not necessarily revolve around the *third texts* of 'Indian art' and 'Indian modernism'. Yet to identify in these texts a critical and creative engagement with seemingly polarised concepts such as tradition/future; ethnicity/citizenship; *desi/marga* (or the continua of folk vis-à-vis institutionalised artistic-linguistic-culturalist practice); nation/fragment; and subject/place, enables the contemporary reader to bring to the table whichever particular configuration of (a), (b) and (c) is deemed most workable: as an analytical or interpretative method pertaining to the historical and cultural textures in question (which, of course, include Kapur's art historical content as well as her own written intervention).

'When Was Modernism?' becomes a route through which to apprehend the possibilities of world art studies. It allows the elaboration of these apprehensions, especially via the negotiation of the subtle and not-so-subtle political geographies of other western and/or post-western pedagogies, such as *world history, world theatre* and *world anthropologies*. The strand of *world anthropologies* makes the connections between (a), (b) and (c) dynamic within the pedagogy of 'world art studies', rather than within the institutions of either 'Indian art' or 'new art history' (Rycroft 2006b). So by using 'When Was Modernism?' to find ways to

cross between the fields of (a), (b) and (c), and to identify such pathways as manifestations of related intellectual genealogies and enquires, contemporary readers become exponents and embodiments of world art.

Daniel J. Rycroft

Selected bibliography

Chakrabarty, D. (2004) 'Minority Histories, Subaltern Pasts', in S. Dube (ed.), *Postcolonial Passages: Contemporary History-writing on India*, New Delhi: Oxford University Press, 229–42.

Elkins, J. (ed.) (2007) *Is Art History Global?*, New York: Routledge.

Gaonkar, D. (2000) 'On Alternative Modernities', in D. Gaonkar (ed.), *Alternative Modernities*, Durham, NC: Duke University Press, 1–23.

Kapur, G. (1995) 'When Was Modernism in India Art', *Journal of Arts and Ideas*, 27–28, 105–26.

——(2000) *When Was Modernism: Essays on Contemporary Cultural Practice in India*, New Delhi: Tulika.

Ribeiro, G. L. and Escobar, A. (eds) (2007) *World Anthropologies: Disciplinary Transformations within Systems of Power*, Oxford: Berg.

Rycroft, D. J. (2006a) *Representing Rebellion: Visual Aspects of Counter-insurgency in Colonial India*, New Delhi: Oxford University Press.

——(2006b) 'Santalism: Reconfiguring "the Santal" in Indian art and politics', *Indian Historical Review*, 33.1, 150–74.

HAL FOSTER, *THE RETURN OF THE REAL: THE AVANT-GARDE AT THE END OF THE CENTURY* (1996)

Hal Foster, *The Return of the Real: The Avant-Garde at the End of the Century*, Cambridge, MA: MIT Press, 1996.

Hal Foster's *Return of the Real* explores a genealogy and theory of art from the 1960s to 1990s by deciphering new meanings in response to a perceived impasse instigated by other theories on a period of significant artistic change. During the 1970s, the 'theoretical' in artistic production became as important a thematic as media-based artistic techniques, including 'text as art'.[1] Conceptual art practices, exemplifying 'Walter Benjamin's idea of montage and history',[2] became predominant, and critical texts and images coalesced in collaborative projects (Peutz 2008: 10). In exploring the artistic and theoretical developments of the period, Foster attempts to use 'critical theory as a conceptual tool' (Foster 1996: xiv).

The book retains an important position in defining the institutional critique and new social sites of art practice and, in particular, how the disbanding of traditional media-based approaches resulted from successive avant-garde seizures (Harrison 1997). Although this is not an easy text, any reader or art practitioner should be able to assemble a personal jigsaw of art theories and concepts, with the possibility for new insights, connections and 'eureka' moments. For this critical commentary, key texts and 'threads' which appear throughout the book are used to form a four-part structure. These four 'threads' are, first, Peter Bürger's *The Theory of the Avant-garde* (1974). Foster questions Bürger's view that the neo-avant-garde was a mere replica of the historical avant-garde of the 1920s and 1930s.[3] The 'returns' – as in the book's title – of historical practices are continuous and inevitable, as for example, when classical art forms were revived in the fifteenth century. Foster argues that a 'return' is not a 'replica', and the repeated 'return of the real' is not mere reproduction (Foster 1996: x).

Second, Foster articulates art in terms of vertical and horizontal axes. He claims that traditional modernist painting and sculpture 'sustained a vertical axis or historical dimension of art' – temporal or diachronic – and also a horizontal axis, which was the spatial, synchronic or 'social dimension of art' (Foster 1996: xi–xii). He suggests that sometimes the vertical axis is sublimated in favour of the horizontal variant, so challenging judgements of 'quality' based on the past. Foster asks whether socially engaged practice can extend the horizontal without subjugating the quality of the vertical. Third, Foster's discusses the minimalist tendencies of repetition and simulacra through various art practices, especially painting. Finally, he explores the discourse on artists as ethnographers discussing how often socio-political works result in new audiences and sites (Coles 2000; Kester 2004) which in turn may produce or generate different vertical creative axes.

In Foster's consideration of Bürger's *Theory of the Avant-garde* he describes it as 'intelligent', explaining that Bürger considers the historical avant-garde to be an '*absolute origin*' and that a single theory of 'avant-garde' can subsume and destroy the 'false autonomy of bourgeois art' (Foster 1996: 8). Foster hypothesises that, in retrospect, the 'institution' consumed historical avant-garde practices and that he considered this as a flaw in Bürger's argument. For Bürger, the 'neo-avant-garde' was the renaissance of 'Dadaesque happenings', with Fluxus[4] in the 1950s and the return of the Duchampian found object or readymade in the 1960s.[5] Foster suggests that at its inception, avant-garde work cannot be recognised for its historical importance as it arrives before its time (Foster 1996: 29). He argues that the repetition of the found object in art forms a connection with its historical sibling and therefore is a deferred action:

Once repressed in part, the avant-garde did return, and it continues to
return, but *it returns from the future*: such is its paradoxical temporality.
(Foster 1996: 29)

Although Lucy Lippard's (b. 1937) *Six Years: The Dematerialization of the
Art Object* (1974) is not mentioned in the book, it is an important text to
read in conjunction with Bürger, in order to understand artist groupings
and artistic intentions in the 1960s and 1970s. Lippard states that although
'Conceptual Art emerged from Minimalism' it was in opposition to a 'less is
more' ethos. New 'inexpensive, ephemeral, unintimidating' conceptual
mediums encouraged women to address new socio-political subjects
(Lippard 1997: xii–xiii). In *Return of the Real*, Foster's choice of theorists
is predominantly male and the pictorial examples of art works are
overwhelmingly by male artists.

In his analysis of the vertical and horizontal axes, Foster argues that both
Dada and Constructivism extended the vertical axis, or created new ascen-
sions, through challenging medium-specific formalism. Foster questioned
whether painting could again ascend the vertical axis following the political
prowess and success of Abstract Expressionism. He suggested that the
complex relationship between the historical- and neo-avant-gardes,
allowed revisionist accounts to complicate the future of avant-gardism.
Walter Benjamin's (1892–1940) critique of the author and producer pro-
vides a site for creative practice after the Marcel Duchamp and the R. Mutt
case.[6] Theodor Adorno's (1903–69) prophecy of the culture industry has
arguably culminated in the contemporary commodification of late
modern art by global collecting practices. Artists have attempted to appro-
priate the culture industry resulting in the complexity of today's cultural
production, which might be understood as a parallax of Foster's axes.

As an example of the propagation of Foster's horizontal axis, artists continue
to explore the causality, temporality and narrative of the avant-garde.
For example, Suzanne Lacy (b. 1945) involved a local community for
three years in order to challenge attitudes towards race and racism and to
highlight the recognition of older women in society, in particular Afro-
American (Lacy 2010). Her final performance, *Dark Madonna* (1986), was a
living sculpture of women standing on plinths in the Franklin Murphy
Sculpture Garden, Los Angeles, a site usually occupied by male sculptors.

In chapter 4, Foster discusses the 'return' of conventional painting in
the 1980s as 'neo-geo and simulationism', referencing works by artists
such as Sherrie Levine (b. 1947), Peter Halley (b. 1953), Ross Bleckner
(b. 1949) and Gerhard Richter (b. 1932) (Foster 1996: 99). For Foster,
the paintings by these artists appear decorative and superficial and he
suggests that for them the 'return' to painting meant the 'institutional

critique had come to a dead end' (Foster 1996: 101). The paintings, Foster asserts, have a technological appearance and are situated within a craft and skills context but also within a post-industrial society and at a time of increased wealth, allowing the return of art as a commodity. The vertical axis of the painting tradition is perceived to have been extended through Daniel Buren's (b. 1936) site-specific installations in the 1980s, by challenging the support/surface and 'exhibition' display rubrics.

In *Return of the Real*, Foster critiques painting from within the medium in a modernist tradition, rather than recognising an expansion of painting. David Batchelor (2000) heralds the end of medium specificity, with colour/paintings using found objects or consumer detritus (Batchelor 2006/7: 1). Foster identifies that the horizontal axis extends with the social interaction of the works through familiar, ready-made objects and the vertical through the 'return' of Minimalist similes of Flavin and fluorescent tubes. Painting is released from the support and surface when it is not wall-bound. Foster's horizontal and vertical axes are thus nurtured, to ensure that society is reflected and engaged with art production, rather than the commercial art object being reserved for the elitist art fairs.

In chapter 5, Foster segregates the photographic image as the referential or as simulacrum (Baudrillard 1981), but he also recognises that both are located in Warhol's serial images where suffering and death prevail (Foster 1996: 130). Photography is perceived as the essence of reproduction, concealing truth, beholding death, and is judged useful to painters. Jean-François Lyotard recognised that 'photography did not pose an external challenge to painting any more than did industrial cinema to narrative literature' (Lyotard 1992: 14). Roland Barthes' 'punctum' (1982) is the piercing rupture in a photograph. Foster identifies this in Warhol's repeated silkscreen where there is 'slippage' and as the 'blur' in Gerhard Richter's paintings (Foster 1996: 134–7). Partially due to his longevity, Richter's oeuvre is a paradigm of reversal and 'return', from performance in *Black Mountain*, simulacrum of grand masters, grey canvases, appropriation of found objects (photographs), political imagery, deconstruction of colour to squares and reflection as portrait (Storr 2003). Richter's adherence to the vertical axis is judged by Foster to be interconnected to the horizontal through his engagement with social narrative.

In chapter 6, Foster discusses the siting of art and post-colonial discourse, the expanded medium and the inclusion of social issues. He questions those artists whose work 'maps' societies and cultures only to exhibit the resultant 'art objects' in a classical museum space (Foster 1996: 190). Martha Rosler's (b. 1943) work exemplifies this where the derelict residents are shown through formally exhibited text with photography – securing the work as belonging in the gallery institution (Rosler 2004: 191–96).

Foster's intervention explores and evaluates some of the shifts and conflicts which have defined successive re-conceptualisations of post-modern and recent art practice. Usefully he provides a framework including particular terminology for deconstructing and critiquing aspects of art practice and theory since the advent of the neo-avant-gardes of the 1950s and 1960s.

Anna Webber

Notes

1 Charles Harrison cites historical examples where text appears in painting, including Poussin's *Arcadian Shepherds* (1627) and the journey to *Index* 1972 by *Art & Language* where the ten 'authors' contributed to filing cabinets of text (Harrison 2001: 26).
2 *Public Space with a Roof* was a research project in the SMART Project Space in Amsterdam in 2008. The intention was to 'blur the borders' in contemporary practice where the artist is the curator, activist and author, with the medium being the exhibition. (Peutz 2008).
3 In this instance, the term 'Historical avant-garde' includes art movements from the beginning of the twentieth century, for example Constructivism, Dada and Surrealism. The label of the 'neo-avant-garde' is related to 'the radical art movements in the 1950s and 1960s, including Fluxus, Happenings and later Conceptual Art, Installation and Performance Art' (Gaiger and Wood 2003: 56).
4 Fluxus were collaborative events and happenings, without an object and with no specific outcome. Artists: Allan Kaprow, Jim Dine, Claes Oldenburg, Robert Watts, George Brecht and John Cage. All that may remain after the event are writings, film, photographs and traces – an ephemeral experience (Drucker 1993; Hendricks 2003).
5 In the 1950s and 1960s various artists used commercial and industrial production as a source, creating art objects in various editions. Often these varied in scale and used sculptural media to simulate the original object such as Andy Warhol, Claes Oldenburg, Joseph Beuys and George Maciunas.
6 'R. Mutt' was the signature on *Fountain*, a urinal presented as a work of art by Marcel Duchamp in 1917.

Selected bibliography

Barthes, R. (1982) *Camera Lucida: Reflections on Photography*, New York: Hill and Wang.
Batchelor, D. (2000) *Chromophobia*, London: Reaktion Books.
——(2006/7) 'Painting as a New Medium', *Art & Research: A Journal of Ideas, Context and Methods*, 1.1, Winter, www.artandresearch.org.uk/v1n1/painting.html (accessed 12.9.11).
Baudrillard, J. (1981) *Simulacra and Simulation*, Ann Arbor: University of Michigan Press.

Bürger, P. (1974) 'Theory of the Avant-Garde', reprinted in J. Gaiger and P. Wood (eds) (2003) *Art of the Twentieth Century*, New Haven, CT: Yale University Press.

Coles, A. (ed.) (2000) *Site-specificity: The Ethnographic Turn*, London: Black Dog Publishing.

Drucker, J. (1993) 'Collaboration without Object(s) in the Early Happenings', *Art Journal*, 52.4, Winter, 51–58.

Finch, M. (1998) 'Support/Surfaces', *Contemporary Arts Magazine*, 20, www. mick finch.com/supports_surfaces.htm (accessed 24.8.11).

Foster, H. (1996) *The Return of the Real: The Avant-Garde at the End of the Century*, Cambridge, MA: MIT Press.

Gaiger, J. and Wood, P. (2003) *Art of the Twentieth Century: A Reader*, New Haven, CT: Yale University Press.

Harrison, C. (1997) *Modernism*, London: Tate Publishing.

——(2001) *Essays of Art and Language*, Ann Arbor: University of Michigan Press.

Hendricks, G. (2003) *Critical Mass Happenings, Fluxus, Performance, Intermedia and Rutgers University, 1958–1972*, Chapel Hill, NC: Rutgers University Press.

Kester, G. (2004) *Conversation Pieces*, Berkeley: University of California Press.

Lacy, S. (2010) *Dark Madonna*, at www.suzannelacy.com/index (accessed 24.8.11).

Lippard, L. (1997) *Six Years: The Dematerialization of the Art Object from 1966 to 1972*, Berkeley: University of California Press.

Lyotard, J.-F. (1992) *The Postmodern Explained to Children: Correspondence 1982–1985*, London: Turnaround and Rutgers, NB: Rutger's University Press.

Peutz, T. (ed.) (2008) *Endless Installation: A Ghost Story For Adults. Public Space With A Roof*, www.smartprojectspace.net/pdf_papers/090321endles.pdf (accessed 24.8.11).

Rosler, M. (2004) *Decoys and Disruptions: Selected Writings 1975–2001*, Cambridge, MA: MIT Press.

Storr, R. (2003) *Doubt and Belief in Painting*, New York: Museum of Modern Art.

ALAIN BADIOU, *HANDBOOK OF THE INAESTHETIC* [*PETIT MANUEL D'INESTHÉTIQUE*] (1998)

Alain Badiou, *Petit manuel d'inesthétique* [*Handbook of the Inaesthetic*], Paris: Seuil, 1998.

Alain Badiou's (b. 1937) most important philosophical works are *Being and the Event* (1988) and *Logics of Worlds* (2006). For any discussion of the position of the arts in his work, these must be supplemented by the shorter *Manifesto for Philosophy* (1989), and by the collections of essays *Conditions* (1992) and *Handbook of Inaesthetics* (1998c). While the longer

systematic texts must be regarded as the core of Badiou's work, on which the numerous essays depend, these essays are not only a valuable route into his system, but also show how that system can be extended and elaborated.

Alain Badiou is not a philosopher of the visual arts, but the philosophical systems which he has developed give a prominent role to art as such. Badiou treats poetry as pre-eminent among the arts, and his remarks about art are usually extrapolated from his notion of what constitutes poetry. In treating poetry as the paramount art, Badiou follows in a line of descent from Martin Heidegger (1889–1976). Unlike Hegel, who discerned a dialectical progression in the arts, with poetry as a final stage in the process of knowledge before the emergence of a properly self-knowing reason, Heidegger treated poetry as a mode of language which opened on to Being in a manner that philosophy could not.

In *Being and the Event*, Badiou argues that philosophy and poetic language are opposed and rejects Heidegger's attempted construction of an ontology (or science of 'being-as-being') based on poetic language in favour of an ontology based on mathematical language. In this respect, Badiou readily allows himself to be identified with Plato, who famously banished poets from his Republic. While Heidegger aimed for a restoration of a lost 'presence' through art, Badiou argues for a 'subtractive' account of being which can neither be 'presented' nor 'represented'. In adopting this position, Badiou is attempting to gain conceptual leverage against all of those models in French philosophy which have taken inspiration from Heidegger and attempted, in one way or another, to conflate philosophy and art (the ideas of Philippe Lacoue-Labarthe (1940–2007) and Jean-Luc Nancy are among his targets). Against what he perceives as the attempt to make philosophy into a totalising discourse in which being itself is somehow grounded or made to appear, Badiou argues that philosophy should have only a limited function and should not attempt to substitute itself for other discourses or sciences. So mathematics must be regarded now as the science of being, and political theory as the science of society. Although Badiou was and remains a committed leftist in the tradition of 1968, a Maoist who has worked to support the rights of undocumented workers in France, his system attempts a complete separation of politics and philosophy, although in his principal philosophical task of creating a quasi-mathematical model of the 'event' (that is, a model of change in the human but not in the natural realm), it could be argued that he has silently adopted political revolution as his point of reference for theorising the eruption of the essentially new.

In *Manifesto for Philosophy* and *Conditions*, which are important satellite works of *Being and the Event*, Badiou distinguishes philosophy from what he describes as four 'generic procedures' or 'truth procedures'. Philosophy, in its newly restricted mode, generates axioms which can prove clarifying in each of these 'generic procedures', but does not itself produce 'truth', which in any case is now seen as a procedural effect, rather than a fixed product. These 'generic procedures' are named as 'science (or more precisely the matheme), art (more precisely the poem), politics (more precisely interior politics, or politics of emancipation) and love (more precisely the procedure which makes truth of the disjunction of sexed positions)' (Badiou 1992: 79). Hence the three collections of essays which appeared in 1998 map three of these procedures: Metapolitics, the Inaesthetic and Transitory Ontology – but notably not love.

The theory of art as such can begin to find its way through Badiou's work by reference to *Handbook of Inaesthetics*. In *Being and the Event* Badiou had emphasised poetry, especially Stéphane Mallarmé (1842–98), and had virtually treated poetry as a quasi-philosophical discourse, even in the context of an argument designed to set apart philosophy and poetry. Badiou seems generally to assume that poetry is the model for all the arts, and his interest in literature tends to mainstream high modernism. Indeed, Badiou presents his own canon of what he calls the 'age of poets', which is now over and the demise of which represents the collapse of the venture to establish poetry as ontological philosophy. The canon includes just seven figures: Friedrich Hölderlin (1770–1843), Mallarmé, Arthur Rimbaud (1854–91), Georg Trakl (1887–1914), Fernando Pessoa (1888–1935), Osip Mandelstam (1891–1938) and Paul Celan (1920–70).

Badiou has also written enthusiastically on Samuel Beckett (1906–89), whose work again can easily be read in terms of a philosophical ontology. It is therefore a relief that Badiou adds reference to dance, theatre and cinema in *Handbook*, but notable that he finds little to say about the visual arts as such. The first essay of the collection, 'Art and Philosophy', would appear to set the ground for a treatment of art, which might properly embrace all the arts. Badiou, however, appears reluctant to set himself the task of analysing the visual arts – and therefore visuality, spaciality, figurality – and where further reference to the visual arts is found in *Logics of Worlds*, the use of visual arts as simple examples of presentation is disappointing. In this respect, Badiou contrasts with the efforts of several figures in the modern French tradition to articulate the distinction between language/discourse and the muteness of the visible/spatial, for example Jean-François Lyotard's (1924–98) *Discourse, Figure* (1971), which returned to André Breton's (1896–1966) notion of the

'savage' eye, and mapped visual art as the silent site of alterity, plasticity and desire. If Badiou has not so far developed a way to think about the visual arts, or even about the visual, his notion of the limits of philosophy and of art itself as a truth process might yet achieve effects in the realm of the visual arts, in ways that Badiou has not apparently himself anticipated.

Such a development might take as its starting point the attempted displacement of traditional philosophical aesthetics presented axiomatically as the epigraph of *Handbook*:

> By 'inaesthetic', I mean a relationship of philosophy to art which, positing that art is itself a producer of truths, does not claim in any fashion to make it an object of philosophy. Contrary to aesthetic speculation, the inaesthetic describes the strictly intra-philosophical effects which are produced by the independent existence of certain works of art.
>
> (Badiou 1998c: 7)

According to Badiou, the poets of the 'age of poets' constructed oeuvres, which had affinities with philosophy, and were treated as quasi-philosophers. Philosophers from Friedrich Nietzsche (1844–1900) to Heidegger and Jacques Derrida (1930–2004) have envied the poets and attempted to conflate philosophy and poetry. Heidegger saw poetic language as an alternative to technology and mathematics; Badiou defends mathematics against Heidegger, finding that art as a truth process has affinities with it. The poets of the 'age of poets' accepted that art was objectless and, according to Badiou, their poetry is characterised by the attempt to go beyond subject–object relations and open a way to Being. Heidegger was wrong to oppose the knowledge of mathematics to the truth of poetry since, according to Badiou, whose principal model for poetry (and therefore his principal model for art), is Mallarmé, poetry has a powerful affinity with mathematics in that it has blindly perceived that mathematics, like poetry, lacks an object. According to this argument, the unconscious identification of poetry with mathematics already undermines Heidegger's reliance on it.

A new relation between art and philosophy must be mapped. The three existing models have all been superseded: the didactic in which art is at the service of truth (Plato); the romantic in which art alone is capable of truth (Lacoue-Labarthe and Nancy); and the classical in which art is not related to truth, but is concerned to transfer desire to an object (Aristotle). To these correspond the three main types of modern thought: Marxism (Brecht) which has a didactic view of art;

hermeneutics (Nietzsche, Heidegger) in which poetic-philosophical discourse approaches Being; psychoanalysis (Freud, Lacan) where the artwork is treated as an imaginary investment. The new thinking must show that art is itself a truth process (not a representation); is 'immanent' ('rigorously coextensive with the truths it gives') and 'singular' ('these truths must not be found anywhere but in art'). Philosophy must show that art produces truth as opposed to opinion (*doxa* – the distinction is Platonic). The question of today, states Badiou is: 'is there anything but opinion, that is to say, one will excuse (or not) the provocation, is there anything other than our "democracies"?' (1998c: 29)

David Ayers

Selected bibliography

Badiou, A. (1988) *L'Être et l'événement* [*Being and the Event*], Paris: Seuil.
——(1989) *Manifeste pour la philosophie* [*Manifesto for Philosophy*], Paris: Seuil.
——(1992) *Conditions*, Paris: Seuil.
——(1995) *Beckett: L'increvable désir*, Paris: Hachette.
——(1998a) *Abrégé de métapolitique*, Paris: Seuil.
——(1998b) *Court traité d'ontologie transitoire*, Paris: Seuil.
——(1998c) *Petit manuel d'inesthétique* [Handbook of the Inaesthetic], Paris: Seuil.
——(2006) *Logiques des mondes: L'Être et l'événement 2* [*Logics of the World: Being and Events 2*], Paris: Seuil.

NICOLAS BOURRIAUD, *RELATIONAL AESTHETICS* [*ESTHÉTIQUE RELATIONNELLE*] (1998)

Nicolas Bourriaud, *Relational Aesthetics*, Paris: Les Presses du Reel, 1998. The English translation of 2002 is referred to here.

The curator and art critic Nicolas Bourriaud's (b. 1965) *Relational Aesthetics* is a collection of essays published in 1998 in response to an exhibition called 'Traffic' in Bordeaux, 1996 which he curated (Bourriaud 2002a: 7). The book is a product of Bourriaud's need to set out his emerging awareness of a new strain of practice and rising 'collective sensibility' (Bourriaud 2002a: 7) between himself as curator and the artists shown in 'Traffic' such as Felix Gonzalez-Torres, Liam Gillick, Rirkrit Tiravanija, Dominique Gonzalez-Foerster and Carsten Höller. The nature of the book is 'formative' rather than 'summative' in knowledge

in that the writing is a response to the ideas in the art exhibited (Gillick 2006: 96). To this end there is some ambiguity in the discussion generated which is formed from the notion that Bourriaud's debate is 'ongoing' (Gillick 2006: 96) or from 'the middle' (Bourriaud 2002a: 13).

His intention at the time of publication was to create a freshened 'utopian' opening in theoretical discourse surrounding the reception of art and its relationship with 'human experience' where the audience becomes a community (Bishop 2005: 116). The discourse he creates moves away from older debates around the reception of art as relating to the 'private symbolic' aesthetic experience (Bourriaud 2002a: 14) and rather tired 'end games' around the nature of originality in an attempt to find a common denominator for the artists he discusses in each chapter (Bourriaud 2002a: 7).

The essays which make up the book and the glossary of terminology (which is explanatory in its nature and extremely useful) collectively liberate commonly held discourse from the past surrounding the ideology of the gallery space and its aesthetic conventions (O'Doherty 1999). Bourriaud rejects the notion of the gallery as a rarefied environment where objects displayed are ordered, judged, commodified and controlled by the collective gaze of the audience, the institution and history. Rather, he states that his is an aesthetic theory which consists in 'judging artworks on the basis of the interhuman relations which they represent, produce or prompt' (Bourriaud 2002a: 112).

Bourriaud uses a number of analogies that situate his new notion of aesthetics and its relationship to 'form' as full of potentialities, in a similar way to how relationships evolve in the day to day through structures, constructs, places and spaces – either natural, manufactured or virtual. What this implies is a type of linked 'co-existence' that is not without problems or challenges but that bring possibilities for new ways of understanding the self and the world in relation to new institutions and structures, as well as 'meaning' and 'content' (de Oliveira et al. 2003: 109).

The art discussed becomes a catalyst for an experience of viewing situated in the present and in the notion of 'rapport' where social connections born from exchanges with the forms (usually installations) are transformed and given a new aesthetic focus through affiliations, interactions and embraces in the gallery space and beyond. Claire Bishop in *Installation Art* (2005) asserts that ideas in the art that Bourriaud discusses are responses to changes in economic structures (the prominence of the service industry) and the promotion of virtual 'relationships' as well as the alienation of the individual in society, and that this promotes 'physical interaction' (Bishop 2005: 14) as well as a creative and make do and mend attitude to how to go about encountering the experience in the space (de Certeau 1984: 24).

Certain ideas stand out in the development of chapters which relate to themes such as the exploration of human behaviour and subjectivity, the development of social bonds through participation and transitivity, democracy (in relation to media, technology and sexual politics) discursiveness and interdisciplinarity. The art discussed presents an interesting shift in the way we perceive the gallery space to function. As opposed to setting up a rarefied contract between art and the viewer as 'ivory tower', a rather more 'shabby chic' or 'low impact' (Bishop 2005: 14) model emerges of the gallery as convivial arena where a collage of diversions (de Certeau 1984: 25) is formed, partly from the social and cultural 'junk' in it. Art is brought back to the populace and in the experience of it the audience is liberated from having to pay any attention to it at all if they wish (O'Neil 2007: 202)

In essence Bourriaud's relaxed socialist rhetoric (Bishop 2005: 119) is born partly out of a desire to respond positively to Guy Debord's *Society of the Spectacle* (2005), Situationism (Bourriaud 2002a: 9) and their Modernist activist critique of capitalism as a socially alienating force where all relationships are acted out through the spectacle and empty mercantile nature of the arts and media representation. Bourriaud stirs the melting pot of Modernist and Postmodern art history and theory to enable his analysis of issues in art to take shape. Echoes are present in his readings of art that connect to but 'go beyond' Fluxus (Bourriaud 2002a: 8) which attempted to attack the conventional labels and monetary values ascribed to art through happening, performance and poverty (of materials), for example.

In Bourriaud's readings of art allusions are made to the influence of Joseph Beuys and aspects of Romanticism (Bishop 2005: 106) where the experience of looking at art is returned to the realm of 'social realism' and the formation of a 'subject' in society who has to 'make do' in the edges and experiences that surface (or not) in the moments around encountering art (Bourriaud 2002a: 14). There are also debts to Gilles Deleuze and Félix Guattari in the way that Bourriaud becomes a 'mediator'/ 'middleman' (O'Neil 2007: 22) who embraces the 'eddy' of culture and finds a way to productively get on and 'do' whilst being dragged around in it through curatorial activity (O'Neil 2007: 26 and 30) and 'forming, inventing and manufacturing concepts' (Bourriaud 2002a: 96).

Relational Aesthetics also signals the end of older definitions of the curator as a gatherer and conserver of art (Barker 1999). The publication of the book and Bourriaud's subsequent works, *Post Production* (2002b) and *Altermodern* (2009), reinforce the meaning of the term curator today; as an elevated, independent and creative force (Taylor 2005: 123) who enters into a 'tête-à-tête' through the discourse he creates with art, institution and audience.

This type of interdisciplinary practice as a type of creative 'resistance' (Rugg and Sedgwick 2007: 59) to Modernist gallery ideology is emblematic of the capacity of the curator today to create an independent textual discourse which conceptually defines its own debate. Here the discursive (O'Neil 2007: 203) nature of Bourriaud's practice and that of some of the artists he champions through writing and dialogue becomes vital to how the work comes to be understood as a series 'possibilities of knowledge' rather than 'fact' (O'Neil 2007: 203). This has given rise to some criticisms of Bourriaud's ideas, most notably from Claire Bishop in the article 'Antagonism and Relational Aesthetics' published in *October* magazine, 2004 partly because of the unfinished feel of much of the work discussed and how in the 'fish bowl' created by art it can feel more like entertainment or part of economic strategies in the gallery (Bishop 2004). She also argues that the nature of the art he chooses to discuss as 'on going' enhances the role of the curator as social engineer (Bishop 2004), where the audience, like a 'society of extras' (Bourriaud 2002a: 113) wait on the sidelines to be confirmed as 'subjects' through participation in the event.

Notably Liam Gillick's response to Bishop in *October* entitled 'Contingent Factors: A Response to Claire Bishop's "Antagonism and Relational Aesthetics"' (2006), whilst clearing up some issues with respect to Bourriaud's intentionality over the writing of the book, criticises Bishop's methodology (Gillick 2006: 99) and reading of ideas in Bourriaud's book as a 'battle about intellectual territory' (Gillick 2006: 97) without serous critique (Gillick 2006: 106). Debates over the credibility of ideas in Bourriaud's book (Gillick 2006: 96) (with its democratic overtones) and critical responses to it present a new textual continuum which is culturally relevant to the understanding of art through notions around democracy. In their writings Bishop, Gillick and Bourriaud reference Chantal Mouffe's relevance to the notion of opposition inherent to the different understandings and interpretations of ideas in *Relational Aesthetics* and of how democracy informs them – 'democracy occurs when the frontiers between different positions continue to be drawn up and brought into debate' (Bishop 2005: 119). Implied is the notion that the lines or barricades that form divisions, contradictions (Gillick 2006: 96) between the intentions of artists, curators and the reception of their creative output are constantly being re-drawn. The implications in the book are for art, curatorial practice and writing to shake free of 'didactic' (Gillick 2006: 106) positions whilst maintaining influence and to give up the tussle for the 'last word'.

The professional trajectory of the author and the artists who participated in *Traffic* is a partial indicator of the success of Bourriaud's

more egalitarian strategy and of the power of conversation to become a legitimising authority in contemporary art.

Kath Abiker

Selected bibliography

Barker, E. (ed.) (1999) *Contemporary Cultures of Display*, London: Yale University Press.

Bishop, C. (2005) *Installation Art*, London: Tate Publishing.

——(2004) 'Antagonism and Relational Aesthetics', *October*, 110, 51–79.

Bourriaud, N. (2002a) *Relational Aesthetics*, Paris: Les Presses du Reel.

——(2002b) *Post Production*, New York: Lukas and Sternberg.

——(2009) *Altermodern*, London:Tate Publications.

Debord, G. (2005) *The Society of the Spectacle*, London: Rebel Press.

de Certeau, M. (1988) *The Practice of Everyday Life*, London: University of California Press.

Gillick, L. (2006) 'Contingent Factors: A Response to Claire Bishop's "Antagonism and Relational Aesthetics"',*October*, 115, 95–107).

de Oliveira, N., Oxley, N. and Petry, M. (2003) *Installation art in the New Millennium*, London: Thames and Hudson.

O'Doherty, B. (1999) *Inside the White Cube*, Berkeley: University of California Press.

O'Neil, P. (ed.) (2007) *Curating Subjects*, London: Open Editions.

Pooke, G. and Newall, D. (2008) *Art History: The Basics*, London: Routledge.

Rugg, J. and Sedgwick, M. (ed.) (2007) *Issues in curating contemporary art and performance*, Bristol: Intellect Books.

Taylor, B. (2005) *Art Today*, London: Laurence King.

JOHN PICTON, 'YESTERDAY'S COLD MASHED POTATOES' (1998)

John Picton, 'Yesterday's Cold Mashed Potatoes', in Katy Deepwell (ed.), *Art Criticism and Africa*, London: Saffron Books, 1998, 21–25.

John Picton's paper was given at a conference (Courtauld Institute, London, 1996) entitled 'Art Criticism and Africa' for the *International Association of Art Critics* – founded in 1951 by UNESCO to promote world art criticism including 'developing countries'. The title of Picton's paper referred to the lyrics of 'A Fine Romance' sung by Billie Holiday rejecting 'yesterday's cold mashed potatoes' and welcoming today's 'hot tomatoes'. Picton compared the unappetising food to the 'failed paradigms' and 'tired clichés' invented by scholars belonging to European colonising communities who had denied colonised subjects and their

post-colonial descendants the powers to express authoritative judgements on art in Africa. In contrast he expected a present day menu of ideas about art to offer more appetising prospects.

Picton's manifesto asserted that African artists and viewers produce art criticism now and always produced art criticism as an essential part of the process of art-making during two million years: longer than anywhere else. Artistic discrimination is not the exclusive domain of European colonisers and their heirs, and what artists and viewers in Africa said and say about the visual arts is not just of local importance. It is central to the histories of art-making everywhere. As the teacher who introduced the first graduate and postgraduate qualifications to be accredited in the History of African Art in any British university (from the early 1990s), Picton took up new positions as a researcher. Rather than examining things made in Africa as anthropological evidence of the beliefs and technologies of 'primitive' societies, art historians focus on the objects themselves to contemplate their thoughtful and artful design, and to understand their meanings for their makers and subsequent viewers. The shift from ethnography to art history that is registered in this text indicated a rejection of colonialist scholarship, and the shadow it had cast over post-colonial societies.

Picton's authority derived from the fact that he had acted out these intellectual changes in his working life: in the Nigerian Department of Antiquities (1961–70); at the British Museum, in the separate section then called the 'Museum of Mankind' (1970–79); and as Reader in African Art at the School of Oriental and African Studies, University of London. The value of this text resides in the influence and location of the speaker in the metropolis of the largest former imperial power, and its timing during a decade in which there was a watershed in temporary exhibition policies for African art, and ground was laid for changes in the permanent display of African art in key institutions.

Picton argued that if it is agreed that one may research the histories of art in Africa then it must also be understood that this art-making produced concomitant traditions of art criticism. Picton assumed the widest definitions of 'art' to comprise the skilled making of things by humans following George Kubler (1912–96) who had written: 'The universe of man-made things simply coincides with the history of art' (Kubler 1962: 1). As Picton explained, words for skill and its assessment abound in African languages. Furthermore:

> [i]t is hard to imagine that as people learned to talk … they did not learn to talk about the things they were making. The probability is that making and talking (including talking about making) evolved in relation to each other perhaps even in a functional relationship to

each other. (I use the term function in a sort of mathematical sense, i.e. not as a synonym for use or intention, but to refer to an inter-related variability: in the words of my grandfather's dictionary, 'a magnitude so related to another magnitude that to values of the latter there correspond values of the former'.)

(Picton 1998: 22)

He also proposed the widest definition of 'art criticism' to signify dis-cussion whether oral or written by makers and users to debate what works well: in his words 'as a discourse that enables, directs, understands, encourages, imagines and discourages, but which does not determine', art-making. (Picton 1998: 22). Picton argued that that these critical tra-ditions continued to evolve as colonisers' notions of art and art criticism were translated selectively by emerging nation states and 'domesticated' within the context of 'ideas, practices and discourses that have developed in part in consequence of traditions that were in existence before the impositions of colonial rule' (Picton 1998: 22). Indeed, studying the art history and art criticism of the continent of Africa entailed valuing its art making as a whole, now and from its inception. The viewpoints of European modernism, anthropology and archaeology that had demoted the importance of twentieth-century developments in the visual arts in Africa should not to be imitated by art historians (Picton 1997: 11–12). Picton advised researchers studying the present day to seek continuities since, ' there will always be traces of older practices within newer traditions'. Further:

we ought not to privilege painting and sculpture to the exclusion of other forms of practice. Many art forms and traditions in Africa are contemporary with each other, each with its own means of addres-sing issues of current relevance and concern. Apart from painting and sculpture, there are print making, masquerade, textile design and manufacture, photography, fashion design, and the personal arts and all manner of 'popular' arts; and these are indeed interdependent mediums, though the substance of that interdependence will shift from one place to another.

(Picton 1998: 25)

Picton questioned 'yesterday's' imperialist assumptions that had led European scholars to assert that the arts of easel painting, sculpture and architecture taught in European academies as 'Fine' were the sole arts to count as 'Art' and warrant philosophically refined Art Criticism. Other kinds of visual art were defined as crafts or forms of technology by them.

Thus European colonisers categorised everything made by their subjects as inferior visual arts requiring no theoretical discourse to guide production. From this imperialist eminence it had been claimed as if it were some 'eternal truth' that there was neither Art nor Art Criticism anywhere in the world except modern Europe. Picton argued rather that the apparently timeless verity of such a definition had itself lasted only a few centuries. Even within the traditions to which European Imperialists were heir, ideas about art had constantly shifted. In fact, expertise in the visual arts had been called 'techne' by Greek writers, 'art' in Latin and Romance languages and 'craft' by Anglo-Saxons, and then had been used in a variety of ways:

> If the ideas and practices subsumed under the rubrics of art and art criticism are unstable, while entailing developments in other domains and practices, then one should beware telling anyone else what they do and do not have.
>
> (Picton 1998: 21)

Picton's manifesto for art history and art criticism also holds museological interest since it provides insight into the ideas of the curators who put on the ground breaking festival of African visual arts in 1995 called *Africa95*. Over the course of one year *Africa95* used major exhibition spaces in the United Kingdom to show the widest range of the contemporary visual arts of Africa and its diaspora to complement the first temporary exhibition devoted to earlier African art to be shown in the Royal Academy, London. As described by Picton, 'the initial suggestion [in 1991] of an African festival had been Robert Loder's, in response to the difficulties that would face the Royal Academy if it were to include the developments of the twentieth century within its *Africa the Art of a Continent* exhibition' then being planned for 1995 (Picton 1997: 12). This watershed in the history of temporary exhibitions of the visual arts of Africa arguably laid the ground for some cognate changes in the permanent display of African art in major museums in Britain. For example the 'Sainsbury African Galleries' in the British Museum opened in 2004 to show contemporary works newly purchased for the permanent collection, together with older holdings of earlier visual art. The text also has historiographical significance since Picton's proposals for a history of art and art criticism for Africa have parallels with other campaigns during the late twentieth century to reform the discipline in order to include new fields under the heading of the 'New Art History', a term first coined in 1982 (Borzello and Rees 1986: passim). Comparison may be drawn for example with the way Feminist Art History documented

the fluidity of what counts now and counted as art in the past, so as to enable study of women's works (Parker and Pollock 1981: passim).

Catherine King

Select bibliography

Borzello, F. and Rees, A. (1986) *The New Art History*, London: Camden Press.
Kubler, G. (1962) *The Shape of Time*, New Haven, CT: Yale University Press.
Parker, R. and Pollock, G. (1981) *Old Mistresses: Women, Art and Ideology*, London: Routledge.
Picton, J. (1997) 'Tracing the lines of art: prints, drawings and sculpture from Nigeria and southern Africa', in John Picton (ed.), *Image and Form*, London: School of Oriental and African Studies, 11–18.
——(1998) 'Yesterday's Cold Mashed Potatoes' in Katy Deepwell (ed.), *Art Criticism and Africa*, London: Saffron Books, 21–25.

JUDITH BUTLER, *GENDER TROUBLE: FEMINISM AND THE SUBVERSION OF IDENTITY* (1999)

Judith Butler, *Gender Trouble: Feminism and the Subversion of Identity*, New York: Routledge, 1999.

First published in 1990 and reissued in 1999 with a new preface, *Gender Trouble* remains Butler's best known and most influential work to date.[1] A germinal text for the emerging field of queer theory, the book's major contribution is its critical examination of the identity categories in sexual political debate. Butler maintains that a commitment to identity, one which considers the content of categories such as sex, gender and sexuality to be self-evident and unambiguous, will inevitably deny the complex reality of people's lives and the impure histories of political struggle.

The main target of Butler's intervention is the heterosexism of feminism. At that time, and although the women's movement had been forced to admit the racial and economic tensions that divided women and their allegiances, the facticity of 'woman' was relatively intact as the reference point for these debates. However, feminism's heteronormativity was more awkwardly engaged, perhaps because gender and sexuality had come to imply one another. Indeed, the lesbian experience had even been generalized as a shared female erotic – something akin to the commitment, friendship and sensual familiarity that attaches to being female.

Importantly, Butler's critique of what could be described as a hetero-sexist fundamentalism is not a simple corrective that attempts to replace one mistaken identity or perception with a more worthy or accurate one. As her aim is to acknowledge the complex forces that render *any* identity inherently unstable, Butler extends her criticisms of feminism's identity politics to contest a presumptive lesbian and gay identity that defines itself against the failures of feminism. In sum, *Gender Trouble* explores the tactical juggle that comes with admitting the provisional nature of identity, while at the same time acknowledging that identity is a political necessity with an experiential reality.

Gender Trouble is organized into three main chapters. Chapter 1, 'Subjects of Sex/Gender/Desire', introduces the reader to the basic terms of the debate, exploring the continuities and discontinuities between these categories as well as the foundational status of 'woman' for both feminism and the sex/gender distinction. Chapter 2, 'Prohibition, Psychoanalysis, and the Production of the Heterosexual Matrix', revisits Claude Lévi-Strauss and structural accounts of social organization, interrogating the explanatory importance of the incest taboo as the default line of cultural intelligibility. Butler deploys a psy-choanalytic approach to the question of identity formation in order to understand how structural heteronormativity is achieved, and then con-siders psychoanalysis and the incest taboo through the lens of Michel Foucault's work on the repressive hypothesis. Importantly, Foucault's insight is that the nature of power is so thoroughly perverse that even juridical power and repression can incite the law's subversion.

Chapter 3, 'Subversive Bodily Acts' forms the final section, and together with a brief conclusion, 'From Parody to Politics', is popularly regarded as *Gender Trouble*'s signature argument. Although Butler's uneasy response to the book's enthusiastic reception was to significantly rethink performativ-ity, this early representation, given its broad acceptance, has enduring significance for those wanting to understand the plastic nature of identity formation. Butler's discussion of sexual identification in biological discourse is also helpful as it exemplifies how readers in cultural studies might engage information in the sciences that purports to represent biological 'truths'.

As Butler's work is difficult for a reader who is not already familiar with aspects of Contintental thought, an attention to just one opening fragment of this book's argument will illustrate what is at stake in the twists and turns of Butler's style of criticism. Chapter 1 begins with several brief citations whose collective consequence represents a significant assault on the very foundations of sexual identity and desire:

'One is not born a woman, but rather becomes one.' Simone de Beauvoir
 'Strictly speaking, "women" cannot be said to exist.' Julia Kristeva
 'Woman does not have a sex.' Luce Irigaray
 'The deployment of sexuality ... established this notion of sex.' Michel Foucault
 'The category of sex is the political category that founds society as heterosexual.' Monique Wittig

(Butler 1999: 3)

To situate these assertions and explain their transgressive impact, Butler begins with a discussion of 'woman', a category whose substantive referent in sexual anatomy seemed to provide natural support for feminism's earliest struggles toward emancipation. It was as if being a woman was a fact whose simple self-evidence could unite ethnic, class and racial differences and even transcend cross-cultural experience. Coupled with the global identity of 'woman' were similarly sweeping assumptions about men, in particular, that all women suffered the oppression of a universal system of male domination, a patriarchy, whose exploitative advantage for males was clear.

Although not in direct disagreement with this, the growing appreciation that cultural factors were a powerful force in determining how biology was interpreted certainly complicated the picture. Beauvoir's provocative claim that 'woman' is a cultural artefact significantly displaced biology's organizing relevance for feminism, just as anthropological and historical research discounted sexual anatomy as an explanation of gender diversity. As Butler explains:

Originally intended to dispute the biology-is-destiny formulation, the distinction between sex and gender serves the argument that whatever biological intractability sex appears to have, gender is culturally constructed: hence, gender is neither the causal result of sex nor as seemingly fixed as sex.

(Butler 1999: 9–10)

Given the apparent disjunction between sex and gender we should not be surprised by 'the fragmentation within feminism and the paradoxical opposition to feminism from "women" whom feminism claims to represent' (Butler 1999: 7). Butler's point here is that identity politics disavows the violent exclusions, the normative demands and compromises which any definitional unity exacts. In other words, the lived reality of 'women' may incorporate such different experiences that the very existence of a shared identity becomes tenuous.

However Butler takes the argument further, underlining the scandalous implications of separating sex from gender when she asks if '*man* and *masculine* might just as easily signify a female body as a male one, and *woman* and *feminine* a male body as easily as a female one' (Butler 1999: 10). Butler justifies her question by returning to Beauvoir's rejection of biological determinism, noting '[t]here is nothing in her account that guarantees that the "one" who becomes a woman is necessarily female' (Butler 1999: 12). And yet even in this last suggestion, indeed, in the very terms of its expression, there is a sense that corporeal reference, the substantial fact of anatomical sex, precedes or restrains the multiple possibilities and meanings of a *later* disruption.

This enduring and explanatory reliance on the purportedly given, dimorphic materiality of anatomical sex, even within arguments that would separate sex from gender, leads Butler to ask:

> If the immutable character of sex is contested, perhaps this construct called 'sex' is as culturally constructed as gender; indeed, perhaps it was always already gender, with the consequence that the distinction between sex and gender turns out to be no distinction at all.
>
> (Butler 1999: 10–11)

Butler's interest is in the culture of 'sex' and its genealogy: how does 'sex' come to signify a pre-cultural, passive and immutable anatomical substance (body) which precedes gender interpretation (cognition/ mind)? In other words, if the dichotomy 'sex is to nature as gender is to culture' is actually an internal differential within culture itself, then what structures generate these oppositional and politically inflected differences?

Central to Butler's argument is a conviction that culture is capable of producing ontological (ways of being) and epistemological (ways of knowing) frames of reference which are so powerful that they congeal into the apparent invariance and irreducibility of material reality. In other words, culture informs the lived perception of what makes a meaningful world. For Butler, we are subjected to/through the weight of these material truths and live them as defining parameters of identity. The political implications of these regimes of meaning can be so subtle that their sexualized and sexualizing logic goes entirely unnoticed. Given this, it makes sense that Butler will focus much of her analytical attention on the political infrastructure, the economies of signification, that operate through language, discourse and other representational media.

Vicki Kirby

Note

1 Parts of this entry appear in Vicki Kirby, *Judith Butler: Live Theory*, London: Continuum, 2006.

Selected bibliography

de Beauvoir, S. (2010) *The Second Sex*, trans. Constance Borde and Sheila Malovany-Chevallier, New York: Alfred A. Knopf.

Butler, J. (1993) *Bodies that Matter: On The Discursive Limits of 'Sex'*, New York: Routledge.

——(1999) *Gender Trouble: Feminism and the Subversion of Identity*, New York: Routledge.

——(2004) *Undoing Gender*, New York: Routledge.

Foucault, M. (1980) *The History of Sexuality Vol. 1: An Introduction*, trans. Robert Hurley, New York: Vintage Books.

Kirby, V. (2006) *Judith Butler: Live Theory*, London: Continuum.

Salih, S. with Butler, J. (2004) *The Judith Butler Reader*, London: Basil Blackwell.

INDEX

death, xxxii, 4, 17, 23, 32, 37, 40,
44, 49, 72, 82, 87, 95, 119, 124,
140, 148–49, 168, 172, 188,
198, 213
Debord, Guy (1931–94), x, xxvii, 89,
108, 131–35, 174, 221, 223
decline, 33, 73, 82, 185
de-colonisation, 64, 67, 207
Deleuze, Gilles (1925–95), x, xiv, xxii,
xxvii, 57, 157–61, 221
depiction, 18, 19, 30, 140–41, 159,
161, 166, 179
dérive, 133–34
Derrida, Jacques (1930–2004), xv, 48,
150, 174, 187, 218
design, xii–xiv, xviii–xix, xxix, 35, 38,
47, 63, 79–80, 101, 115, 121–22,
125–26, 128, 172, 180, 200, 202,
224–25
desire, 13, 33, 54, 56, 57, 58, 74,
93–94, 105, 108–9, 132, 145–47,
169, 202, 218, 221, 228
détournement, 133
dialogic paradigm, 203
diaspora(s), xxviii, 94, 199–200, 226
Dickie, George (b.1936), 163
Didi-Huberman, Georges (b.1953), x,
xxviii, 52–53, 187–92
difference, (cultural), xv, xxviii, xxix,
xxxii, 59, 85, 112, 147, 150, 168,
185, 187, 196, 198–99, 205
digital, 85, 88
discourse, xiii, xxi, xxiii, xxv, xxvii,
xxviii, xxxi, 7, 42, 48, 63, 66, 90,
93, 105, 119, 134, 160, 167, 175,
179, 190, 199–201, 203, 205, 211,
213, 216–17, 219–22, 225–26, 228,
230
display, 82, 90, 153, 155–56, 180, 184,
213, 223–24, 226
documentary photography, 175
Dolce, Lodovico (1508–68), viii, xxv,
36–40
drawing, xxvi, 29, 35, 39, 47, 70, 75,
91, 102, 147, 151, 204
dreams, xix, 80, 111, 140, 143, 191
Duccio, Agostino di (1418–81), 77
Duchamp, Marcel (1887–1968), 48,
103, 176, 212, 214
Durandus, William (c.1230–96), 14, 16

Dürer, Albrecht (1471–1528), viii, xxv,
27–31, 76, 100–1
Duve, Thierry de (b.1944), 46–48, 120
Dwan Main Gallery, 154

earth, 17, 39, 82–83, 106–7, 110, 145,
160
economy, economic, xxxi, 52, 64, 68,
73, 145–46, 156, 171–72, 176, 180,
184, 191, 220, 222, 227
ecphrasis, ekphrasis, 8, 10–12, 170
écriture féminine (feminine writing), 149
ecumenical council, 17–18, 22
Egyptian, 62
embodiment, 66–67, 90, 149;
embodied subjectivity, 152
Emerson, Peter Henry (1856–1936),
128, 205
emotion, xiv, 47, 132
empathy, ix, 59–63
Enlightenment, (The) European, xxv,
46, 52, 89, 98, 135, 172, 177, 205
epigraphy, 42
epistemology, 49, 52; epistemological,
xxi, xxviii, 66–67, 200, 230
essentialism(ist), 52, 103, 151, 194,
196, 198–99
ethnicity, 193, 196, 200, 209
ethnography, xxviii, 64–67, 224
Etruscans, 42
Eurocentric, 52, 200, 203
Europe, xiii, xiv, 16, 18, 41, 86, 103,
123, 125, 137, 185, 205, 226
Evans, Walker (1903–75), 128, 131,
144, 147–48, 178
exhibition, xv, xxix, xxx, 98, 121–22,
124–25, 130, 155, 183, 194, 196,
202, 213–14, 219, 224, 226
Expressionism, 117, 212

face, 57, 62, 91, 100, 108, 117, 137,
146, 159–60, 185, 226
faciality, 159–60
fame, 28, 31, 34, 46, 101
Fanon, Frantz, (1925–61), ix, xxviii,
105–10, 183, 187, 193, 195
fantasy(ies), 57, 78–80, 115, 140, 145
fascism, 83–84, 86–87, 150
feminism, feminist, xi, xv, xx, xxvi,
xxviii, xxx, 57, 59, 100, 105, 110,